MW00791874

PLACES IN ITALY

A Private Grand Tour

THIRD EDITION

Francis Russell

WILMINGTON SQUARE BOOKS
an imprint of Bitter Lemon Press

❁

WILMINGTON SQUARE BOOKS
An imprint of Bitter Lemon Press
47 Wilmington Square
London WC1X 0ET

Third edition 2019

Some portions of this book were previously pubished in
52 *Italian Places* (Allemandi, 2007) and
101 *Places in Italy* (Wilmington Square Books, 2014)

A CIP record for this book is available from the British Library

ISBN 978-1-912242-21-4

1 3 5 7 9 8 6 4 2

Designed and typeset by Sally Salvesen
Index by Christine Shuttleworth
Printed in China

Frontispiece: Villa Barbaro,
Paolo Veronese, Salla di Bacco, fresco (detail).

In memory of
Contessa Ester Bonacossa
(1903–1992)
who introduced me
to so many places
and people
in Italy

CONTENTS

❉

INTRODUCTION TO THE THIRD EDITION

THIS IS AN expanded, and I hope improved, edition of a book written in 2005 at the suggestion of Umberto Allemandi. The patterns of civilization lie more thickly upon the Italian peninsula than on any commensurate area of the earth. Successive civilizations have left their trace: Greek and Etruscan, Roman and Byzantine. Invaders have come and gone. But the peoples of Italy have shown an irrepressible artistic resilience unmatched elsewhere. England was in the van at certain moments. So, arguably more often, was France. Holland had its great century. But only of Italy can it be said that for three millennia no century or indeed generation has failed to leave its contribution; and that, with a consistency that can only humble the foreigner, so many strata of this creative achievement have determined the course of civilization throughout Europe.

Like anyone who revisits a country he loves, I am irresistibly drawn back to the places and works of art that aroused and have sustained that love. But I always try also to see sights that are new to me. In this respect Italy has proved – and will always prove – to be inexhaustible. Umberto asked for a selection of the fifty places that matter most to me; self-indulgence led me to raise the number to fifty-two. A hundred and one were included in the second edition of this book: now there are a hundred and fifty. As will be obvious to the reader, my deepest interest lies in painting of the Italian Renaissance. The pursuit of this determined the course of my early sightseeing. But pictures – and sculptures – only make proper sense in the context of the buildings for which they were commissioned. These reflect the political and religious complexion of their cities and towns, which in turn must be seen in the context of their landscapes, the territories from which they drew their livelihood and upon which their strategic or economic importance depended.

Umberto charged me to be personal in the expression of my views. No sightseer is unprejudiced. I selected the places I myself would most have liked to revisit, and which, perhaps selfishly, I thus believed would give most pleasure to others. Where great towns are concerned, I outlined what I would choose to see again, the walks or perambulations I would take, the churches or museums in which I would linger. Buildings, however wonderful, that are not readily accessible to the public are omitted. It is not within the scope of this book to record opening hours of museums. But in Italy, churches open early and the

traveller is advised to take advantage of this.

The selection was mine and involved many sacrifices. As I write I hear the advice of Ester Bonacossa, Etta to her English friends, when I was planning tours: 'don't forget Cividale'; 'don't neglect Cefalù'. In the second edition Cividale was one of four dozen additional places, many of obvious importance but others equally eloquent of the past, that ought to be better known. For this third edition, in which Cefalù duly appears, I have been more self-indulgent in my selection. Some of the omissions for which I was fairly taxed – and indeed regretted myself – have been made good. A number of smaller towns have been chosen, mostly because they can readily be visited in conjunction with more major centres, particularly in areas that offer most to the sightseer. Montesanto is here as a warning not to neglect opportunity.

But much, too much, more inevitably is still omitted: Aosta and Ivrea in Piedmont; Vigevano and Lodi in Lombardy; magical Torcello and unselfconscious Chioggia, Fanzolo and Treviso in the Veneto; San Danieli del Friuli and Spilimbergo in Friuli; Faenza in the Romagna; and in Tuscany, Collodi. I have had to be equally ruthless in Umbria, forfeiting Spello, Amelia, Narni and Norcia, as well as Senigaglia, Jesi and Recanati and Tolentino in the Marche, not to mention numerous remote early churches both there and in Abruzzo. Nearer Rome, many interesting places are passed by. So further south is Herculaneum, as well as Barletta, Bari, Altamura and Otranto in Apulia. In Sicily Taormina is still an absentee, as are Catania, Noto and Erice.

Some sites are briefly touched upon in the entries for neighbouring places,

and in a few instances, particularly in Sardinia, churches and other places that can be conveniently seen on brief journeys are linked. A few places, including Ninfa, are absent because I have not visited them; while others are passed over for the irrational reason that they failed to come up to personal expectation. Those who want to explore are admirably served by the red guidebooks of the Italian Touring Club and that pocket-sized volume so indispensable to my early Italian sightseeing, the 1932 Oxford edition of Berenson's *Italian Pictures of the Renaissance*.

Italy has changed since I came to know it in 1966, and continues to change. White oxen are no longer used to plough in Tuscany. Peasant farmers have left for the towns. Tracts of country have been suburbanized, whether by Italians or foreigners, their former farmhouses severed from the landscape by intrusive fencing. Windfarms have invaded the hills of Basilicata, as effectively as the Normans did. New building in many areas has been uncontrolled. So has the motorcar. But prosperity has meant much that seemed in danger has been safeguarded; and just as the Italian authorities have long sought to restrain the export of works of art, so they have taken heroic steps to preserve a prodigious architectural inheritance. Despite valiant efforts to prove the contrary, many of the artistic achievements of twentieth-century Italy do not represent a natural or organic process of evolution. And I am certainly not qualified to write about these. While I would love to see again that enchanted room muraled by Severini for the Sitwells at Montegufoni, I cannot claim a strenuous appetite for Modigliani or Morandi. I have been more impressed by architecture of the

fascist period in Libya and Ethiopia than in Italy and do not intend to revisit Carlo Scarpa's celebrated mausoleum at Riese, although I do admire Giancarlo dei Carli's cascading additions to the University of Urbino and his housing scheme near Terni. But it is not for such things that most tourists go to Italy.

Works of art cannot be taken by storm. Buildings and towns take time to explore. I shall always be grateful to those – recorded in the same geographical order as the text – whose unstinted hospitality has enabled me to take that time: the late Contessa Ester Bonacossa in Milan and at San Remigio; Signora Francesco Sella and the Mazzotta family in Milan; the late Mrs Henry J. Heinz Jr, at the Casa Ecco; the late Contessa Marina Luling Buschetti and subsequently Diamante and Vittorio dalle Ore at Maser; the late Contessa Anna Maria Cicogna, Elisabetta Foscari, Luciana Moretti, Marina Atwater and François Borne in Venice; the late Marchese Franco Bianci di Castelbianco at San Domenico di Fiesole; the late Sir John Pope-Hennessy, the late Mrs Elizabeth Marangoni, the late Sir Harold Acton, Fausto Calderai and Neri Torrigiani in Florence; the late Mrs Vincent Astor at Montevettolini; the late Principessa Letizia Buoncompagni, the late Mrs Earl Magrath, Contessa Viviana Pecci-Blunt and the late comte Henri de Beaumont at Marlia; the Francesco Pesenti in the Lucchese; the late Conte Giovanni Tadini at Agnano; the Cavendishes at the Casa al Bosco; Jonathan and Elisabetta Mennell near Monteroni; Max and Joy Ulfane at Fighine; the late Miss Ursula Corning, as whose guest at Civitella Ranieri – and in 1984 at San Fabiano – over thirty-three summers I must have spent a total of some twenty months; the late Marchese Uguccione Ranieri di

Sorbello, Marchesa Marilena Ranieri di Sorbello and their son Ruggero, almost every year since 1968 at the Casa Sorbello, Perugia, and, once, at Pischiello; the Bizzari at Todi; Alessandra Montani della Fargna at Poreta; the late Duca Roberto and Duchesa Franceschiella Ferretti di Castelferreto at Castelfidardo; the late Tomasso Buzzi at La Scarzuola and in Rome; Alice Goldet in Rome; Sir Mark and Lady Lennox-Boyd at Oliveto; Barone Maurizio Baracco at the Villa Emma; the Carlo Knights in Naples and Capri; the David Bensons at Bussento; Francesco Pantaleone at Palermo; the Dibbets family near Noto; and Adrian and Jessica White in Sardinia. As I only learnt to drive at the age of thirty-six, I will always be indebted to those who motored me in the past: to Ester Bonacossa; to Ursula Corning and so many of her guests, including the late Mrs Cyril Egerton and her niece, the late Mrs Simon Ricketts; to Hugh Roberts; and, not least, to my mother.

The original edition of this book owed much to the editing of Anna Somers Cocks and her associates, who must have been sorely tried by my dyslexia. This edition has been edited with unfailing tact by Sally Salvesen; I'm also indebted for much practical help to Abbie Winter and Victoria Koehn. I am grateful for constructive suggestions to Alessio Altichieri, Jamie Macdonagh, Antonio Mazzotta, Marco Riccomini and James Sassoon. Mistakes are mine. The illustrations used in the previous volume were not available: I am greatly indebted to Antonio Mazzotta for the use of several of his images which are indicated with his initials; most of the rest are mine.

F.R.

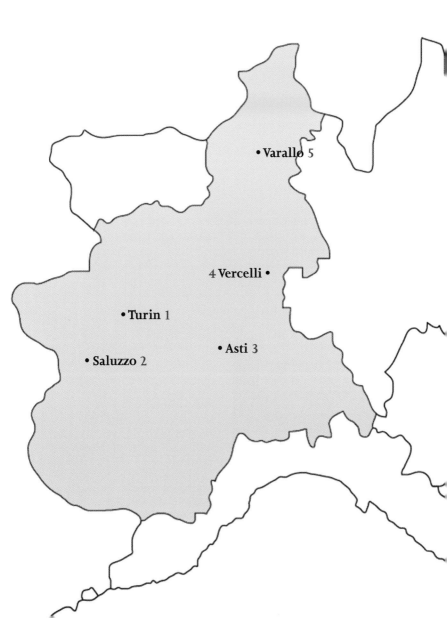

Piedmont

- Varallo 5

4 Vercelli •

• Turin 1

• Asti 3

• Saluzzo 2

I

TURIN

❀

OF THE GREAT Italian cities, it is Turin of which the visitor has fewest expectations. I had cumulatively spent over a year in Italy before my first visit in 1973; Hugh Roberts, with whom I was travelling across northern Italy, wanted to spend four days, rather to my surprise. How right he was.

Until the age of the railway, Turin was the first Italian city most English or French tourists saw. Although some crossed the high passes to the Val d'Aosta with its bristling castles, most would have taken the Mont Cenis and thus descended to Susa, pausing perhaps to see the well-preserved Arch of Augustus, and then continued on the successor of the Roman road, passing beneath the spectacularly sited abbey of San Michele della Chiusa.

The natural capital of Piedmont, Turin is set on the flank of a productive plain above a bend of the river Po as this circles the north-western edge of the Monferrat range. Turin had been a major Roman city, as the gaunt Porta Palatina still attests. In 1280 it passed to the house of Savoy; and the city's enduring fascination is inextricably linked with the course of that dynasty, counts and, from the fifteenth century, dukes of Savoy. Exiled in 1536, the Savoys returned in 1559. Their political acuity in dealing with both France and neighbouring Italian states consolidated their power. Vittorio Amadeo II inherited in 1675. His role in the War of the Spanish Succession, in which his kinsman Prince Eugène distinguished himself as the Austrian commander while Turin itself almost miraculously defied the French siege of 1706, led to his elevation as the King of Sicily in 1713 and, after the loss of that island to the Bourbons, King of Sardinia in 1720. He died in 1730, by when he had transformed his capital.

The Palazzo Reale with its ponderous façade, begun in 1646 and completed in 1660 by Vittorio Amadeo's father, is the central monument of Turin. The sequence of staterooms on the *piano nobile* expressed a determined taste for power. From the piazza in front of the palace one sees equally clearly how the ambitions of the Savoys found architectural expression. A decisive victory of 1557 prompted a vow to build a church dedicated to Saint Lawrence, but it took over a hundred years for work to begin on the west side of the piazza. In 1666 Guarino Guarini was called in, and building

Susa, the Arch of Augustus, 9–8 BC

proceeded over two decades. Guarini's dome at San Lorenzo, so ruthless in the logic of its internal structure and ingenious in the use of light and shadow, is a *tour de force*.

A short walk from the corner of the palace leads to the chaste late *quattrocento* cathedral, Roman in type, to which Guarini appended his stupendous chapel to house the most celebrated treasure of the house of Savoy, the Holy Shroud. The shrine was, and after its restoration will doubtless be again, the most unsettling of baroque statements, a vertiginous orchestration of black marble. Guarini was also enlisted in the urban development of Turin, a cherished project of successive rulers. The curving brick cliff of the main elevation of his Palazzo Carignano has no equal.

Opposite San Lorenzo is another major royal monument, the Palazzo Madama, with a wonderfully articulated façade of 1718–21 applied to the much-reconstructed medieval castle by that most protean of architectural draughtsmen, the Sicilian Filippo Juvarra. Within is a prodigious staircase, regal yet oddly free of pomp. The civic museum on the first floor, recently rearranged, documents the history of the area and used in an old-fashioned way to be the perfect setting for a key collection of pictures and sculptures by the masters of Renaissance Piedmont.

The prosperity of modern Turin means that the complexion of the old town has changed dramatically. Blackened façades are now clean. Crumbling palaces have been rehabilitated, sometimes ruthlessly, as banks and offices. The visitor should wander. Strike across from the Palazzo Madama and follow the Via Dora Grossa (now named after Garibaldi), turning to see how Juvarra's frontispiece of the former dominates the axis, and return by the parallel Via Corte d'Appello to follow the Via Roma to the Piazza San Carlo, with the façade of Santa Cristina by Juvarra balanced by the copy of this at San Carlo. Linger on the arcaded Via Po, inaugurated in 1673, with its complement of churches and the Royal University – hence the number of bookstalls. To the south are more straight streets and many of the finer palazzi. Among the many churches of the area, none is more satisfying than San Filippo, where Juvarra worked from 1715 onwards; major altarpieces by the most celebrated painters of contemporary Rome and Naples, Maratta, Solimena and Trevisani, testify to the ambition of the new kingdom. Turin had become a major capital; foreigners on the Grand Tour might study there, and in the early 1760s the English Minister, James Stuart Mackenzie, reported on British visitors to his brother, the Prime Minister, while making arrangements to buy Consul Smith's collection from Venice for the young King George III.

Like other Italian dynasties, the Savoys were driven away in the wake of Napoleonic victories. They returned in 1814. The Neoclassical susceptibilities of King Carlo Felice were satisfied in the great piazza at the end of Via Po and the Chiese Madre on the opposite bank of the river, Bonsignore's solemn reworking of the Pantheon. The king's cousin and successor, Carlo Alberto, commissioned the dramatic equestrian monument of 1838 to their heroic ancestor Emanuele Filiberto in the Piazza San Carlo from Baron Carlo Marochetti; for the anonymous Glaswegian author of *Travelling Notes* (1864) this was the outstanding artistic sight of Turin. With the Risorgimento and the transfer of the capital of Carlo

Alberto's heir, Vittorio Emanuele II, as King of Italy, first to Florence and subsequently to Rome, the Savoys ceased to reside in Turin. It became a political backwater, elegant and aristocratic.

The increasing economic importance of Piedmont was reflected by the development of the museums of Turin, notably the Galleria Sabauda, whose holdings of works by regional painters

of the Renaissance were supplemented by much of the dynastic collection of the Savoys, and the Museo Egiziano, which houses the most comprehensive collection of Egyptian antiquities in Italy and is rivalled in Europe only in Berlin, London and Paris. Both institutions are housed in the former Collegio dei Nobili.

The considerable twentieth-century expansion of the city was due in part

Filippo Juvarra, Stupinigi, Hunting Lodge, designed in 1729–30.

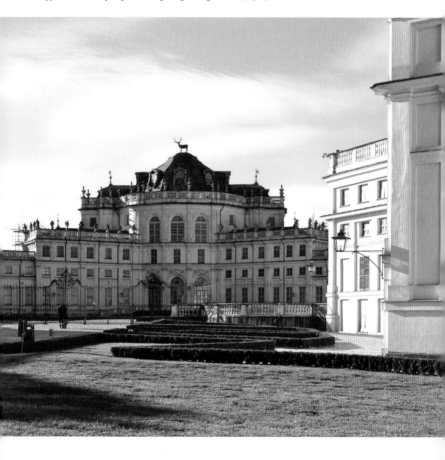

to Fiat and the Agnelli, who, after the exile of King Umberto in 1945, became its substitute dynasty. The city has now lost its visual relationship with the hinterland. There is no longer any game to pursue in the vicinity of the great hunting lodge that Juvarra designed in 1729 for the ageing King Vittorio Amadeo, reached by an impressive avenue some five kilometres to the south of Turin. Vast though it is, Stupinigi, whose stag-crested domed central block seems to thrust upwards through the flanking wings, is neither pompous nor monotonous – as are so many contemporary palaces of similar scale. In winter the white stucco seems to echo the snow-capped mountains beyond. And despite recent thefts, the royal apartments, with furniture by Pietro Piffetti, pastoral landscapes by Cignaroli and pastel portraits by Liotard, still breathe with something of the spirit of *settecento* court life.

The Savoys had other palaces outside Turin, including Rivoli and Raconigi – the latter partly decorated by the Torinese Giovanni Battista Borra, who had travelled as draughtsman with Robert Wood and James Dawkins to Palmyra and Baalbec and made his mark in England before returning to serve his monarch. Even grander was the never finished Venaria Reale with a spectacular gallery and the Cappella di Sant'Uberto by Juvarra; the complex and garden have recently been restored. Yet another palace was begun behind the most dramatically placed of Turin's monuments, Juvarra's Basilica di Superga, the Valhalla of the Savoys, on the hill to the east, begun in 1715 and completed in 1731. The huge domed church flanked by massive towers hangs above the city; its platform is the vantage point from which Turin's urban development can best be understood.

2
SALUZZO

✣

ON THE DEATH of Adelaide Manfredi in 1091, Bonifazio del Vasto inherited much of her father's duchy of Turin and Susa, which was subsequently divided among his seven sons. Saluzzo fell to Manfred, founder of a line of marquises that endured until 1548 and did much to embellish their city.

The visitor arrives in the lower town, the south side of the main street of which, the Corso Italia, follows the line of the medieval walls. The Cathedral of 1491-1501 was built outside these, on the north side of the corso. The retardataire late gothic façade does not wholly prepare one for the ambitious scale of the interior. Above one of the altars on the right is a fluent *Adoration of the Shepherds* by Sebastiano Ricci, an unexpected Venetian rococo apparition. On the opposite side of the church are the surviving sections of a major polyptych by the northern painter Hans Clemer in which Ludovico II of Saluzzo and his consort, Marguerite de Foix, appear as donors.

Diagonally across from the cathedral is a former gate in the city wall beyond which is the former Episcopal Palace. Take one of the narrow streets or flights of steps and climb to reach the Salita del Castello, lines with lesser palaces the fronts of many of which incorporate medieval elements. Some way up, on the right, is the loggiaed Palazzo Comunale overhung by the Torre Comunale of 1462 with its sixteenth-century octagonal top. Next to this is the Palazzo dell'Arti, its façade with murals in grisaille. The salita

ends opposite the wide round tower which Ludovico II added to his castle in 1491-5.

To the east of the Palazzo Comunale a street runs down to the most memorable church of Saluzzo, San Giovanni, begun in 1330 but not finished until 1504. Steps lead downwards to the nave. The glory of the church is the lavishly gothic choir, designed in 1474 by Antoine Le Moiturier as a funerary chapel for Ludovico I.

On the left wall ifs the tomb of Ludovico II by the Pavian sculptor Benedetto Briosco, a recumbent effigy set in an intricately carved canopy. To the left of the church is the cloister, off which are the chapterhouse and refectory. In the former, flanked by murals of the saints is the monument to Galeazzo Cavassa, vicar general of the marquisate, who died in 1483, a work of great refinement by the Comasque sculptor Matteo Sanmicheli.

Abbey of Staffarda from the east.

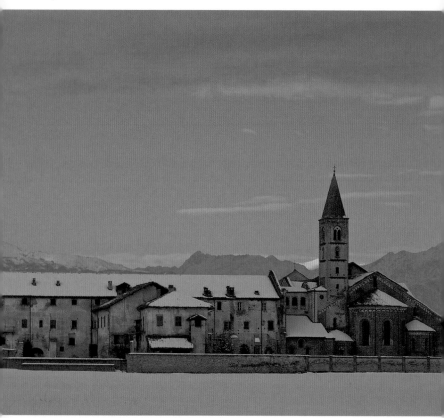

Nearby, on the north side of the Via San Giovanni is the Casa Cavassa, begun for Galeazzo and altered for his son Francesco, who served as vicar-general under Marguerite de Foix. A rare survival, the house is now a museum: appropriately enough it holds Clemer's *Madonna della Misericordia*, in which Ludovico II is shown as donor.

Walking downwards, try to pass the Municipio in the former outpost of the Jesuits and find the small square with the painted façade (1757) of San Nicolò beside the former seminary and, at a right angle to this, the admirably fluent brick front of the deconsecrated Santa Margherita.

Some ten kilometres north of Saluzzo, clearly visible from the upper town, is the great Cistercian Abbey of Staffarda, endowed by Manfred I in 1135. On the approach the Romanesque campanile seems to vie with the conical peak of the Monviso to the west. Much of the medieval monastery survives, its scale attesting to the efficiency of the Cistersians as agricultural entrepreneurs. The entrance is now through the cloister. The late twelfth-century church with its brick piers is in every sense a muscular structure. There is a moving pigmented group of the *Crucifixion* datable about 1500 in the right aisle, which like so many of the treasures of Saluzzo is clearly by a northern master.

3
ASTI
✿

SET ON THE north bank of the river Tanaro, the former Roman *colonia* of Hasta remained a town of considerable importance in the early medieval age, caught up with the ambitions of regional powers including the marquesses of Monferrat, the counts of Savoy, the Angevin kings of Naples and the Visconti. In 1529 Asti passed to the Emperor Charles V to become the dowry of his sister-in-law, Beatrice of Portugal on her marriage to Carlo III of Savoy.

The main street, running from the Piazzale Torino in the west across the town, the Corso Alfieri, is named after Asti's greatest son, Vittorio Alfieri, the playwright who lived for many years with Louise, Countess of Albany, widow of Charles Edward Stuart, 'Bonnie Prince Charlie'. With its procession of *palazzi* the street implies the prosperity of Savoyard rule. The first building of interest is the mid-eighteenth-century Santa Catarina by G.B. Feroggio with its elegant oval dome. Beside this is the dodecagonal Roman Torre Rosso of brick with a Romanesque upper section.

Ahead, immediately before the Palazzo Alfieri, where the dramatist was born, the first road on the left leads up to the Cattedrale, an imposing fourteenth-century building, the character of which is not significantly altered by subsequent changes and reconstruction. The earlier campanile was reduced in height in the seventeenth century; while the beautiful porch on the south flank with its statuary is of after 1450. Within the frescoes of 1696-1700 on the gothic vaults come are

somewhat disconcerting. The same can be said of the way that Gandolfino d'Asti's key altarpiece of *1501* was rearranged in the baroque altar in the right transept. The murals in the choir are by the versatile Genoese Carlo Innocenzo Carlone. In some ways the most satisfying works of art in the cathedral are Gandolfino's *Marriage of the Virgin* and the terracotta *Pietà* of *1502* in the left aisle.

Return to the Corso Alfieri. Further on, to the left, is the Palazzo di Bellino, now a museum. Opposite the Via San Martino leads to two surviving medieval towers and the refined thirteenth-century Casa-forte dei Roero di Cortanze. The road intersects with the Via Quintino Sella, with the gothic Casa Roero: the Casa dei Roero di Monteu with its tower is nearby on Via Malabayla. This

concentration of private towers reminds us that Asti, like other towns, was divided between Guelf and Ghibelline factions, led respectively by the Solari and De Castello families. Head eastwards for the gothic San Secondo, the campanile of which survives from the previous church, but like that of the cathedral was subsequently reduced in height. From the church turn right to cross the Corso Alfieri to reach the Piazza Medici with the finest of the towers of Asti, the *trecento* Torre Troyana. Return to the corso and continue eastwards. On the right, just before the Piazza 1 Maggio, is the Battistero di San Pietro, an early twelfth-century rotunda of great distinction.

Part of the charm of Asti is that there are few cities in Italy where so little notice is taken of the tourist.

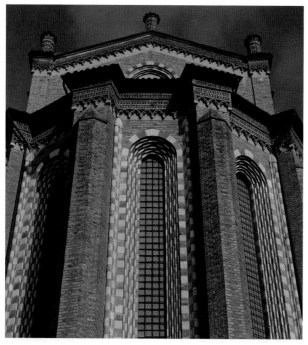

Cattedrale, south transept.

4

VERCELLI

✤

VERCELLI ADVERTISES ITSELF as a 'città d'arte' with some reason. It boasts one of the great gothic churches of northern Italy, and gave birth to a significant school of Renaissance painters. And although the town has grown considerably, there are still places from which the towers of Sant'Andrea can be seen across fields of waving maize.

It is at Sant'Andrea that a circuit should begin. Although much restored, this remains the quintessential Italian statement of Cistercian austerity. The deep rust of the brick contrasts with the warm stone of the windows and other elements, and the towers are striking. The church, more impressive than lovable, is perhaps seen to best advantage from the adjoining cloister. Much of the fabric of ancient Vercelli survives: a medieval core round the arcaded Piazza Cavour; the massive brick castle of the Savoys, now the Palazzo del Giustizia; palaces that are less numerous and ambitious than those at neighbouring Casale Monferrat – so loved by my old friend Giovanni Tadini, who had the advantage of knowing about their inhabitants, past and present; a scattering of good Neoclassical buildings; an appropriately eclectic synagogue of 1878; and the industrial gothic of the Mercato Pubblico of 1884. But the sightseer has come for other things.

Some way east of the Piazza Cavour is

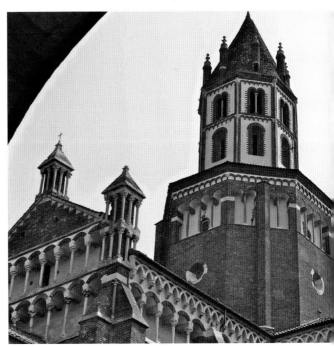

Sant'Andrea, the tower from the cloister.

the Museo Borgogna, housing the collection left to the city by Antonio Borgogna (1822–1906) and the municipal holdings. The most distinguished of Borgogna's early Italian pictures was a tondo of his Sienese period by Sodoma, who was born at Vercelli. The collection of pictures by painters who, unlike Sodoma, remained at Vercelli is comprehensive, with an unrivalled group of altarpieces and smaller works by Defendente Ferrari, a touching artist who learnt much from northern pictures, as well as the vacuous productions of his follower Girolamo Giovenone and panels by the grand protagonist of the Piedmontese school, Gaudenzio Ferrari, and by his able successor Lanino. The upper floors house more of Borgogna's pictures. The star is Hans Baldung Grien's *Charity*, which with the Dürer *Adoration* in the Uffizi is one of the finest German Renaissance pictures in Italy; Borgogna bought it from the Manfrin collection at Venice, where once it kept incongruous company with Giorgione's *Tempesta*. Borgogna was also interested in some aspects of contemporary painting. He bought pictures of historical and Arab subjects; he owned Gaetano Chierici's *La buona matrignana*, showing a hen protecting her chicks from rats, and, less expectedly, a triptych of 1885 by the Bruges painter Edmond van Hove which reinterprets the art of Quentin Massys

with an almost pornographic intensity.

Leave till last the noblest achievements of the Renaissance in Vercelli, Gaudenzio's frescoes in the church of San Cristoforo. In 1529–30 he painted the *Madonna del Melarancio* for the high altar; the enlargement of the choir means that this is now placed much higher than the artist intended. Commissions followed for the frescoes in the chapels on either side of the presbytery. Work began in that on the right, dedicated to the Magdalen. On the east, altar, wall, is the prodigious upright *Crucifixion*, the lower part of which is unfortunately covered by a later altar, so that, for example, we cannot see the hands of the dice-playing soldiers. The drama is concentrated. The Virgin swoons; the Magdalen is seen from behind in *profil perdu*; a white horse returns our gaze. This and the equally original compositions on the right wall were executed in 1530–32.

The balancing frescoes of the Chapel of the Assumption are of 1532–4. The iconography of the *Assumption of the Virgin* allowed less scope for diversion than the *Crucifixion*. On the lower tier of the side wall are the *Birth of the Virgin* and the *Adoration of the Magi*, between which are portraits of kneeling donors in fixed profile who seem oddly less palpable than the kings and their attendant dwarf and pages.

5

VARALLO

❖

THE RIVER SESIA carves a circuitous course to the south-east from the flank of the Monte Rosa. Varallo has long been the principal town of the Valsesia. It is best approached by the old road from the south, which passes the still isolated porticoed Cappella della Madonna di Loreto, with a beautiful external frescoed lunette of the *Adoration* by Gaudenzio Ferrari. High above the main piazza, from which it is approached by a picturesque ramp, is the Collegiata di San Gaudenzio, with a notable polyptych of about 1516–20 by Gaudenzio. Below are the narrow curving streets of the ancient town, whose charm has not been reduced by recent prosperity. A short, but by no means direct, walk leads to the Pinacoteca with half a dozen pictures, including two of David with the head of Goliath, by the most forceful artist of Counter-Reformation Piedmont, Tanzio da Varallo. The impact of these masterpieces is diminished by an irritatingly theatrical display, from which the museum's exemplary collection of maiolica is happily spared.

A few dozen yards beyond the Pinacoteca, you reach the limits of the original conurbation. To the left is the house identified as that of Gaudenzio, who is the subject of a nearby statue of 1874 by another local artist, Pietro della Vedova. This is eloquent of the high place that the greatest master of the High Renaissance in Piedmont held for the generation of Giovanni Morelli and Sir Charles Eastlake. Behind the statue is the great Renaissance conventual church of Santa Maria delle Grazie. The nave is dominated by the arcaded west wall with Gaudenzio's prodigious frescoes of the life and passion of Christ. Executed in 1513, the series evinces that narrative instinct and sense of objective realism for which Gaudenzio was so remarkable: he leaves us in no doubt that the Bad Thief was bad and the Good Thief repentant. The frescoes, which are enriched by sections of stucco, demand patience and field glasses, and are best seen without artificial light on a clear morning when Gaudenzio's disciplined use of colour tells to particular effect.

Santa Maria delle Grazie was founded by Bernardino Caimi, as was the Sacro Monte for which most visitors come to Varallo. Caimi returned from the Holy Land in 1481 and determined to replicate the pilgrimage route of Jerusalem. After his death in 1499 impetus was lost, but in 1517 the project was revived. Gaudenzio understood exactly what was required of him, but once again momentum faltered. After another long pause, the Sacro Monte found in 1565 a determined advocate in the Archbishop of Milan, Carlo Borromeo; and a series of additional chapels were designed by one of the most consistently rewarding Italian architects of the period, Galeazzo Alessi, who had been brought up in Perugia in the shadow of Perugino and Raphael but is perhaps best known for his Genoese palazzi. Momentum was maintained, and major Lombard and Piedmontese painters and sculptors were called in. The high bluff of the Sacro Monte hangs over the town. Although you can drive and there is a funicular, it is best to walk up the steep path above Santa Maria delle Grazie. The last two bends are marked by chapels and the pilgrim then reaches the Sacro Monte.

Sacro Monte, Chapel V: Gaudenzio Ferrari, Adoration of the Magi (detail). A.M.

The first chapel – of 1565–6 – looms beyond the gateway: Alessi at his most simply classical. The *Fall of Man* is represented. The statues in painted terracotta are by local masters, while Alessi enlisted his Perugian near contemporary, Orazio Alfani, for the murals; he did not repeat the mistake. The pilgrim to this New Jerusalem follows a fixed labyrinthine route, turning and circling up the wooded hillside. The cycle continues with the *Annunciation*. Gaudenzio is first encountered in Chapel V, with the story of the Magi, his statues perfectly complemented by his frescoes. In Chapel VI, Gaudenzio's *Nativity* is particularly inventive: the Virgin rests the Child on an ostensibly real manger. Prodigious in a wholly different way, although far less moving, is the high drama of Chapel XI, the *Massacre of the Innocents*, with no fewer than ninety-five statues, including the slaughtered children's toys, and fluent frescoes by Giovanni Battista and Giovanni Mauro della Rovere.

The chapels are as ingenious architecturally as in their decoration; Chapels XXXIII–V are gathered round what is in effect a piazza, with astounding views up the narrow valley of the Sesia as it carves its course downwards from the west. Many of the finest sculptures in the higher chapels are by Tanzio's brother, Giovanni d'Enrico, who shared his sense of realism and worked particularly happily in conjunction with one of the greatest Milanese masters of the late sixteenth century, Morazzone. Most extraordinary of all is Chapel XXXVII, dedicated to the Crucifixion, for which Gaudenzio took an earlier wooden statue of Christ as the centrepiece of a seamless combination of sculptures and murals that must have seemed startlingly original when it was created and has not lost its capacity to move. In the presence of such a masterpiece, one understands why San Carlo Borromeo saw the Sacro Monte as a powerful instrument of the Counter-Reformation. For the life of Christ is told in a language that must have been instantly comprehensible to the pilgrim. One hopes that most of those who make the pilgrimage today are oblivious to the spurious classicism of the late nineteenth-century façade of the basilica where their circuit ends.

The Sacro Monte set the precedent for those at Varese and Orta. With its sequence of classical chapels, this surely was also among the ancestors of the great gardens of eighteenth-century England and elsewhere, with their defined circuits of temples and other buildings. And in the nineteenth century it struck a strong chord with such visitors as the Revd S.W. King, whose description in *The Italian Valleys of the Pennine Alps* of 1858 could hardly be surpassed, and Samuel Butler, whose *Ex Voto* of 1888 is understandably still in print.

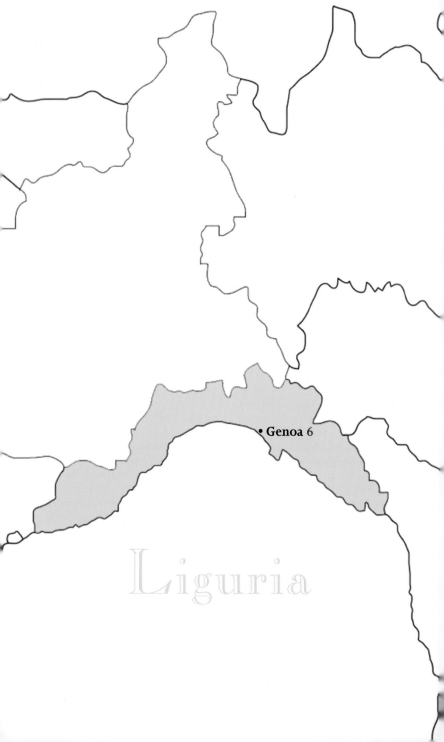

Liguria

• **Genoa** 6

6

GENOA

✿

S O L O N G T H E maritime rival of Venice, Genoa, which cleaves to hills that descend abruptly to the Ligurian coast, remains a major port. It also remains a place of contrasts, as anyone who strays from the Strada Nuova with its astonishing procession of palaces will find if he takes the narrow *salita* downwards to the appropriately dedicated church of the Magdalen: even on a Sunday morning whores stand in wait. But that should not deter the sightseer, for there is much to be found within the tight confines of the medieval town. Genoa rewards the patient walker who disregards fixed itineraries.

Genoa had become a significant Mediterranean power by the eleventh century, contributing to the success of the Crusades yet eventually helping to undermine the Frankish kingdom of Jerusalem. The wealth of the Genoese republic is implied by the great Romanesque cathedral of San Lorenzo; the campanile is the most splendid among several in the city, while the treasury still boasts such prized relics as the cup which Christ used at the Last Supper and a chalcedony platter thought to be that on which the head of the Baptist was delivered to Herod, with a beautiful fifteenth-century enamel head of the saint. Equally remarkable is the large silver-gilt reliquary of the saint made in 1438–45 by Teramo Danieli in collaboration with Simone Caldera. Near the site of the original castle is a secular counterpart to the campanile, the tower of the Embriachi, whose most ambitious fortification was

the castle of Jebail in what is now the Lebanon. The significance of Genoa as intermediary with the East is expressed also in artistic terms, most notably in the *Last Judgement* at the west end of the cathedral, which is by a major master of towards 1300 from Constantinople. Parallel ties with the north are expressed in the exquisite fragments of Giovanni Pisano's tomb of the wife of the Holy Roman Emperor Henry VII, Margaret de Brabant, who died at Genoa in 1313; these are now divided rather perversely between the new museum of Sant'Agostino and the Palazzo Spinola.

Medieval Genoa faced the sea, and despite later building one can still sense something of its waterfront – now Via Gramsci – by the old port. The city gradually expanded landwards, and one small area, round the Piazza San Matteo, gives an idea of its late medieval character, with the striped gothic façades of the houses of the Doria. The elaborate portal of one of these is surmounted by a relief of *Saint George*, whose popularity is attested by several others in the city, notably that of the Palazzo Valdettaro-Fieschi by the productive Ticinese *quattrocento* sculptor Giovanni Gagini.

The patrons of Genoa would continue to look for outside talent. Her merchants commissioned at least two works from Jan van Eyck, whose world is echoed in the frescoed *Annunciation* by Justus van Ravensburg (1451) in the upper cloister of Santa Maria di Castello; this is charged with the realistic detail of the north. In 1506 Gerard David supplied a major altarpiece for the Sauli family, for San Girolamo della Cervara rather than Genoa itself; four elements of this are now in the Palazzo Rosso, including the *Crucifixion* in which Christ is majestically silhouetted against a bank of dark cloud.

Joos van Cleve's Raggi triptych remains in the church of San Donato, while Giulio Romano's *Martyrdom of Saint Stephen*, a masterly homage to Raphael, is still in the church of that saint.

Andrea Doria, 'padre della patria', was favoured by Emperor Charles V. His Villa Imperiali (Palazzo del Principe), to the west of the town, has now been sensitively restored by his successors. This is remarkable not least for the elaborate decorative scheme devised by Raphael's former pupil Perino del Vaga, whose heroic *Fall of the Giants* is one of the less familiar masterpieces of Renaissance decorative painting. Portraits by Sebastiano del Piombo and Francesco Salviati and an exceptional group of Flemish tapestries suggest the artistic horizons of the family. The Doria also employed the Tuscan Montorsoli, in the church of San Matteo, and the Perugian Galeazzo Alessi.

Alessi, an architect of genius, was responsible for another Sauli commission, the vast domed church of Santa Maria Assunta in Carignano (1549–1602), which recalls Sangallo's scheme for St Peter's in Rome. Alessi may also have been consulted about the scheme for the Strada Nuova. Conceived in 1550, this is a canyon of palazzi built for members of the closely interrelated Genoese patriarchate, Pallavicino and Spinola, Lomellino and Grimaldi, among others, bankers whose wealth was vastly augmented by their control of the silver of the Spanish empire. Garibaldi, after whom the street is now named, would not have sympathized with them.

Although Genoa had already produced a significant painter of her own, Luca Cambiaso, many commissions

Cathedral, west door (detail).

continued to be awarded to artists from elsewhere. The Crucifixion by Federico Barocci from Urbino in the cathedral is a deeply felt statement of Counter-Reformation piety, wonderfully rich in colour, while Francesco Vanni's Last Communion of the Magdalen (Santa Maria Assunta in Carignano) is a visionary restatement of Sienese sensibility. Rubens's youthful reaction to his experience of Italy fires his Circumcision of 1605 in the church of the Gesù, where his more mature Saint Ignatius is complemented by major altarpieces by Reni and Vouet.

Such were the painters preferred by the patricians who rushed to be painted by the young Anthony van Dyck in the early 1620s. Van Dyck set the standard of Genoese portraiture for a century, and no Genoese master of the period was immune to his influence. Yet, by the mid-seventeenth century, Genoa was both less rich and less dependent on outside talent. Castiglione's Nativity of 1645 at San Luca, in the commercial heart of the city, is an indigenous masterpiece of enchanting originality, and would, half a century later, be balanced by a comprehensive scheme of decorative frescoes by another local master, Domenico Piola, whose numerous altarpieces in Genoese churches are consistently effective. Nonetheless, outsiders continued to find employment: the French Pierre Puget supplied two prodigious sculptures at Santa Maria Assunta in Carignano and the equally extraordinary gilt-bronze high altar at San Siro, while the Bolognese Marcantonio Franceschini had in 1714 a key role in the beautifully coordinated decoration of the church of San Filippo Neri, which represents the later baroque of Genoa at its most appealing.

Damage in the Second World War and the ruthless restoration programmes of

Franco Albini at both the Palazzo Bianco and the Palazzo Rosso of the Strada Nuova mean that, despite their splendid collections, one must look elsewhere to understand secular taste in baroque Genoa. The visitor should abandon the Strada Nuova and cut down through the maze of the old city for the Palazzo Spinola, which was decorated in two phases (1614–24 and 1730–37), the latter for Maddalena Spinola di San Luca. Her suite of rooms on the second floor remains substantially intact. Then make for the Via Balbi, the second of the new roads of the city constructed between 1602 and 1620, passing the all but inaccessible Palazzo Durazzo Pallavicini, to visit the Palazzo Reale, so named since its acquisition by the King of Piedmont in 1824. With twenty-five bays – as opposed to its neighbour's fifteen – this was remodelled by Carlo Fontana for Eugenio Durazzo from 1705 onwards. Of the interiors created for the Durazzo, three are particularly memorable: the Sala del Veronese (so named for a picture which the Savoys sent to Turin) with restrained rococo decoration; the splendidly orchestrated Galleria degli Specchi, whose frames are invaded by gilded ivy; and the Anteroom beyond, with an enchanting ceiling that is the undisputable masterpiece of Valerio Castello, most appealing of the later Genoese baroque painters. The Savoys would later lay a heavy Neoclassical hand on the palace, their resourceful designer Palagio Palagi unexpectedly employing an English craftsman, Henry Thomas Peters, on parquetry floors and the furniture of a bathroom. Look out from the terrace across the restored gardens towards the sopraelevata – the road which does such visual violence to the city – and the port beyond.

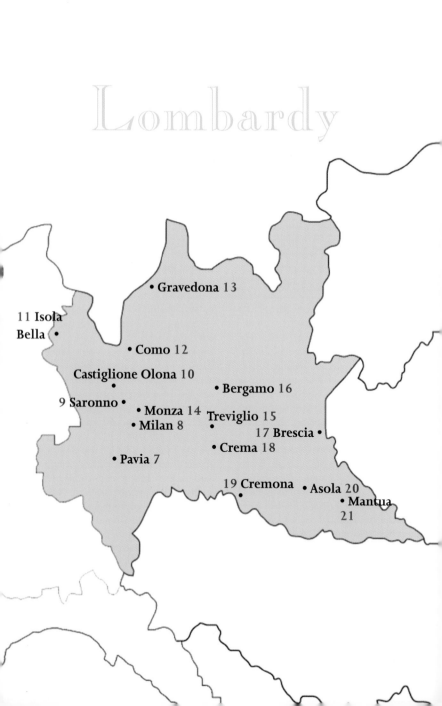

Lombardy

• Gravedona 13

11 Isola
Bella •

• Como 12

Castiglione Olona 10
•

9 Saronno • • Bergamo 16
 • Monza 14 Treviglio 15
 • Milan 8 •
 17 Brescia •
 • Crema 18
 • Pavia 7

 19 Cremona • Asola 20
 • • Mantua
 21

7

PAVIA

✿

PAVIA'S RISE WAS due to her position near the confluence of the Ticino with the Po and at the junction of major Roman roads. Conquered in 572 by the Lungobards, or Lombards, she became the capital of their kings. The Visconti established their *signoria* in 1359 and founded the university two years later. Already overtaken economically by Milan, Pavia was nevertheless of continuing strategic importance, and it was outside the walls that King Francis I of France was captured in 1525 by the forces of Emperor Charles V. Spanish rule was followed by that of Austria, and it is to Empress Maria Theresa and her son Joseph II that the Neoclassical university buildings are due.

Pavia is visibly prosperous. Public buildings and private palaces abound. Of the churches two, both Lungobard foundations, are of particular interest. San Michele, facing a small piazza 200 metres north of the Ticino, was reconstructed after 1117. The sandstone façade is a masterpiece of controlled decoration. Across the town, near the angle of the city walls, is San Pietro in Ciel d'Oro, which was reconstructed in 1132. The west front follows that of San Michele, but was more ruthlessly restored in the nineteenth century. Behind the high altar is the Arca di Sant'Agostino, in which the relics of Saint Augustine of Hippo were placed; the sculpture blends Pisan and local influence. To the east of the church, also restored, is the enormous brick castle begun by Galeazzo II Visconti in 1360–65. The north side of the quadrangular

structure was destroyed in 1527, but the vast porticoed courtyard still testifies to the resources of the dynasty.

Interesting as the city is, Pavia's outstanding monument is the Certosa, some nine kilometres to the north. From a distance its pinnacles strike a defiant note across the level plain. The foundation stone was laid by Gian Galeazzo Visconti in 1396, but his death in 1402 interrupted work. This was resumed and given further impetus by Francesco I Sforza, ruler of Milan from 1450. Successive architects, Venetian and Milanese, were called in. The façade was designed by the sculptor Giovanni Antonio Amadeo, but its upper half was only completed in the sixteenth century. The reliefs, so typical of Milanese Renaissance taste, are by Amadeo and his associates, while the portal of 1501–6 is largely by Benedetto Briosco. The interior is of equal magnificence. Some pictures have gone – including the main tier of Perugino's altarpiece, which is now in London – but nowhere can Milanese sculpture of the Renaissance be studied more comprehensively, and much glass of the period survives. So do the fine choir stalls designed by Ambrogio da Fossano, il Bergognone, the one major Milanese painter of his generation who did not allow himself to be unduly swayed by the example of Leonardo. His frescoed *Ecce Homo* in the north transept, framed by *trompe l'oeil* architecture, shows how moving an artist he could be.

Leave from the south transept, pausing to examine the delicate doorcase by Amadeo, to the small cloister (1462–72). The arcades are decorated with terracotta. The luxuriant green of the enclosed garden contrasts with the varying hues of the brick of the walls and the vertiginous pinnacles of the southern flank of the church. A passage

Certosa: Ambrogio Bergognone, Carthusian at a Window, *fresco.* A.M.

leads to the enormous Chiostro Grande, its outer wall with the twenty-four cells of the monks. The eye, lifted upwards in both church and the small cloister, is here drawn horizontally. The decoration is less sumptuous, for we are now in a world of silence and devotion.

The Carthusians were suppressed by the reforming Emperor Joseph II, who redeployed their riches or such projects as the university. But it says much for the intelligence of the Italian state that, as recently as 1968, the Certosa was made over to the Cistercian Order.

8

MILAN

❖

OF THE GREAT Italian cities only Milan has been comprehensively cut off from its hinterland by modern building. So it is reassuring to ascend the campanile of the cathedral on a clear winter's day and see the Monte Rosa gleaming on the horizon. Milan has a complex past – Roman, Byzantine and Lungobard – and has long been the dominant city of Lombardy. Power passed in the twelfth century from the archbishops to the commune, and in 1277 the Visconti established their *signoria*. Their duchy was taken over in 1450 by Francesco I Sforza, whose younger son Ludovico il Moro is celebrated not least as the patron of Leonardo. The French endeavoured to secure Milan, but on the extinction of the Sforza line in 1535, it passed to Spain and, in the early eighteenth century, to Austria. The French invasion of 1796 led to the creation of the Cisalpine republic, of which Milan was the inevitable capital, and its successor, Bonaparte's kingdom of Italy. The Austrians recovered Milan in 1814, retaining it until 1859, when it was absorbed in the new kingdom of Italy, of which it was to become the financial powerhouse.

The Stazione Centrale – as good a place to arrive as any – is a gargantuan statement of Italian ambition. Designed in 1906, it took a quarter of a century to build. And later you may wish to linger in an earlier and more engaging statement of national confidence, the cruciform Galleria, with its patriotic dedication: 'A Vittorio Emanuele II dai Milanesi' (To Vittorio Emanuele II from

the Milanese). This most spectacular of shopping arcades, off the Piazza del Duomo, was begun in 1865, and like the station remains close to the pulse of Milanese life.

Even a brief study of a map shows how Milan grew: the clearly marked line of the later walls, the names of whose gates survive, and the roughly oval circuit of streets that marks the earlier walls with which the massive brick Castello Sforzesco was associated. The Piazza del Duomo lies at the geographical centre, presided over by the unhappy façade of the Duomo itself. It is within that the great building asserts its magic, the tall columns soaring to the vaults. By day the Renaissance stained glass deserves study; at night, as candles glitter, one is lost in a primordial forest of stone. The decoration is rich, and there are two exceptional masterpieces. The Trivulzio candelabrum in the north transept, with its monsters and humans emerging from trailing fronds, is a prodigy of Norman medieval metalwork, so it is disgraceful that the tourist is now denied access to it; while the tomb of Gian Giacomo de' Medici of 1560–63 in the south transept is arguably the masterpiece of Leone Leoni.

Milan is famous for its churches. The Basilica of Sant'Ambrogio, dedicated to the patron of the city, was the seminal building of the Lombard Romanesque; while in Santa Maria delle Grazie to the north-west, the domed crossing and choir added by Bramante to the late gothic nave represent the consummation of late fifteenth-century Milanese classical architecture. The church and its cloister are visually more compelling than the abused ghost of Leonardo's *Last Supper* in the refectory nearby. Returning to the centre by the Corso Magenta, pause

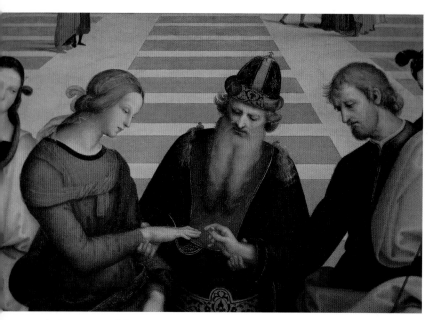

Raphael, Marriage of the Virgin, 1504 *(detail)*.

at San Maurizio, the Monasterio Maggiore, to see the well-restored murals by Bernardino Luini, the most consistent Milanese master of the early sixteenth century.

If you want to escape from fellow tourists there is a particularly satisfying walk from the Piazza del Duomo. Take the Via Torino and pause at the first church, set back on the left, San Satiro, where Bramante's ingenious *trompe l'oeil* treatment of the choir disguises the constraints of the site. Further on, to the right, is San Giorgio al Palazzo, with a chapel decorated in 1516 by Luini, whose altarpiece of the *Deposition* is beautifully complemented by his frescoes. Head on for the Porta Ticinese, but stop at San Lorenzo, set behind a row of sixteen Roman columns that were pillaged from

earlier buildings and re-erected as part of the portico of the basilica. Much of the original structure, datable about AD 400, survives. The scale of the building is impressive, but inevitably it is overlaid with much later work. Further south, just before the gate, is Sant'Eustorgio, another early foundation, rebuilt in the late eleventh century, but with an elegant campanile of 1297–1309. The church itself is fine. But it is for the Cappella Portinari, to the east of the choir, that one returns. Pigello Portinari ran the Milanese branch of the Medici bank and called in a fellow Florentine, Michelozzo, to design his chapel. The frescoes of 1466–8 are, however, by the outstanding Lombard master of the time, Vincenzo Foppa. Nowhere is the sobriety of the man more eloquently expressed. In the

chapel is the fourteenth-century *arca* of the Dominican Saint Peter Martyr by the Pisan Giovanni di Balduccio and his assistants, which demonstrates that Portinari followed in a long tradition when he employed Tuscans in Milan.

To return by an alternative route make east for the Corso Italia. On the opposite side of this is Santa Maria presso San Celso. Work started in 1490 under the direction of a sequence of architects; Galeazzo Alessi's front was begun in 1560. There are outstanding altarpieces by Bergognone and the Venetian Paris Bordon, among others. Returning northwards you pass San Paolo Converso with a vigorous façade designed by the painter Giovanni Battista Crespi, il Cerano. Turning right immediately after the church, you emerge on the Corso di Piazza Romana opposite San Nazzaro Maggiore, which is entered through the remarkable funerary chapel of the Trivulzio, designed by an earlier painter, Bartolommeo Suardi, il Bramantino. Not far to the north of this is Sant'Antonio Abbate with pictures by many leading Lombard painters of the post-Renaissance period, including – flanking an altar on the left – Giulio Cesare Procaccini's poignant *Visitation*. Between this and the Duomo, behind the Palazzo Reale, is San Gottardo al Corte, a Visconti foundation of 1330–6, with a splendid campanile and Cerano's visionary *San Carlo Borromeo*.

The museums of Milan are justly celebrated. It makes sense to visit them in chronological sequence. The earliest, the Ambrosiana, was founded by Cardinal Federico Borromeo and still contains much of the remarkable collection he presented to it in 1618, including the celebrated profile portrait of a lady long given to Leonardo, a distinguished

group of panels by Luini, Caravaggio's only pure still life, a key series of works on copper by Jan Breughel the Elder and a most remarkable survival, Raphael's majestic cartoon for the *School of Athens*. Other early acquisitions include Leonardo's wonderful *Portrait of a Musician*.

Housed in the former seat of the Jesuits, the Pinacoteca di Brera was founded in 1803. Milan, as the capital of the Cisalpine Republic, received a not ungenerous proportion of the spoils looted by the French from elsewhere in Italy – and because the city reverted to Habsburg rule in 1814 there was no question of restitution. The religious houses of Lombardy were despoiled – the Brera's holding of Lombard masters is unrivalled – as were those of Venice. The Papal States in particular suffered grievous losses: from the Marche come Gentile da Fabriano's Valleromita polyptych, Piero della Francesca's incomparable Montefeltro altarpiece and a group of Crivellis only outshone in the National Gallery, London; and from Città di Castello in Umbria, Raphael's peerless early *Marriage of the Virgin*. Beauharnais, Bonaparte's viceroy, himself presented what is perhaps the most moving picture in the collection, Bellini's poignant *Pietà*. Among the later pictures are Caravaggio's *Supper at Emmaus* and Bellotto's breathtakingly fresh views of Gazzada.

More recent pictures, by such artists as Francesco Hayez and Giovanni Segantini, are shown in the Galleria d'Arte Moderna, housed in the Neoclassical Villa Reale, built in 1790 for the Belgioioso family. Very different in character is the Museo Poldi Pezzoli. Gian Giacomo Poldi Pezzoli, who died in 1879, left his collection to the public. Although this core donation has been vastly expanded, the museum still just retains something

of the atmosphere of a private house. Works of art complement the pictures, the most memorable of which, Pollaiuolo's familiar profile *Portrait of a Woman*, two distinguished Botticellis and the Mantegna *Madonna*, formed part of the original bequest. The collection makes an interesting contrast with its somewhat later counterpart in the Palazzo Bagatti Valsecchi. This was built in the Lombard Renaissance style by Giuseppe and Fausto Bagatti Valsecchi, whose pioneering taste for cycling was matched by their connoisseurship. Bellini's majestic *Saint Giustina* has pride of place in the most atmospheric neo-Renaissance private house in Italy.

The Castello Sforzesco is for the determined sightseer. The vast quadrangular fortress of the Visconti and their Sforza successors was subjected to a 'radical' restoration from 1893 onwards. Nowhere else can Lombard Renaissance sculpture be studied so comprehensively. Bambaia's recumbent effigy of Gaston de Foix represents its high point. Happily Michelangelo's visionary, if unfinished, late Rondanini *Pietà* has been moved to a gallery of its own on the west side of the courtyard. In the substantial Sala della Balla on the first floor are the tapestries of the *Months* designed for Leonardo's patron, Marshal Trivulzio by Bramantino and woven at Vigevano. Wonderfully imaginative in detail, these are arguably the most accomplished tapestries ever executed in Italy and certainly stand comparison with the finest Flemish productions of their time. Rather oddly they are hung in reverse order.

9

SARONNO

❖

BECAUSE OF THE activity of the Arundel Society Saronno was less unfamiliar to a Victorian audience than it is today. Too close to Milan for comfort, the town itself has no claims on the tourist. But on its northern fringe is one of the most beautiful sanctuaries of northern Italy, the Madonna dei Miracoli. A miracle of 1447 led to the construction of the church, begun in 1498 to the design of the versatile Giovanni Antonio Amadeo, whose scheme for the sanctuary itself was realized. Work on the church followed, and the subtle classical west façade projected by Pellegrino Tibaldi at the behest of Cardinal Carlo Borromeo was only completed in 1612.

But satisfying as the building is, it is for the frescoes by Bernardino Luini and Gaudenzio Ferrari that this is most remarkable. Pass through the church to reach the sanctuary, where on the cupola Gaudenzio painted a *Concert of Angels* in 1534–6, a swirling interwoven composition whose unceasing movement seems almost deliberately to challenge the more static mode of Luini, who had died in 1532. On the left is the Cappella del Cenacolo, for which Andrea da Milano supplied an effective and characteristically Lombard polychrome group of the *Last Supper*.

Beyond, at the entrance to the Anticappella, are frescoes of four saints by Luini, finished in the year of his death. More remarkable is Luini's work inside the Anticappella, with large compositions of the *Marriage of the Virgin* and *Christ among the Doctors*. Luini was aware that

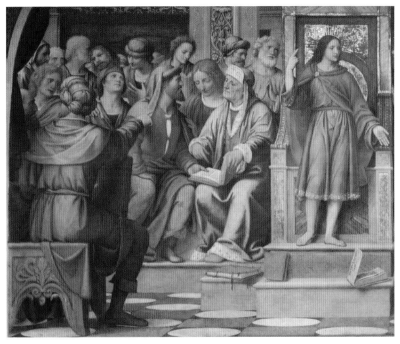

Madonna dei Miracoli: Bernardino Luini, Christ among the Doctors, fresco (detail), 1525.

these would be seen laterally by pilgrims bound for the Cappella della Madonna beyond. Here the painter pulls out every stop. The lateral murals, the *Circumcision* of 1525 – in the background of which the Holy Family sets out for Egypt passing an accurate representation of the sanctuary and campanile from the east – and the *Adoration of the Magi*, whose train winds down through the landscape, are projected though arches which are shown from a position just within the chapel; there are Sibyls in the spandrels of the arches and in the lunettes above, and on those of the other walls the Evangelists are paired with the Doctors of the Church. Wind may ruffle the palm tree in the *Circumcision* yet Luini's

dignified classicism is immutable. This and his discursive narrative taste help to explain why the Arundel Society went to the not inconsiderable expense of reproducing the Saronno frescoes. The very sobriety of Luini's types reminds us that he was an early exponent of the 'Lombard realism' that some seventy years later would be the springboard for the artistic revolution wrought by Caravaggio. Luini responded to the challenge of the commission, but may have found it more congenial to paint the less orchestrated lunette of the *Nativity* in the cloister. In the words of a wise fellow guest to whom I once showed them, the murals at Saronno are indeed 'perfectly marvellous'.

10

CASTIGLIONE OLONA

THE ROAD FROM Saronno to Varese leads through a distressing sequence of overgrown settlements. These do nothing to prepare us for the charm of the old town of Castiglione Olona, scarcely half a mile off to the left, on a spur above the wooded valley of the Olona. Castiglione was held from early medieval times by the Castiglioni family. Branda Castiglioni (1350–1443) had a successful career as Bishop of Piacenza, as Legate to Hungary and, from 1412, as Bishop of Vespré. Like other churchmen the cardinal, as he became in 1411, knew he had to build within his lifetime, but as he died in his nineties he had more time than could rationally have been anticipated to make his mark at Castiglione.

The road descends to the triangular central Piazza Garibaldi. On the east, set back, is the cardinal's palace, Casa Castiglioni. On the ground floor is the small chapel, with rather worn murals by the Sienese master Vecchietta. The main stair mounts to a loggia with views out over the town and vestigial decorative frescoes, including a relatively unusual compartment with covered jars. Off this is the large hall, a door from which opens to the bedchamber, with contemporary murals of putti among trees by a local artist. Beyond is a further chamber with a remarkable panorama by the Tuscan master Masolino da Panicale, whom the cardinal had previously employed with Masaccio at San Clemente in Rome. This shows his see in Hungary, a sizeable town in a valley between steep bare hills, some of which are crested with castles.

Across the piazza a road rises, passing the church of the Santissimo Corpo di Cristo completed between 1441 and 1444, which has been attributed to Vecchietta. The chaste classicism of the pilastered walls affirms the cardinal's interest in contemporary Tuscan taste. The road climbs up to the gate of his most ambitious foundation, the Collegiata. Castiglioni himself is seen kneeling before the Madonna and Child in the lunette of 1428 above the main door. The imposing brick church represents the moment when the late Gothic melts into the early Renaissance; and to experience the processional subtlety of the building (which is now entered by a side door), you should walk to the west entrance before approaching the apse. The decoration is a further affirmation of the cardinal's leanings. The outer arch was frescoed by a lesser Florentine, Paolo Schiavo, while the vault and the upper and part of the lower register of murals are by Masolino, from whom Schiavo took over in the *Stoning of Saint Stephen*. The rest of the altar wall and the fictive architecture and marbelling below are by Vecchietta, as is the *trompe l'oeil* portrait. Masolino is at his most lyrical in the narrow triangular compartments of the vault, notably the *Annunciation* and the centrally placed *Coronation of the Virgin*, with their sinuous elongated figures. The cardinal's tomb is on the left of the choir.

The Baptistery is to the north of the church. This is an intimate space, with an outer rectangle opening to a narrower area, in which Masolino's murals tell to marvellous effect. Above the door there is a surprisingly accurate view of Rome, in which the Pantheon and other monuments can be seen. The frescoes represent the life of Saint John the Baptist, the *Baptism* itself dominating the end wall,

Palazzo Castiglioni, staircase: Lombard School,
Vessels, fresco (detail), c. 1430.

the Jordan set in a hilly landscape which
flows into that of the adjacent *Preaching
in the Wilderness*. On the right wall of the
outer section, again linked in space, are
the celebrated scenes of *Herod's Feast* and
Salome receiving the Baptist's Head; the loggia
in which she is placed is too deep to
convince. Graffiti remind us that even in
the sixteenth century monuments were
not invariably treated with respect.

The Baptistery murals reveal the
workings of a painter of ineffable charm
at a moment of artistic rediscovery. The
reverse might be said of the extraordi-
nary seventh-century murals in Santa
Maria foris portas near the atmospheric
ruins of the Roman town of Castelseprio
four kilometres to the south. Here we
see a beautiful last gasp of the art of the
ancient world, the Virgin in her flutter-
ing robe resting after giving birth to her
tremulous Child, the Magi described in
bold swathes of reddish brown with a
sense of movement that would be lost
for many centuries. There is no hint
whatever of this in the rather haunting
eighth-century frescoes in the surviv-
ing Roman tower below the town to the
east which survives as it became part of
the Monastero di Torba: this has recently
been sensitively restored by FAI (Fondo
Ambiente Italiano).

11

ISOLA BELLA

ISOLA BELLA SEEMS to float upon the
waters of Lake Maggiore. From Stresa
the ordered terraces defy the drama
of the hills beyond. The brief crossing
conveys us to the landing stage near the
palace conjured into existence for Count
Carlo III Borromeo from 1631 onwards,
but only completed in 1958. The palatial
interior houses part of the remarkable
collections of the Borromeo, rich in
Lombard works both of the Renaissance
and later periods; it is not difficult to
understand why Mussolini arranged for
the Stresa Treaty between Italy, England
and France to be signed here in 1935.
The grand baroque and Neoclassical
rooms on the *piano nobile* are perhaps less
memorable than the sequence of rooms
on the ground floor, grottoed chambers
decorated with stucco and marbles and
pebbles that catch light reflected from
the water. Among the objects that have
come to rest in these rooms are such
rare survivals as horse trappings from
the time of Cardinal Federico Borromeo.

To the south of the palace is the gar-
den, also begun in 1631. The count and
his architect, Angelo Crivelli, exploited a
natural hill, which was partly cut away
and then built up with substructures
supporting ten superimposed terraces.
The resulting rectangular ziggurat dom-
inates the island. On the upper ter-
race, some thirty-three metres above
the lake, is the theatre, presided over
by the heraldic unicorn of the family.
Carlo III's third son, Vitaliano VI Bor-
romeo, who succeeded in 1652, con-
tinued the project, calling in Carlo

Fontana and Francesco Castelli; he died in 1690, the year in which the Dutch painter Gaspar van Wittel, known in Italy as Vanvitelli, prepared the studies on which his views of the island were based. The terraces were originally planted with cypresses, citrus trees, box and vegetables. Later generations have enriched the planting, but the design of what is in effect a baroque answer to the Hanging Gardens of Babylon is unimpaired. Wandering up and down the terraces, not all of which are accessible, we are almost uncomfortably aware that we are in a garden like no other, a statement of patrician control over a once untamed landscape.

The Borromeo have held the islands that bear their name since 1501. In the mid-sixteenth century they built a villa on the larger Isola Madre, the lost terraced garden of which can be seen in some of Vanvitelli's views. The island is now celebrated for its botanical garden. This is most easily reached from Pallanza, which is best known for the Giardini Botanici of the Villa Taranto, but more memorable for a romantic neo-baroque terraced garden, San Remigio, created from the 1890s by the half Anglo-Irish Marchese and Marchesa Silvio delle Valle di Casanova, which has until recently languished under state control.

Isola Bella, the lower terraces

12

COMO

COMO, AT THE southern end of the eponymous lake, is the successor of a significant Roman town and indeed retains much of its plan. After a ferocious struggle with Milan in 1118–27, Como remained independent until 1335 when it was taken by the Visconti. Thereafter the city was under Milanese control. The Piazza del Duomo, far from the port, lay at the centre of both civic and religious life. The Broletto was built in 1215, while the cathedral beside it was only begun in 1396. Como had a remarkable tradition of masons, supplying craftsmen to work throughout Italy, but the cathedral is their most impressive achievement. The early Renaissance façade with its profusion of sculpture repays close attention, but it is easier to access the key figure, Tomaso Rodari, in the Porta della Rana on the north front. The space within is unexpectedly dark, and it takes some time to adjust the eye to survey the tapestries suspended between the columns of the nave, many of which were devised by Giuseppe Arcimboldi. The altarpiece of the fourth chapel on the right is by Luini. He also painted the inside shutters of the altarpiece from Sant'Abbondio, representing the two Adorations, which with Gaudenzio's later *Flight into Egypt* and *Marriage of the Virgin* of the outer sides now flank the third altars on both sides of the church. As at Saronno, Gaudenzio emerges as the more inventive artist.

There are two other notable churches, the late twelfth-century San Fedele of particularly ingenious plan, and, in a now rather run-down area outside the walls, the Benedictine Sant'Abbondio, which was consecrated by Pope Urban II in 1095. Thoroughly but not unsympathetically restored in successive campaigns, this is an austere masterpiece of Romanesque architecture. The deep polygonal apse is decorated with a major fresco cycle of about 1350.

Como is understandably famous for the villas beside the lake. The most

Cathedral, the north door by Tommaso Rodari.

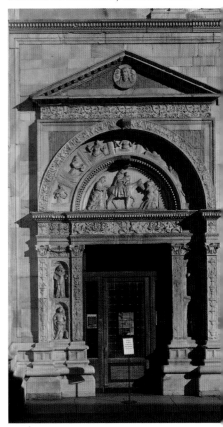

accessible, some forty kilometres up the lake's west side, is the Villa Carlotta at Tremezzo. Built in the early eighteenth century, this was acquired in 1801 by Count Sommariva, whose success in the service of Bonaparte was matched by his energy as a patron of Neoclassical sculptors. A number of his acquisitions remained in the villa when it passed to the Saxe-Meiningens, notably Canova's *Palamedes* and a version of his *Magdalen in Penitence*, now most unworthily displayed. The planting of the garden is equally abysmal, but this does not seem to diminish its popularity. Across the arm of the lake, but in easy reach by ferry from Cadenabbia, is the architecturally more distinguished Villa Melzi, built in 1808–10 in the most elegant Neoclassical taste for another adherent of the French, Francesco Melzi d'Eril, and set in a lakeside *jardin anglais*. Numerous lesser villas can be seen from the road to Tremezzo, which passes a number of modest Romanesque churches.

<div style="text-align:center">

13

GRAVEDONA and OSSUCCIO

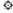

</div>

LAKE COMO IS justly celebrated for its villas. But it is equally remarkable for its religious monuments. This is particularly true of the west bank, because the key Roman road across the Splügen Pass descended by way of Chiavenna to the head of the lake. Approaching from the north, the first significant town is Gravedona, the glory days of which were in the twelfth century when it achieved a quasi-independence, allied with Milan against Como. From 1183 for a decade it boasted a mint. Later, with nearby Sorico and Dongo, it was the centre of the semi-autonomous Tre Pievi (Three Parishes) until King Philip II of Spain granted this as a county to Cardinal Tolomeo Gallio.

Just before Gravedona is reached, facing south beside the lake and visible from the shore is the Palazzo Gallio of about 1586 with angle towers designed by Tibaldi for Cardinal Gallio. In the centre of the town is the elegant Renaissance Santa Maria delle Grazie. Beside the lake is one of the most appealing and beautifully set Romanesque buildings in Italy, the midtwelfth-century Santa Maria del Tiglio, built on the site of a much earlier baptistery. The campanile rises in the centre of the west front, and the other sides all have elegant semi-circular apses. Within, the single, unitary space is very satisfying: there are fragments of a sixth-century mosaic and early medieval murals.

Immediately to the south is the substantial church of San Vincenzo, a rebuilding of 1072, the interior of which

was comprehensively remodelled in the baroque period, when the not-unsatisfying porticoed forecourt was added. Only the crypt of the Romanesque church survives almost unscathed.

The relative wealth of the small communities beside the lake is well expressed in the sixteenth-century Santa Maria just to the right of the main road a kilometre north of Acquaseria. This retains its full complement of frescoes by local artists of the period.

Just under nine kilometres south of Menaggio at Ospedaletto, a small Romanesque church with an eccentric gothic top to its campanile is hard by the main road. A road on the right climbs up to Ossuccio, with a cluster of rough stone houses near its church. Higher up the road reaches one of the lower chapels of what must be the most charming Sacro Monte I know. By comparison with those of Orta or Varese this is a modest affair. The fourteen chapels were built between 1635 and 1714 on a wide path that climbs at times quite steeply towards the sanctuary of the Madonna del Soccorso. The Ticinese stuccadore Agostino Silva was responsible for many of the plaster groups of scenes from the New Testament, including *Christ among the Doctors* and the Crucifixion, while minor local artists were responsible for the pretty murals. The charm of the place is undeniable: worn cobbles, structures of varying yet complimentary forms, echoes of the stylistic mainstream, but above all the beauty of the unfolding views of the lake below and over fields that have not wholly lost their agricultural purpose. We can understand why those who flock to Ossuccio on the annual festival in September feel closer to their faith.

Santa Maria del Tiglio.

14

MONZA

❧

MONZA IS NOW part of the extended conurbation of Milan and the history of the town has inevitably been affected by that of its greater neighbour. So it is perhaps surprising that in some respects it is there that we feel closer to former rulers of both. Monza was the chosen seat of the, Lombards or Lungobards, whose Queen Teodolinda built a chapel attached to their palace in 595. Such was the genesis of the Cathedral, the treasury of which affords a unique view of Lombard taste. More than a millennium later it was at Monza that the Habsburgs created the great villa which was subsequently taken over by the Savoys.

The route from Milan, by rail or road, reaches the main street, through the town, the Via Italia. This passes the lavish, albeit restored, late fourteenth-century brick front of Santa Maria della Strata to reach the thirteenth-century Arengario, originally the Palazzo del Comune, also of brick with its loggia and tower. Before reaching this, turn right for the irregular piazza dominated by the splendid, if much-restored, façade of the Duomo by Matteo da Campione (1370–90), who reused the lions and the carved lunette of the door of the previous building: the medallions of Teodolinda and King Agilulfo are later insertions. The interior of the church was progressively transformed in the sixteenth and seventeenth centuries. Reliefs from Matteo's pulpit were redeployed for the organ gallery.

To the left of the choir is the Chapel of Queen Teodolinda, which now enshrines the so-called Iron Crown of Lombardy. The chapel is understandably celebrated for the frescoes by the Zavattari brothers and their assistants which are arguably the most ambitious expression of the artistic pretensions of Filippo Maria Visconti for whom the cycle was begun in 1445. The story of Teodolinda, which is related in five tiers, had a direct relevance to Visconti's wish to secure the succession to his *signoria* of Milan; and the project was completed for his son-in-law, Francesco I Sforza. The Zavattari record the sumptuary extravagances of their time, but no exaggerated artistic claims can be made for them.

The adjacent Museo del Duomo is altogether more remarkable, although the arrangement is in some respects unnecessarily theatrical. Aachen apart, the treasury at Monza has no rival. The sequence begins with vases in lead and glass from the Holy Land given to Teodolinda by Pope Gregory. There follow three superb ivory dyptychs, of which that of Stilico, son-in-law of the Emperor Heraclius – datable about AD 400 – is the finest, presented to the Duomo by King Berengar. Yet more extraordinary is the silver group of a hen with seven chicks found in Teodolinda's tomb. Round this is ranged a constellation of equally rare survivals: the be-jewelled covers of her Gospels, enriched with classical cameos; a comb believed to have been owned by her; the cross of her husband Agilulf; and that of their son, Adaloald, which is studded with jewels like boiled sweets, among many more. Further on is Gian Galeazzo's own contribution to the treasury, the chalice that marks a high point of late medieval Milanese metalwork.

Beyond the Arengario, the Via Carlo Alberto passes the much-restored Romanesque brick church of San Pietro. Further on, across a picturesque piazza to

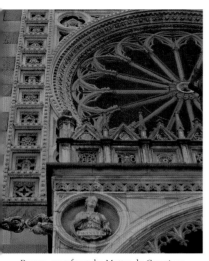

Duomo, west front, by Matteo da Campione (detail), 1370–90.

15

TREVIGLIO

❖

THE LAND TO the east of Milan was for many centuries a frontier territory where patterns of artistic patronage were often determined by political allegiance. Only thirty-three kilometres away, beyond the Adda that flows from Lake Como towards the Po, is Treviglio, with its great campanile to which the road from the west is aligned. Treviglio was twice controlled by Venice (in 1445–54 and 1499–1509), but her traditional fealty was to Milan. The town drew on the agricultural riches of the plain, and it is fitting that there is now a tractor depot on the outskirts.

Treviglio preserves her ancient core. This centres on the Collegiata of San Martino, whose late *settecento* front is rather put out of countenance by the massive Romanesque campanile of brick at its northern angle. The church retains its *quattrocento* plan, but the interior has been much altered. The choir is flanked by intelligent canvasses, the *Last Supper* and the *Fall of Manna*, by Giovanni Battista Moroni's most plausible follower, Giovanni Paolo Cavagna. But it is not for these that we have come. On the right wall is the former high altarpiece, the polyptych by Bernardino Butinone and Bernardino Zenale, which, as Berenson wrote, 'still lights up with splendour the sordid market town of Treviglio, where both were born'. This is in some ways the most characteristic achievement of Milanese painting of the time it was ordered, 26 May 1485, just before the impact of Leonardo's arrival was felt.

the right, is Santa Maria with a fine brick campanile of 1339. The church itself was remodelled at the behest of San Carlo Borromeo and contains a number of altarpieces by the most fastidious of late sixteenth-century Piedmontese painters, Guglielmo Caccia, il Moncalvo; the most appealing, *The Adoration of the Magi*, is above the first confessional on the right.

Continue northwards, passing a plantation, for the Villa Reale, the palatial residence begun by Giuseppe Piermarini for the Archduke Ferdinand in 1777. This was subsequently owned by the French viceroy, Eugene Beauharnais, who greatly extended the park to the east. Recovered by the Habsburgs after the fall of Napoleon, the villa passed to the Savoys. The suite of rooms on the first floor was redecorated for King Umberto I and his consort, Margherita: the bathrooms apart there is little of interest. But the park itself, particularly in the late autumn, is rather magnificent.

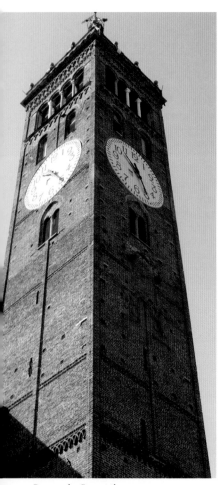

Duomo, the Campanile.

The altarpiece is in three tiers above a predella: Saint Martin and the Beggar are flanked by panels with three saints below; above are the Madonna and Child with angels between further trios of saints; and at the apex, seen in perspective in a roundel in the pediment, is the Risen Christ. The gilding of the frame is echoed by that of the fictive arcade within which the figures are set. The painters knew when to be extravagant in colour, yet also understood the power of restraint. This is beautifully demonstrated in the main panel: Saint Martin's charger is white, as are his armour and the beggar's drawers, their pallor only emphasized by the orange of the horse furniture and the sharp green of the festoon. In the background is a walled town with a great gateway, presumably intended to represent Tours, while the campanile of Treviglio itself is seen, beside Saint Peter, in the adjacent panel. The artists knew of the achievement of Mantegna, of the Ferrarese, and above all of Foppa, but had digested these in their own manner.

Treviglio, although not sordid, is, as it were, a one-polyptych town. But before leaving, take the road from the northwest angle of the piazza to the sanctuary of the Beata Vergine delle Lacrime. On the left of the presbytery is a predella by an associate of Butinone with a view of the Collegiata in its quattrocento state.

16

BERGAMO

❖

THE OLD ROAD from Milan runs north-east, past Gorgonzola to cross the river Adda at Vaprio, where a number of prominent Milanese families built villas that have changed relatively little since Bernardo Bellotto recorded these in the 1740s. Beyond, the road turns somewhat northwards for the last fifteen kilometres to Bergamo, which from 1428 until 1797 was the western outpost of Venetian territory.

The upper town, the Città Alta, is as satisfying as any of its size in northern Italy, its plan dictated by the strategic promontory which its defences exploit. The logical place to begin is the central Piazza Vecchia, overlooked by the palazzo of the Podestà Veneto, the local governor. Walk through the portico of the Palazzo della Ragione into the Piazza del Duomo. On the left is the not very appealing cathedral, ahead the flank of the magnificent Santa Maria Maggiore, with the façade of the adjoining Cappella Colleoni. Designed by Giovanni Antonio Amadeo and built in 1472–6, this domed monument to the great *condottiere* Bartolomeo Colleoni is perhaps the purest achievement of the Lombard Renaissance. In the eighteenth century the interior was enriched with a series of canvasses by Giovanni Battista Tiepolo, Giuseppe Maria Crespi and others. The elaborate classical decoration of the façade contrasts with the Gothic porch of the church. The interior is lavishly decorated with tapestries and an exceptional baroque confessional. The choir stalls have no equal. The intarsia

panels, with scenes from the Old Testament, were designed by no less a genius than Lorenzo Lotto. And nowhere are the wayward eccentricities of that most individual of Venetian Renaissance masters more evident than in these inventive designs.

Lotto worked in and around Bergamo on a number of occasions between 1516 and 1533. Because his stature was not properly recognized until the appearance of Berenson's monograph in 1894, there was no incentive for the French to appropriate pictures by him. To see two closely related masterpieces of 1521, descend from the Città Alta to the palazzo-lined Via Pignolo. Go first to Santo Spirito. Lotto's altarpiece is on the fourth altar on the right. The Madonna and Child are enthroned between four saints with the infant Baptist below and a wonderfully animated semi-circle of youthful angels above. The glowing eloquence of Lotto's colour is matched by the energy of his characterization. Uphill, in the relatively modest San Bernardino in Pignolo, is the later of the two pictures, again a *sacra conversazione* with the Madonna and Child and four saints, but with a recording angel in place of the Baptist and four flying child angels holding a canopy above the throne. Of the two pictures, this is the more concentrated masterpiece.

Higher up the Via Pignolo is the turn on the right for the Accademia Carrara, one of the most distinguished museums of its scale in Italy. Among the components of the collection are the pictures acquired by the pioneer of the art of attribution, Giovanni Morelli, including one of Bellini's most perfect Madonnas. Naturally artists who worked in the city are well represented: Andrea Previtali and Giovanni Cariani; Lotto with his

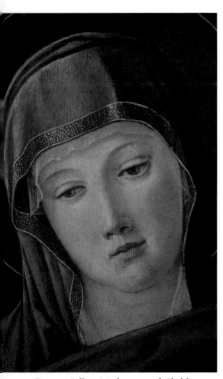

Giovanni Bellini, Madonna and Child
(*detail*).

beautiful, if truncated, *Mystic Marriage of
Saint Catherine* and the wonderfully ani-
mated predella panels of 1516 from his
great altarpiece in the church of San Bar-
tolommeo in the lower town; Moroni
with a dozen of the portraits that record
the patrons of mid-sixteenth century
Brescia and Bergamo with such deter-
mined objectivity; and his early eight-
eenth-century successor Fra Galgario
with some two dozen canvasses, includ-
ing the refreshingly unsentimental *Young
Painter*. The careers of both Moroni and
Fra Galgario demonstrate that, subject
to Venice as this was, Bergamo was no
artistic backwater.

17

BRESCIA

✧

BRESCIA WAS A significant settlement of
the Gauls well before it was drawn into
the orbit of Rome. Its subsequent fate
was determined by patterns of political
dominance throughout northern Italy.
Brescia emerged as a free commune in
the early twelfth century, but later was
held in *signoria* by an almost bewilder-
ing succession of families, including the
Scaligeri of Verona and the Visconti of
Milan; in 1426 it passed to the Venetians,
for whom it was of vital importance for
the production of cannon. Their rela-
tively benign rule was interrupted in
1509–16 but lasted until 1797. The letters
of Lady Mary Wortley Montagu give an
idea of the civilities of patrician life in
the area in the mid-eighteenth century.

The city is rectangular in plan, with
the Castello at the north-east angle. More
or less in the centre is the small piazza
fronting the richly decorated Palazzo
del Comune or Palazzo della Loggia of
1492–1574. This was begun by Filippo
de' Grassi, who was also responsible for
the west section of the Monte di Pietà on
the south side of the piazza. To the east
side is the larger Piazza del Duomo. On
the opposite side is the Broletto, with its
eleventh-century tower, the powerhouse
of civic life in medieval Brescia. South of
the Broletto is the Duomo Nuovo, and
beyond this the rather more remarkable
Duomo Vecchio. This ambitious late elev-
enth-century rotunda overlay a much
earlier church; the presbytery was added
in 1488–98. Above the high altar is the
Assumption of the Virgin by Alessandro Bon-
vicino, il Moretto, the grandest, if not

always the most appealing, of the great masters of Renaissance Brescia.

Both Moretto and his older contemporary Girolamo Romanino are splendidly represented in the Pinacoteca Tosio-Martinengo in the south-east corner of the city. Romanino was deeply affected by his experience of Venice and is a seductive artist, while Moretto's late *Ecce Homo with an Angel*, restrained in colour, is one of the most moving north Italian pictures of the mid-sixteenth century. The museum offers a comprehensive view of painting in Brescia and the area from the *Trecento* onwards, with fine examples of such artists as Foppa and Civerchio. There is also a little known early masterpiece by Raphael, a small panel of *Christ blessing*.

A remarkably high proportion of the major pictures supplied to Brescian churches in the Renaissance remain *in situ*: works by Moretto can be seen in nine churches, while Romanino is represented in eight. Few visitors have the time to visit them all, and unfortunately the key churches are widely spaced. Sant'Alessandro, at a corner on the shortest route from the Duomo Vecchio to the Pinacoteca, is a building of little consequence. But on the first altar on the right is a picture of huge interest, the *Annunciation* that is the most substantial extant work by Jacopo Bellini, Giovanni's father. Some little way to the north-east is an architecturally even less appealing church, San Clemente, with a fine altarpiece by Romanino and five by Moretto.

Making to the north-west from the Palazzo del Comune, it is not difficult to find San Giovanni Evangelista, another

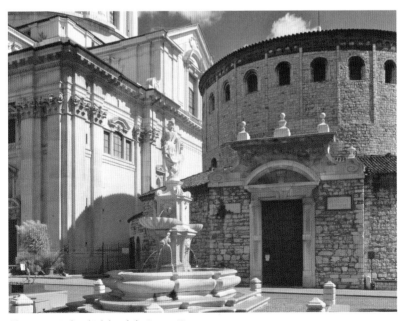

The Duomo Vecchio (right) and the Duomo Nuovo.

much remodelled church, for which both Romanino and Moretto worked extensively. The latter's uncompromising *Massacre of the Innocents* is on the third altar on the right, while his high altarpiece of 1521–2 is flanked by the shutters he supplied for the organ. The Cappella del Sacramento of the left transept, built in 1509–10, was decorated by both artists, Romanino receiving the left wall, with a lunette of the *Mass at Bolsena* and other scenes, while Moretto was responsible for that opposite, and for the *Coronation of the Virgin* with portraits of the donors, Francesco and Giovanni Cesari, above the altar. The two painters worked simultaneously in 1521–4, and their collaboration was constructive rather than competitive; yet even so one senses that Romanino's was the easier narrative flow, while Moretto had a more elevated sense of his role.

The church of Santi Nazzaro e Celso is near the south-west angle of the town on Via Matteotti. Moretto is seen at his most seductive in the *Coronation of the Virgin* of 1534 on the second altar on the left, and at his most austere in the *Blood on the Redeemer* of 1541 on the third altar of the opposite side. Both he and Romanino were deeply aware of the distinction of the *Resurrection with the Annunciation and Saints*, which was ordered for the high altar in 1520 from Titian and delivered two years later. The continuing presence of this relatively early masterpiece by the great Venetian shows how significant a contribution an import of the kind could make in a city like Brescia; and although the patron, Altobello Averoldo, was in the papal service, the commission can perhaps be seen as a subtle statement of Brescian loyalty to Venice, which had only recovered the city from the French four years earlier.

18

CREMA

TREVIGLIO IS LOMBARD; its neighbour Crema, previously a fief of the Visconti of Milan, was held from 1449 until 1797 by Venice, and a Venetian orientation can still be sensed in this most charming of cities in the Lombard plain. 'Few people visit Crema,' John Addington Symonds observed in his *Sketches of Italy* of 1879. This is still the case.

Crema should be approached from the west through Faustino Rodi's elegant Arco di Porta Ombriano put up in place of the original gate in 1805. The great campanile of the Duomo is already in

Faustino Rodi, Arca di Porta Ombriano, 1805.

sight. The street, now the Via XX Settembre, has an air of unassertive well-being. Soon on the left you pass the chromatic rendered façade of the church of the Trinità by a local architect, Andrea Nono, which was completed in 1740. Further on, a road on the right leads to the ambitious Palazzo Virmercati Sanseverino (1592–1602) and a group of other mansions that testify to the long prosperity of Venetian rule. Return to the main road and continue towards the Torazzo – a clock tower above an arch with the lion of Saint Mark in place – of the Palazzo del Comune, behind which the Duomo can already be seen. This is a characteristic Lombard brick construction, begun in 1284 and finished in 1341, and for Symonds no other building of the type was more beautiful. The façade is much higher than the body of the church, while the wonderful campanile, which rises to an octagon, is at the east end; as Symonds wrote, this is of 'the gracefullest, most airily capricious fancy'.

Continue eastwards. From the last turn on the right before Piazza Garibaldi can be seen the grandiloquent but unfinished baroque Palazzo Terni de' Gregori Bondetti, whose Piacentine architect, Giuseppe Cozzi, knew exactly how to exploit the lateral viewpoint; opposite the palazzo is the Museo Civico. The Piazza Garibaldi is closed with a second arch of 1805 by Rodi, the Arco di Porta Serio. From here a road lined by planes leads after more than a kilometre to the great monument of Renaissance Crema, the sanctuary of Santa Maria della Croce.

The original architect, Giovanni Battagio (who worked there in 1490–3), was strongly influenced by Bramante, and there are few more satisfying brick structures in his style; Symonds understandably admired 'its tranquil dignity and harmony of parts'. Externally circular and rising to a dome, with extensions at the arms of the cross of which that on the south side is the principal entrance, the church is octagonal within. The presbytery is raised above a crypt. That the decoration is later reminds us of the trouble relatively small communities had finding money for such projects. The frame above the high altar is dated 1499, but it was not until some two decades later that the altarpiece was supplied. The lesser Venetian painter Benedetto Diana's *Assumption of the Virgin* is his masterpiece: the aged Virgin, dressed in deep blue, is set against a glowing yellow ground and flanked by angels emerging from clouds touched with butterscotch and bronze, while the apostles stand below, their paler robes, in which pink and reds and greens predominate, contrasting with the slate grey of the classical architecture behind. Diana was no innovator. He reacts to the achievements of greater men, most obviously the mature Bellini. And at Crema he rose to the occasion.

19

CREMONA

CREMONA HAS A quiet self confidence
that in part reflects its past. A Roman
colonia from 218 BC, its original plan can in
part still be traced. It retained its impor-
tance under the Lombards and later was
allied in turn with neighbouring towns
and the Emperors Frederick Barbarossa
and Frederick II. Ruled by the Visconti
from 1334, it was part of the dowry of
Bianca Maria Visconti on her marriage
to Francesco I Sforza in 1441. Cremona's
fate would continue to be dependent on
that of Milan. Its artistic wealth reflected
the consistent agricultural productivity
of its territory, while its wider fame is
partly owed to the achievement of its
makers of musical instruments, most
notably Stradivarius.

A natural approach is from the
north-west – the route from Milan.
From the Piazza Risorgimento, near the
railway station, the main street, now
the Corso Garibaldi, strikes towards the
Duomo, the campanile of which beck-
ons the traveller from afar. The road is
lined by buildings of interest: on the
left San Luca, set back, its brick front
with a *quattrocento* portico, followed by
the baroque Palazzo Stanga Rossi di San
Secondo; then, to the right, the distin-
guished Palazzo Remondini designed in
1496 by Bernardino de Lera. Further on
is the brick Palazzo del Popolo, the for-
mer power base of the Guelfs in the city,
opposite the late Neoclassical portico
that masks the earlier church of Santa
Agata: this is notable for Gian Cristoforo
Romano's chaste Trecchi monument of
1502, and, in the choir, the four frescoes

of scenes from the life of the saint by
Giulio Campi. Campi was a versatile art-
ist as can be seen in the small church
of Santa Margherita which he designed
and decorated. This is on the Via Guido
Grandi which forks to the right beyond
the Palazzo del Popolo, passing the the-
atrical neo-gothic façade of the Palazzo
Trecchi. Further up the road, a turning
on the left leads to Sant' Agostino, a fine
late gothic brick church for which in
1494 Perugino supplied the altarpiece
still hung in the right aisle although in a
later frame. The picture understandably
had a strong influence on local masters.

The Piazza del Duomo is unforget-
table. Even in Italy it would be hard to
match the concentration of great medi-
eval buildings that surround it. The
religious and the secular are neatly bal-
anced: on the west side are the Palazzo
del Comune, substantially of 1206–46,
and the elegant Loggia del Militi of
1292, both of brick in contrast to the
pale marble of the façade of the Duomo
opposite; at the south end is the octag-
onal Romanesque Baptistery, begun in
1167.

The best vantage point from which
to survey the Duomo is the upper floor
of the Palazzo del Comune, which also
deserves to be visited for the *Miracle of the
Loaves and Fishes*, the outsize masterpiece of
the highly individual Luigi Miradori, il
Genovesino, who settled at Cremona and
died there in 1654.

The Duomo is of Greek-cross plan
and it makes sense to walk round the
building before going in. It was begun
in 1107, but damaged by an earthquake
in 1117 and only consecrated in 1190,
while work on the transepts followed a
century later and was not completed till
the mid-fourteenth century. The main,
west, front was faced in marble in the

late thirteenth century, the great rose window dating from 1274. The outsize lions of the porch of 1183 are by Giambono di Bissone, but other sculptures were recycled: the statues of the Virgin and saints above are by a Tuscan master. In the fifteenth century the façade was truncated to make it conform better with renaissance taste and loggias flanking the porch were added. The fronts of both transepts are essentially unscathed. The great apse had to be altered after the earthquake. Visual unity is enhanced by the brick turrets that rise above both façades and apse. Oddly reminiscent of minarets, these are of course dominated by the prodigious brick campanile that soars so inexorably to the left of the main front: begun in 1267 this was heightened

from 1287 onwards with two octagonal sections surmounted by a conical top.

The decoration of the Duomo was also achieved in stages. The key master of Renaissance Cremona, Boccaccio Boccaccino frescoed the conch of the apse in 1506: his *Christ with Saints and Symbols of the Evangelists* is brilliantly effective. Boccaccino was called in in 1515 for the first of the sequence of New Testament scenes above the arcades of the nave, commencing with the *Dream of Joachim* on the left and continuing to the *Circumcision*. The next two frescoes, above the fifth arch, are by the eccentric Gian Francesco Bembo. The cycle was continued beyond the organ by Altobello Melone and Boccaccino. The scenes above the three furthest arches on the right are by Melone

Duomo, west front.

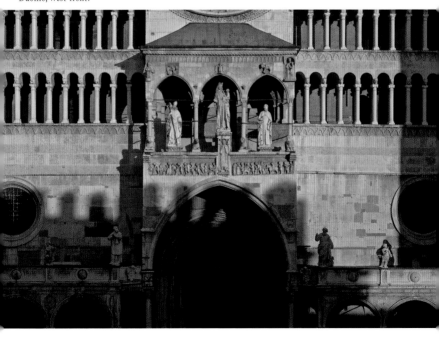

(1517), whose yet more painterly fellow Brescian, Girolamo Romanino was responsible for the Passion scenes (1519) in next two bays. The last three bays were painted by another gifted outsider, Pordenone, in the following year. These no doubt secured him the commission for the vast *Crucifixion* above the main door and the strikingly original *Deposition* of 1522 to the right of this: Pordenone lays out the dead Christ on his floor and the emotion of the grieving Maries is palpable.

There is much else to enjoy: Pordenone's Schizzi altarpiece above the first altar on the right, works in tempera by Boccaccino and Aleni, as well as Vincenzo Campi's deeply felt *Deposition* in the north transept. Opposite this is a *tour de force* of Renaissance silver, the cross of 1470–8 by Ambrogio del Pozzo and Agostino Sacchi.

A key monument of Cremona is a mile and a half to the south-east, just outside the spreading conurbation. Francesco I Sforza and Bianca Maria Visconti were married in a modest church dedicated to Saint Sigismund. On 20 June 1463 the foundation stone of a monumental replacement was laid at Bianca Maria's behest. San Sigismondo possibly designed by Filarete was perhaps the most advanced Lombard architectural project of the time. What impresses now is the visual unity of the interior, with frescoes by Bernardino Gatti and members of the Campi family as well as other Cremonese masters. Giulio Campi's *Pentecost*, the final component of the ceiling of the nave, is a visionary achievement. Access to the choir is no longer allowed, so it is difficult to study the *intarsie* of the stalls which were designed by Giulio Campi.

20

ASOLA

❀

EQUIDISTANT BETWEEN BRESCIA, Mantua and Cremona, Asola was pulled in differing directions in the fifteenth century. Contested by the Gonzaga and the Visconti, the Asolani submitted to Venice in 1440: their town remained Venetian until the fall of the republic in 1797.

Asola is laid out on a grid plan, with the Piazza XX Settembre at its heart, dominated at the north end by the church of Sant'Andrea. This was built on somewhat conservative lines from 1472 and completed in 1514. A lesser artist, perhaps Antonio della Corna, frescoed the chapels on either side of the main entrance, while the polyptych above the high altar, said to have been a gift of the republic, is a provincial homage to a type associated with the Vivarini workshop. The altarpiece of the *Nativity* in the first chapel on the right is by the local boy, Giovanni da Asola, who echoed with

Sant'Andrea: Girolamo Romanino, Christ Crowned with Thorns (detail), 1525–6.

some success the early Titian and Palma Vecchio.

In 1525–6 a master of altogether different calibre, Girolamo Romanino, was commissioned to decorate the organ on the left side of the nave and the pulpit opposite. The organ shutters are of the *Virgin appearing to Augustus and the Tiburtine Sibyl* and the *Sacrifice of Isaac*. The prophets are depicted in the panels of the parapet; while the wall below is frescoed with saints and landscapes. Groups of saints are shown on the pulpit, while on the pier before which the preacher would have stood is a fresco of *Christ crowned with Thorns*. Executed at speed this is a deeply felt masterpiece.

Opposite the church on Via Garibaldi is the town's modest museum, with eroded pictures in tempera by Romanino's great Brescian rival, Moretto, originally in the now remodelled Palazzo Comunale. At the north end of the street is the handsome late seventeenth-century Palazzo Beffa Negrini. The doors and window frames are of white marble, the upper windows are surmounted by heads while those below are carved with trophies. The palazzo seems oddly out of place in a modest town, and was indeed built for an outsider, Nicolò Sebregondi from the Valtellina.

MANTUA

PROTECTED TO THE north by a bend of a tributary of the Po, the Mincio, where it forms two lakes, Mantua had the distinction of being mentioned in the *Aeneid* and has long been one of the major towns of the Po Valley. But it is to the Gonzaga that it owes its outstanding monuments. Luigi Gonzaga secured the *signoria* in 1328. His descendants were successively marquises from 1433 and dukes from 1530. The direct line died out in 1627. In the resulting war the city was sacked and the ducal picture collection sold to King Charles I of England. Neither under the cadet branch of the family which succeeded, nor under subsequent imperial rule, did Mantua fully recover.

The prodigious Ducal Palace is at the north-eastern corner of the town, protecting the Ponte San Giorgio, Mantegna's view of which in his *Death of the Virgin* in the Prado is still recognizable. The entrance to the palace is on the unexpectedly large Piazza Sordello. The medieval building was altered as fashion dictated until the eighteenth century. Its plan is complex. And the public tour is exhaustive. The relatively recently discovered fresco by Pisanello marks the emergence of the Gonzaga as sophisticated patrons, and works by Rubens and Feti testify to the enduring artistic leanings of the family. At the heart of the palace is the late fourteenth-century Castello di San Giorgio. The courtyard was designed by Mantegna and executed by the Florentine architect Luca Fancelli, Perugino's father-in-law. Successive remodellings

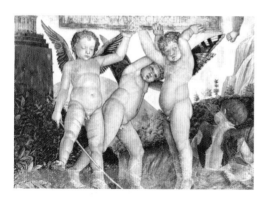

Palazzo Ducale: Andrea Mantegna, Camera degli Sposi, fresco (detail).

have mercifully spared what must always have been the most thrilling room in the castle, the Camera degli Sposi. Frescoed by Mantegna between 1472 and 1474 for Marchese Ludovico Gonzaga, this is one of the high points of Renaissance art. Inspired by his profound study of antiquity, the painter records his patron and his relations and hangers-on with a heroic objectivity. Long known as the 'camera picta', the painted room, the Camera degli Sposi was unprecedented in the implied unity of its pictorial surfaces and the intelligence – and beauty – of Mantegna's visual conceits.

After such a masterpiece, the Duomo on the other side of the Piazza Sordello may come as an anticlimax. Yet, despite the late façade, this too is a pioneering building, designed by Raphael's artistic co-heir, Giulio Romano, court painter to Francesco II Gonzaga, who succeeded at Mantua in 1519.

At the southern end of the piazza, the Voltone di San Pietro leads to the Piazza delle Erbe. On the opposite side of this, to the right, is the most celebrated of Mantua's churches, Sant'Andrea. This was planned by the high priest of quattrocento classicism, Leon Battista Alberti, in 1470 and begun two years later by Fancelli; the

massive late baroque cupola was designed by Filippo Juvarra. The interior is monumental yet restrained, and in it, most appropriately, is the tomb of Mantegna. Work on the church overlapped with that on San Sebastiano 800 metres southwest on the Largo XXIV Maggio. This was designed by Alberti in 1460. Restoration has not affected the integrity of the elegant interior, perhaps the first of the Renaissance on a Greek cross plan.

Continuing in the same direction for 300 metres, one is confronted on the left by the uncompromising rusticated façade of the Palazzo Tè, the extraordinary villa created for Francesco II Gonzaga between 1525 and 1535 by Giulio Romano. A painter by training rather than an architect, Giulio was wonderfully inventive in his deployment of architectural forms. Yet, however original the building must have seemed to contemporaries, it is in the frescoed decoration that Giulio's own restless personality was more freely expressed. He knew how to divert his patron – and succeeded triumphantly. The visitor can still see why. The Sala dei Cavalli, with heroic murals of horses, is followed by the most sophisticated of all Giulio's mythological compositions in the Sala di Psiche.

Giulio's imagination was fertile. Almost simultaneously he could design elaborate silver vessels – all alas lost – and the overwhelming drama of the *Fall of the Giants* in the Sala dei Giganti. Giulio was supported by an équipe of painters who worked from his own clearly defined drawings. He was fortunate in the skill of his associates, including the young Francesco Primaticcio, whose work at Fontainebleau was to be a natural sequel to the project.

The strategic importance and long economic prosperity of the Po Valley mean that the area has a rich architectural inheritance. Late medieval brick fortifications abound, and lesser dynasties ensured that their towns echoed those of more powerful counterparts. Cadet branches of the Gonzaga were no exception. At Sabbioneta, thirty-three kilometres south-west, Vespasiano Gonzaga created his own capital on a grid plan. Both the Palazzo Ducale and the Palazzo del Giardino were begun in 1568, to be followed by the octagonal church of the Incoronata and Vincenzo Scamozzi's sophisticated Teatro all'Antica. Another branch of the family held Castiglione delle Stivere, thirty-eight kilometres north-west of Mantua. Here too there is a former Ducal Palace; equally imposing is the Collegio delle Nobili Vergini, founded for daughters of families who did not wish to pay dowries by the brother of the then marquess, the future San Luigi dei Gonzaga. Sabbionetta and, less immodestly, Castiglione show how the Gonzaga and their buildings at Mantua influenced their relations.

Palazzo Te: Sala dei Cavalli, *designed by* Giulio Romano, *fresco* (detail). A.M.

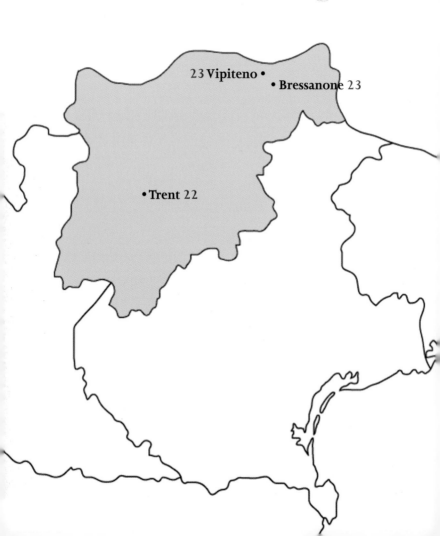

Trentino
Alto Adige

23 Vipiteno •
• Bressanone 23

• Trent 22

22

TRENT

❂

TRENT MUST ALWAYS have had the air of a frontier city. On the left bank of the Adige near the confluence of the Férsina, the city controls the key transalpine route across the Brenner Pass. The Roman Tridentum was already a place of some consequence. In the early eleventh century, the Holy Roman Emperors granted control of the Trentino to a succession of prince-bishops, who were to rule Trent more or less continuously until the French invasion of 1796. Restored to Austria after the defeat of Bonaparte, the Trentino and the Alto Adige to the north were Italy's major prizes for her less than glorious intervention in the First World War. A cataclysm of a different kind, the Reformation, had for two decades made Trent the epicentre of the Catholic world: the Council of Trent, which was opened in 1545 and reconvened for the last time in 1562, set the future course of the Roman Church.

At the heart of the city, on the south side of the Piazza del Duomo, is the Romanesque cathedral. This was begun to the design drawn up by the Ticinese mason Adamo d'Arogno in 1212, but subsequently modified. The restrained north façade does not prepare one for the rich external decoration of the central apse. The austere interior was the setting for the opening of the Council on 13 December 1545. The piazza itself, with a pretty eighteenth-century fountain, is flanked by a number of fine buildings, including the much-restored Palazzo Pretorio, and, at the corner of the Via Belenzani, the Casa Bella, whose façade

with frescoes of *c.*1530 by Marcello Fogolino is a precious survival.

The Via Belenzani, generously wide, is flanked by a sequence of distinguished *palazzi*, some of which housed those who attended the Council. Ahead is the baroque church of San Francesco Saverio, on the Via Roma. Turn to the right to reach the vast Palazzo Fugger of 1602. Less ambitious but more appealing is the Palazzo Tabarelli, down the Via Mazzurana to the right, with a richly decorated front of 1512–27.

Palazzo Tabarelli.

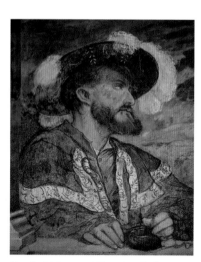

Castello del Buonconsiglio, stairs: Girolamo Romanino, Martino Malpaga (*detail*), 1531–2.

Further east, set against the town wall, is the Castello del Buonconsiglio, which was from the thirteenth century the seat of the prince-bishops. The medieval fortress was extended for Bishop Bernardo Clesio in 1528–36 and now houses a number of museums. The frescoes supplied for Clesio in 1531–2 by the Brescian Girolamo Romanino are among the signal achievements of decorative painting of their time. The sequence begins on the ground floor and continues up a staircase to the *piano nobile*, culminating in the Loggia opening to the Cortile dei Leoni and in the Audience Chamber reached from the latter. Romanino's affinity with the north is exemplified in the realism of his portraits of the labourers who attend the slightly sinister official, Martino Malpaga, on the staircase and in the lunettes of groups of musicians juxtaposed with Old Testament and mythological scenes in the Loggia. He clearly knew how to divert and edify his patron.

23

BRESSANONE
and VIPITENO

NORTH OF TRENT the valley of the Adige gradually narrows. The castles that still stud its flanks show how strategically important the valley was, for it led to the Brenner, lowest of the passes across the Alps, a route that must have been used for millennia before the Romans laid out their road to Augusta (Augsburg). Bolzano (Bozen) is the main city of the region. A short walk reveals something of its history: from the Duomo, with a renaissance façade that was altered in the gothic period, and San Domenico, notable above all for the chapel of Saint John the frescoes of which reflect those of Altichiero at Padua, to the vainglorious monument commemorating Italy's acquisition of the Alto Adige at Versailles.

Further north, Bressanone (Brixen) is of greater interest. In 1027 the Emperor Conrad II granted a substantial territory to the bishopric of Bozen and, notwithstanding later vicissitudes, the Prince-Bishopric endured until 1808. Much of the early urban fabric survives. At its heart is the gothic parish church of San Michele. This is overshadowed by the Duomo, the vast interior of which is a showcase for Austrian artists of the eighteenth century including Paul Troger and the Unterbergers. The cloister is of the fourteenth century: the rather well-preserved frescoes express the divided artistic allegiance of the painters of the Tyrol in the *Quattrocento*. The spirited narratives express a very Germanic taste for incident, but there is also a

strong connection with north-Italian painting of the period.

The temporal power of the Prince Bishops of Bozen is expressed most forcefully in their formidable moated palace, which was remodelled in the late sixteenth-century. Ranged round a handsome courtyard, this now serves as the local museum, with considerable holdings of both pictures and sculpture by Tyrolean artists. Pride of place must, however, go to a remarkable survival from the treasury of the Duomo, the tenth-century cope of Saint Albuino, embroidered in Byzantium with blue falcons holding rings in their beaks against a ground of gold.

Some 29 kilometres further on is Vipiteno (Sterzing), the last significant town on the Roman road before the pass. By 1248 the area was held by the counts of Tyrol, who in 1280 founded the so-called Città Nuova south of the earlier Città Vecchia. The town was granted an exclusive right of hospitality to travellers in 1304 and in the fifteenth century silver mines became an additional source of wealth, as the parish church demonstrates.

Before seeing this, the visitor should go to the south end of the Città Nuova, a handsome narrow street that runs straight to an arch below a high tower. It is flanked by tall sixteenth- and seventeenth-century buildings, including on the left the Golden Cross hotel founded in 1604 and the Post Haus that is even older. Across the street is the handsome Rathaus with a projecting angle tower. Beyond the arch is the Città Vecchia. Across an irregular square is the white rendered former hospital with the small church of the Holy Spirit with frescoes of biblical scenes culminating with the *Last Judgment* on the west wall which reflect the late gothic taste of northern Italy.

The parish church is some way south of the Città Nuova. It is a fifteenth-century building, the successive interventions to which are well documented. In 1451 the Ulm master Hans Multscher received the commission for the high altarpiece, four statues from which are incorporated in the existing altar. Two others and four large double-sided narrative panels are now in the museum attached to the adjacent – and wholly charming – Commendatory of the Teutonic Order. As the wooden statues of Saints Florian and George show, Multscher was a sculptor of a high order: his panels of scenes from the life of the Virgin and the Passion demonstrate that he was also a painter of exceptional distinction, aware of recent developments in the Netherlands and largely independent of Italian influence. The panels were intended to be 'read' from a distance but nonetheless repay close scrutiny: he painted the expiring Virgin with as much conviction as he depicted the grimaces of those who tormented her son.

Bressanone, Duomo: Cope of Sant Albuino, Byzantine, 10th century.

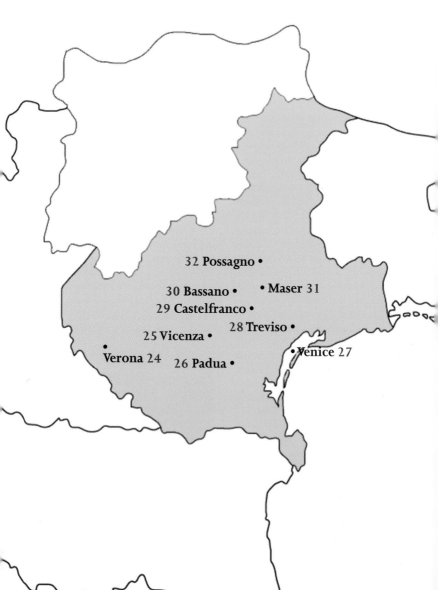

The Veneto

32 Possagno •

30 Bassano • • Maser 31

29 Castelfranco •

28 Treviso •

25 Vicenza •

• Verona 24 26 Padua • • Venice 27

24

VERONA

❧

VERONA HAS LONG haunted the English imagination. The city lies on the banks of the Adige as it cuts in a reversed S downwards to the plain. On the ancient route from Turin to Aquileia and from the Brenner Pass to the south, the Roman city of Claudia Augusta was rich enough to boast a substantial amphitheatre, the Arena. Verona retained her eminence, as residence in turn of the kings of the Ostrogoths and the Lombards. Later, as a free commune, she was inevitably caught up in the struggles of successive emperors. The *signoria* of the Scaligeri, which lasted from 1260 until 1387, was a period of immense prosperity. Verona's independence ended in 1405 when she passed to Venice. But political dependence did not inhibit Verona's artistic individuality. The gothic fantasies created for the Scaligeri were succeeded under Venetian rule by the sinuous line of Stefano da Zevio and the early Renaissance naturalism of Pisanello. In the sixteenth century Verona supported one great architect, Michele Sanmicheli, and boasted a school of painters, the most spirited of whom, Paolo Caliari, il Veronese, became in effect a Venetian. The last two centuries of Venetian rule were less productive, although the buildings of the Neoclassicist Luigi Trezza merit more attention than they have received. After the fall of Bonaparte Verona became a stronghold of the Quadrilateral, the series of fortresses that secured Austrian rule until 1866.

The old road from the west keeps to the flank of the southern shore of Lake Garda. This reaches the sixteenth-century walls at the Porta San Zeno, one of the simpler of the series of gates and bastions designed by Sanmicheli. A little beyond is the piazza dominated by the monumental Romanesque façade and campanile of the Basilica di San Zeno Maggiore. Below the rose window by Maestro Briolato is the main portal of c.1138 by the sculptor Niccolò, its celebrated bronze doors with panels illustrating biblical scenes and the life of Saint Zeno. These were begun in the twelfth century and, like so much later Veronese art, reveal northern influence. The interior of the basilica is equally impressive, restrained to the point of austerity. On the high altar is Mantegna's majestic triptych of the Madonna and Child between groups of four saints, shorn alas by the French of its predella. Painted in 1457–9, this was the most influential north Italian altarpiece of its generation.

The road continues to the river and the spectacular thirteenth-century Castelvecchio which, with the fortified Ponte Scaligero of 1354, commanded the western approach to the medieval town. The castle contains a distinguished picture collection. At the eastern corner of the Castelvecchio is the reconstructed Arch of the Gavi, built late in the first century ad of the local white stone. The wide Corso Cavour that runs northeast to the heart of the city follows its Roman predecessor. This is flanked by a notable series of palaces, including on the right Trezza's Palazzo Balladoro and two buildings by Sanmicheli: the Palazzo Canosa (1530–37) on the left, its back to the river, and the splendid Palazzo Bevilacqua to the right. Ahead is the Roman Porta dei Bursari. A sharp turn to the right, into the Via Oberdan, leads to the great monument of Roman Verona, the

spectacular first-century ad Arena, which is exceeded in size only by the Colosseum in Rome and the amphitheatre at Santa Maria Capua Vetere: for the Victorian historian, E.A. Freeman this brought out 'the massive grandeur of the true Roman style of building'. It is difficult to disagree.

The medieval city overlies its Roman predecessor. From the Porta dei Borsari, the line of the *decumanus maximus* is followed by the Corso Porta Borsari and the Corso Sant'Anastasia. The successor of the forum is the Piazza delle Erbe, surrounded by medieval houses. The Arco della Costa on the north-east side leads to the Piazza dei Signori. This is in effect

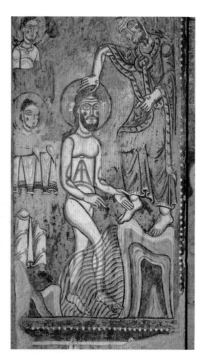

San Fermo, crypt: Veronese School, Baptism, fresco, 13th century.

a courtyard surrounded by civic buildings, the most appealing of which is the late fifteenth-century Loggia del Consiglio. Opposite is the Volta della Tortura, through which, by walking round the Palazzo dei Giudici on the left, you come to the most celebrated monuments of medieval Verona, the tombs of the Scaligeri. Cangrande I della Scala, who died in 1329, followed by Mastino and Cansignorio, who died respectively in 1351 and 1370, were buried in prodigiously elaborate free-standing structures that resemble contemporary reliquaries. In these, Veronese gothic architecture and sculpture reached its apogee.

Not far to the south of the Piazza delle Erbe is San Fermo. The numerous frescoes in the church include, on the left wall, Pisanello's *Annunciation*. In the crypt are some of the best-preserved Romanesque murals in the Veneto, including, on one of the piers, a forceful *Baptism*.

A short walk north-east of the piazza is Sant'Anastasia, perhaps the most impressive of Veronese gothic churches. Built in brick by the Dominicans, this was begun in 1290. The fine main door is of the following century. Above the arch of the chapel to the right of the presbytery is the celebrated fresco of Saint George by Pisanello which, with the San Fermo *Annunciation*, is among the few extant monumental works by the artist. The Piazza Sant'Anastasia is linked by the Via Duomo to the Duomo, a massive and imposing building, oddly unlovable for all the magnificence of the decoration of the façade by Maestro Niccolò and the scale of the Romanesque apse.

Bellotto's celebrated views of Verona remind us how little much of the city has changed, although both the beautiful partly Roman Ponte Pietra and the Ponte Navi had to be reconstructed after the last

World War. While the great monuments of the medieval city are concentrated in the peninsula so effectively defended by the Adige, there is much of interest on the opposite bank. One might begin just within the walls near the earliest of Sammicheli's gates, the Porta San Giorgio, with the fine Renaissance church of San Giorgio in Braida. The *Martyrdom of Saint George* on the high altar is a dramatic masterpiece by Veronese. There are also excellent altarpieces by Girolamo dai Libri, the most accomplished local painter of the turn of the fifteenth century, and by Moretto. Further down the left bank of the Adige as it curves to the south is the Roman theatre, built against the hillside. Beyond is Santa Maria in Organo, with an elaborate façade by Sanmicheli and distinguished marquetry choir stalls by Fra Giovanni da Verona. The Via Santa Maria in Organo continues as the Via Giusti, dominated by the Palazzo Giusti del Giardino, known for the terraced garden with its celebrated view over the city.

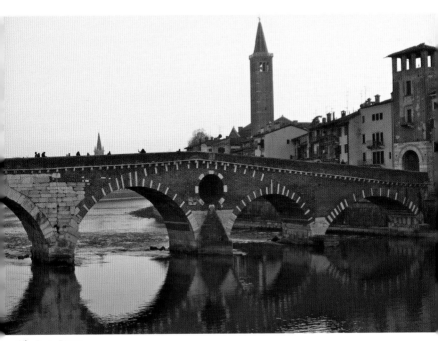

The Ponte Pietra.

25

VICENZA

❧

VICENZA PASSED TO Venetian rule in 1404. Much survives of the medieval town, but it was as a Venetian dependency that Vicenza became a major artistic centre. Of her painters the finest was Bartolomeo Montagna, an accomplished follower of Bellini. It is, however, to her architects, and above all to Andrea Palladio, that the city's fame is due, and nowhere else can their achievement be so fully studied.

Santa Corona: Giovanni Bellini, Baptism *(detail).* A.M.

The traveller from the west arrives in the Piazza Castello. Ahead is the main street, the Corso Palladio, flanked by Palladio's Palazzo Bonin and the Palazzo Piovini of 1658 by Antonio Pizzocaro, an oddly neglected local architect. After some 300 metres on the right is the former Palazzo Trissino, by Palladio's successor Vincenzo Scamozzi, with a restrained courtyard. The streets on both sides of the palace run into the Piazza dei Signori, across which is the prodigious basilica. This late gothic successor of the earlier Palazzo Comunale was spectacularly refaced by Palladio, whose project was approved in 1549. Opposite is Palladio's later (1571) Loggia del Capitaniato, which backs onto the Palazzo Trissino. The road to the right of this leads across the Corso Palladio to the Contrada Porti, which is literally lined with *palazzi*, including Palladio's Palazzo Barbaran da Porto (no. 11) and Palazzo Iseppo da Porto (no. 21). It is fascinating to observe how the architect responded to the challenges such commissions offered.

Return to the Corso Garibaldi, and turn left to reach the finest late gothic palace of Vicenza, the richly decorated Palazzo Da Schio. Further on, again on the left and set back, is Santa Corona, a major Dominican foundation of 1261. At the end of the left aisle is a magnificent altar of 1501, probably designed by Rocco da Vicenza. This frames a little-known masterpiece by Giovanni Bellini, his late *Baptism*. Age had only quickened Bellini's ability to use landscape for emotional effect.

Continue on the Corso, passing the so-called Casa di Palladio, to reach the lateral façade of the architect's most ambitious and elaborately decorated Vicentine house, the Palazzo Chiericati. This houses the Pinacoteca Civica. The pictures include a significant group by Montagna, an irresistible early altarpiece by the purest of Bellini's pupils, Giovanni Battista Cima, in which a lizard is shown, and Tiepolo's serene *Immaculate Conception*. Diagonally opposite the palace is the best known of all Palladio's buildings in the town, the Teatro Olimpico, designed in 1580 at the very end of his career. Faithful to the precepts of Vitruvius, the theatre has no rival of its date.

The charm of Vicenza is partly owed to its position on a curve of the river Bacchiglione. To the south is the Monte Berico. An old woman experienced

visions of the Virgin here in 1426 and 1428, and a shrine was built to commemorate these. From near the Porta Lupia, the processional route, covered by an eighteenth-century portico of 150 arches symbolizing the beads of the rosary, climbs steeply to the Basilica di Monte Berico. The much altered building is not prepossessing. But it boasts two masterpieces, Montagna's noble *Pietà* of 1500 and, in the refectory, Veronese's sumptuous *Feast of Saint Gregory*, which was slashed by Austrian troops during the abortive revolution of 1848.

The two most celebrated villas of Vicenza are east of the basilica. The Villa Valmarana dei Nani and its *foresteria* were decorated by Giovanni Battista Tiepolo and his son Giovanni Domenico in 1757. The programme in the villa was literary, with rooms dedicated to the *Iliad, Orlando Furioso*, the *Aeneid* and *Gerusalemme Liberata* implying parallels between Homer and Virgil, on the one hand, and the great Italian poets, Ariosto and Tasso. The Valmarana wanted to live in a world of poetic enchantment and the Tiepolo obliged. In the *foresteria* the mood is less sophisticated, with the carnival scenes and illustrations of rural life that Domenico was so uniquely qualified to supply.

A quarter of an hour's walk between high walls overhung with trees leads to the last and most perfect of Palladio's villas, the Villa Rotonda. This was begun in 1550, but only finished by Scamozzi over half a century later. The approach is unforgettable, and the villa sits majestically in its landscape, the four porticoed façades at once linked and crowned by the central dome. The logic of the design is inexorably satisfying, and none of its imitations in England or elsewhere is so completely successful.

26

PADUA

❖

PADUA IS THE greatest city of the Venetian *terra firma*. Between the river Brenta and the Euganean Hills that shimmer so unexpectedly over the plain, and since Roman times the hub of several key roads, Padua began to recover its earlier importance in the ninth century. The University was founded in 1222, and the death of the future Saint Anthony of Padua in 1231 meant that it became the centre of his cult. The *signoria* passed in 1337 to the Carrara, who succumbed to the Venetians in 1405. Venetian rule hung lightly on the city, which continued to enjoy considerable wealth. The French arrived in 1797, to leave in the wake of Napoleon's defeat; their Austrian successors withdrew in 1866, when – as was so often the case – after a suspiciously unanimous vote Padua became part of the Italian kingdom.

Every approach to Padua has been marred by new buildings, so the station is the most logical starting point. A brief walk leads to a bridge across the river Bacchiglione and the site of the Roman Arena. Here Enrico Scrovegni built the chapel that bears his name and was consecrated in 1305. The structure, which Giotto himself evidently planned, is simple. But the frescoed decoration was the most sophisticated, indeed revolutionary, of the period in Italy. Nowhere is the genius of Giotto more cogently expressed or his ability to control his associates more effectively demonstrated. The murals of the lateral walls – scenes from the lives of the Madonna and of Christ – reveal the artist's preoccupation with form and

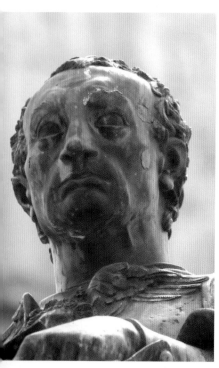

Donatello, Equestrian statue of Gattamelata,
bronze (detail). A.M.

space, as well as his genius for narrative, while the grisaille Virtues and Vices of the dado, *trompe l'oeil* bas-reliefs, challenge contemporary sculpture. Visitors can no longer linger, so should read their guidebooks before entering the chapel.

Alas, in 1944 a stray bomb, doubtless of the type devised by my maternal grandfather, caught the great church of the Eremitani behind the Arena, and only fragments survive of the long-celebrated frescoes by Mantegna and his associates. Rather than contend with what is no more than an archaeological reconstruction, I prefer to make for the centre of the town, pausing perhaps

in the Neoclassical Caffé Pedrocchi of 1830, before trying to lose myself in the arcaded streets of brick buildings. A little to the west of the café, between the Piazza delle Erbe and the Piazza della Frutta, is the substantial Palazzo della Ragione of 1218–19. Inside on the first floor is the immense *salone* that was intended for the tribunal. Further west is the Piazza dei Signori, with the elegant Renaissance Loggia della Gran Guardia. The street beside this leads to the Piazza del Duomo. The Duomo itself is not of particular distinction. In the annexed Baptistery, however, is the very remarkable cycle of frescoes painted for the wife of Francesco I da Carrara in 1376–8 by Giusto de' Menabuoi. With his contemporary Altichiero Altichieri, Giusto was one of the outstanding painters of his generation in northern Italy. His taste is elegant and discursive.

Return through the Piazza delle Erbe, passing the University, to turn right on the Via del Santo. In the Piazza del Santo is Donatello's wonderful bronze equestrian portrait of the *condottiere* Gattamelata. Executed in 1453, this more than challenged its classical predecessors and is one of the defining achievements of the early Renaissance. Behind looms the great Basilica di Sant'Antonio, the Santo. This was begun in 1232, a year after Saint Anthony's death. The interior is prodigious. There are notable frescoes, including those by Altichiero in the right transept, but it is above all for its sculpture that the Santo is remarkable. The now-dismembered high altar designed by Donatello had a profound influence on the course of both sculpture and painting in northern Italy: a remarkable series of reliefs from it survive, including a compelling masterpiece, the *Deposition*. To the left is the great candelabrum by

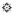

the outstanding Paduan High Renaissance bronze worker, Andrea Briosco, il Riccio. He designed the Chapel of the Tomb of the Saint in the left transept, to which most of the major sculptors active in the area in the early sixteenth century contributed.

To the right of the basilica is the Oratorio di San Giorgio of 1377–84. This is remarkable for the cycle of frescoes by Altichiero and his associate Jacopo Avanzo, perhaps the most successfully monumental murals of their time in the Veneto. Beside the oratory is the Scuola di Sant'Antonio, which was enlarged in 1504–5. The upper *salone* was decorated with frescoes of miracles of the saint by a number of artists, including the ageing Montagna. The three scenes by the young Titian still seem startlingly dramatic. How revolutionary they were is perfectly demonstrated by the company they keep. Despite obvious debts to others, Titian had already found a personal language; we see types that will be encountered in much later works and are left in no doubt that the painter had a deep love of landscape.

South-west of the Piazza del Santo is the road to the Prato della Valle. Set in an irregular esplanade, this oval garden is surrounded by a canal lined with seventy-eight statues of illustrious citizens. It was willed into existence in 1775 by the enlightened Venetian *podestà*, Andrea Memmo, about whom we know so much from Andrea di Robilant's *A Venetian Affair* (2003). At the south-east corner of the Prato is the large Basilica di Santa Giustina, reconstructed in the mid-sixteenth century. The interior is, as was intended, dominated by Veronese's enormous and vibrant high altarpiece, the *Martyrdom of Saint Giustina*.

27

VENICE

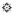

NO CITY HAS quite the magic of Venice. Protected by the lagoon, Venice emerged as a powerful entity in the Dark Ages. By 1000 she controlled the coast of Dalmatia and her destiny as a great colonial and trading empire was set. By the fifteenth century she had gained control of much of northern Italy. A patrician republic, La Serenissima, under an elected Doge, Venice retained her independence until the French invasion of 1797. In the Middle Ages and the Renaissance it was her wealth and power that impressed the world, in the seventeenth century her constitution that was admired, not least in England. With the eighteenth century it was the very fabric of Venice that delighted the outsider – as Canaletto and Guardi learnt to their profit – and the fascination that the city would continue to exercise can be experienced in the pictures of Bonington and Turner, in the impassioned writings of Ruskin, and in the equally eloquent responses of three cosmopolitan Americans, Henry James, Whistler and Sargent.

Despite the development that has disfigured so much of the Veneto, the most memorable approaches to Venice remain the old roads, the villa-lined Terraglio from Treviso or the route beside the Brenta through Dolo and Stra. A causeway now crosses the lagoon towards the city that seems to lie on the waterline. The Grand Canal cuts a reversed-S course that divides the city in two unequal sections. This is the main thoroughfare of Venice, designed to impress. And it does. The tourist should take the vaporetto (Linea

1) that proceeds down the canal, sitting near the bow so that you can be mesmerized by the kaleidoscopic sequence of churches and *palazzi*. The canal runs eastwards to curve towards the Rialto, the elegant bridge that marked the original commercial heart of Venice; its course continues southward and then to the east and at length commands the celebrated view of Santa Maria della Salute and the Dogana, with the Molo.

The Molo was the scene of many of the ceremonies of the Venetian republic: to the right is the prodigious gothic Ducal Palace, to the left Sansovino's majestic Libreria. The Piazzetta between them is dominated by the rebuilt campanile and by the spectacular lateral view of the many domed Basilica di San Marco. The basilica is the spiritual, indeed the emotional, centre of Venice. The wonderful drama of its façade and domes, and the measured rhythm of the interior,

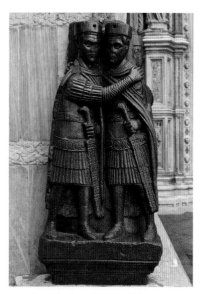

San Marco: the Tetrarchs.

impress immediately; the remarkable mosaics take rather longer to digest. The magic of the place is most palpable in the early morning, when those who want to pray can visit the north transept. But return later as a tourist to wonder at such miracles as the Pala d'Oro, the jewel-studded altar-front. The treasury must be the most remarkable in Italy, and the panels by Paolo Veneziano in the museum mark the highpoint of gothic painting in Venice. The galleries above the nave, alas, are less accessible than in the past; and admirably as these are now displayed, it is a poor commentary on our polluted and polluting world that the great classical bronze horses from Byzantium have had to yield their places on the façade to replicas. That the bronzes, like the inscrutable *Tetrarchs* of porphyry in the Piazzetta, were spoils from the Fourth Crusade of 1204 makes one feel a little less resentful of the depredations Venice would suffer in her turn.

The Piazza San Marco faces the west front of the basilica. It is flanked by the Procuratie Vecchie, to the south, and the Procuratie Nuove, the last begun about 1585. Tourists now outnumber Venetians under the loggias. Yet of the piazza itself one never tires.

Even when crowds mean that the basilica and the Ducal Palace are untempting propositions, the piazza is a logical place from which to set out. My choice depends on the time. In the mid-afternoon I would make east for San Zaccaria, hoping to catch the sun on the inexorably beautiful late altarpiece by Giovanni Bellini. I might then go on to San Giorgio degli Schiavoni, the confraternity of the Dalmatians; in the lower hall, in their original positions at the height the artist intended, are Carpaccio's celebrated canvasses that are among

Accademia: Giovanni Bellini, Donà delle Rose Lamentation (detail).

the masterpieces of Venetian narrative taste in the Renaissance. Ruskin at one time considered the *Triumph of Saint George* the finest picture in the world, while Sir George Sitwell would create a room inspired by the *Vision of Saint Augustine*; and any observant child will delight in, for example, the detail of the *Saint George and the Dragon*.

One of the pleasures of Venice is trying to lose the way. I like to wander. An early start from the piazza might take me in a northerly arc, by way of the *campo* of Santa Maria Formosa, to Santa Maria dei Miracoli, the most exquisite church of Renaissance Venice, built in 1481–9 to the design of Pietro Lombardo. Further north is the Gesuiti, with a dramatic statement of Titian's maturity, the *Martyrdom of Saint Lawrence*. Beyond is the Fondamenta Nuove, where Venetians still outnumber their visitors. There are boats to the cemetery island of San Michele, to Murano and to Torcello, with its matchless Romanesque cathedral. But I might prefer to resist these temptations and to make on, keeping as near to the lagoon

as possible and crossing at least five bridges, for the Madonna dell'Orto. This is a majestic late gothic brick church, memorable not least for its pictures. Cima's *Saint John the Baptist with other Saints* is as sharp in detail as any relief by the Lombardo and perfectly controlled in colour, while Tintoretto is found at his most cerebral – in the *Presentation of the Virgin* – and at his most visionary – in the *Last Judgement* of the choir. Further west is Sant' Alvise with Tiepolo's *Way to Calvary* of 1743, in which snow is seen on the distant mountains as might be expected at Easter in the Veneto.

There are few more charming areas of Venice to linger in. But the committed sightseer will take one of the bridges over the canal and find his way, passing perhaps the Ghetto Nuovo, to the Canareggio canal. Across this is the most abused of the great churches of the city, San Giobbe. The right wall of the nave is lined with the altar frames of masterpieces by Basaiti, Bellini and Carpaccio, all long since immured – as if in a sanitized hospital ward – in the Accademia.

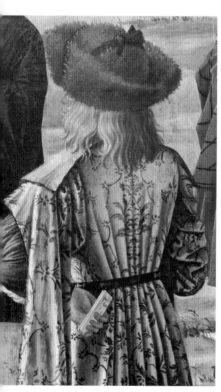

Accademia: Vittore Carpaccio, Return of the English Ambassadors, *from* The Legend of Saint Ursula *(detail).*

The Accademia must take pride of place among the museums of Venice. For there, as nowhere else, the miraculous kaleidoscope of Venetian painting from Paolo and Lorenzo Veneziano to Rosalba Carriera and Guardi can be surveyed. Go early and linger for as long as possible in the small rooms with the Bellini Madonnas, his Donà delle Rose *Pietà* and Giorgione's *Tempesta*. But do not neglect the less intimate masterpieces, Bellini's San Giobbe altarpiece, the haunting late Titian *Lamentation*, the major works by Veronese and Tintoretto, or Carpaccio's

grandest achievement, the sequence of canvasses of the life of Saint Ursula.

Venice's civic museum, the Museo Correr, is also remarkable: the Bellinis there can still be seen in natural side light, as the artist would have expected. The Ca' d'Oro is the most elegant of early fifteenth-century Venetian palaces. Alas, the ruthless recent reorganization of the collection means that one can no longer sense the tact with which Barone Franchetti treated the house. The institutional fate of Ca' Rezzonico, the greatest of the eighteenth-century palaces, also on the Grand Canal, has been kinder: the collection of *settecento* pictures, furniture and sculptures perfectly complements the building.

Remarkable as the resources of these institutions are, the achievement of the great Venetian artists is best understood by seeing works of art that remain in context. Within a triangle marked by the Frari, San Sebastiano and the Gesuati, opening hours and the whim of sacristans permitting, an astonishing sequence of masterpieces can be experienced.

At the apex is the vast late gothic Franciscan church of Santa Maria Gloriosa dei Frari. The building is well named, its brick apses without rival, the campanile only exceeded in height by that of Saint Mark's. The sustained richness of the interior is almost impossible to describe. The choir is dominated by Titian's triumphant *Assumption*, a work of unparalleled ambition. Later, by 1526, the artist would supply his equally remarkable – and in some ways more influential – altarpiece for the Pesaro family. The two pictures were potent statements of an artistic revolution that owed so much to the painter's early mentor, Bellini, whose incomparable triptych of 1488 in the sacristy, still in its proper frame,

had in turn been revolutionary in its day. Other major Venetian churches are rich in sculpture, but none competes in range perhaps with the Frari, for impressive state monuments to public figures are complemented by Donatello's spare *Saint John the Baptist* and Canova's pyramidal memorial to Titian.

Behind the Frari is the Scuola di San Rocco, grandest of Venetian institutions of the kind. The building was begun in 1515, but in view of its scale it is hardly surprising that work proceeded slowly. The lower hall, vast and tenebrous, is adorned with a series of eight canvasses by Tintoretto, all but two drawn from the New Testament. Tintoretto was also responsible for the ceiling compartments and twelve further scenes from the life of Christ of the upper hall and the ceiling and Passion scenes of the adjacent hostel, culminating in the prodigious *Crucifixion*. Tintoretto as a portrait painter was truthful and objective; as a religious master he is no less truthful. He has a force that demonstrates that his study of models after Michelangelo had not been vain. But his sense of drama is his own. And his technical abilities were perfectly calibrated for the project.

It is not easy to look at any work of art after brooding with Tintoretto at San Rocco. So it is as well that there is a short walk to Santa Maria del Carmelo, where a supply of coins is necessary to illuminate Cima's tender *Nativity* of c.1509 and Lotto's *Saint Nicholas in Glory* with its irresistible landscape. If a sacristan is about, ask to see the bronze relief of the *Deposition* with portraits of members of the Montefeltro family by the Sienese Francesco di Giorgio in the right apse.

From there it is a short way to San Sebastiano, built between 1505 and 1545, where the third giant among Venetian painters of the time worked over a long period from 1555. Paolo Caliari, il Veronese, lacked perhaps the spiritual fervour of Tintoretto, but at San Sebastiano he demonstrates his full range, although the large *Last Supper* from the refectory was among the pictures removed by the French to Milan and so is now in the Brera. The organ shutters and, not least, the main altarpiece, the *Virgin in Glory with Saints Sebastian, Catherine and Francis*, express the qualities that secured Veronese's lasting fame: his elegant types, his dazzling highlights and assured use of architecture.

Veronese's enduring legacy can be experienced nearby. Cross the canal and turn right for the Zattere, with its ever-shifting views to the island of the Giudecca and Palladio's great church of the Redentore. Near a vaporetto stop is the most ambitious church of eighteenth-century Venice, Massari's Santa Maria dei Gesuati. The ceiling was frescoed by Giovanni Battista Tiepolo, whose three compositions perfectly complement the architecture and stucco decoration. For altarpieces the three dominant masters of the time were called in. Sebastiano Ricci's *Pius V with Saints Thomas Aquinas and Peter Martyr* on the left is a late tribute to Veronese. This was followed by Piazzetta's luminous and subtle *Saints Vincent Ferrer, Hyacinth, Louis and Bertrand*, whose restrained colour reads almost like a rejection of Ricci's homage to the Venetian past. Tiepolo's beautiful *Madonna and Child with Saints Catherine, Rosa of Lima and Agnes*, above the first altar on the right, is perhaps his happiest statement as a religious painter. The Gesuati perfectly demonstrates that Venice was no artistic backwater when the Serenissima fell so suddenly to the force of revolutionary France in 1797.

28

TREVISO

❖

ON THE NORTH bank of the Silo and intersected by its tributary, the Bottenige, the Roman Tarvisium had the sense to submit to Attila. The city flourished under the Goths and the Lombards, before being sacked in 911. Allied in 1164 with Verona and subsequently with the Lombard League, Treviso took control of a substantial territory. In 1237 it was seized by the Ezzelini: their fall ushered in a period of conflict between Guelfs and Ghibellines, won in 1283 by the former when their leader, Gherardo da Camini secured the *signoria*. After the death of his son in 1312, Treviso was

Attributed to Alessandro Leopardi, Porta di Santa Quaranta, 1517.

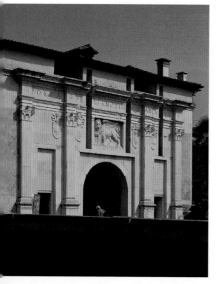

ruled by imperial vicars, by the Scaligeri of Verona, and in 1339-81 by Venice, to which it finally passed in 1389, becoming the Serenissima's first major town on the *terra firma*. A fiercely fought siege in 1509 left the Venetian authorities of their need to fortify the place: the walls were strengthened by Fra' Giocondo and handsome gates were built later.

The perfect approach is through the most splendid of these, the Porta di Santa Quaranta of 1517 at the northwest corner of the enceinte. Attributed to Alessandro Leopardi, this with its crisp masonry and lion of Saint Mark is the architectural counterpart of the sculpture of Tullio Lombardo. Within is the wide Borgo Cavour, on the left of which are the Library and the Museo Civico, with detached frescoes by Tommaso da Modena, who worked in Treviso in 1349–54, and a representative collection of later Venetian pictures. The road leads into the Via Canova, which circles round towards the fine Romanesque Baptistery and the Duomo, with its memorable cluster of seven cupolas. The east end of this Romanesque structure was altered by the Lombardo, but the nave was left until the eighteenth century and the ionic portico was appended in 1836. On the second altar to the right is a fine *Adoration* by the most consistent Trevisan painter of the Renaissance, Paris Bordon. Further on is Martino Lombardo's Cappella dell' Annunziata of 1519–20 with Titian's *Annunciation* above the altar. The insistent design of the pavement draws the eye to the wonderfully named donor, Canon Broccardo Malchiostro, who observes from the far side of the deep arch in which the scene is set, and the distant foothills of the Alps.

The Via Canova runs into the Calmaggiore leading to the central Piazza

dei Signori, dominated by the Palazzo del Trecento, the three hundred nobles and citizens elected to the Maggior Consiglio del Comune, begun in 1217 and the adjacent Palazzo del Podestà. There are a number of good churches in the eastern part of the town across the Battenigo, notably San Francesco, with fine frescoes by Tommaso da Modena, and late-gothic Santa Maria Maggiore: while Guglielmo Bergamesco's Porta San Tommaso of 1518 at the eastern end of the northern line of the wall is also distinguished.

The one church that should not be missed is San Nicolà, in the south-west part of the town. A towering structure in which the Romanesque melts as it were into the gothic, as the splendid apses show, this was not completed until 1858. Tommaso da Modena's fresco of Saints Agnes, Romuald and John the Baptist on the second pier to the left of the nave is a survivor from the original decoration of the church. The high altarpiece, begun by another Trevisan, Pier Maria Penacchi, was finished by a greater master, Girolamo Savoldo in 1521. On the left wall is what is surely the signal masterpiece of Renaissance Treviso, the monument to Agostino Onigo by the sculptor Antonio Rizzo and the young Lorenzo Lotto, whose two standing heralds, arrogant in their youth, are unforgettable.

Beside the church in the former convent is the Seminario Vescovile. Off the cloister is the Sala del Capitolo dei Domenicani, with the remarkable series of portraits of members of the order which Tommaso da Modena completed in 1352. Tommaso, who was perhaps the most forceful Emilian master of his time, clearly understood the rigorous intellectual discipline of the Dominicans. There is a chilling power in his frescoes in the room.

29

CASTELFRANCO

❖

FOR THOSE WHO love Renaissance painting it is always satisfying to see pictures by artists in their native towns. The choice on the Venetian *terra firma* is wide: wall-protected Conegliano, with Cima's great high altarpiece in the Duomo; Feltre, where the less familiar Morto da Feltre painted his masterpiece – a fresco of the *Transfiguration* – in the sacristy of the Ognissanti; Pordenone and its territory in which one can follow the early development of that towering figure, Giovanni Antonio de' Sacchis, il Pordenone; or indeed San Daniele del Friuli, where Pordenone's most spirited Friulian contemporary, Pellegrino da San Daniele, worked in the church of Sant'Antonio Abbate. Few names in the history of western art are more resonant than that of Giorgio da Castelfranco, whom we know as Giorgione. And so it is to his town, Castelfranco, that we go.

Castelfranco was founded in 1199 by the Trevisans, but despite the ostensible strength of their fortress it fell to the Paduans a mere sixteen years later. It was not until 1339 that the place was secured by Venice. When I first knew it, Castelfranco still seemed almost rural. But there has been much development on the fringe of the town. At its heart is the Castello, in reality a small fortified town, quadrangular in plan with a remarkably complete circuit of walls reinforced at regular intervals by towers and surrounded by a moat. In the centre is the piazza, with the elegant *settecento* church dedicated to San Liberale. Here, in the chapel to the right of the presbytery, is the altarpiece

of the *Madonna and Child enthroned with Saints Liberal and Francis*, which is one of the few pictures more or less unanimously recognized as being by Giorgione. Subtly asymmetrical paving draws us to the saints, the armoured Liberal with his lance, Francis moving his hands in mute communication, both below the level of the foot of the throne – the base of which is so high that the Virgin must have required help, human or divine, to mount it. At either side is a plausibly continuous landscape, suffused by a golden glow. For Giorgione was above everything a painter of mood.

The visitor is kept at some distance. We can absorb the painter's message without sensing too closely the vicissitudes this masterpiece, for masterpiece it is, has undergone. For neither time nor the restorer has been considerate to the Castelfranco altarpiece. King George III's early mentor, Lord Bute, was not altogether impressed in 1773; and, unable as we are to inspect Giorgione's touch, we have, if we expect to begin to comprehend the picture, to respect the sense of silent, absolutely silent, contemplation that the painter so clearly intended to convey. When we have absorbed this, we begin to know why Giorgione had so profound an influence on his contemporaries.

Castelfranco, town walls.

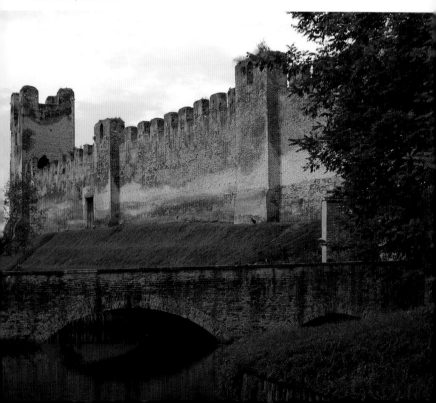

30

BASSANO

✤

STRATEGICALLY PLACED BESIDE the Brenta as this descends to the plain and below the Monte Grappa, the site of Bassano was occupied in early times, but the town, as such, is first recorded in 901. Controlled from the twelfth century by a succession of families, the Ezzelini, the Scaligeri, the Carraresi and the Visconti, it passed to Venice in 1404.

Bassano as a town has a calm self-confidence. Its finest church is San Francesco on the Piazza Garibaldi, on the façade of which is a relatively well-preserved fresco of the *Annunciation* by the Paduan *trecento* master, Guariento, a fine *Crucifix* by whom hangs above the high altar. San Giovanni Battista, in the adjacent Piazza Libertà is of some interest for the baroque Cappella del Sacramento of 1713. North of the Piazza Libertà, is the smaller and more charming Piazza Monte Vecchio, with the Casa Michieli -Bonato decorated with now eroded murals by Jacopo Bassano and the *quattrocento* Monte di Pietà. From the north-east corner a road curls down towards the most celebrated monument of Bassano, the Ponte Coperto across the Brenta. The covered wooden bridge is first recorded in 1209, but has been reconstructed on numerous occasions, after damage from floods and war and it had to be rebuilt in 1948. But even Palladio when called in in 1569 respected the original design. The suburb of Angarano on the further bank, with the ambitious Palazzo Bonaguro, is of some interest, and the best view of the town is from the bank south of the bridge, with the castle and the solid

campanile of the Duomo behind this.

It is not primarily for its buildings that Bassano is memorable. The town gave its name to a remarkable dynasty of painters of the da Ponte family. Francesco (c. 1470–1539/41), a competent but provincial artist, was the founder of the line. Jacopo (c. 1513–1592) was an artist of altogether different calibre, establishing a successful workshop in which he was joined by his sons, Francesco II (1549–1592), Leandro (1557–1622) and Gerolamo (1566–1621). The Museo Civico next to San Francesco has an unrivalled holding of pictures by the Bassano. Jacopo's development can be followed from the early *Flight into Egypt*, by way of the iconographically unusual *Saint Anne with the infant Virgin and Saints* of 1541, the arresting *Martyrdom of Saint Catherine*, the *Pentecost* of the 1560s, the *Adoration of the Shepherds* of 1568 to the haunting *Saint Martin* of about 1580. Rooted in the artistic traditions of his territory, Bassano took an intelligent interest in the work not only of his Venetian contemporaries, including Titian, but also in artists from further afield. His genius was to achieve a wholly personal synthesis that was in turn to have a pervasive influence.

Ponte Coperto.

31

MASER

❖

NORTH-WEST OF CASTELFRANCO, on a ridge between hills, outliers of Monte Grappa, is Asolo, a small town overhung by a fortress that enjoyed a brief moment of greatness as the seat of Catarina Cornaro after she had surrendered the kingdom of Cyprus to Venice in 1489. The road below Asolo

is fringed by villas that once had uninterrupted views across their productive agricultural estates. It is from this that the finest, Maser, built in the 1560s, should be approached. The road turns slightly to reveal the Tempietto, the chapel designed by Palladio, a subtle reinterpretation of the Pantheon; on the left the statued terraces of the villa itself come into view, the central block projecting from the hillside framed by arcaded wings, the stucco painted a buttery cream that glows in the sunlight.

Palladio's patrons were Daniele Barbaro, Patriarch of Aquileia, and his brother Marcantonio; the former was one of the most civilized Venetians of his generation, a statesman and translator of Vitruvius. The architect's genius was to take advantage of the retention of an existing structure at the core of his building and to understand so well how to turn a steeply sloping site to advantage. At the Villa Rotonda the challenge had been to achieve a building that could be seen from every angle, at Fanzolo to design a villa approached on a central axis: at Maser the position of the public road meant that lateral views were of particular importance. The Barbaro were practical men. Their villa was to be the centre of a working farm, but it was also to represent an ideal, inspired by the writings of such classical writers as Pliny. For the *piano nobile*, the first floor of the central block but at ground level on the back, the brothers employed Paolo Veronese, who, perhaps because of his

Villa Barbaro: Paolo Veronese, Salla di Bacco, fresco (detail).

early association with Sanmicheli, had a greater empathy for architecture than any other painter of the age. His contribution was complemented by work in stucco attributed to Andrea Vittoria, but apparently designed by Marcantonio Barbaro himself.

You arrive at the east end of the arcade. Where this reaches the central block, external stairs lead up into the cruciform gallery, the Sala della Crociera, at the heart of the projecting block. Veronese's landscapes on the longer walls, leading to the central window commanding the terraces and the farm beyond, are compromised; but the murals of the shorter lateral sections, sophisticated trompe l'oeils with servants at false doors flanked by statuary, show how brilliant a decorative painter he was. In the rooms at the outer corners, the Stanza di Bacco and the Stanza del Amor Coniugale, each with an elegant stucco chimneypiece, Veronese can be seen at work. He follows his rough incisions in the plaster, but never slavishly. The spectator is captivated by the monochrome animals of the dado, the happy optimism of the landscapes and of the humans and animals that move in them, by the bright highlights of the fabrics which are so characteristic of the painter, and by the very confidence of his figures. The frescoes imply the intended function of the rooms; and when I first stayed in the house in 1966, the Stanza di Bacco was indeed still used as the dining room, its counterpart as a drawing room.

The Sala dell'Olimpo is very different in scale. This opens from the north end of the Crociera, and the walls are decorated with yet more landscapes, impeccably preserved, in one of which the villa itself is seen transposed to a very different terrain. Above, on trompe l'oeil balconies, are patricians, members of the Barbaro family perhaps or the Patriarch's guests and their dogs, below the soaring vault with the most ambitious of all Veronese's frescoes in the house, the gods on Olympus. On either side of the Sala dell'Olimpo are balancing enfilades of rooms, of which the nearest, the Stanza della Lucerna and the Stanza del Cane, were decorated by Veronese with yet more landscapes and, above, opposite the windows, fictive canvasses of the Madonna and Child as tender as any of the artist's independent pictures of the kind. The eye is drawn through these rooms to the splendid mural of a gentleman returning from the hunt at the east end of the enfilade and the less well-preserved lady at the opposite end, their presence expressing the purpose of the rooms as bedrooms, so judiciously maintained by Contessa Marina Luling Buschetti when she restored the house in the 1930s. These rooms are all lit from the north and open onto a terrace across which is an equally remarkable survival, the Nympheum, a fountain flanked by stucco figures and – much damaged by exposure – a further ceiling by Veronese, or 'Paolo' as the contessa used, with affectionate familiarity, to call him.

Among Palladio's villas it was only at Maser that his contribution was matched by those of a painter of equal distinction. And it is the seamless harmony of their contributions that makes the house the most perfect secular statement of Venetian patrician taste of its time.

32

POSSAGNO

✤

As Maser is the finest statement of a domestic ideal of the sixteenth century, so Possagno, hardly fifteen kilometres across the hills to the north, is a *locus classicus* of Italian neoclassicism. It was here, in a valley below the southern flank of Monte Grappa, some seventy-five kilometres north-east of Venice, that the last outstanding Venetian artist, Antonio Canova, was born in 1757. The greatest Italian sculptor of his time, Canova had an international celebrity. He dominated the artistic world of Rome for over a generation, and still deserves the gratitude of his country for the skill with which he superintended the return to the Italian states after 1815 of most of the works of art appropriated for the Louvre.

Canova's house, near the centre of the small town, might be that of a successful merchant or lesser nobleman. But

Antonio Canova, the Tempio.

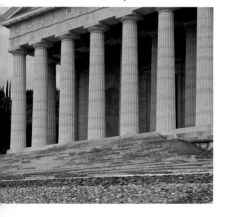

what distinguishes it is the gallery constructed to display the full-scale plaster models for many of the sculptor's most celebrated marbles. The early *Theseus*, the uncompromising *Madame Mère*, the heroic *Napoleon*, the poignant *Magdalen in Penitence* and a constellation of others express the artistic and indeed the political preoccupations of Canova's time. Together these models constitute a secular memorial to the sculptor. Nearby, in contrast, is a well-lit modern wing in which many smaller works, including Canova's unexpectedly delicate models in terracotta, are most intelligently displayed. In the more modest rooms of the original house are his less successful efforts as a decorative painter. One leaves with some understanding of the range of the man.

Above the town, with its back to the steep hillside, is the Tempio, a vast circular church with a commensurate portico of massive Doric columns, a building that seems to increase in scale as one walks up towards the platform on which it stands. The design was conceived by Canova himself. Work began in 1819, three years before his death, but was only completed in 1830. The church is an uncompromising masterpiece, inspired by both the Pantheon and – for the portico – the Parthenon. It is at once powerfully effective in its restatement of the Neoclassical ideal, and yet convincing as a religious statement of a counter-revolutionary age when the Veneto was under Habsburg rule. The position of the Tempio reminds us that Canova was not only a idealist but also a visionary, with the Romantic's understanding of the way in which so rigorously academic a structure would work in his clear native air, its meticulously cut stone in sharp contrast to the windswept trees that seem to tumble down the hill behind.

Friuli

35 Udine •

• Cividale del Friuli 36

• Palmanova 34

• Aquileia 33

• Trieste 37

Grado 33

33

AQUILEIA and GRADO

❀

THE DISTANT PROSPECT of the campanile across the coastal plain does little to prepare the visitor for the great basilica of Aquileia. The Roman city, founded in 181 bc, became an important Christian centre and the seat of a bishopric in the early fourth century, but was sacked by Attila in 452. It was only in the early ninth century that a grant from Charlemagne led to the construction of a new church on the site of the one founded soon after 313 by Bishop Teodoro, and the present basilica was constructed during the long patriarchate of Popone (1019–42). His successors were to rule much of the former duchy of Friuli until their temporal powers passed to Venice in 1420. In 1509 Aquileia itself, with part of Friuli, was returned to imperial rule; except during the Napoleonic occupation it remained under Austrian control until 1915.

To the west of the basilica, approached from the portico through the so-called Chiesa dei Pagani, is the octagonal Baptistery, much restored. The structure of the church is due to Poppone, but as the positions of the bases of the columns of the arcades flanking the nave show, the floor level was originally roughly a metre higher, covering the remarkable mosaic pavement of Teodoro's time. While the mosaic is the glory of the church, this also boasts contributions from its Venetian rulers: the elaborate tribune in the raised presbytery and the altar of the Sacrament to the right, both by the Ticinese carver Bernardino da Bissone, and, in the right transept, an admirably lucid altarpiece of 1503 by the Friulian painter Pellegrino da San Daniele. The ninth-century crypt under the presbytery, built for Patriarch Maxentius, is notable for

Aquileia, Basilica: Cripta dei Scavi, mosaic floor, snails (detail).

its relatively well-preserved early trecento frescoes of scenes from the life of Saint Mark and the Passion of Christ. A door on the left of the church leads to the Cripta degli Scavi, a substantial section of Teodoro's shrine that has been excavated round the base of the campanile. Fragmentary walls suggest the scale of the complex, and there are more mosaics, including representations of fruit, chickens and, more unusually, snails. The campanile itself was apparently built partly of spoil from the Roman amphitheatre. What survives of the Roman town has indeed been severely robbed, and is perhaps principally of interest to the archaeologist, although the finds in both the archaeological and Christian museums are of some importance.

Aquileia and Grado are only eleven kilometres apart. The fort on what was then the island of Grado was originally an outpost of its greater neighbour and with the collapse of Roman rule was much more easily defended. By the seventh century Grado had been drawn into the orbit of Venice, and even now visitors to the old town sense that they are in the territory of La Serenissima. The centre of the town round the port is relatively unscathed. There are three early churches, of which the most distinguished is the basilica of Sant' Euphemia, built under Elia, who was Patriarch of Aquileia in 571–87, and consecrated in 579. The fine original mosaic pavement survives; so does the gilded silver paliotto on the high altar that was sent from Venice in 1372. But the basilica is perhaps most memorable for the harmony of its parts. Beside it is a yet earlier, if restored, octagonal Baptistery. The charm of Grado is that its Venetian core has not been degraded by the modern coastal resort that has grown up round it.

34

PALMANOVA

❖

THE CONFIDENCE OF Venetian Renaissance art and architecture may seem oddly at variance with the political imperatives that confronted the republic. The subtle reports of her ambassadors imply one aspect of the prodigious efforts that were necessary to secure the interests of La Serenissima. But the role of the military was even more important. Far more was spent on fortifications throughout Venice's territories than on religious or civic buildings: the carved maps of some of these on the façade of Santa Maria del Giglio at Venice must have served as an uncomfortable reminder of republican responsibilities. That Venice's empire could only be maintained at considerable cost is obvious, for example, in the great fortress at Famagusta on Cyprus. Nearer to hand, some twenty kilometres east of Udine, is Palmanova, one of the most complete monuments of late sixteenth-century military architecture and, not insignificantly, one of the few places in the republic that early seventeenth-century visitors on what was later to be termed the Grand Tour chose to see.

The threats posed by both the Holy Roman Empire and the Ottomans meant that it became necessary to reconsider the defence of the Venetian terra firma, and in 1593 the decision was taken to erect a fortress on the site of the town of Palmada, under the control of Giulio Savorgnan and with the assistance of a number of architects including Scamozzi. Palma, as the place was renamed, was a state-of-the-art proposition, embodying the most up-to-date views about defence.

Vincenzo Scamozzi, the Porta Cividale.

The fortress, on which work continued for some twenty years, takes the form of a star with nine points. There are three gates opening to straight streets that end in alternate sides of the central hexagonal Piazza Grande; subsidiary streets radiate from the remaining sides.

Planting a garrison proved easier than establishing a self-sufficient town, and even now the piazza with its statuary and inscriptions has a somewhat theatrical air. The main buildings are the Duomo and the Palazzo dei Provveditori Generali, the former like the three gates by Scamozzi. But it is not for its individual components that Palma, or as it was renamed in 1807 Palmanova, is remarkable. It is as a whole – albeit one that was reinforced with additional bastions in the late seventeenth century, and with an outer circuit of these under Napoleon – that Palmanova is unique. The evident strength of the defences makes it seem the more ironical that the most delicate Venetian draftsman of his generation, Giuseppe Bernardino Bison, was born there in 1762.

35
UDINE

✣

THE ISOLATED HILL crowned by the Castello of Udine was granted by the Emperor Otto II to the Patriarch of Aquileia in 983, and in the thirteenth century this became the main residence of several of his successors as they sought to enforce their temporal rule. In time the Venetians emerged as the patriarchate's main adversaries in the Friuli and Udine fell to them in 1420, her subsequent fate depending upon that of Venice itself. The central Piazza Libertà is the paradigm of a Venetian public space, with the mid-fifteenth-century loggiaed Palazzo del Comune and opposite the elegant arcade of San Giovanni of 1533, with the associated clock tower designed by Raphael's versatile associate, Giovanni da Udine, in 1527. At the north end of the arcade a gate designed by Palladio leads to the late gothic covered way that climbs up towards the church of Santa Maria del Castello. This seems modest enough beside the mass of the Castello, an outsize Renaissance palace begun in 1517 and finished in 1595. Now the museum, it houses a substantial collection of pictures including Carpaccio's serene *Blood of the Redeemer*.

From the south end of the piazza, the Via Aquileia leads to the much-restored Duomo. Two of the altarpieces on the right, the *Trinity* and *Saints Hermagorus and Fortunatus* of 1738 and 1737 respectively, are by Giovanni Battista Tiepolo, as are the earlier frescoes (1726) of the Chapel of the Sacrament. The east end of the Duomo was transformed with a riot of stucco, sculpture and murals in

the eighteenth century at the expense of the richest family of the area, the Manin, builders of the outsize villa at Passariano. Monuments to the Manin are placed above carved choir stalls of astonishing virtuosity. Facing the south wall of the Duomo is the small Oratorio della Purità of 1757. The relatively modest height of the ceiling means that one can relish the ostensibly effortless touch of the mature Tiepolo's fresco of the *Assumption of the Virgin*. The frescoed *Immaculate Conception* above the altar is also by him, while the Old Testament scenes on the lateral walls are by his son, Domenico.

Not far to the east is the Palazzo Arcivescovile, begun in the sixteenth century. The Venetian patriarchs of Aquileia may have lost the temporal powers of their medieval predecessors, but nonetheless had considerable resources at their disposal. The palace is princely in scale. Patriarch Dionisio Delfino was a discriminating connoisseur, calling in the young Tiepolo in 1726 to decorate the ceiling of the staircase with a fresco of the *Fall of the Rebel Angels* framed by stucco and grisaille compartments. In the two summers that followed, Tiepolo decorated the first floor Galleria degli Ospiti with scenes from the Old Testament. The artist was just thirty, but there is nothing immature about his wonderfully inventive compositions. The nearly toothless Sara kneels at the door of a wooden shack by which the Angel has alighted; Abraham bows in prayer; Isaac is open-eyed in surprise as the Angel stays his father's sword. Tiepolo's narrative intelligence is matched by his chromatic range. This is emphasized by the contrast between the three richly coloured mural compartments and the grisaille scenes framing the central *Jacob and Laban* and the fictive niches with statues of female prophets at

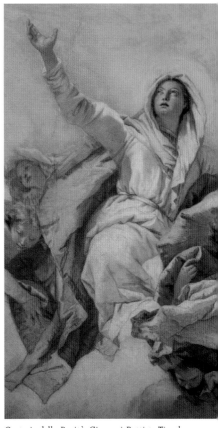

Oratoria della Purità: Giovanni Battista Tiepolo, Assumption of the Virgin (*detail*).

either side and between the windows on the opposite wall. We are close enough to see Tiepolo's incised underdrawing and thus experience something of his creative process. He was to paint more ambitious schemes later in the career that took him to Wurzburg and to Spain; but there is a freshness about the frescoes in the Galleria that Tiepolo would never surpass, and indeed did not altogether match in the ceiling of 1728 in the nearby Sala del Tribunale.

36

CIVIDALE DEL FRIULI

✥

THERE ARE FEW places in Italy where the post-Roman world seems more palpable than Cividale, the successor of the frontier town of Forum Julii on the right bank of the river Natisone that took the name of its founder, Caesar. Here as everywhere else in Italy the death throes of the western empire brought chaos. But in 568 the Lombards who had occupied Pannonia to the east for two generations, migrated though the mountains and set out to conquer much of the peninsula, choosing Cividale as the capital of a duchy that controlled much of the Friuli. Lombard rule ended with the defeat of the wonderfully named Rotgaud in 776. The

duchy passed to Charlemagne and his successors, of whom Lothar founded a school at Cividale in 825; in 1077 Henry IV granted the Friuli to the patriarchs of Aquileia. They effectively held Cividale until 1419, when it fell to Venice.

The medieval city lies within the line of the Roman walls. The most dramatic approach is from the south, over the Ponte del Diavolo across the deep gorge of the Natisone. The road rises steeply to the L-shaped Piazza del Duomo. The front of the Duomo is on the right, a restrained Renaissance replacement of its predecessor destroyed in an earthquake of 1448, with, above the high altar, the *pala* of Patriarch Pellegrino II (ruled 1195–1204), who is shown before the Madonna and Child. To the right of the Duomo is the Museo Cristiano, with two remarkable survivals of the eighth century, the octagonal Baptistery of Patriarch Callisto (737–56) and the altar of Duke

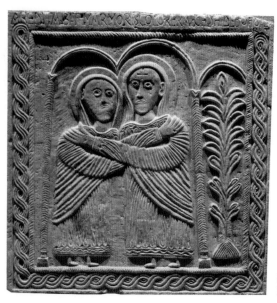

Museo Cristiano: Altar of Ratchis, Visitation, 734-7.

Ratchis (734–7), carved with vigorous reliefs of Christ in Majesty, the Visitation and the Adoration of the Kings in an idiosyncratic linear style. With the exception of Pordenone's Noli me Tangere, the pictures are of marginal interest.

The piazza beyond the Duomo is dominated on the east by Palladio's Palazzo dei Provveditori Veneti. This now houses a substantial archaeological collection. Opposite the lateral façade of the Duomo is the Palazzo de Nordis, with remarkable medieval works of art including an enamel associated with one of the Lusignan kings of Jerusalem and the veil of the Beata Benvenuta Boiani; embroidered in white on a white ground with the Crucifixion and representations of Saint Ursula and her virgins, this remarkable survival is of about 1300.

Return towards the river and take the turn to the left before the bridge. Ask in the bar at the corner for the keys to the 'Celtic Hypogeum' just up the road on the right; cut from the rock, this has now been identified as a place of purification for Cividale's Jewish community in the medieval period. The narrow street climbs towards the lane from which the Lombard tempietto is now entered through a later convent. The Lombards were often content to make do with the buildings of their Roman and Byzantine predecessors, and although relatively modest in scale the tempietto is perhaps the most distinguished of their monuments. The interior is above all remarkable for the elongated figures of female saints in stucco high on the original entrance wall, which are now said to be of about 760. Pause outside and follow the path to the cliff edge, to look out across the bend of the river and the picturesque Borgo di Brussana towards the encroaching mountains.

37

TRIESTE

AMONG THE CITIES of Italy, Trieste is an anomaly. For it lost its economic raison d'être when, in 1918, it ceased to be the main Mediterranean port of the Austrian empire and, severed from its Istrian hinterland, became part of Italy. Originally settled by the Veneti, who gave the town its name, Trieste became a walled Roman colonia under Octavian; long held by Byzantium it subsequently was a commune. Pressure from Venice led the city to appeal to the Duke of Austria in 1368, and thereafter it was drawn into the Austrian orbit. But it was not until 1719, two years after he had challenged Venetian control of the Adriatic, that the Emperor Charles VI declared Trieste a free port.

Before surveying the modern city, it makes sense to search out the evidence of its predecessor on the hill behind. The walk uphill could take in the scruffy husk of the Roman theatre, which must once have had breathtaking views over the gulf, and the elegant Triumphal Arch, built for Octavian, the future Emperor Augustus, in 33 BC. The way climbs steeply uphill between the Museo Civico and the atmospheric Orto Lapidario, with numerous Roman inscriptions, to the cathedral. Dedicated to the local martyr, San Giusto, this takes the place of a Roman temple, parts of the foundations of which can be seen to the north. The jambs of the main door are sections of a Roman stela with portraits of men of the Barbia family; to the left of the front is the campanile, which was remodelled in 1337–43. The church is unexpectedly wide, the central nave flanked by four

Cathedral, jamb of the west door, incoporating Roman portraits of the Barbia family

aisles. The mosaic of the left apse is of the twelfth century. In a chapel of 1364 on the extreme left, behind an elegant baroque wrought-iron screen made in Ljubljana, is the treasury: on the west wall is a distinguished *Crucifixion* by an artist close to Paolo Veneziano. The detailed account of the walls of Jerusalem in it remind us that the cathedral itself was protected in turn by the Roman walls and by those of the medieval Rocca, now replaced by the formidable Castello built in phases by the Emperor Frederick III from 1470 and under his successors over a period of some two centuries.

The commercial centre of the city has long been on the lower ground beside the sea. A walk might start by the Canal Grande, dug in 1756, dominated at the landward end by the late Neoclassical church of Sant'Antonio. Heading southwards down the Riva there are two fine

Neoclassical buildings, the Palazzo Carciotti, built in 1802–5 for a Greek merchant by an architect of German extraction, and the slightly earlier Teatro Comunale. A little way behind the latter is the Piazza della Borsa, with the Borsa Vecchia of 1806–9 by the Marchigian Antonio Molari, who interpreted classical models to particular effect. A road from the piazza leads to the east corner of the rectangular Piazza Unità d'Italia. The name belies the fact that this was the centre of the Austrian city. The ambitious Fountain of the Continents at the eastern end is of 1751, but the huge buildings that line the piazza (except to the north-west where it is open to the sea) are an orchestrated statement of prosperity in the last phase of imperial rule. The procession of Neoclassical palazzi continued southwards along the Riva.

The importance of Trieste to the later Habsburgs is expressed in the Castello di Miramare, some eight kilometres up the coast. Built in 1856–60 for the ill-fated Archduke Maximilian by the German architect Karl Junker, this seems to grow from a low cliff above the water. It is substantially larger than one might at first imagine. The archduke's taste was that of his time and rank, and enough of the original contents survive for us to leave with a clear idea of this. It is touching that his wife, Charlotte, chose in 1857 to be painted in Milan wearing the costume of the Brianza by Jan Frans Portaels (whose *Jewess of Cairo* serves to remind us of the religious tolerance of the Dual Monarchy), for within two years both Milan and the Brianza had been lost to Italy. The archduke's journey to Smyrna is commemorated by a series of pictures, but understandably we are shown nothing of the tragedy of his attempt to secure a Mexican empire.

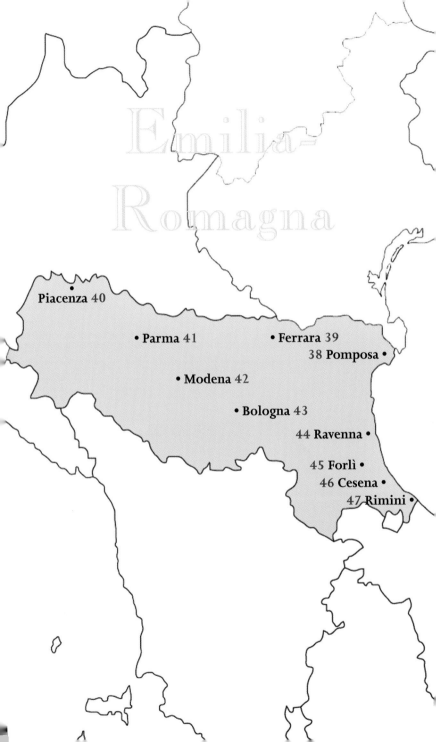

Emilia-Romagna

Piacenza 40

• Parma 41 • Ferrara 39
 38 Pomposa •

 • Modena 42

 • Bologna 43

 44 Ravenna •

 45 Forlì •
 46 Cesena •
 47 Rimini •

38

POMPOSA

✿

DRIVING TO POMPOSA on the main road
from Chioggia to Ravenna, it is at first
almost impossible to believe that the
area was once a wilderness. But even
now, particularly when approaching
from the south, as the prodigious brick
campanile rises above the poplars that
now flourish on reclaimed land, one
has a sense that the great Benedictine
monastery was indeed a place apart.
Apparently founded in the seventh
century although not recorded until
the ninth, Pomposa flourished in the
eleventh century and became a notable
centre of intellectual life. The abbots

exercised temporal power over a con-
siderable area from the eleventh-cen-
tury Palazzo della Ragione, altered in
1396, opposite the monastery, which
now serves as the ticket office. Decline
began to set in during the thirteenth
century; the area became unhealthy and
the last monks left in the sixteenth cen-
tury. The buildings were abandoned to
agricultural use and only restored in the
late nineteenth century.

To the left of the church is the cam-
panile, in nine sections and forty-eight
metres high, which was under construc-
tion in 1063. The brickwork is relieved
by marble and by friezes, also in brick,
and most unusually by circular Fatimid
plaques, presumably imported from
Cairo. The relationship of the openings
of the upper levels is particularly happy.
The body of the church, dedicated to

Abbazia, the Campanile.

the Virgin, was completed in the ninth century, but subsequently extended westwards by two bays, to which the atrium was added before 1026 when the building was reconsecrated. The front is richly decorated, and the frescoes of the nave constitute the most extensive extant scheme of the mid-fourteenth-century school of Bologna. The Last Judgement is shown on the entrance wall, and scenes from the Old and New Testaments and the Apocalypse in three tiers above the lateral arcades. The imaginative detail of the Apocalypse scenes is particularly striking. The apse of the raised presbytery was frescoed in 1352 by the most winning and sinuous of the Bolognese of the time, Vitale da Bologna, with Christ in Majesty above representations of the Evangelists, the Doctors of the Church and the life of Saint Eustace.

To the south of the church is a large court, with the chapter house on the east side containing frescoes of the Crucifixion, of saints and of prophets by a painter strongly influenced by Giotto, whose work was familiar to the emergent painters of the city of Rimini further down the coast. One of the noblest, Pietro da Rimini, was called in, about 1318, to supply three murals for the refectory on the south side of the courtyard: the Madonna with Saints between the Last Supper and the Miracle of San Guido degli Strambiati. Because so much has been lost at Rimini itself, these rank with Pietro's cycle in the Cappellone di San Niccolò at Tolentino among the most ambitious extant schemes of what was, if only rather briefly, a significant local school. Distinguished as the murals are, it is less for these than for the scale of the complex, and the way it rises up from the inexorable level expanse of the plain as it nears the coast, that Pomposa is most memorable.

39

FERRARA

❖

FERRARA, IN THE heart of the level valley of the Po, a few kilometres south of the river, has always been of strategic importance. For some 400 years it was held by the Este – of whose line the House of Hanover is a junior branch. Their great brick Castello, begun in 1385 for Niccolò II d'Este by Bartolino da Novara, is the geographical and historic centre of the city, which was significantly extended to the north and east by Borso d'Este (ruled 1450–71) and his half-brother Ercole I (1471–1505). Two blocks to the south is the cathedral, most remarkable for its accurately restored Romanesque main portal and Guercino's triumphant Martyrdom of Saint Lawrence in the right transept. The cathedral's other treasures are shown in the new museum in the nearby church of San Romano: beautifully displayed illuminated choirbooks; Romanesque reliefs removed from the façade; the Madonna of the Pomegranate by that subtlest of Sienese gothic sculptors, Jacopo della Quercia; and masterpieces of 1469 by the greatest painter of fifteenth-century Ferrara, Cosmè Tura, the dramatic Saint George and the Dragon and touchingly nervous Annunciation, respectively the outer and inner shutters of an organ.

The Este were deeply cultivated. An illegitimate son, Baldassare, himself became an accomplished painter. Much has been lost, and the major altarpieces of quattrocento Ferrara have been dismembered. So the Palazzo di Schifanoia, in the eastern part of the town, is a most precious survival. Begun in the late

fourteenth century by Alberto d'Este and subsequently enlarged under Borso d'Este and Ercole I, this is most celebrated for the Salone dei Mesi. Only seven of the original murals of the months survive. These are by Tura's contemporary, Francesco del Cossa, and the young Ercole de' Roberti. Their imaginative and discursive compositions capture the world of Borso's court, its extravagance and dynamism, its *douceur de vivre*. They remind us too of the inextricable links between Renaissance towns and the rural life that supported them. Piero della Francesca had worked for the Este. And there are echoes of his art in the Schifanoia frescoes, but the painters of these had very different aesthetic preoccupations than that austere genius. They sought to delight and to divert. And so they do.

There are other notable Renaissance palaces. Biagio Rossetti's unfinished Palazzo di Ludovico il Moro, built for Ercole I's ambassador to Milan, to the south of the Palazzo di Schifanoia, now houses the archaeological museum. Better known is the Palazzo dei Diamanti,

Cathedral and Campanile.

on the Corso Ercole d'Este, north of the Castello. This was begun about 1493 by Rossetti for Sigismondo d'Este. The spectacular façade with blocks of white diamond-pointed marble still clamours for attention. The type spawned a considerable progeny in Italy, Spain and, indeed, as far afield as Crichton Castle in Scotland.

The palace now houses the Pinacoteca Nazionale, with a comprehensive holding of Ferrarese pictures. There are fragments of Tura's lost altarpiece of 1474 from Sant'Andrea and panels by his contemporaries. The High Renaissance is strongly represented. Interest now focuses on Dosso Dossi, a wayward genius whose poetic landscapes reveal the fascination of the plainsman for the hills. But it was not always so, and works by Benvenuto Tisi, il Garofalo – for example, the central panel of his Costabili altarpiece from Sant'Andrea – show why

that artist was long considered a northern Italian near equal of Raphael. The later masters of Ferrara are also appealing: Scarsellino, consistently enchanting, particularly on a small scale; and Carlo Bononi, individual in colour and subtle in his interpretation of the artistic revolution of the Carracci at Bologna.

On the death of Alfonso II d'Este in 1597, Ferrara reverted to papal rule, the Este retaining their duchy of Modena. Ferrara paid a heavy artistic price, losing such masterpieces as the Bellini Feast of the Gods now in Washington, DC, and the early Titian Bacchanals in Madrid, not to mention the London Bacchus and Ariadne. But despite what it has suffered, Ferrara retains a strange magic. Bicyclists happily still outnumber drivers, and as the sun clears the morning mist one can imagine that Borso and his courtiers might be preparing to set out for the chase.

Castello Estense, remodelled by Girolamo da Carpi from 1554.

40

PIACENZA

❧

PIACENZA, THE ROMAN Placentia, on the right bank of the Po makes few concessions to the tourist. And although on the Via Emilia, the great

Roman thoroughfare that linked Milan with the Adriatic, it is surprisingly little visited. But much remains of the city's glory days, when she belonged to the Lombard League that defeated Barbarossa at Legnano in 1176. Only later was Piacenza subordinated to the Visconti, the Sforza, the French, and – from 1545 – the Farnese, whose Bourbon heirs, briefly ousted in 1734–48, were expelled by the French in 1796. In 1816 the city passed with Parma to Napoleon's wife Maria Luisa; in 1859 it was absorbed in the new Italian kingdom.

The strands of Piacentine history are aptly expressed in the central Piazza dei Cavalli, named after Francesco Mochi's equestrian bronzes of Alessandro Farnese and Ranuccio, his son, unveiled respectively in 1625 and 1630. These are among the masterpieces of baroque sculpture: look up at the restless chargers, with their swinging manes and trampling hoofs. Behind these statements of political power is the Palazzo del Comune, begun in 1280, one of the most convincingly monumental secular buildings of the age, stone below, brick above.

Piacenza is rich in early churches. Sant'Antonino, the original cathedral, was rebuilt in the eleventh century; the hexagonal dome floats above the gothic Paradiso, the great brick entrance added in 1350. The Duomo itself is a little way to the east. Built between 1120 and 1233, this

– like almost every Romanesque church in Italy – has been much restored. But the façade, pink below, grey above, is most satisfying, as is the great brick campanile, best seen from the courtyard to the left. To bear the weight of the huge octagonal crossing, lateral piers were necessary, and the last bay of the nave was raised so that the transepts are symmetrical. Morazzone was called in to decorate the dome, but only completed two sections of the vault. He was followed by Guercino, whose frescoes, all but invisible by natural light, must always have lacked the delicacy of the artist's preparatory drawings for these. Between the Duomo and the station is a third notable church masked by a later arcade, San Savino. The interior has been ruthlessly purged of baroque excrescences. The crypt is notable not least because much of the original black and white pavement survives.

To the north-west corner on the Via di Campagna are two fine churches by the architect of Renaissance Piacenza, Alessio Tramello: San Sepolcro, begun in 1513, and the Madonna di Campagna of 1523–8, the first of conventional Latin cross plan, the second, yet grander, conceived as a Greek cross with a central dome. The great Friulian master Pordenone first worked at Piacenza in 1525, and it is his contribution that makes the Madonna di Campagna so remarkable. The murals of the dome, with *God the Father in Glory*, and the pendentives of the *Evangelists*, realized in 1528–31, are effective because Pordenone understood that legibility was of paramount importance. He also decorated the chapels in the angles on the left side of the church, dedicated respectively to Saint Catherine and the Magi, introducing Tramello's dome in the background of his *Disputation of Saint Catherine*. How observant Pordenone was

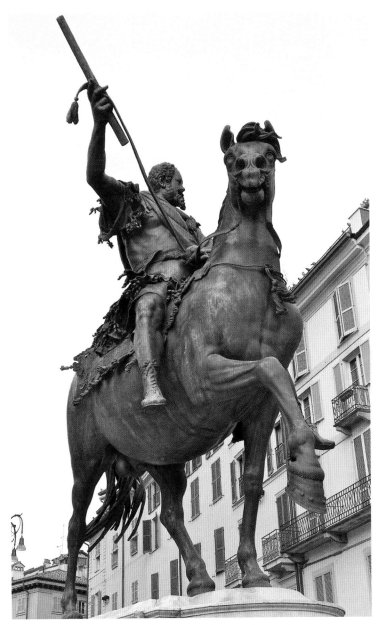

Francesco Mochi, equestrian statue of Duke Alessandro Farnese, bronze, 1625.

Madonna di Campagna: Pordenone, Christ among the Doctors, fresco (detail).

is seen in his *Adoration of the Magi*, where the detached timbers are described in affectionate detail and he imagines an audience of watchers from the windows in the distance. His psychological range is evident in the expressions of the doctors whom Saint Catherine confounds, one desperately searching for help in his book.

The Palazzo Farnese, begun in 1538 but never finished, was ruthlessly stripped when the Bourbons left for Naples in 1734. The Pinacoteca deserves to be visited, however, for a little-known masterpiece, Botticelli's *Madonna and Child with the Infant Baptist*. This is among the first and freshest of his *tondi*, its equilibrium established by a frontal parapet. There is perhaps no more perfect hedge of roses in western art, and the open-eyed Child lies on the purple lining of the Virgin's billowing cloak, which protects him from the red and white roses below. The picture remains in its original frame attributable to Giuliano da Maiano. To be able to see such a masterpiece in peace makes up for the capricious opening times of the Collegio Alberoni, whose great treasure is Antonello da Messina's hauntingly beautiful *Christ at the Column*.

41

PARMA

❧

FROM PIACENZA, THE Via Emilia follows the margin of the Po Valley, skirting the foothills of the Apennines. The next town of consequence is Fidenza, with a fine early cathedral. Parma follows, at the crossroads of the route from Mantua to the coast at La Spezia. Like that of other strategically placed cities, her history is complex. Imperial rule was followed by republican, as were the Visconti by the Sforza. The papacy recovered Parma in 1521, but in 1545 Pope Paul III granted it as a duchy to his nephew, Pier Luigi Farnese. The Farnese were succeeded by the Spanish Bourbons, whose contribution is particularly evident in the ducal palace of Cologno, fifteen miles north-east.

The city is divided by the river Parma. The western section has a sleepy charm. The great monuments are to the east. The Piazza del Duomo is in the historic centre. On the south side is the octagonal Baptistery begun in 1196, a masterpiece of the transitional phase when the Romanesque responds to gothic forms. The pink Veronese marble softens the austerity of the design, with tiered loggias and canopied pinnacles. The sculptor Benedetto Antelami worked on the building, both inside and out, to spectacular effect. From the Baptistery the visitor should go to the church of San Giovanni Evangelista directly east of the Duomo. This was an early building, but was reconstructed at the turn of the sixteenth century. Antonio Allegri, il Correggio – the painter of the Parmese school – was called in. He designed the fictive frieze of the nave,

San Giovanni Evangelista:
Correggio (Antonio
Allegri), Vision of
St John, dome fresco,
1522–3.

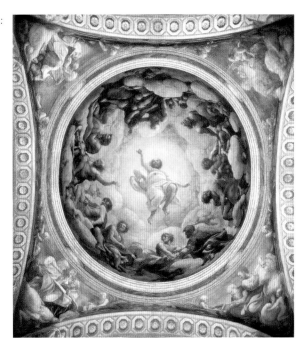

and his *Vision of Saint John* in the cupola was in every sense a visionary work, the saint shown in a nimbus of golden light surrounded by the apostles.

The Duomo is a Romanesque structure, although the campanile is Gothic. In the right transept is Antelami's masterpiece, the remarkable relief of the *Deposition* dated 1178. The cupola was decorated in 1526–30 by Correggio. A natural sequel to his work at San Giovanni, Correggio's *Assumption of the Virgin* was a conception of dazzling, indeed vertiginous ambition. Trained in the tradition of Mantegna, the painter devised a language of expression that helped to inspire the baroque. The visitor should advance slowly up the nave and watch as the campaign of illusion is revealed. Very different in character is the third of Correggio's mural schemes at Parma, in the Camera di San Paolo, ordered in 1518 by the abbess of the monastery of that name. The vault is of sixteen compartments, with ovals of pairs of putti. Below these are delicate monochrome lunettes of classical themes.

Correggio's counterpart among the painters of High Renaissance Parma was Parmigianino. Correggio was the master of restraint, an Emilian Raphael in his ability to codify a personal canon of religious expression – he was not responsible for the 'smirking correggiosities' of which George Eliot complained in *Middlemarch*. Parmigianino was his equal in delicacy of expression. But his line has a nervous vigour of its own. His subtle qualities are perfectly expressed in the extraordinary decoration of the Bramantesque church of the Madonna della Steccata, finished in 1539. Frescoes and

stucco play equal parts in a scheme of immense sophistication, alas unfinished.

The vast Palazzo della Pilotta was begun by the Farnese. Of the original interiors the most impressive was the enormous Teatro Farnese, severely damaged by bombing in 1944. The picture collection of the Accademia, founded in 1762 by Filippo of Bourbon, Duke of Parma, and enlarged when expropriated pictures were returned from Paris in 1815, was augmented by Napoleon's widow, Maria Luisa of Austria, who ruled Parma as duchess from 1816 until 1847. Inevitably Correggio is the focus of interest. The two lateral canvasses from the del Bono chapel at San Giovanni Evangelista, the *Martyrdom of Four Saints* and the *Deposition*, are both works of charged drama. Viewed diagonally in their intended setting, the two must have seemed startlingly realistic. The *Madonna of Saint Jerome* and the *Madonna della Scodella* are rivalled among the artist's major altarpieces only by those at Dresden. The enduring popularity of these *tours de force* is due to Correggio's ability to match the intimacy of his drawings and smaller panels on a large scale. Their ostensible simplicity masks a lifetime's absorption of ideas, visual and iconographic, Italian and northern.

The city has much else to offer. Later churches include Ferdinando Galli Bibbiena's Sant'Antonio Abate, with its theatrical façade. Neoclassicism is represented by the Teatro Regio, near the Palazzo Ducale, begun in 1821 for Maria Luisa by Nicola Bettoli, whose discipline of detail is impressive. The duchess also commissioned a late masterpiece by the great Florentine sculptor Lorenzo Bartolini, the monument of 1840–1 to her second husband Count Neipperg in the Steccata.

42

MODENA

✿

THE SITE OF Modena was inhabited long before the place became a Roman *colonia* in 183 bc, owing its importance in part to the construction of the Via Emilia. Decline set in during the late imperial period, but subsequently the city revived. Like other north Italian cities, Modena was drawn into the disputes of its neighbours. In 1288 the *signoria* was obtained by Obizzo II d'Este, Marquis of Ferrara, whose family lost it in 1306, but recovered it thirty years later and retained it until the French invaded in 1796, when Ercole III fled. His Habsburg nephew, Francesco IV succeeded to the duchy in 1814, but his heir Francesco V abandoned this in 1859.

Arriving from the north on the Via Emilia, the visitor reaches the Largo Porta Sant' Agostino. On the right is the massive Palazzo dei Musei, built by Francesco III in 1753 as the arsenal, but subsequently used as the Albergo dei Poveri and in 1788—a remarkably early date—transformed as the Albergo delle Arti. The large courtyard makes an excellent setting for a considerable collection of Roman and later sculpture. The palace houses the Galleria Estense, with works from the former ducal collection and other sources. Among the former are Velasquez's portrait of Francesco I and Bernini's bust of him, as well as a prodigious carving by Grinling Gibbons, the presence of which is explained by the marriage of King James II to Maria d'Este. Many of the masterpieces of the ducal collection were sold to Augustus the Strong and are therefore at Dresden,

but there is still an impressive holding of northern Italian pictures.

The great monument of Modena is the Duomo in the heart of the city, a block to the right of the Via Emilia on the site of a fourth-century basilica built round the tomb of San Geminiano. Work began in 1099 and the saint's body was translated to the new church in 1106 in the presence of Pope Paschal II and the formidable Matilda, Countess of Canossa. The Duomo was not, however, consecrated until 1184. It is one of the supreme achievements of the Italian Romanesque. The west front, with its doorcases and rose window by Anselmo da Campione and the four great reliefs of scenes from Genesis by Wiligelmo (1099–1106), is remarkable enough. But the south façade, with the beautiful early gothic Porta Regia, and the apses, of which there are clear views from the Piazza Grande are arguably even more impressive. Beside the north apse is the exceptional campanile, the Ghirlandina, also of the twelfth century but with an octagonal crown of 1319 by another mason from Campione, Arrigo.

Despite later introductions, among which is the Saint Sebastian altarpiece in the left aisle by Dosso Dossi, the interior impresses for its architectural unity and because early fittings survive in situ: the extraordinary pontile at the end of the nave, by Anselmo da Campione and assistants of about 1170, the ambo of between 1208 and 1225 by later Campionese sculptors and the pulpit of 1322 by Arrigo by the second pier to the left of the nave. The tomb of San Geminiano is in the crypt below the presbytery: don't miss the Madonna della papa, a

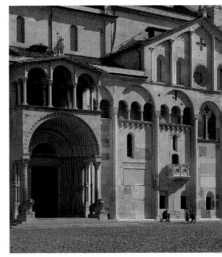
Duomo, south front.

polychrome terracotta group of 1480 by Guido Mazzoni.

On the east side of the Piazza Grande is the Palazzo Comunale, begun in 1194 but subsequently enlarged and later comprehensively remodelled in the Seicento. In other Italian towns the palazzo might have been the centre of power. But in ducal Modena it wasn't. The duchy was ruled from the vast Palazzo Ducale to the north, reached by several of the streets that rise from the Via Emilia. Francesco I chose a follower of Vignola, Bartolomeo Avanzini, to replace the original castle of the Este from 1629 onwards. The front is more oppressive than beautiful, but, by comparison, the palaces of her husband must have seemed both modest and outmoded to Mary of Modena.

43

BOLOGNA

❖

BOLOGNA IS NOT the most immediately lovable of major Italian cities. Her enduring prosperity is partly due to her position at the point of the Via Emilia where the historic route over the Futa Pass from Florence debouches from the Apennines to the vast plain of the Po. And to understand Bologna it is best to approach from the successors of the Via Emilia: from the Via Ugo Bassi to the Piazza Porta Ravegnana, which overlie the *decumanus* of what was already a major town. With the collapse of the Roman empire, Bologna's importance dwindled, only to recover dramatically in the period after 1164, when she joined the Lombard League. The struggle between the empire and the papacy was finally resolved in favour of the latter. When the *signoria* of the Bentivoglio family was suppressed in 1506, papal rule was ruthlessly reimposed. This, contrary to what might be supposed, ensured the consistent wealth that made it possible for Bologna to support the most influential school of painters in post-Renaissance Italy. Their achievement was what attracted most northern travellers to visit Bologna in the age of the Grand Tour. And as Ruskin was the high priest of the generation that dismissed the Carracci, Reni and their followers, it is appropriate that another Briton, Sir Denis Mahon, did more than anyone else to rehabilitate their reputation in the twentieth century.

The Carracci would recognize much of the centre of Bologna today: the brick arcades of the streets, which Sir Denis

also loved, benign alike in rain and sun; the two leaning towers, the Torre degli Asinelli and the Torre Garisenda, already seen as symbols of the city; the major public buildings that flank the Piazza Maggiore; and not least, dominating this, the monumental façade of the cathedral, San Petronio, with the wonderful doorway by the Sienese Jacopo della Quercia, whose bas-reliefs express at once the lyricism and the languor of the late Gothic. In the adjacent Piazza Fontana is a later masterpiece, the bronze Fountain of Neptune completed in 1566 by another brilliant outsider, Jean de Boulogne, for whom it earned the name by which we know him, Giambologna.

Although Bologna could claim a notable indigenous school of painters and miniaturists, her patrons were never parochial. The career of the late fifteenth-century sculptor Niccolò da Bari, known as Niccolò dell'Arca, perfectly illustrates this. An arch in the portal of the south-east corner of the Piazza Maggiore leads to the narrow Via Clovature, with, on the left, Santa Maria della Vita. To the right of the high altar is Niccolò's extraordinary terracotta group of the *Pietà*, almost northern in dramatic tension.

Niccolò owed his sobriquet to his contribution to the *arca* of Saint Dominic in the great basilica of San Domenico, 250 metres to the south, reached more directly from the second turning to the right off the Via Clavature. The church was begun in 1221, the year of the saint's death, and the façade, although restored, is original. The Dominicans were determined patrons. Giunta Pisano supplied

Opposite: Giambologna, Fontana di Nettuno, *bronze, 1566.*

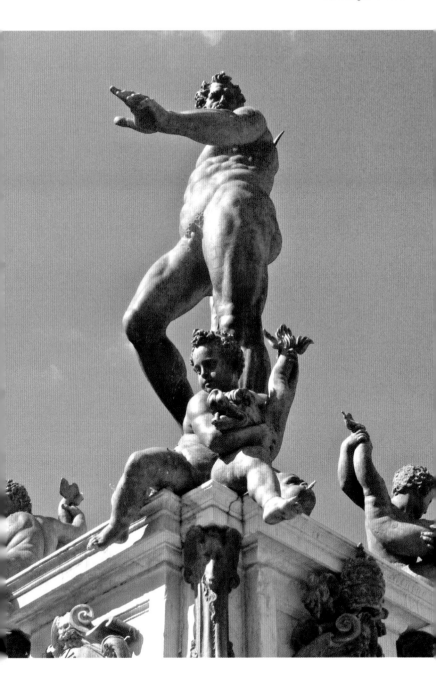

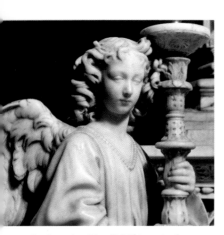

San Domenico: Niccolò dell'Arca, Angel.

painter of Renaissance Bologna, Francesco Francia, who was trained as a goldsmith and evolved a restrained classical style. The murals of the lateral walls, in one of which Giovanni II Bentivoglio and his family appear, are by his equally accomplished contemporary, Lorenzo Costa.

Three hundred metres beyond the church, on the left, is the Pinacoteca Nazionale. Here you can study the long development of the Bolognese school from the fourteenth century onwards, as well as pictures by artists from elsewhere painted for the city – from the late Giotto altarpiece to Raphael's heroic *Saint Cecilia* originally in San Domenico. There are outstanding altarpieces by the three Carracci, Annibale, Agostino and Ludovico, of which Annibale's early *Baptism* is the most appealing; these are complemented by familiar masterpieces of Guido Reni – the greatest master of *seicento* Bologna – including the majestic *Pala dei Mendicanti* and the powerful *Crucifixion* of 1617, and the wonderfully subtle *Saint William of Aquitaine* by the youthful Guercino. The later Bolognese also repay attention: Donato Creti, particularly on a small scale, is exquisite in touch; Giuseppe Maria Crespi impresses for the humanity of both his genre scenes and his religious commissions; while the Gandolfi leave one in no doubt of their almost physical relish for their chosen medium. The vigour of later Bolognese painting was no isolated phenomenon; it was paralleled in the enduring vitality of the ancient university, where the curious can still see the alarmingly well-observed waxes of foetuses used for instruction in the medical school.

the great *Crucifix* in a chapel off the left aisle, while Nicola Pisano, who relied in part on assistants, executed the reliefs of the saint's tomb in his chapel on the right. Two hundred years later, in 1469, Niccolò da Bari was called in to supply a *cimasa* with free-standing statues. His candelabrum-bearing angel on the left is among the most delicate sculptures of the *Quattrocento*, and is not outshone by the pendant supplied in 1494 by the youthful Michelangelo. The later decoration of the chapel is also remarkable, with Guido Reni's powerful *Apotheosis of Saint Dominic* in the cove of the apse.

From the Piazza Porta Ravegnana, the Via Zamboni runs at a diagonal to the grid of the early town. On the right is one of Bologna's major churches, San Giacomo Maggiore, another thirteenth-century foundation. At the east end is the Bentivoglio Chapel, consecrated in 1486. The altarpiece is by the most influential

44

RAVENNA

✿

PROTECTED BY THE marshes of the Po Valley, Ravenna was for some two centuries the outstanding artistic centre on the Italian peninsula. There was a town here long before Emperor Augustus chose the site of his new naval port of Classe, and the growing city was walled by Claudius. Its relative security was the reason why in 402 Emperor Honorius chose it as the capital of his western empire in place of Milan. His sister and heir, Galla Placidia, was in turn succeeded by Valentinian III. When the empire was destroyed by the barbarian Odoacer in 476, he too made Ravenna the capital of his kingdom. He in turn was defeated by Theodoric the Goth (ruled 493–526), who also retained Ravenna as his capital and became an advocate of what its critics termed the Arian Heresy. Theodoric's successors were vanquished in 540 by the forces of the Byzantine Emperor Justinian. Ravenna remained the capital of the Byzantine Exarchate until the Lombard

conquest of 751. Thereafter her significance waned. Long a pawn in the struggle between the Holy Roman Emperors and the papacy, Ravenna was controlled by Venice — her painters echoing their patrons' political allegiance — from 1441 until 1509, when Pope Julius II reasserted papal rule. The letters written at Ravenna by Lord Byron, intent on his affair with Teresa Guiccioli, give some idea of the dull prosperity that papal control engendered. And it was only well into the nineteenth century that the importance of the great monuments of Ravenna was recognized.

The city is not large, and for the visitor who has time it makes sense to see the great buildings and study their mosaics in a roughly chronological order. Two of the most remarkable are entered through the courtyard of the Museo Nazionale. Resist the temptation to commence with the church of San Vitale, however elated you may be by the wonderful sense of space, and cut through it to the so-called Mausoleum of Galla Placidia that was apparently built, not long before 450, by the empress. The plan is a Latin cross. The astonishingly well-preserved mosaics are coeval with the building and represent a natural evolution from earlier Roman

Mausoleum of Galla Placida, mosaic decoration of soffit.

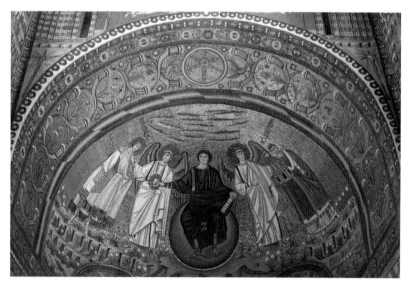

San Vitale: apse mosaic, Christ with two Archangels, San Vitale and Bishop Ecclesio with a model of the church.

work in the medium. The dominant colour is a deep nocturnal blue against which the white robes of the saints stand out in a luminous manner.

Then return to San Vitale, which was consecrated in 547. The plan was novel, an octagon with a central cupola, and the architecture is perfectly complemented by the remarkable cycle of mosaics in the eastern section. The apse and the vault above, with the lateral walls, are resolved into a wonderfully unified whole in which green predominates, with gold and, once again, white. In historical terms the most revealing compositions are those with, respectively, Emperor Justinian and his empress, Theodora, flanked by their attendants. Seeing these no contemporary onlooker could have doubted the reality of Byzantine power.

Some way to the south, near the late baroque cathedral, is the octagonal orthodox Baptistery, whose mosaics are of not long after 450. The great cupola was treated in three tiers, a circular *Baptism* in the centre, apostles under a canopy and, below these, altars flanked by decorative panels. The cathedral contains two unusually fine sarcophagi from Ravenna's heyday, and there are fine mosaics in the small Cappella di San Giorgio now accessed through the associated museum. Further east, beyond the central piazza, is the Baptistery of the Arians, build under the Goths early in the sixth century; here too the cupola is crowned by a mosaic of the *Baptism*.

A short walk southwards down the Via Roma leads to Sant'Apollinare Nuovo, the remarkable church built by the Arian King Theodoric. The splendid round campanile is of the ninth century, but the tremendous cycle of mosaics in the nave is largely of Theodoric's time.

Again there are three tiers, the uppermost of scenes from the life of Christ, then prophets and saints, and, below, views of Theodoric's palace with male martyrs paying homage to Christ, balanced by a representation of the port of Classe, with virgins preceded by the Magi adoring the Madonna and Child. Theodoric's palace lay behind the church. Taking Via Alberoni just beyond this and turning left after going under the railway, or approaching from the north by following the walls of the Renaissance Castello Brancaleoni, it is a short walk to the king's other major monument, his mausoleum. Significantly this is of a traditional Roman type, the successor of the great circular *mausolea* of antiquity. The recent restoration is exemplary but antiseptic.

The last outstanding building of early Ravenna is outside the walls, sadly encroached upon by modern roads. Sant'Apollinare in Classe was built near the port that was so vital to Ravenna's power. Consecrated in 549, it is the close contemporary of San Vitale, but altogether more ambitious in scale. The splendid detached campanile is a later addition, perhaps of the tenth century, and the brick church itself has been much restored. The scale of the interior is most impressive; and one senses something of its original richness from the marching grey and white veined columns, although much of the marble facing was appropriated for reuse at Rimini by Sigismondo Malatesta in 1449. The eye is drawn to the apse with the magnificent sixth-century mosaic of the *Transfiguration*, in which Christ is represented by the Cross. Below is Saint Apollinaris in episcopal robes, flanked by twelve lambs, symbolizing the faithful, and a representation of Paradise, with stylized trees, plants and flowers among small

rocks. Here again green is used to almost mesmerizing effect.

With the fall of the Byzantine Exarchate, Ravenna ceased to be a capital. The campaniles of Sant'Apollinare Nuovo and Sant'Apollinare in Classe are the great monuments of Romanesque Ravenna. In the fifteenth century the Venetians sought to redevelop the city, with some success. Their impact can also be sensed in Ravenna's museum, the former Galleria dell'Accademia. There are serene altarpieces by Niccolò Rondinelli, a Ravenna-born adherent of Bellini. His near contemporaries, the brothers Zaganelli, by contrast veered towards their Ferrarese and Bolognese counterparts. The *clou* of the collection is unquestionably the peerless recumbent effigy of the warrior Guidarelli Guidarello by Tullio Lombardo.

Sant'Appollinare Nuovo: mosaic, Port of Classe.

45

FORLÌ

✿

FROM BOLOGNA THE Via Emilia runs south-eastwards below the line of the Appenines. The sequence of towns continues: Imola, still dominated by a formidable fortress, and Faenza, best known for maiolica and with an excellent museum dedicated to this, are followed by Forlì, a city that makes few concessions to the tourist. Ghibelline for much of the thirteenth century, Forlì was fought over by neighbouring powers and local families, of whom the Ordelaffi secured the *signoria* in 1315. On the death of Pio III Ordelaffi in 1480, Pope Sixtus IV granted the city to his nephew, Girolamo Riario, whose formidable widow, Catarina Sforza Riario, lost it to Cesare Borgia after a sixteen-day siege in 1500. After his death in 1503 and a brief Ordelaffi interlude, Forlì passed to papal control.

The Via Emilia, renamed Via Garibaldi, is flanked by some of the many *palazzi* that testify to the prosperity of Forlì's landowners under papal rule. A few early houses survive, including no. 133–5 set behind a brick loggia where the painter Marco Palmezzano lived. A little further east, a turn to the left leads to the Duomo, a grandiose Neoclassical reconstruction of 1841 onwards: two richly decorated earlier lateral chapels survive. The Via Garibaldi ends at a corner of the central piazza, between the *quattrocento* brick Palazzo del Podestà and the much-reconstructed Palazzo del Municipio, with a Neoclassical frontage of 1826 that dominates the west side of the Piazza.

San Mercuriale, Campanile, 1178–80.

Diagonally opposite is the great monument of Forlì, the Abbey of San Mercuriale, the façade of which is dwarfed by the wonderful brick campanile of 1178–80: restored as this is it as satisfying as any of its counterparts in northern Italy. The nave is flanked by brick arcades, which are on two levels towards the altar. On the right wall, moved from San Biagio, is the impeccable tomb of Barbara Manfredi, wife of Pino III Ordelaffi, who died in 1466, by the Florentine Francesco di Simone Ferrucci: she lies on her sarcophagus in a draped niche. Further on, in its original frame is an altarpiece by Palmezzano, whose *Immaculate Conception*

is in the Cappella dei Ferri opposite, perfectly complemented by the arch in Istrian stone that separates this from the aisle.

Two churches, Sant' Antonio Abbate and Santa Maria dei Servi can be seen on the way to the Rocca di Ravaldino, the strong point of Forlì at the southern angle of the walls. The fortress was a major preoccupation of Girolamo Riario, whose widow made it her residence.

The section of the Via Emilia east of the piazza is now the Corso della Repubblica. On the south side of this is the Pinacoteca. When I first knew it, this was a very old-fashioned institution, still selling catalogues of the 1938 Melozzo da Forlì exhibition, held there at the instance of Mussolini, who came from nearby and regarded Forlì with particular favour as the scale of the Piazza della Vittoria at the east end of the Corso della Repubblica attests. It is not difficult to understand why the Duce would have admired the *Pestapeppe* (Pepper Grinder), in which Melozzo's affinity with Piero della Francesca is evident. Two exquisite panels by Fra Angelico apart, the finer pictures are all by artists associated with the town. There are significant works by Romagnol artists of the Renaissance, not least Melozzo's pupil Palmezzano. There are two fine Guercinos, but it is the two astonishing masterpieces by the eccentric but inspired Guido Cagnacci that linger in the memory. Painted in 1642–4 for the tambour of the dome of the Duomo these outsize canvasses of saints Valerian and Mercurial, patrons of Forlì, in glory show the saints and their attendants below angels and wingless musicians borne on clouds. Clearly intended to be seen from below, these seductive and colourful pictures can be seen as Cagnacci's response to Correggio.

46

CESENA

❖

CESENA, FORLÌ'S NEIGHBOUR on the Via Emilia, is a comfortable town. It lies at the northern end of the main route through the Apennines from the upper valley of the Tiber, and has been occupied since prehistoric times. Contended for by the Church and others, it was granted by Pope Urban VI in 1379 to Galeotto Malatesta, whose family held it until 1460. Cesena subsequently reverted to the Church, and for obvious strategic reasons was chosen in 1500 by Cesare Borgia as the capital of his short-lived duchy of the Romagna. The town was the birthplace of successive popes, Giovanni Angelo Braschi, Pius VI (1775–99) and Barnaba Chiaramonti, Pius VII (1800–22), who survived the indignities to which he was submitted by Bonaparte to regain his sovereign status and be portrayed by Sir Thomas Lawrence for the Waterloo Chamber at Windsor. A patient man, he was the last pope to create a great palazzo for his family, contending with the other mansions of the local plutocracy.

The cathedral and churches of Cesena are not of especial interest. Nor perhaps is the Rocca Malatestiana, begun for Galeotto, continued by his successors, and strengthened from 1466 by the papal governor. But the Biblioteca Malatestiana is one of the great libraries of Europe.

The Neoclassical front of the Palazzo delle Scuole gives no hint of what lies behind: a stair leading to the long corridor to the Biblioteca Comunale. Here a door surmounted by a pediment with the elephant of the Malatesta opens to the

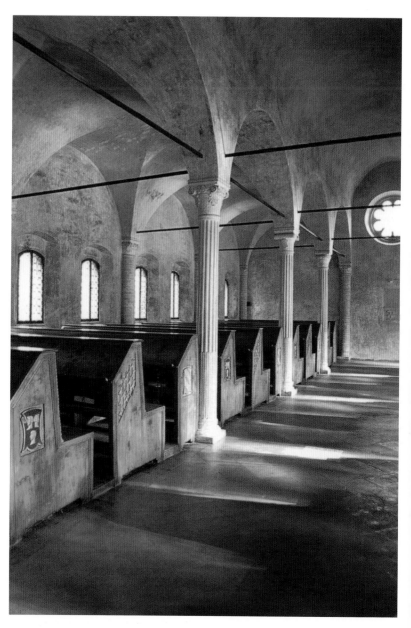

Cesena: Matteo Nuti, Biblioteca Malatestiana.

Biblioteca Malatestiana. Commissioned
by Malatesta Novello, who ruled Cesena
from 1429 until 1460, and inspired by the
library Cosimo de' Medici had commis-
sioned for the Dominican Observants of
San Marco in Florence, this was built in
1447–52 as the library of the Franciscan
convent. The architect was Matteo Nuti,
who also worked on the Rocca. The
library is an aisled room eleven bays in
length; the central barrel-vaulted sec-
tion is higher than the cross-vaulted
aisles and divided from them by arcades
resting on fluted columns. One's first
impression is of beautifully controlled
light, distributed through the pairs of
smallish arched windows in each bay of
the lateral walls and the octofoil window
high on the end (east) wall. The reading
desks in the aisles were thus served by
natural sidelight. No fewer than 136 of
the manuscripts ordered by Malatesta
remain in the Biblioteca, which is thus
the oldest humanist library of the kind
to survive at least substantially intact,
largely because after Malatesta's death
the Franciscans preserved it until their
convent was suppressed. Before leaving,
make a point of trying to see the exte-
rior of the library, its purpose beautifully
expressed in the rows of almost pointed
windows set in stone frames high on the
brick walls.

47
RIMINI

✥

THE ROMAN COLONY of Ariminum was
founded in 268 bc and the place became
an important city where two of the
great roads of the ancient world met.
Inevitably Rimini was caught up in the
rivalries between popes and emperors
and later the rival Guelf and Ghibelline
convictions of its great families. Of these
the Malatesta prevailed in 1295. Over
the ensuing century and a half they
expanded their territory. Sigismondo
Malatesta (1417–1468) was one of the
great men of his age, but his successors
inherited a diminished entity. Cesare
Borgia won the *signoria* in 1500: after
the chaos following his death, Rimini
passed to papal control.

Rimini retains two major Roman
monuments: the Bridge of Tiberius over
the Marecchio, begun under Augus-
tus; and, at the far end of the Corso
di Augusto, successor of the Roman
decumanus, the Arch of Augustus of 27
bc, the earliest substantially intact arch
of the kind, that marked the junction of
the Via Emilia with the Via Flaminia, the
road to Rome.

The civic life of medieval Rimini cen-
tred round what is now the Piazza Cavour,
off the corso, with the much-restored
brick Palazzo Comunale. At the far end is
the large Neoclassical Teatro Comunale,
opened in 1857, which like many other
buildings in the town was damaged in
the Second World War. To the left of the
piazza the Via Sigismondo leads to Sant'
Agostino, the choir of which retains,
albeit in uneven condition, a major cycle
of early *trecento* frescoes by the anonymous

Riminese master provisionally named after them: the lateral narrative scenes are particularly inventive, as the literal description of the collapse of the Temple at Ephesus exemplifies. A little further on is the eighteenth-century San Bernardino, with three altarpieces by the most refined Bolognese painter of the time, Donato Creti. Few seek the church out, and the same goes for San Giuliano across the Roman bridge. The church was rebuilt in 1553–75, but a signed polyptych of 1409 by Bittino da Faenza was retained. The altarpiece of the *Martyrdom of Saint Julian* designed by Paolo Veronese remains in place above the saint's fluted sarcophagus.

It is, of course, for the church of San Francesco, the Tempio Malatestiano, just off the corso that Rimini is most celebrated. Sigismondo Malatesta had a deep interest in architecture. He himself had a hand in the design of the now rather neglected Castello Sismondo that protected the western flank of his town. The solution adopted from 1447 at San Francesco was idiosyncratic. Matteo dei Pasti remodelled the existing church while, after 1450 Leon Battista Alberti was called in to encase this in a strikingly original classical structure, its front conceived on a heroic scale in the form of a Roman triumphal arch. Only the lower section of this and the lateral façades were completed, as Malatesta's ebbing military fortunes cramped his architectural ambitions. Yet unfinished as it was, the Tempio is one of the heroic buildings of its age, even though when seen from the side the relationship between the original windows of the church and Alberti's niches is disturbing.

Within, only the lateral chapels of the first three bays were achieved. The impact of these owes much to the sculptures and reliefs of Agostino di Duccio and his associates. Sigismondo's own tomb on the entrance wall was abandoned.

Bridge of Tiberius.

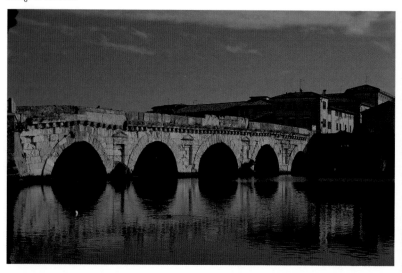

Tempio Malatestiano, Leon Battista Alberti, frieze.

But his third wife, Isotta degli Atti died before financial difficulties set in, and her tomb, in the second chapel on the right, designed by de Pasti is of the most refined quality. Sigismondo dedicated the first chapel on the right to his patron, Saint Sigismund, Agostino's statue of whom is above the altar. For the chapel opposite commemorating his ancestors Sigismondo commissioned the extraordinary monument from Agostino. The next chapel was originally dedicated to the Beato of the family, Galeotto Roberto Malatesta: the fluent reliefs on the pilasters were designed by Agostino, as were those celebrating the Liberal Arts and the Planets respectively in the third chapel on the left and that opposite. Malatesta went to considerable lengths to secure materials of the highest quality, including from Ravenna, the nearest source of the coloured marbles so prized in antiquity. He intended colour to be a dominant element of the scheme: high-up sections of trompe l'oeil brocade survive and before the Tempio was restored in the nineteenth century polychromy must have been in greater evidence – as this is in Agostino's work at Perugia.

Sigismondo's initial is omnipresent, and Agostino's relief of him is in the chapel to his ancestors. But, rather surprisingly, the finest portrait was originally above the door inside the sacristy between the first and second chapels on the right and thus almost invisible: it is now in the fourth chapel on the right. Malatesta kneels before his saint: behind him, looking in either direction, are two dogs, and, above these, a tondo with the Castello Sismondo. The painter, Piero della Francesca, understood what his patron required: this is not surprising as Malatesta held the small town of Citerna that overlooks the cemetery of Monterchi, patria of Piero's mother.

The Tempio deserves detailed study, but, if time allows, go to the Museo Civico, next to another unfinished Riminese church, San Francesco Saverio. The clou is a tender masterpiece, Bellini's *Dead Christ with four Putti*, the head of one of whom is teasingly hidden behind that of Christ. With its restrained tonality the panel reads like a bas relief; and the painter was clearly aware of the importance of sculpture to the decoration of the Tempio Malatestiano for which this was commissioned.

Tuscany

51 Pistoia •

• Lucca 52

• Prato 50

• Pisa 53 • Florence 48

Poggio a Caiano 49 66 La Verna •

67 Borgo San Sepolcro

• San Gimignano 55

Volterra 54 • 65 Arezzo •

• Siena 56

San Galgano 64 • Cortona
57 •

61 Monte Oliveto

58 Massa Marittima Montepulciano 63

59 Montalcino • 62 Pienza •

60 Sant' Antimo

48

FLORENCE

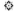

THAT WE THINK of Medicean Florence as the artistic epicenter of the Renaissance world owes much to the writing of the sixteenth-century artist-cum-propagandist Giorgio Vasari. But Florence's greatest writers, Dante and Boccaccio, lived before the banking dynasty rose from obscurity, and the city had a long history. Strategically placed beside the river Arno, Florentia was a major Roman city; she came to prominence again in the eleventh century and was subsequently at the heart of the long struggle between papacy and empire, between Ghibelline and Guelf. The commune was succeeded by a republic. Commerce and banking greatly enriched the city, although the Black Death of 1348 dramatically affected growth. Political divisions and aristocratic rivalries were assiduously exploited by the Medici, and from 1434 Cosimo il Vecchio effectively ruled Florence. His grandson Lorenzo il Magnifico consolidated the family's position, exercising a tight control over the expanding territory that Florence dominated. Lorenzo's successors were driven out in 1494 and again in 1527, only to return in 1530. Lorenzo's illegitimate great-grandson Alessandro became duke in 1531, and his cousin and heir Cosimo I was elevated as Grand Duke of Tuscany in 1569. On the death of his descendant Gian Gastone in 1737, the grand duchy passed to Francis, Duke of Lorraine, consort of the Empress Maria Theresa. Ferdinand III was expelled by the French in 1799, but recovered Tuscany in 1815; he and his son Leopold

II were the most enlightened Italian rulers of their time. The grand duchy was in 1860 absorbed in the new kingdom of Italy, of which in 1865–71 Florence was the capital. Despite losing this status to Rome, Florence long continued to be the most cosmopolitan city of Italy, with a large number of expatriate residents, many of whom left their mark on her institutions and monuments.

When I first was in Italy, in 1966, Ester Bonacossa pronounced that May was the month for Florence – and for fireflies. Alas, except perhaps in deep November or early February, the tourist cannot now hope to escape his kind. Queues no longer snake outside the Uffizi, but even though a more sensible ticketing system has been introduced, the obvious highpoints of the collection – the early Florentine pictures, the extraordinary Botticellis and the two early Leonardos – are under constant siege. Moreover, the new galleries do less than justice to celebrated masterpieces by Raphael and the great Florentines of the High Renaissance, and the choice of background colours is bizarre. At the Accademia groups surround Michelangelo's *David* although almost no one looks at the early altarpieces. The same goes for the Museo Archeologico, which houses such treasures as the *Chimera of Arezzo* and an outstanding collection of Attic black-figure vases. By contrast, the steps of the Duomo are crowded and a long line leads to the visitors' entrance. If you plan to study the bronze door of the Baptistery that remain *in situ*, that on the south with reliefs by Andrea Pisano of 1330 you should aim to go at dawn, when you may also share the Piazza della Signoria with the pigeons who breakfast on the last night's horse droppings. If you wish to examine the incredible

sixteenth-century sculptures in the piazza, Donatello's heroic *Judith* or Giambologna's *Rape of the Sabines*, you will have to ignore the exhausted tourists who settle round them.

Yet with a little patience, the magic of the city exerts itself. My favourite approach is from Pian dei Giullari to the south. The narrow Via San Leonardo twists between the unyielding walls of a sequence of villas, some more modest than others. At length the Forte Belvedere looms on the left; ahead is the Porta San Giorgio, to the east of which is a well-preserved section of the medieval city wall. Within the gate, the Costa San Giorgio descends steeply. As it curves there are changing views towards the centre of the city on the further bank of the Arno. Make to the left for the church of Santa Felicità, in a small piazza stepped back from the Via Guicciardini. Nothing quite prepares one for the Capponi Chapel immediately to the right of the entrance. The altarpiece, the *Deposition* by Pontormo (1528), is the most distinguished picture of the period

in Florence to remain in its intended setting, and thus to be seen at the level the artist intended. The body of Christ has been taken from the Cross, and is borne by two youths as the Maries grieve; the emotional conviction of the design is given a deeper poignancy by Pontormo's hauntingly beautiful colours, his idiosyncratic range of blues and reds and pinks: colours which, if the eye is given time to adjust, sing more surely by the filtered daylight than when artificially illuminated, and must have been yet more eloquent in flickering candlelight.

The Via Guicciardi to the left leads to the Piazza Pitti with, on the east, the vast, partly rusticated façade of the Palazzo Pitti, seat of the Medici and their successors. The grand ducal collections were by any standard prodigious, and the Galleria Palatina in the series of staterooms with outstanding *seicento* frescoes and stucco is a remarkable survival: an early nineteenth-century arrangement of pictures in a traditional hierarchical tiered hang. The Medici would be

Baptistery, South Door: Andrea Pisano, Hope *(left)* and Humility *(right), gilt-bronze, 1330.*

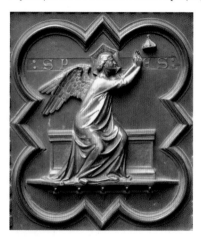

astonished by how little attention is now paid to the two breathtakingly beautiful altarpieces of the *Assumption of the Virgin* by Andrea del Sarto, which they bought in 1602 and 1639 respectively. Other masterpieces, not least the portraits by Raphael, his *Madonna della Sedia* and the wonderful Titian portraits, still keep their place in those contemporary halls of fame – the postcard stalls – but some former stars, Cristofano Allori's intent *Judith* or the Carlo Dolcis for example, are the preserve now of the art historian.

Happily the descendants of the Medicis' subjects continue to enjoy the Boboli Gardens that stretch behind the palace to the city wall. Begun for Eleanora of Toledo – so familiar to us from Bronzino's portrait in the Uffizi – to a design of 1550 by Niccolò Tribolo, these were developed over the following hundred years as successive waves of grand ducal taste demanded. There is much sculpture, including an explicit *cinquecento* masterpiece, Vincenzo de' Rossi's *Paris and Helen* of 1560, and Giambologna's *Venus rising from the Bath* in the Grotta di Buontalenti.

Opposite the Pitti, narrow streets cut westwards towards the church of Santo Spirito, which is in some ways the most characteristic religious building of *quattrocento* Florence. The architect was Filippo Brunelleschi – most famed, of course, for his astounding dome of the Duomo. Santo Spirito is of traditional cruciform plan with subsidiary aisles. The exterior is of sober stucco, a honeyed cream. Within, one is struck by the visual coherence of the architecture and of the many late *quattrocento* altarpieces and altarfronts still in place round the transepts. Patrons and painters compete, but on strictly complementary terms. The later altarpieces – of which the most

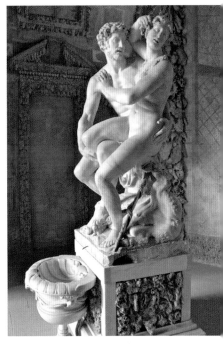

Boboli Gardens, Grottoes of Buontalenti: Vincenzo de'Rossi, Paris and Helen, *marble, 1560.*

memorable are by that narrator of near genius Aurelio Lomi – are more ambitious in scale.

Two blocks to the west is another celebrated church, Santa Maria del Carmine. The Corsini Chapel in the left transept is perhaps the most completely satisfying monument of baroque Florence. But it is not for this that the tourist-pilgrim comes. Your objective is the Brancacci Chapel opposite, which alas can no longer be entered from the body of the church, with the revolutionary frescoes of the short-lived Masaccio that heralded the Tuscan Renaissance in painting, their softer, more lyrical counterparts by his associate Masolino, and the courageous

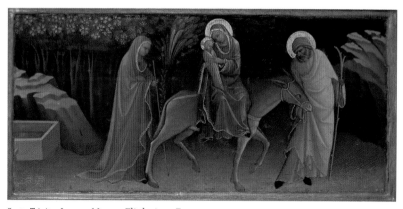

Santa Trinita: Lorenzo Monaco, Flight into Egypt.

scenes by Filippino Lippi that completed the cycle.

From the Piazza del Carmine it is a short walk to the Arno. The view from the south bank as one makes for the Ponte Santa Trinità has not materially changed since it was depicted by Zocchi and Thomas Patch in the eighteenth century, although traffic has deserted the river for the lungarni – and motorcycles are noisier than boats. Across the bridge is the church of the same name, an ancient foundation that remains a convincing place of prayer. Behind a grill in its original setting on the right is a haunting masterpiece by the last great painter of gothic Florence, the *Annunciation* by Don Lorenzo Monaco, with the Angel and Virgin in profile and, between, a stand of trees with trunks silhouetted against the gold ground of the panel; below, the Christmas narrative is continued in predella panels of almost unprecedented delicacy. Nearby is the Sassetti Chapel with Ghirlandaio's altarpiece and the admirably controlled fresco cycle which explain why he was so dominant an influence in late

fifteenth-century Florence. Like his Medici masters, Francesco Sassetti knew what he wanted.

At the heart of the city are the great octagonal Baptistery and the Duomo, crowned by Brunelleschi's majestic dome, which with the campanile beside the nineteenth-century west front and the tower of the Palazzo della Signoria dominate the skyline. The Duomo is as much a statement of Florentine power as the palazzo, its interior majestic yet strangely chilling despite a constellation of great works of art including the celebrated murals of *condottieri* by Uccello and Andrea del Castagno. East of the Duomo is the Museo del Opera del Duomo that has recently been brilliantly rearranged. The justly famous *cantorie* by Donatello and Luca della Robbia complement earlier sculpture from the cathedral, and have now been joined by Ghiberti's celebrated reliefs from the Porta del Paradiso of the Baptistery, by his earlier, more lyrical bronzes from the north door, and by Michelangelo's late *Pietà.*

The visitor with time will want to see more of the great churches that now, like

San Marco: Fra Angelico,
Annunciation, fresco
(detail).

the Duomo, sensibly charge for admission: Santa Maria Novella, with its wonderfully arrogant façade, for Masaccio, Orcagna and Ghirlandaio; San Lorenzo for Donatello, Verrocchio and, above all, Michelangelo, whose expression of a personal architectural language in the adjacent Laurentian Library is arguably as remarkable as the Medici tombs in the New Sacristy; cold Franciscan Santa Croce, that Valhalla of the Florentines, for Giotto and the Gaddi, Taddeo and Agnolo, not to mention Donatello's relief of the *Annunciation* and the chaste tomb of Bonnie Prince Charlie's widow, the Countess of Albany, and that incomparably pure masterpiece of the *Quattrocento*, Brunelleschi's Pazzi Chapel off the Cloister. Then find your way to the medieval Bargello, which with its prodigious holdings of Tuscan sculpture has been, except where Michelangelo is

concerned, spared the tyranny of trendy display. The concentration of works by Donatello and his successors has no equal.

It is in quieter places that it is more easy to understand the successive waves of Florentine taste: at Orsanmichele, where Daddi's altarpiece glows by candlelight in Orcagna's massive tabernacle of 1349–59; in the Convento di San Marco, where the genius of Fra Angelico is seen in the museum but most perfectly expressed in the frescoes of the cells – I must declare an interest as it was a Christmas card of the upright *Annunciation* that opened my eyes at the age of nearly six; in the Badia, with its monuments by Mino da Fiesole and Filippino Lippi's beautiful *Vision of Saint Bernard*; at Santa Maria Maddalena dei Pazzi, where Perugino's silent *Crucifixion* (accessible only on Tuesdays and

Thursdays) remains so compelling a religious image; in the Ognissanti, where murals of Saints Jerome and Augustine by Ghirlandaio and Botticelli are so tellingly juxtaposed; in the Annunziata, where Andrea del Sarto and his contemporaries continued the decoration of the atrium and he returned to fresco his overdoor of the *Madonna del Sacco* in the cloister; or the Chiostro dello Scalzo, with Sarto's admirably inventive grisaille frescoes of the life of Saint John the Baptist.

One of the pleasures of sightseeing in Florence is the way that the city, as if unwittingly, discloses its past. Tourists searching for a fashionable *gelateria* may sense that the curving walls of a huddle of buildings represent the line of the Roman amphitheatre west of the Piazza Santa Croce; a maze of narrow streets and the Palazzo della Signoria tell of the medieval republic already rich from banking, and the façades of the many Renaissance palaces in, for example, the Borgo degli Albizi still demonstrate the prosperity of Medici rule. Moreover, we can survey the city from certain viewpoints, Bellosguardo or the walk up to San Miniato al Monte, the polychrome façade of which glows in the evening sun.

Our understanding of what Florence meant to earlier generations of visitors is enhanced in the Museo Horne, formed by Herbert Horne, whose monograph on Botticelli has had no rival in English for over a century. Across the Arno the Museo Bardini, with the collection assembled by the leading Florentine dealer of the same period, has a complementary message. Florence can seem a forbidding city of uncompromising grey stone, but despite the depredations of Bardini and his predecessors her treasures are literally inexhaustible.

49

POGGIO A CAIANO

❁

THE POLITICAL POWER of the Medici was underpinned by their vast territorial possessions. And many of their villas survive to demonstrate their predilection for rural life. Among these Poggio a Caiano is the most remarkable. The sprawling town is not perhaps prepossessing. But we are in a different sphere once through the gate to the villa Giuliano da Sangallo devised for Lorenzo il Magnifico. This crests a low eminence. The elegance of its line, with open loggias and on the first floor a wide *portico in antis* crowned by a stretched pediment, is not diminished by the later belfry; and the innovative layout of the square structure can still be appreciated despite subsequent interventions, of which those of the Savoys were particularly unsympathetic.

The villa was still unfinished on Lorenzo's death, and work was interrupted when his son Piero was banished in 1494. After the Medici returned in 1512, the project was revived, and it was given an added impetus by the election of Lorenzo's son Giovanni as Pope Leo X a year later. The huge central hall was intended to celebrate the Medici, as the emblems on the barrel vault remind us, and the pope's friend Paolo Giovio devised the iconographic programme for the decoration of the room. Andrea del Sarto and Franciabigio were entrusted with the decoration of the two longer walls, while the much narrower lateral ones were allotted to Pontormo. At the time of the pope's death in 1521, Pontormo had supplied his remarkable mural of *Vertumnus and*

Villa: Giuliano da Sangallo, detail of façade.

Pomona in the upper part of the right-hand wall, while Franciabigio had completed the lower part of his *Return of Caesar from Exile*, and Sarto had realized much of the *Tribute to Caesar* diagonally opposite. There are beautiful passages in both narratives, but neither has the magic of Pontormo's fresco, which is among the masterpieces of secular decoration of the time. Alessandro de' Medici, who regained his inheritance in 1531, attempted to revive the scheme, but this was only completed after Alessandro Allori was enlisted in 1578. Allori did his best to respect what he found, for he was well aware that his own uncle and mentor, Bronzino, had been a pupil of Pontormo.

For a contrasting view of Pontormo's genius, go on to the little town of Carmignano, some five kilometres to the west. On the right wall of the parish church is

his altarpiece of the *Visitation*, touching, as the iconography demands, charged with emotion and characteristically inventive in colour. Only the wayward nature of the artist can explain why the panel was not borne off by the Medici or Napoleon's agents.

A few kilometres to the south, high on a ridge, is Artiminio, the substantial villa devised for Grand Duke Ferdinando I in 1594 by Bernardo Buontalenti. The architect evidently took Poggio a Caiano as his model, and, at least from a distance, his façade floats majestically above the olive groves. At Artiminio even more than at Poggio a Caiano the Medici could escape from the machinery that ensured their rule, and it cannot be wholly coincidental that the most interesting of the interiors is the small bathroom decorated by Bernardino Poccetti.

50

PRATO

❧

THE CITY OF Prato grew up round the priory of Santo Stefano of Borgo al Cornio, now the Duomo. Originally held by the Alberti, in 1187 this was a commune, which sought to maintain its independence from local powers, not least Florence. In 1326 Prato sought the protection of Naples, but in 1351 Queen Giovanna I sold it to Florence. From the twelfth century Prato had specialised in the wool trade and the textile industry grew steadily in importance. The well-documented career of the merchant Francesco di Marco Datini (1339–1410) demonstrates the European range of his business and the prosperity that Prato's subservience to Florence assured.

The Duomo was comprehensively rebuilt from 1211 onwards. The façade was remodelled in phases, most notably in 1434–8 when the extraordinary external pulpit of the Holy Girdle (that

Michelozzo, bronze capital from the external pulpit.

of the Virgin which was the church's great treasure), on which Donatello and Michelozzo collaborated, was added at the right corner: this has now been replaced by a replica. The girdle is enshrined in the splendid gothic chapel on the left of the nave which was frescoed by Agnolo Gaddi with characteristic efficiency.

The cycle with scenes from the lives of Saint Stephen and the Baptist of 1454–66 in the Cappella Maggiore or choir is the most impressive achievement in fresco of Fra Filippo Lippi, who also designed the stained glass window. The adjacent Cappella dell'Assunta is equally remarkable. With the exception of two compartments, the *Stoning* and the *Burial of Saint Stephen* and the *Marriage of the Virgin* by the modest if charming Andrea di Giusto, the frescoes are by Paolo Uccello. His authorship was disputed in the past but is now generally accepted. Uccello's artistic preoccupations are powerfully expressed, not least in the *Presentation of the Virgin*, with its insistent perspective and almost obsessive pursuit of architectural plausibility. The Museo del Opera del Duomo, tickets to which allow admission to the choir, houses a number of fine pictures, including an altarpiece by Lippi, a crucifix by Botticelli and Dolci's extraordinary *Custodian Angel* of 1675. The eroded reliefs of putti by Donatello from the pulpit are well exhibited, as is the extraordinary bronze capital by Michelozzo on which this was set.

Two blocks south of the Piazza del Duomo is the Piazza del Comune, with the much-restored Palazzo Pretorio. This has been intelligently adapted as Prato's museum. The large room with early altarpieces is unforgettable: these range in date from the major polyptych

with two predellas by the most consist-
ently refined master to work in mid-*tre-
cento* Florence, Giovanni da Milano, to a
number of pictures by Lippi, who had a
long connection with the town. Higher
up the building is a gallery with later
altarpieces, including three fine rela-
tively recent gifts, two by Allori and
Santi di Tito's *Multiplication of the Loaves
and Fishes*. On the top floor there is a
substantial group of plaster models by
Bartolini including that of the dog of
Horace Hall, a marble model for his
Demidov monument and portraits of
Murat, Byron's Guiccioli, the writer
Lady Morgan and others, which con-
trast rather sharply with a series of busts
and other sculptures by Lipchitz.

From the piazza, take Via Ricasoli
to the Piazza San Francesco: Datini's
tombstone by Lamberti is in the epony-
mous church. The Palazzo Datini nearby,
responsibly restored, would be of inter-
est as a merchant house of the early
Renaissance even if we did not know so
much about its owner. Many other rela-
tively modest early buildings survive in
the narrow streets in the area. Behind San
Francesco is the Piazza Santa Maria delle
Carceri, which takes its name from the
basilica designed by Giuliano da Sangallo
and built in 1484–95. Of Greek cross plan
with a central cupola, this expresses the
architect's study of the antique and, in
particular, of the Pantheon. But Sangallo
was also a man of his age and arranged
for Andrea della Robbia to supply the
great terracotta roundels of the Evan-
gelists in white on his customary blue
ground that are integral to the architec-
ture.

Industry laps outside the walls of
Prato, but the place has nonetheless been
largely spared inappropriate develop-
ment.

51

PISTOIA

❀

THE MEDIEVAL FLORENTINES did not
always deal kindly with their neigh-
bours. Like her larger neighbour Prato,
Pistoia – with agricultural and com-
mercial wealth and banks – was a rival;
conquered in 1294, Pistoia became a
protectorate in 1329 and in 1530 was
absorbed in the Grand Duchy of Tuscany.

The town is on the northern margin
of the plain of the Ombrone, backed by
the rising mass of the Apennines. The
parallelogram of the late walls implies
Pistoia's importance. Near the centre
is the Piazza del Duomo, hemmed in
by buildings of surprisingly consistent
interest: the thirteenth-century cathe-
dral, the gothic Baptistery, the Palazzo del
Podestà, begun in 1367, and the impres-
sive Palazzo del Comune. The cathedral's
most celebrated treasure is the silver
altarpiece of San Jacopo, begun in 1287
and progressively augmented in the
ensuing century. Of the numerous reliefs
the finest are arguably the scenes from
the life of the saint of 1367–71 by Leon-
ardo di Giovanni. For the student of the
Renaissance, two works on the opposite
– left – side of the church are of particu-
lar interest. The altarpiece on the right of
the chapel at the end of the left aisle was
ordered from Andrea del Verrocchio. The
executant was his efficient pupil Lorenzo
di Credi, and the vigour of such details
as the fringe of the carpet demonstrates
why Verrocchio's studio was so influen-
tial an artistic powerhouse. Just inside
the main door is another undertaking
of Verrocchio, the tomb of Cardinal
Niccolò Forteguerri, who died in 1473;

this would, if completed to the original scheme, have been the most distinguished mural monument of the age.

The pulpits of Pistoia are very remarkable, and it makes sense to see them in chronological sequence. Leaving the Piazza del Duomo at the north-east corner, continue to the church of San Bartolomeo in Pantano. Its unfinished façade is of Pisan type. The pulpit of 1250 is by Guido da Como, whose narrative reliefs already reflect the advances of contemporary Pisan sculpture. The second of the great Pistoiese pulpits is in San Giovanni Fuorcivitas, on the south side of the Via Cavour – the first major road south of the Piazza del Duomo – which represents the line of the medieval wall. The Romanesque church has been restored and the façade was not finished. Inside you come first to the splendid water stoop, itself attributed to Giovanni Pisano. The pulpit by Fra Guglielmo da Pisa, a follower of Nicola Pisano, was finished in 1270.

The most beautiful sculpture in

Sant'Andrea: Giovanni Pisano, pulput, marble (detail).

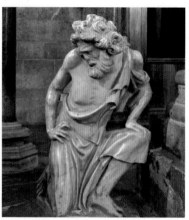

the church is of a different stamp. The glazed terracotta, usually attributed to Andrea del Robbia, is one of the very few free-standing works of serious distinction in the medium. I first saw it with John Pope-Hennessy, who lit candles so we could see how they gave life to the white glaze – as the artist so clearly intended. Tender in expression yet restrained to the point of austerity, the group is as moving on its own terms as Pontormo's picture of the subject some twelve kilometres to the south at Carmignano.

The last – and noblest – of the Pistoiese pulpits is at Sant'Andrea, northwest of the Piazza del Duomo. The arcaded façade – again of Pisan type – is enriched by a central portal with reliefs of 1166. The nave and aisles are relatively narrow. On the left is the pulpit of 1296–1301 by Giovanni Pisano, son of Nicola, whose great pulpit of 1260 in the Baptistery at Pisa had heralded nothing less than the rebirth of Italian sculpture as an intellectual force. Of all the pulpits of the age, that at Sant'Andrea is perhaps the loveliest. Giovanni understood his father's achievement and knew what he had learnt from classical example. He respected, too, his father's narrative discipline. But the son is an artist of the highest order in his own right. His forms have a sinuous gothic generosity, his reliefs a rhythmic conviction. Few works of their generation still speak with equal eloquence.

The *Trecento* marked the zenith of Pistoia's prosperity, as the large Franciscan and Dominican churches confirm, but the Renaissance left its contribution in the small church of Santa Maria delle Grazie, often attributed to Michelozzo but probably by an indigenous architect, and in the loggia of the Ospedale, adorned with a polychrome frieze.

52

LUCCA

❂

THE MAJESTIC WALLS of Lucca, with their sequence of eleven formidable bastions built between 1504 and 1645, offer visual evidence of the city's long independence from the Grand Duchy of Tuscany. Her strategic position and the fertility of her territory ensured the survival of the Roman town. In 1119 Lucca became a free commune; a period of great prosperity – and church-building – ensued. After a phase of political turbulence, the city recovered independence in 1369. Paolo Guinigi held the *signoria* for thirty years until 1430, but thereafter Lucca prospered as an increasingly aristocratic republic until the French invasion of 1799. Granted by Bonaparte as a principality to his sister Elisa and her husband Felice Baciocchi, in 1817 Lucca was awarded to Napoleon's widow, Maria Luisa of Parma, and only passed to Tuscan rule in 1847.

The eighteenth-century tragedian Vittorio Alfieri recollected of his first visit to Lucca that a day there had seemed like a century. Few will agree. While the walls testify to Lucca's determination to preserve her independence and the innumerable villas in the hinterland imply the sustained wealth in later centuries of her leading families, many of the outstanding buildings in the city itself date from the period of the free commune. The church of San Michele in Foro, at the very heart of the grid of the Roman town, epitomizes the Pisan Romanesque. Ruthless restoration does not disguise the richly decorated texture of the façade; the apse is also

distinguished. Passing this, and making north-west, turn right and then left on the Via Fillungo; beyond the bend, to the left, is the great church of San Frediano, largely built between 1112 and 1147. The mosaic of the *Ascension* on the façade is, alas, much restored, but the interior is particularly satisfying. The decoration of the second chapel on the left is the masterpiece of that most eccentric of Bolognese Renaissance painters, Amico Aspertini, whose classicism is informed by a kleptomaniac's accumulation of detail. Further on is the Cappella Trenta, with a sculpted polyptych, dated 1422, by Jacopo della Quercia.

Leave the church and cross the Via Fillungo to the Roman amphitheatre. The centre has been cleared and serves as a playground; houses are built into the structure. However, its form and scale can still be sensed. We can only be grateful that it has been spared from the archaeologists. As Lucca retains so much of the early street plan, it is relatively easy to head south for the Duomo. Founded in the sixth century by San Frediano, this is the most ambitious of the Romanesque churches of Lucca. The upper part of the façade was constructed by Guidello da Como and bears the date 1204; the elaborately decorated portico was begun in 1233. Entering the church, one is immediately impressed by its scale and height. In the left aisle is the octagonal shrine devised in 1482–4 by the local sculptor Matteo Cividale to contain the revered *Volto Santo*, a Romanesque effigy of *Christ on the Cross* in a robe enriched with gothic jewellery. Mentioned by Dante, the *Volto Santo* was – and remains – the religious symbol of Lucca. An early copy is at Borgo San Sepolcro, and the image appears on an early sixteenth-century English cope at Stonyhurst. The people of

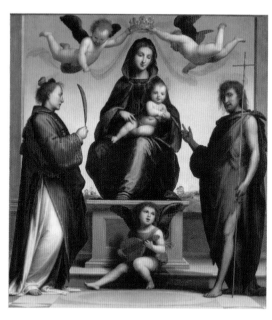

Duomo: *Fra Bartolommeo,*
Madonna and Child with
Saints Stephen and John
the Baptist, 1509.

Lucca still pay it far more attention than the two Renaissance masterpieces in the church.

The earlier and better known of these, in the left transept, is Jacopo della Quercia's extraordinary funerary image of Ilaria del Carretto, wife of Paolo Guinigi. She died in 1405 and the tomb was delivered in 1408. The effigy is placed on a sarcophagus decorated with putti supporting a splendid festoon. The young and exquisitely beautiful consort lies in her eternal sleep, a lapdog at her feet. Fluidly carved in flawless pale marble, the sculpture exerts an irresistible appeal. The most recent restoration has been irresponsibly criticized. Behind the monument, to the left of the presbytery, is the Cappella del Santuario. The altarpiece of the *Madonna and Child with Saints Stephen and John the Baptist* was supplied by Baccio della Porta, Fra Bartolommeo, in 1509. One of the purest achievements of the Florentine High Renaissance, exquisite both in its equilibrium of composition and subtle clarity of colour, this is one of the few major works by the painter which can still be seen in an appropriate setting.

Lucca repays the persistent. There are other early churches. And a wonderfully detached impression of the town and its campaniles can be gained from the walls. The Villa Guinigi houses a substantial museum, including a sensitive portrait of a diffident youth by Pontormo, while the Palazzo Mansi retains the collection of that family. Those with time should try to see at least some of the villas of the Lucchese and their gardens, but will need to check opening times. Of the gardens, the most magnificent are those, impeccably maintained, of the Villa Reale di Marlia, once inhabited by Elisa Baciocchi. The eighteenth-century topiary theatre is a particularly happy survival.

53

PISA

✿

PISA OWES MUCH to its position astride the river Arno as this approaches the sea: a major port under the Romans, the city subsequently had a key role in defending the coast, not least from the Saracens whom it drove from Sardinia in 1015–16. As a free commune which was already a major trading power in the Mediterranean, Pisa became an archiepiscopal see in 1092, and obtained substantial possessions both in Italy and in Sardinia in the ensuing century, taking advantage of the weakness of the Crusaders to demand commercial concessions in their ports. Always in uneasy competition with Florence, Pisa lost ground when local families contended for the *signoria* in the early fourteenth century; Sardinia was lost in 1327, and in 1399 the city was sold to the Visconti of Milan, and finally occupied by the Florentines six years later. Florentine rule was benign, and the Medici took a responsible interest in what became their second city, fostering public institutions and works, including the canal linking it with Cosimo I's successor port of Livorno.

The great monuments of Pisa's glory days are within the north-west angle of the walls: the huge Duomo, begun in 1063; the Baptistery to the west, commenced in 1152 by a builder of genius, Diotisalvi, but not completed for over two hundred years; the Campanile, or Leaning Tower, to the east, begun in 1173 and finished in the mid-*Trecento*; and the appropriately sombre Camposanto, or cemetery, to the north, on which

work started in 1278. The buildings are not aligned, yet the sense of space that flows between them was evidently not accidental. And each successive structure was clearly intended to respond to what was already built, so the richly decorated texture of the circular Baptistery, most sophisticated of medieval rotundas, answers the west front of the Duomo, while the columned tiers of the Campanile seem to float above us, not just because they lean but because they seem so weightless by comparison with the massive bulk of the Duomo. The builders of Pisa understood the properties of light, as one can see when the movement of the sun diminishes and then draws out the shadows cast by the narrow pilasters of the façade of the Camposanto.

To comprehend the achievement of the great sculptors of medieval Pisa, the Pisano, it makes sense to begin with the Baptistery. Here again the builders express a lightness of touch. On the left is the prodigious pulpit begun in 1260 by Nicola Pisano. This is decorated with scenes from the life of Christ, personifications of the Virtues, and, in the spandrels of the canopy, the Prophets. Nicola's genius was to learn from classical statuary how to give life to his forms. The revolution he started, and on which his young son Giovanni collaborated, was to transform the development of Italian sculpture. Nicola strove for the plausible, while Giovanni's taste was more lyrical. The latter's great pulpit of 1302–11 in the Duomo, reconstructed in 1926, is a highpoint of the Italian Gothic. There is a wonderful harmony between the structure itself and Giovanni's sinuous sculpted forms. It takes a little time to realize how successful the interior of the Duomo is; the nave is flanked by double aisles, the cupola of the crossing borne

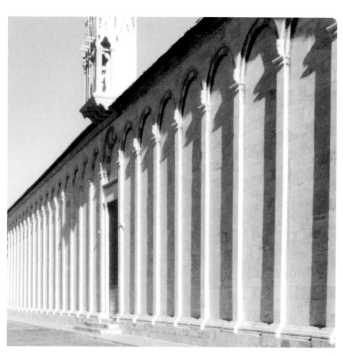

Camposanto.

on arches that imply a knowledge of Muslim architecture. But later accretions, individually distinguished but cumulatively almost oppressive, crowd in, and it is not even easy to concentrate on the five saints by Andrea del Sarto on the pilasters of the presbytery.

The Camposanto suffered gravely in 1944. It is lined with a notable series of funerary monuments, including that of the connoisseur Count Francesco Algarotti, paid for by Frederick the Great of Prussia, and a large number of classical sarcophagi, as well as a vase in Parian marble, the figure of Dionysius in which was copied by Nicola in his pulpit in the Baptistery. The murals are of yet greater interest. Francesco Traini's *Triumph of Death* and *Last Judgement* were the most

arresting achievements of the greatest Pisan painter of the *Trecento*. By contrast, the scenes from the Old Testament by Benozzo Gozzoli strained even that discursive master's narrative abilities.

Pisa is well endowed with churches, the Dominicans' Santa Catarina, with notable *trecento* sculpture and painting, now rather outshining the rivals' San Francesco, although this contains an impressive *Baptism* by Jacopo da Empoli. At the heart of the northern section of the city, on Piazza dei Cavalieri, is San Stefano dei Cavalieri, planned by Vasari as the church of the Order of Knights of San Stefano founded by Cosimo I. Banners taken from the Turks are ranged on the walls. Continuing southwards you reach the Arno, lined by houses that

have changed relatively little since the early nineteenth century when Byron and other English visitors were drawn to the city. On the opposite bank, near the Ponte Solferino, is the quintessential monument of the Pisan Gothic, Santa Maria della Spina of 1323. Wholly harmonious in detail, this must always have seemed exiguous beside the great river.

On the north bank by the east end of the Lungarno Mediceo is the Museo Nazionale di San Matteo. Here, as nowhere else, you can survey the evolution of painting at Pisa. For the Pisano did not function in isolation. Nicola's older contemporary, Giunta Pisano, was the great protagonist of *dugento* painting in central Italy, and his signed *Crucifix* is a work of capital significance. His followers are comprehensively represented. Pisa's relative economic eclipse in the *Trecento* was reflected in that of local painters, and so the great masterpieces in the collection henceforward tend to be by outsiders; among these are the Sienese Simone Martini's pentaptych of 1319 and the *Saint Paul* from Masaccio's altarpece of 1426 from Santa Maria del Carmine.

Like other great Italian cities, Pisa did not exist in isolation. The finest church in the vicinity, some five kilometres south-west, is the Romanesque San Piero di Grado, which marks the spot where Saint Peter disembarked. The isolated setting means that there is nothing to disturb our appreciation of the intelligent use of contrasting black and white stone from nearby San Giuliano, and the sharp detail of the mouldings. On the flank of the hills to the east of the city is the Certosa di Pisa, largely rebuilt in the *Seicento* and nobly positioned. Staying regularly nearby at Agnano, I developed an exaggerated affection for the Napoleonic aqueduct that brought water to the city.

54

VOLTERRA

❖

OTHER ITALIAN CITIES cling to ridges; Volterra straddles a mountain top, dominating the cascading ridges and eroded *balze* of the hinterland. The site perfectly fulfilled the requirements of the Etruscans, whose city of Velathri was defended by walls, some seven kilometres in circuit, that enclosed both the high ground, which would be occupied by the medieval town, and the three ridges descending to the north. Stretches of the walls survive. Roman Volaterrae was also a place of some consequence, as the theatre tucked under the medieval wall near the Porta Fiorentina reminds us. The medieval commune contended with neighbouring San Gimignano and was first briefly occupied by the Florentines in 1254. But it was only in 1472 that Volterra became a Florentine dependency, of which the formidable fortress at the east angle of the city is only the most obvious statement.

Why Volterra mattered to Lorenzo il Magnifico and his successors is self-evident however Volterra is approached. On the road up from Pontedera there are tantalizing glimpses. While it may be easier to park near the Porta Fiorentina, I prefer to enter from the west at the Porta San Francesco. Just within the gate, to the left, is the Franciscan church, austere and bare, but to the right is the large Cappella della Croce di Giorno, frescoed in 1410 by Cenni di Francesco with scenes from the life of Christ and the story of the True Cross. Cenni was little more than an efficient follower of Agnolo Gaddi, but he rose to the challenge; we are left in no doubt that the Innocents were

Duomo: Pieter de Witte, il Candido,
Deposition (detail).

massacred and that Saint Helena did find the right Cross.

The Via San Lino rises steeply to the heart of the city. At an obvious fork, take the right-hand street for the irregular Piazza San Giovanni. The fine Romanesque façade of the Duomo masks a very successful sixteenth-century internal reconstruction. Albertinelli's *Annunciation* apart – memorable for what is perhaps the most beautiful of his landscapes – the lateral altarpieces are by later sixteenth-century masters, including a gifted local man, Niccolò Circignani, a suave Florentine, Santi di Tito, and a gifted northerner, Pieter de Witte, il Candido. Opposite the Duomo is the thirteenth-century octagonal Baptistery, with a font by Andrea Sansovino. Some way behind the Duomo is the Piazza dei Priori, most notable for the Palazzo dei Priori, completed in 1254, ironically the year of the first Florentine occupation.

The best views of the palazzo's tower and the campanile of the Duomo are from the Parco Archeologico at the high point of the hill, with the eroded remains of the Etruscan acropolis. The immense accumulation of Etruscan material excavated at Volterra is shown in the Museo Etrusco on the Via Don Minzoni in the shadow of the Fortezza.

Guaranteed by that emphatic complex, the prosperity of Medicean rule is implied by the many palaces of the city. That of the Inghilrami, patrons of Raphael, is just below the archaeological park, but there are many more. One, the Palazzo Viti in the Via dei Sarti, is now open to the public. Near it is the former Palazzo Minucci, which now houses the Pinacoteca Comunale. There are fine late gothic altarpieces by Taddeo di Bartolo, the most forceful Sienese master of the early *Quattrocento*, and his near contemporary, Alvaro Portoghese, who adapted to Florentine taste. The late *quattrocento* Sienese Benvenuto di Giovanni responds to the *balze* east of the town in the grey and white landscape of his *Nativity*. Of the three altarpieces supplied for Volterra by the Cortonese Luca Signorelli, two are here – the third is in London. No Italian of his time painted books with greater enthusiasm, so it is entirely characteristic that the Virgin in his chromatically charged *Annunciation* has dropped hers. To modern taste Signorelli is outshone by Rosso Fiorentino. His deeply emotional *Deposition* can be read as an inspired reaction to the altarpiece of the subject recently supplied by Signorelli's erstwhile associate, Perugino, for Santissima Annunziata in Florence, where Rosso had worked in the atrium After looking at a great masterpiece it is difficult to attend to less clamant pictures. But do not pass by the *Deposition* or the *Nativity* by Pietro Candido: both perfectly express the pyrotechnical brilliance as a colourist that were to stand him in such stead as a designer of tapestries at the court in Munich.

55

SAN GIMIGNANO

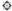

SAN GIMIGNANO IS the paradigm of a medieval Tuscan city. The walls are intact and we still enter through the original gates; the defensive towers of local families which were obsolete even before the imposition of Florentine rule between 1348 and 1354 bristle like porcupine quills on the hill that was settled in early times. Named after a bishop of Modena, San Gimignano had become a free commune in the twelfth century. As in other Tuscan cities, the struggle between Guelf and Ghibelline, between the supporters of the papacy and the emperor, was prolonged. Commercial links with Siena were strong in the fourteenth century and their artistic ramifications can still be experienced.

Much of the fabric of the medieval town survives. At its heart is the Piazza della Cisterna, flanked by a number of early houses and linked to the irregular Piazza del Duomo, which is dominated by the loggia'd Palazzo del Podestà, begun in 1239 and enlarged in 1337, by the restrained front of the Collegiata and the towering Palazzo del Popolo, started in 1288, extended in 1323, and closest to the pulse of the medieval city. Communal pride is clearly expressed in the so-called Sala di Dante, where the poet urged the city fathers to adhere to a league of Tuscan Guelfs in 1300. The room is dominated by Lippo Memmi's *Maestà* of 1317, which follows the pattern of Simone Martini's fresco in the corresponding position in Siena; the lateral sections were tactfully restored by Benozzo Gozzoli in 1467. The Pinacoteca

Civica is housed in the palace. The roundels of the *Annunciation* by Filippino Lippi are breathtakingly beautiful, and are placed on either side of the miraculously preserved tempera panel of the *Madonna and Child with Saints* by Pintoricchio. Most tourists rush by, intent on climbing the tower, which offers an unequalled view of the town.

The Collegiata is now entered from the courtyard to the south, through a vaulted loggia with a fresco of the *Annunciation* by Sebastiano Mainardi, Ghirlandaio's brother-in-law and pupil. The cruciform interior is notable for its frescoes. On the wall of the right aisle is the prodigious sequence of scenes from the Passion of Christ which are traditionally attributed to Barna da Siena. Probably of before 1340, these are the grandest achievements of mid-*trecento* Sienese painting. For Barna's lyricism of line was matched by his narrative acuity and interest in emotion. On the opposite, left, wall is the slightly later cycle of Old Testament scenes by the most forceful and compositionally innovative of Barna's immediate successors, Bartolo di Fredi. The entrance wall was decorated in 1465 by Gozzoli, whose *Saint Sebastian*, punctured by no fewer than thirty-six arrows, is flanked by pigmented statues of c.1421 representing the *Annunciation* by Jacopo della Quercia; Gozzoli's respect for these is implied by the fictive settings he devised for them. San Gimignano boasted its own saint, Fina. Her chapel, the last on the right, decorated by Ghirlandaio, is a perfect statement of disciplined late *quattrocento* taste.

Despite the tourists and the shops catering for them, linger in the Via San Matteo, to the north of the Piazza del Duomo, which is lined with medieval houses. Before the Porta San Matteo turn

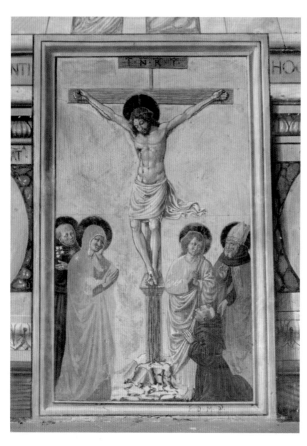

Sant'Agostino: Benozzo Gozzoli, Crucifixion, *fresco,* 1464.

to the right for the austere barn-like church of Sant'Agostino. Gozzoli's frescoes of the life of the saint in the choir are particularly well preserved. He is an engaging artist with a genius for anecdote, and it no doubt suited him to work for patrons whose taste was somewhat outmoded by Florentine standards. He also decorated an altar on the left wall of the church with a mural of *Saint Sebastian* and, below this, a small fictive devotional panel of the *Crucifixion.* The high altarpiece, the *Coronation of theVirgin,* is by Piero del Pollaiuolo, younger and arguably weaker brother of Antonio, here straining at the limits of his abilities.

The supply of water is essential to any town, and San Gimignano was no exception. The Porta dei Fonti leads downhill to the Fonti, a medieval arcaded structure built against the hillside, with, at a lower level, a further arcaded basin. Where women once came for water and to contend with their laundry, an abandoned Vespa is now the only sign of life.

56

SIENA

❧

MOST VISITORS APPROACH Siena from the north – the road from Florence – their sense of anticipation heightened by the sight of the great fortress of Monteriggioni, thrown up in 1203 to repel the Florentines. But it is from the south that one has the most memorable views of the city. High in the centre is the great campanile of the Duomo, below it, to the east, the elegant Torre del Mangia of the Palazzo Pubblico. Other churches can be seen above the tremendous circuit of the walls that defined the limits of the early town and

defended what was in artistic terms perhaps the most self-sufficient centre of the early Renaissance.

This artistic individuality reflected the political position. Although of Etruscan origin, Siena only became a place of importance in the early medieval period. Long the rival of Florence, Siena was a major commercial and banking centre that jealously preserved her independence and republican institutions. Pandolfo Petrucci gained power in 1487, but his sons failed to ensure the succession and in 1530 Siena fell to the army of the Emperor Charles V. In 1552 the city rebelled against his son, King Philip II of Spain. After a long siege, Siena surrendered in 1555, to be granted in 1559 to Cosimo I, Grand Duke of Tuscany. Medici rule was moderately benign, but Siena's

Palazzo Pubblico, with the arms of the Medici and the badge of San Bernardino.

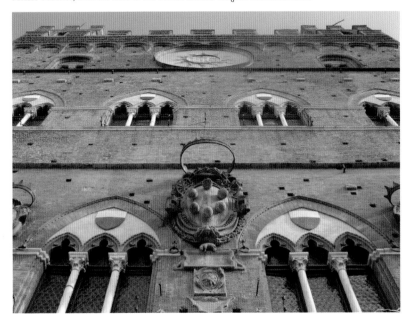

Cathedral: Francesco di Giorgio, pavement border.

enduring medieval character owes much to the fact that she became a backwater.

The fan-shaped Piazza del Campo is at the heart of the town. The great façade of the Palazzo Pubblico, begun in 1297, is, as it were, the stage set of a wide theatre, its audience the façades of the palaces on the circumference. It was in the piazza that San Bernardino preached his austere message in the mid-fifteenth century, and it is there that the annual drama of that great historic Sienese event, the Palio – or horse race – is still played out. The saint's badge is seen above the arms of the Medici on the Palazzo Pubblico, which despite the risk of crowds must be visited. In the vast Sala del Mappamondo are two defining masterpieces of Simone Martini, his frescoed *Maestà* and the extraordinary equestrian portrait of the *condottiere* Guidoriccio Fogliani silhouetted against an undulating horizon of

hills punctuated by bristling fortresses. Equally remarkable are the frescoes of Simone's contemporary, Ambrogio Lorenzetti, in the Sala della Pace. That of *Good Government* celebrates the life of the medieval commune: the town is ordered, its territory peaceful and productive. No earlier Sienese landscape offers so compelling a portrait of contemporary agriculture. The fresco of *Bad Government* is, of course, altogether different in mood – a stark warning of the consequences of anarchy.

As the palazzo was the centre of communal rule, so the Duomo, higher to the west, best approached by one of the narrow streets above the Via di Città, was at the heart of its religious life. The striped gothic structure must always have impressed those who saw it. It does so still, although the façade sculptures by Giovanni Pisano have been moved

to the nearby museum, the Opera del Duomo, and are replaced by copies. After seeing the façades of the cathedral and the incomplete skeleton of what was intended as the nave of its successor, it makes sense to visit the Opera del Duomo. For this now houses most of the components of the epicentral masterpiece of medieval Siena, the *Maestà* of Duccio di Buoninsegna. This double-sided altarpiece was installed on the high altar of the cathedral on 9 June 1311. The Madonna and Child with numerous saints, raised on a predella, faced the body of the church; on the reverse were scenes from the life of Christ. No Sienese painter for over a century evaded the influence of the *Maestà*. And it is not difficult to see why. For in this prodigious complex Duccio codified a religious language which owed much to his immediate local predecessors – whose achievement is only now being recognized – and to Byzantine influence, but nonetheless was without precedent in its visual coherence and narrative force. While Duccio did not himself paint all the subsidiary panels and pinnacles, he exercised so close a control over those who did that their individual contributions cannot be determined.

The interior of the cathedral is as arresting as the façade, with the massive banded piers of the hexagonal crossing. Despite the removal of the *Maestà* – and of Giuseppe Mazzuoli's baroque sculptures of the *Apostles* now in the Brompton Oratory, London – the riches of the cathedral continue to astonish. And it is altogether impossible to do justice to them in a hurry. The building is vast, its scale only emphasized by the attentions the Sienese lavished upon it. The wonderful pulpit of 1265–8 in white marble is by Nicola Pisano and represents a development from

its precursor in the Pisan Baptistery. The remarkable stained glass of the central rose window was designed by Duccio himself.

Not content with adorning walls, the Sienese decorated the pavement of the cathedral with compositions of inlaid marble. Usually largely covered, the pavement is now visible for two months from mid-August. The earliest sections are of 1369 and many major artists were involved, including Francesco di Giorgio Martini, Matteo di Giovanni and Neroccio di Bartolomeo Landi, the protagonists of late *Quattrocento* Sienese art. The designers were responsible not only for their compositions but also for the borders framing them, of which those by Francesco di Giorgio are particularly satisfying. Their High Renaissance successor, Domenico Beccafumi, made a virtue of the challenge the medium imposed: his sections of the pavement, including the *Moses striking the Rock* and the wonderfully animated decorative friezes, exploit its linear potential to the full. Beccafumi, like other Sienese masters, was versatile. His bronze statues of angels in the choir – with their bases of masks of men with flowing hair – are of a compelling plasticity.

The left aisle of the Duomo is particularly rich. The Petrucci apart, no Sienese family could match the Piccolomini, two of whom became popes, Pius II (1458–64) and Pius III (1503); their altar in the fourth bay is by the Roman sculptor Andrea Bregno, but three of the statues, Saints Gregory, Paul and Peter, are by the youthful Michelangelo (1501–11). It was indeed at Siena that Michelangelo and his younger contemporary Raphael were first in indirect competition. Immediately beyond the altar is the entrance to the Piccolomini Library,

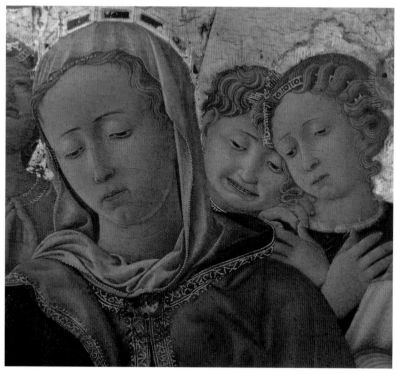

Pinacoteca Nazionale: Domenico di Bartolo, Madonna (detail), *1433.*

commissioned by Francesco Piccolomini to celebrate the career of his uncle, Pope Pius II. The vast frescoes are by the Perugian Benedetto Betti, il Pinturicchio, but, as surviving drawings establish, at least two were designed by Raphael. The compositions are seen through a *trompe l'oeil* loggia in a perspective that allows for the height at which they are placed. Pinturicchio's star has faded since the Victorian era but his narrative gifts have rarely been surpassed. Of equal interest are the illuminated miniatures on display in the cabinets below. These have no rivals of their date, the 1460s, and are by two outstanding north Italian masters, Liberale da Verona and Girolamo da Cremona. Of the two, Liberale is the more emotionally intense, Girolamo the more cerebral and conscious of the classicism of Mantegna's generation.

Leaving the cathedral, follow its east side and go down the splendid flight of steps to the Baptistery. The façade is more austere than that of the cathedral, the interior unexpectedly high. In the font, begun in 1417 by Jacopo della Quercia, one can see how the late Gothic dissolves into the classicism of the early Renaissance. Although only a decade separated

Jacopo's *Expulsion of Zaccarias* from the companion reliefs by his younger Florentine contemporaries Ghiberti and Donatello, the significance of the intellectual revolution they represented is not in doubt.

South-west of the piazza, on the Via di San Pietro, is the Pinacoteca Nazionale. Modern notions of display have not been allowed to disturb traditional arrangements. The collection of Sienese pictures is unrivalled. Duccio's tiny *Madonna dei Francescani* is followed by significant groups of pictures by Simone Martini and the Lorenzetti and their later fourteenth-century successors. The *Quattrocento* is represented in depth, with Domenico di Bartolo's precocious *Madonna* of 1433, rooms devoted to Sassetta and that idiosyncratic visionary, Giovanni di Paolo; to Sano di Pietro, the most productive native master of the mid-century; to the languorous *Madonnas* of Matteo di Giovanni and to the lyrical Neroccio. High Renaissance Siena was no backwater. Sodoma, who arrived from Lombardy, was by any standard a major artist, while Beccafumi was a magician both in his lyricism of line and in his use of colour. Spare a moment, too, for their contemporary Girolamo del Pacchia's beautifully expressed *Visitation*.

Proceeding south from the Pinacoteca, the road descends towards the much-reconstructed church of San Domenico. On an altar on the right is Perugino's *Crucifixion* of 1506, commissioned by the powerful Sienese banker Agostino Chigi, while in the Cappella Piccolomini, opposite a well-preserved fresco by Ambrogio Lorenzetti, is what has some claim to be Sodoma's masterpiece, his *Adoration of the Magi*. The only other Sienese altarpiece of the time still *in situ* that rivals it is in San Martino,

south of the east corner of the Campo: Beccafumi's *Nativity*, which is of a breathtaking beauty, visionary in design and thrilling in chromatic range.

At San Martino you may be alone. This will not be the case in the sanctuary of Saint Catherine to the north-west of the city. The saint died in 1380 and her house was adapted as a shrine in 1464. As John Addington Symonds observed, the sanctuary preserves much of its original character – and on that account alone is a remarkable survival. In the Upper Oratory are a series of pictures of the life of the saint by the most gifted masters of late sixteenth-century Siena, including Francesco Vanni, whose *Canonization of Saint Catherine* perfectly exemplifies his delicate taste.

Many of Siena's major churches lie at or near the extremities of the original urban area: Santa Maria del Carmine (also known as San Niccolò al Carmine) with Beccafumi's *Saint Michael*; Santa Maria dei Servi with the impressive *Madonna del Bordone* of 1261 by Coppo di Marcovaldo; austere San Francesco; its more splendid counterpart, San Domenico, high on the ridge above the medieval Fonte Branda, with a constellation of early altarpieces and Sodoma's persuasive *Saint Catherine in Ecstasy*; and, opposite the cathedral, Santa Maria della Scala, which boasts the outstanding sculpture of mid-quattrocento Siena, Lorenzo Vecchietta's moving bronze of the *Risen Christ* of 1476, placed alas too high for its subtlety to be easily appreciated. All are worth visiting, not least for the pleasure of walking through the city. Changes of level mean that almost every turn discloses an unexpected view of medieval brickwork or the façade of a Renaissance palazzo, with so often at least a glimpse of open country in the distance.

57

SAN GALGANO and MONTESIEPI

❧

IN 1180 GALGANO Guidotti, a noble from nearby Chiusdino who died a year later, built a hermitage on the Monte Siepi, a low hill in undulating country southwest of Siena, and accepted the Cistercian rule. Five years later Galgano was canonized. The Cistercians of Casamari began to build what was to become one of the most important houses of their order in Italy on lower ground to the north. They took over the possessions of a number of Benedictine monasteries and acquired significant landholdings not just in the immediate area but throughout the territory controlled by Siena, gaining considerable political influence.

The great early gothic cruciform church of their monastery of San Galgano, on lower ground to the north, was under construction in 1224, but work continued until the end of the century and the front was never finished. Sacked twice by the English *condottiere*, John Hawkwood (Giovanni Acuto), the monastery was to undergo a slow but inexorable process of decay and was suppressed after the French invasion, its ruins being used for agricultural purposes. The church is now partly roofless, but its skeleton, like those of the equally disciplined and austere Cistercian monasteries in Yorkshire, is hugely impressive. Decoration was kept to a minimum, but the drill was used systematically for carved elements such as bosses. Part of the adjacent monastic building survives, with a large chapter house and an equally substantial vaulted refectory: above is a long corridor off which are monks' cells. Much has gone, but the monastery still dominates its landscape.

After San Galgano, the circular Romanesque church of the saint on the summit of the Monte Siepi, San Galgano di Montesiepi, built in 1183, seems relatively modest. The decision to construct a round church implies a relatively unusual interest in early Christian shrines. The central section of the church from the level of the window sills is in alternating bands of local stone and brick and the interior of the dome, as of the modest apse, is treated in the same way. The building is strangely compelling. What makes it remarkable is the vaulted gothic chapel that opens to the left of the main altar. For this was frescoed, probably in 1334–6, by Ambrogio Lorenzetti. The murals have suffered, but as a result it was not irresponsible to detach these. And we therefore learn much about the probing, experimental genius of the artist. Ahead, on the altar wall – which is broken by a central lancet window – is a mural of the *Maestà*, with in the foreground a reclining figure of Eve that tells us that the artist must have studied a classical prototype. Below, divided by the window are the *Angel of the Annunciation* and the *Virgin Annunciate*. As the *sinopia* reveals, the kneeling Virgin as originally conceived had turned away from the angel, and was shown looking over her shoulder to take in his unexpected message, submissive in surprise. Perhaps Ambrogio sensed that this interpretation was too emotional for his patrons. For in the event he adhered to a more conventional iconography and the Virgin, whose head is happily extant although much of the rest of the fresco has been lost, looks serenely downwards at her visitor and indeed at the spectator today.

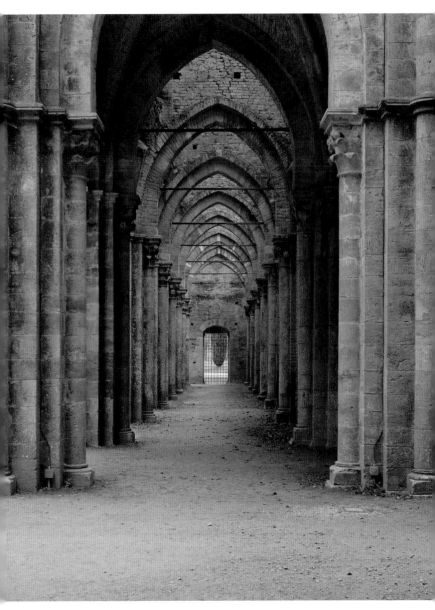

San Galgano, north aisle, 13th century.

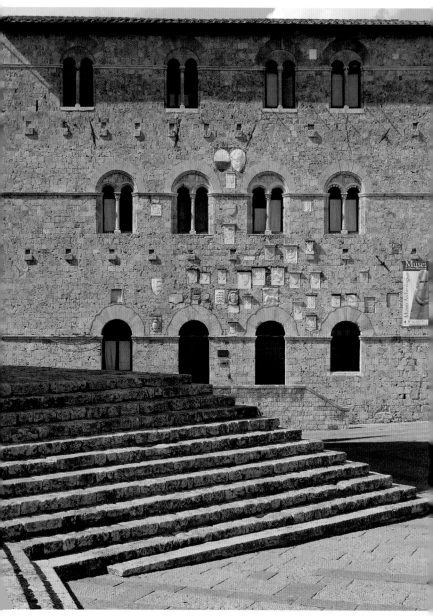

Palazzo Comunale, 1344 onwards.

58

MASSA MARITTIMA

❖

THE ANCIENT BISHOPRIC of Populonia, on the coast, was transferred to Massa Marittima in 835, but the city's position on a hill well inland did not save it from being sacked by Saracens a hundred years later. Copper and silver mines brought considerable riches to the town. Allied in turn with Pisa and Siena, Massa was taken over by the latter in 1335 and remained under Sienese domination until Siena itself passed to the Medici in 1555. Even now the place seems oddly remote from the other historic centres of Tuscany, approached from the east by a road with so many bends that on my first visit, I realised to my shame that my passenger, John Pope-Hennessy, was about to be sick.

The road from Siena runs below the western line of the medieval wall to the Porta al Salnitro just off the Piazza Garibaldi which was the spiritual and secular centre of the medieval town. On the left is the handsome Palazzo Comunale, which was begun in 1344. Diagonally opposite is the magnificent front of the Duomo, begun under strong Pisan influence in the early thirteenth century, and enlarged between 1287 and 1304, when the impressive apse was constructed. The Duomo is particularly notable for its sculpture. The large font by Giroldo of Lugano, which is dated 1267, is decorated with scenes from the New Testament; while the shrine of Saint Cerbonius in the chapel below the apse, with eight panels representing the life of the saint, is the key work of the Sienese Goro di Gregorio who completed it in 1324.

Ambrogio Lorinzetti, Maesta *(detail)*, Faith.

The Via Moncini, to the right beyond the Palazzo Comunale, runs uphill to the Porta alle Silici. On the left is what remains of the Fortezza dei Senesi, constructed by the Sienese soon after their suppression of the commune of Massa.

The greatest work of art in the town is a very different expression of Sienese domination: the extraordinary Maestà by Ambrogio Lorenzetti, now in the Museo Civico. Many of Lorenzetti's pictures have suffered. But the Maestà happily has not. The Madonna and Child are enthroned, flanked by four angels with flowers: below, seated on three steps of differing colour, are Faith, Hope and Charity with at either side paired angels, two making music, two swinging censers, behind whom are saints beyond number, including the six pairs in the lateral pinnacles who are raised above the receding waves of haloes. The animated geese at the lower right corner would instantly have been recognised at Massa as representatives of those who entered the papal palace to attest to the innocence of Saint Cerbonius, and thus related Ambrogio's celestial vision very specifically to their city. With Duccio's Maestà and Simone's fresco in the Palazzo Publico at Siena, it is one of the sublime statements of Sienese devotional painting in the early Trecento.

59

MONTALCINO

❧

I MAY SEEM self-indulgent to add Montalcino to this book. It is inevitably outshone by its greater neighbours, and it boasts no building to be compared with Sant'Antimo in walking distance to the south. But few towns, even in Tuscany where development has on the whole been relatively well-controlled, are more happily placed. Whether approached through the hills to the west or on one of the two roads that climb up from the Via Cassia to the east, Montalcino imposes its presence.

Given to Sant'Antimo in 814, Montalcino later became a free commune. After the Battle of Montaperti, Montalcino

Museo Civico: Bartolo di Fredi, The Virgin returning to her Parents *(detail), 1388.*

abandoned an alliance with Florence and accepted Sienese control. Despite sieges in 1525 and 1553 it remained loyal to Siena even after the republic was extinguished in 1555; in 1559 it passed to the Medici.

At the high point at the southern end of the hill is the uncompromising fortress. Incorporating two earlier towers, this was built by the Sienese in 1361 after an unsuccessful revolt, and was, albeit briefly, to be the last outpost of the Sienese republic. Near the centre of the town is the Piazza del Popolo, with the inevitable medieval Palazzo Comunale, once the Palazzo dei Priori, its front studded with carved coats of arms, and with a statue of Grand Duke Cosimo I. To the right is a late gothic loggia. There are several churches, of which the most ambitious is the Duomo, rebuilt from 1818 by the Sienese Neoclassical architect, Agostino Fantastici, whose fine portico is an unexpected presence.

The Museo Civico is not large. There is a significant collection of early ceramics and Sienese *maiolica*, which is complemented by altarpieces by followers of the della Robbia. The pictures naturally are almost all by Sienese masters, Luca di Tommè, Giovanni di Paolo, Sano di Pietro and Benvenuto di Giovanni, among others. The most forceful Sienese painter of the late *Trecento*, Bartolo di Fredi, worked at Montalcino, executing frescoes in the church of Sant' Agostino. The museum's great treasures are the surviving fragments of a signed polyptych of 1382 and that of 1388 from the Cappella della Carceri. Bartolo was a narrator of genius, as the frescoes at San Gimignano demonstrate, but scenes from the life of the Virgin that flanked the central *Coronation of the Virgin* of the 1388 altarpiece are surely his signal achievements.

60

SANT'ANTIMO

SANT'ANTIMO MUST BE the most lumi-
nous Romanesque church in Italy. The
Benedictine abbey may not have been
founded, as was long believed, by
Charlemagne, but is first recorded in
813. Set in a narrowing valley just west
of the pilgrim route to Rome, the Via
Francigena, that followed the ancient
Via Cassia, the abbey became exceed-
ingly rich in the early medieval period.

First seen across fields, the church
with its beautiful apse and tall cam-
panile makes an indelible impression.
Begun in 1117, it is built of travertine
enriched with alabaster from nearby
Castelnuovo. The west front is austere,
the central door opening to the nave
which is flanked by columns of vary-
ing size, with fine capitals: the finest of

these, the second on the right, repre-
sents *Daniel in the Lions' Den*. Particularly
in the morning, the light draws us for-
wards. The presbytery is set within an
ambulatory with three radiating chap-
els, a scheme implying a knowledge
of the great abbey at Cluny. But there
is no such precedent for the liberal
use of alabaster, whose translucence
gives the ambulatory a magical quality.
To the south is the sacristy, overlying
the crypt of the earlier ninth-century
church; opposite is a smaller cruci-
form space within the lower stage of
the campanile.

Many early churches in Italy have
been ruthlessly restored. This is not the
case at Sant'Antimo, because the mon-
astery fell into decline and was sup-
pressed by that most civilized of popes,
Pius II, in 1462. As a result neither the
Renaissance nor the baroque left its
mark, and little survives of the monastic
buildings. So the great church stands in
unintended isolation.

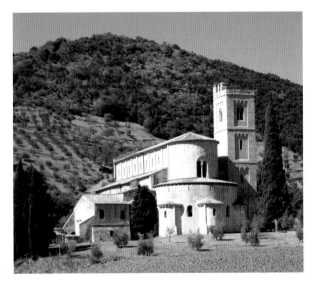

Sant'Antimo, east end.

61

MONTE OLIVETO MAGGIORE

❧

IN 1315 THE young Sienese noble, Bernardo Tolomei, withdrew with two companions to a remote estate of his family in the crete, then known as the Deserto di Ancona. His monastery was recognised two years later and in 1344, under Pope Clement XI, it accepted Benedictine rule. Tolomei and his companions must have followed the Via Cassia before turning left to climb into the undulating hills. But they will not have seen, as we do, the plantation of trees on the steeply shelving ridge that now shelters the monastery.

The visitor descends to a substantial fortified gatehouse begun in 1393 and continues downhill, passing a cistern, to reach the apse of the great church, constructed between 1400 and 1417. At a right angle to the façade of this is the door to the monastery. Within this a passage to

the left leads to the corner of the fairly named Chiostro Grande, built in stages from 1426 onwards. The cycle of scenes from the life of Saint Benedict, begun in 1498–9 by Luca Signorelli and completed in the following decade by the Lombard Giovanni Antonio Bazzi, Sodoma, is one of the great narrative masterpieces of Renaissance painting. Long exposure to the elements has compromised the condition of many of the frescoes, but these have not deteriorated significantly since the Sienese photographer Brogi recorded them from the 1860s. And both painters were instinctive narrators, with comparable gifts of observation and interests in incident. The sequence begins on the east wall.

The great church is gained from the passage at the north-east corner of the cloister with Sodoma's mural of Christ bearing the Cross. The intarsie of the choir are by that great master of the craft, Fra Giovanni da Verona. The smaller Chiostro di Mezzo is reached from the south side of the Chiostro Grande. The rectangular Chiostro Piccolo is to the right of this. A stair from the Chiostro di Mezzo, with

Sodoma, The Departure of St Benedict from his Family to Study in Rome, fresco (detail).

a further, if eroded, fresco by Sodoma, leads to the first floor, from which a further flight Climbs to the library, which, like the *intarsie* of the door, was designed by Fra Giovanni. Here, as elsewhere at Monte Oliveto Maggiore, we feel close to the pulse of monastic life in the Renaissance: it is easy to understand why Bernard Berenson chose to be received into the Roman Catholic church in such a place.

The road northwards across the hills twists down to the modest town of Asciano. The great *Assumption* painted for the town by Matteo di Giovanni is now in London. But when I first knew this, the small museum housed a constellation of Sienese masterpieces in one room: Ambrogio Lorenzetti's *Saint George*; the impeccable triptych by Pietro di Giovanni d'Ambrogio; the *Birth of the Virgin* that is the grandest achievement of the Master of the Osservanza, whose works are now widely thought to represent an early phase of Sano di Pietro's development; and a fine group of panels by Matteo di Giovanni. The now much larger museum deserves to be better known.

62

PIENZA

❖

THE PICCOLOMINI FAMILY held the village of Corsignano, spectacularly placed on a long hill, in still untrammelled country between the towns of San Quirico – on the Roman Via Cassia south of Siena – and Montepulciano. Enea Silvio Piccolomini was born there in 1405; humanist, poet and diplomat, he was elected to the papacy in 1458, taking the name Pius II. Within a year his project to transform the place into a modern city, renamed in his honour, was begun under the direction of the Florentine architect Bernardo Rossellino. The project was far from finished at the pope's death in 1464, but Pienza remains the finest fifteenth-century planned city in Italy.

The approach is from the west – the road from both Siena and Rome. The Via del Corso leads to the central piazza, with a well of 1462 by Rossellino. On

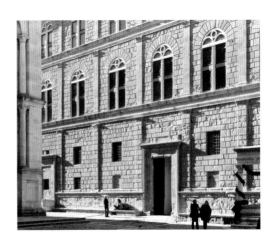

Bernardo Rossellino, Palazzo Piccolomini, 1459–63.

Museo Diocesano:
Sano di Pietro,
Saint Catherine
of Alexandria
(detail of triptych).

the right is the façade of the cathedral, which was completed in the same year. This is flanked by the Palazzo Vescovile adapted for Cardinal Rodrigo Borgia, the future Pope Alexander VI, and the Palazzo Piccolomini, built between 1459 and 1463 by Rossellino in the most up-to-date Florentine mode; opposite are the much-restored Palazzo Comunale and the palace built for the pope's friend, Cardinal Giacomo Ammannati.

The cathedral replaced a Romanesque priory. Like so much Sienese architecture and painting of its period – 1459–62 – this is still Gothic in taste. The structure was too massive for the site and buttresses were needed to support the choir, which was built out to the very extremity of the hill. The interior is restrained, with elegant choir stalls, again of 1462, also of gothic form. The five altarpieces were all painted in Siena between 1461 and 1463. The most remarkable is in the chapel to the left of the high altar, Vecchietta's *Assumption of the Virgin*. Sculptor-cum-painter Vecchietta was an artist of deep originality, aware of, but not overawed by, the achievement of Florentine contemporaries. The other altarpieces

are more conventional. One is by the consistently individual Giovanni di Paolo, another by that most predictable Sienese master of the age, Sano di Pietro, and two are relatively early works of Matteo di Giovanni, who was to influence most of the emergent Sienese artists of the following generation. Seen together in their proper setting, the five pictures offer a microcosm of Sienese painting of the period.

The Palazzo Vescovile now houses the Museo Diocesano. The great treasure is the fourteenth-century *opus anglicanum* cope presented to the Duomo by the pope and now named after him. England was famous for her medieval embroidery, and the Pienza cope, with its scenes from the lives of Saints Catherine of Alexandria and Margaret of Antioch and of the Virgin, shows why. The vigorous detail parallels that of contemporary illuminated manuscripts. The pictures include an exceptionally well-preserved *Madonna* by Pietro Lorenzetti and an impeccable early triptych by Sano di Pietro.

Had Pius II reigned longer more palaces would have been constructed by favoured cardinals. As it is, there is a happy contrast between the buildings at the heart of the city which he willed into existence and the more modest houses lining the main street. There are marvellous views over the surrounding country, where, alas, traditional methods of agriculture are in retreat.

Two nearby churches deserve to be seen. The unassuming Romanesque Pieve di Corsignano – with the font in which Pius II was christened – is a kilometre or so to the west. Rather further, north of the road to San Quirico, is the monastery of Sant'Anna in Camprena. Opening times are capricious, but if they can be seen, the spirited frescoes by Sodoma more than justify the detour.

63

MONTEPULCIANO

✿

PIENZA'S NEAR NEIGHBOUR, Montepulciano, is equally remarkable, yet very different in character. An Etruscan foundation, the town was fought over in the early medieval period by Siena, Arezzo and subsequently Florence, which was in effective control from 1290 except for a brief period in 1495–1511 when the

Petrucci of Siena gained control. But even under Florentine dominance, Siena had a strong artistic influence.

The town is best approached from the north-east through the restored Porta al Prato, which marks the start of the winding spinal street, the Via Roma, for which Montepulciano is justly celebrated. The sequence of palaces begins with the Palazzo Avignonesi at no. 37 on the right, and the Palazzo Tarugi opposite this, both attributed to Vignola. A little further up, on the right, is Sant'Agostino with a distinguished front by the

Montepulciano, with San Biagio.

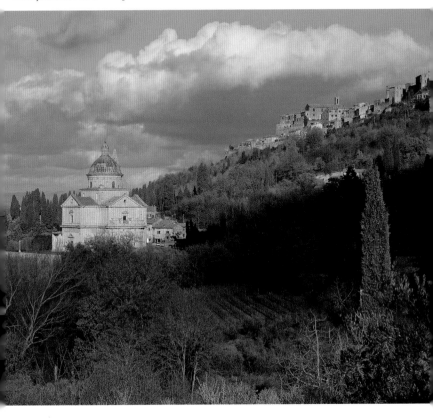

Florentine sculptor Michelozzo, a fine relief of the Madonna by whom is above the door. Further on, in Via Cavour, to the left, is the Palazzo Cervini, designed by the elder Antonio da Sangallo. A street opposite the further corner of this leads to the Via Mazzini. Turn left, leaving San Francesco on the right. The Museo Civico in the Palazzo Neri-Orselli-Bombagli on the left houses a representative and well-arranged collection of Tuscan pictures. Ahead is the Piazza Vittorio Emmanuele, on the far side of which is the cathedral. To the right is the dignified fourteenth-century Palazzo Comunale; and on the left the Palazzo Tarugi, formerly Nobili, given to Vignola and, set back, the Palazzo Contucci begun in 1516 by Sangallo and finished by the Sienese painter, Baldassare Peruzzi.

The façade of the cathedral is less distinguished than those of its neighbours. The interior, begun in 1592 on the site of an earlier church, is notable for two great works of art. Immediately to the left of the main door is the remarkable effigy from Michelozzo's dismembered tomb of Bartolomeo Aragazzi, secretary to Pope Martin V. This and the other fragments of the tomb in the cathedral are the sculptor's signal achievements. Happily the great high altarpiece of 1403 by the Sienese Taddeo di Bartolo survives

intact. The main panel represents the *Assumption of the Virgin*: the *Annunciation* and the *Coronation of the Virgin* are shown in the pinnacles, scenes from the Passion and saints in the predella and further saints in the lateral pilasters. Taddeo was an uncompromising artist; and his glowing polyptych leaves the viewer in no doubt of his fervour.

As the great altarpiece and the distinction of its palaces demonstrate, Montepulciano was a place of considerable wealth. This made possible the construction of what is unquestionably its outstanding monument, the great church of San Biagio on a terrace below the town to the north-west. The 'discovery' of revered images led to a competitive wave of church-building throughout Italy. San Biagio was begun to the design of Sangallo in 1518, but in view of its ambitious scale it is hardly surprising that the church was not completed until 1545. The masonry is of a mellow travertine. The plan is cruciform, with detached campaniles, one never finished, set between the arms of the cross flanking the entrance front on the north: from every viewpoint it is the prodigious dome that dominates. The building is externally a masterpiece, but the cavernous interior is perhaps less successful.

64

CORTONA

❖

THE OLD ROAD south from Arezzo fol-
lows the line below the hills that flank
the Val di Chiana. This passes the town
of Castiglion Fiorentino and the spec-
tacular castle of Montecchio Vesponi,
once owned by the English *condottiero*
Sir John Hawkwood. Then the ancient
city of Cortona comes into view. The
main road twists up the hillside, pass-
ing the greatest of the Cortonese villas,
built for Cardinal Silvio Passerini. It is
no longer possible to drive through the
Porta San Domenico, so the motorist
should follow round the town walls to

the left, your reward a splendid section
of Etruscan polygonal masonry. A short
walk from the Porta Colonia leads to the
Piazza del Duomo.

The cathedral itself is not particularly
remarkable, but the Museo Diocesano in
the former church of the Gesù opposite
most certainly is. Among Tuscan muse-
ums of the kind, only that at Asciano,
admittedly much smaller, boasts so high
a proportion of masterpieces. Fra Angel-
ico's *Annunciation* from the church of San
Domenico is indisputably the finest of
his several altarpieces of the subject. The
Angel is inexorable in his message, the
Virgin perfect in her submission to it.
The predella too is of the utmost refine-
ment; in the *Visitation* the painter shows
the view from the town, with hills to the
left, the level valley on the right and in

Museo Diocesano: Fra Angelico, Saint Dominic raising Napoleone Orsini, *predella panel*
(detail).

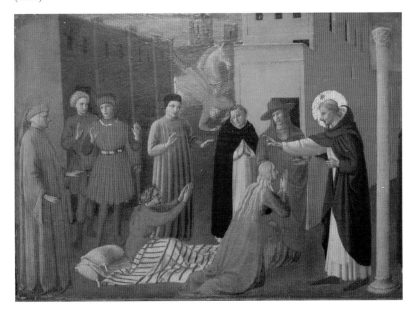

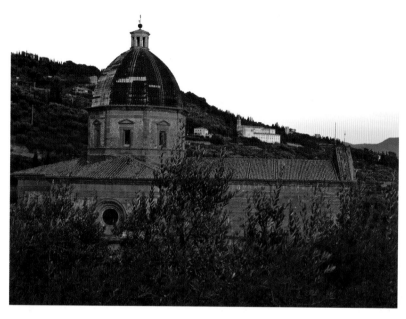

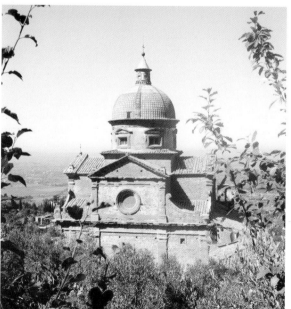

Above: Santa Maria del Calcinaio: designed by Francesco di Giorgio, begun 1485.

Left: Santa Maria Nuova: designed by Giorgio Vasari and executed by Cristoforo Infregliati, 1550–4.

the distance Lake Trasimene. The frate's own monastery was associated with San Domenico, for which he also supplied a polyptych, which happily survives with its predella. Cortona had for over a century turned to Sienese painters, including Pietro Lorenzetti. This tradition was represented by the polyptych of the mid-1430s, also from San Domenico, by Sassetta. He was well aware of the challenge posed by Fra Angelico and rose to it with his innate poetic conviction.

The Cortonese could claim no artistic school of their own. The sculptor of the font by the *Annunciation*, which used to be attributed to the wonderfully named Cuccio di Nuccio, would hardly have been employable in Florence. But the town can boast one painter of genius, Luca Signorelli. Downstairs is a room with a significant group of late altarpieces by him, the finest his *Deposition* of 1502. Nearby is the remarkable cope with embroidery designed in 1525 for Cardinal Passerini by no less an artist than Andrea del Sarto. The frescoes in the lower church were an early project of the Aretine Giorgio Vasari, who in his childhood had known Signorelli.

There is much to see in the town. The Accademia Etrusca in its eighteenth-century heyday received self-portraits from Zoffany and Northcote. Although Fra Angelico's altarpieces have gone, there is a frescoed lunette by him at San Domenico. And the church contains an exceptionally complete late gothic altarpiece by Lorenzo di Niccolò – supplied second-hand by the Medici – as well as a masterpiece of Signorelli's early

collaborator, Bartolomeo della Gatta. The *Assumption of the Virgin*, like the frescoed *Saint Jerome* of the cathedral at Arezzo, shows that Bartolomeo came close to being a painter of genius.

The energetic can walk uphill, passing several small palaces and a good bust of one of the Tomassoni, for porticoed San Niccolò with its *Dead Christ with Saints* by Signorelli, simple yet of power. Higher still is the ugly sanctuary of Santa Margherita of Cortona, redeemed by the saint's sculptured tomb of 1362 and by a late masterpiece of the Sienese Counter-Reformation, Francesco Vanni's visionary *Immaculate Conception*. At the apex of the hill is the well-named Castel del Girifalco (gyrfalcon).

Below the walls of the town, respectively to the south and the north, are two domed churches, Santa Maria del Calcinaio (lime-worker) and Santa Maria Nuova. The former, of Latin-cross plan, was begun in 1485, apparently to the design of that most versatile of Sienese artists, Francesco di Giorgio; with its crumbling *pietra serena* enrichments, this exemplifies the controlled classicism of the late *Quattrocento*. Santa Maria Nuova, by contrast, is centrally planned. The design was due to Vasari, but the executant mason was a local man, Cristoforo Infregliati. Built in 1550–4, the church deserves to be open more regularly than it is. Foundations of the kind mushroomed in the area during the Renaissance, as towns competed to commemorate miraculous visions like that of the Cortonese lime-worker who saw an image of the Virgin.

65

AREZZO

❧

AREZZO IS A confident city. Its ancient core, the successor of the Umbrian and Roman Arretium, descends the west-facing slope of an outlier of the hills to the east. The town is at the intersection of ancient routes – that from the north from the Valdarno running southwards down the side of the Val di Chiana, and the road across the mountains from the Adriatic – and Arezzo was the natural entrepôt of a productive agricultural area.

The approach from the west is not prepossessing. For the walls now protect the city from the enemy of our times, intensive development. The driver should use one of the car parks outside the southern section of the wall, and cut across to the central Corso Italia. The tourist with limited time will rush on to San Francesco. But the secret of sightseeing is to make time. So I would begin with the beautiful and well-restored Santa Maria della Pieve, on the right of the street, a paradigm of the Tuscan Romanesque with its tiers of columns, tympanum and splendid detached campanile. The interior does not disappoint. The high altar – with an admirable and appropriate polyptych by Pietro Lorenzetti – is raised above a generous crypt. Leave by the side door to see the external treatment of the apse from the Piazza Grande.

Continue up the Corso Italia, passing the shield-studded Palazzo Pretorio, and follow round to the Via Ricasoli with the lateral façade of the cathedral on the right. This major gothic building has also

been restored. Few Italian churches are richer in early sculpture, and none perhaps boasts finer early sixteenth-century glass than the sequence of windows of 1520–6 by the French-born Guglielmo de Marcillat. Piero della Francesca's static *Saint Margaret* is on the left wall by the door to the sacristy, in one of the rooms of which is a detached fresco of *Saint Jerome in the Wilderness* by an outstanding local artist of the following generation, Bartolomeo della Gatta. Bartolomeo never disappoints. Saint Jerome is set in his rock-strewn vision of the desert of Calchis.

The importance of Arezzo to the Medici is implied by the statue of Grand Duke Ferdinando I beside the cathedral; designed by Giambologna, it was executed by his assistant, Pietro Francavilla. Continue northwards and take the first turn to the right for the least well-known of the great churches of Arezzo, San Domenico. The front offers no hint of what is within, an unrivalled series of murals by Aretine masters of the late medieval period, notably Spinello Aretino and his son Parri Spinelli. Spinello is unfailingly efficient, while Parri evolved an idiosyncratic gothic idiom suggesting an obstinate indifference to the artistic preoccupations of his Tuscan contemporaries. The greatest work of art in the church, suspended above the choir, is the *Crucifix* by Cimabue, one of the signal masterpieces of the late *Dugento*.

On leaving the church, turn right and take the second street on the left. Almost immediately on the right is the Casa di Vasari, where works by the Aretine writer-cum-artist, Giorgio Vasari have been assembled. There are further pictures by Vasari in the Museo Civico just to the right of the further end of the street. The museum also houses one of

the finest public collections of maiolica in Italy. Diagonally opposite the museum is the Via Cavour. Follow this, passing a small piazza with the church of Santissima Annunziata, with an external fresco of the subject by Spinello, and the Badia, with a high altar by Vasari that was originally in the Pieve, for the piazza of San Francesco.

Arezzo-centric as Vasari was in the *Vite*, which has left its mark on all later accounts of early Italian art, he would be surprised by our reverence for Piero della Francesca. San Francesco is an austere barn of a church, with a choir flanked by lateral chapels. Lorenzo di Bicci had been called in to decorate the choir in 1447, but fortunately had only completed the vault when he died in 1452. Piero was subsequently enlisted. His was a rare intelligence. He understood what he could achieve and what he could not, and how the play of light could infuse his nobly static forms. The legend of the True Cross is related in three tiers of compartments flanking the central window and on the lateral walls, which are visually anchored in their setting by the vividly coloured fictive marble facings below. Influenced in youth by Fra Angelico, Piero was an artist of conviction: the Virgin accepts the announcement of her impending death from the Angel with an impassive composure; the Emperor Constantine dreams, oblivious of his servants; and the Queen of Sheba's bearing is echoed by the deportment of her attendants. We witness the melée of two battles, with the trampling of hoofs and the lowering

Cathedral: Bartolommeo della Gatta, Saint Jerome, fresco (detail).

of lances; we see the resolve of the just victors and the fear of the fallen, yet share the painter's detachment from them. Like other very great artists, Piero carried his style to its logical conclusion. As one can see elsewhere in the church, his example certainly overwhelmed his follower Lorentino; it must also have puzzled Vasari, and evoked little wider interest until the mid-nineteenth century. Piero's reputation now rests on his very restraint, on the subtle logic of his compositional architecture and above all on the classic integrity of his types.

66

LA VERNA

❖

THE RELIGIOUS HAVE always been drawn to remote places, and the visitor to Tuscany should try to see some of the monasteries that made so important a contribution to spiritual life. Southeast of Florence, on the flank of the Pratomagno, is Vollombrosa, which gave its name to the monastic order instituted by San Giovanni Gualberto and haunted the imagination of Milton. Across the hills to the east is Camaldoli,

where the order of that name was founded by Saint Romuald. Further south is La Verna, then a wild fastness, to which Saint Francis withdrew in the company of Fra Elia (Brother Elias), who witnessed his stigmatization there on 17 September 1224.

The main approaches from Bibbiena and Pieve Santo Stefano climb steeply, for the mountain is 1,283 metres high. It takes its name from the dense woodland that crowns the Monte Penna. Inevitably La Verna became a place of pilgrimage, and this it very much remains, with a cluster of small buildings often crowded with the devout.

The visitor now enters through an

Chiesa Maggiore: Andrea della Robbia, Annunciation, *glazed terracotta.*

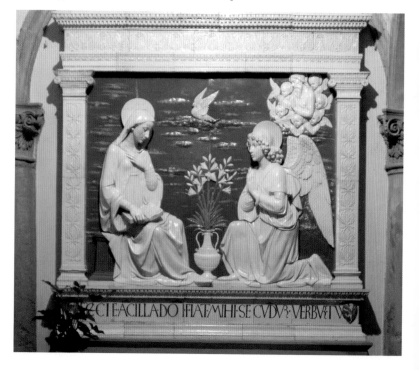

arch and follows a passage, eventually arriving in the irregular central court by the main church. Cross this to the modest gate to which pilgrims formerly climbed. Their first sight on entering, ahead and to the right, was the small church of Santa Maria degli Angeli, first built in 1216–18 by Count Orlando dei Cattani, who had given the mountain to Saint Francis. The interior is subdivided by lateral altars with polychrome glazed terracotta reliefs by Giovanni della Robbia that contrast with the restrained tonality of Andrea della Robbia's main altarpiece of the *Virgin entrusting her Girdle to Saint Thomas*. To the right of the church is a corridor that leads to the small museum, with a handful of pictures and a collection of vestments. The processional route continued to the Chiesa Maggiore, begun in 1348. Nowhere perhaps is Andrea della Robbia, the gifted son of his father Luca, seen to better effect. The grandest of his reliefs in the church is the *Ascension*, but Andrea's genius as a religious artist is more perfectly expressed in two ostensibly less ambitious compositions, the *Adoration* and the *Annunciation*, in both of which his disciplined palette, predominately of blue and white, is particularly successful.

From the chapel the pilgrim proceeds through the Corridor of the Stigmata to the small Chapel of the Stigmata dominated by the glazed altarpiece of the *Crucifixion* by Andrea della Robbia that has some claim to be his masterpiece. Certainly this is among the more compelling religious images of its time.

La Verna remains a place of rare beauty, not least in September when the woods are carpeted with pale pink cyclamen. It has, too, an unexpected magic when mist shrouds the unpretending buildings.

67
BORGO SAN SEPOLCRO

❖

THE MOST NORTHERLY major town of the Tiber Valley, Borgo San Sepolcro lies at the junction of two great historic routes, that from the Romagna in the north to Perugia and eventually to Rome, and the road that crosses the Trabaria Pass to the east, linking the Adriatic coast with the Tuscan heartland. Fought over by local families and powers, and controlled by the papacy for much of the fifteenth century, the town was a major prize when it fell to Florence in 1515.

Pinacoteca Comunale: Piero della Francesca, Resurrection, fresco (detail), c. 1463.

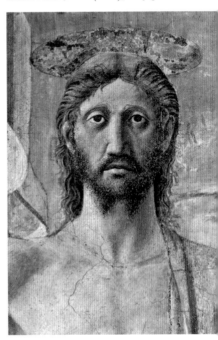

Massive fortifications attest to Borgo's importance as a frontier fortress. That the town had long acclimatized itself to Florentine taste is demonstrated by the career of its outstanding artist, Piero della Francesca, whose mentors were Fra Angelico and Masaccio. Piero, so long overlooked, has now been a cult figure for almost a century. His sphere of activity was, to a remarkable extent, dictated by geography. His major commissions were all for places in direct reach of his native town: Rome and Perugia to the south, Ferrara to the north, Arezzo to the west, and to the east Urbino and Rimini. Furthermore, Piero's Riminese patron, Sigismondo Malatesta, obtained

Citerna – hardly ten kilometres from Borgo – which overhangs the cemetery of Monterchi, from which Piero's fresco of the *Madonna del Parto* was recently hijacked by the authorities of that town. The prodigious fresco cycle at Arezzo is, of course, Piero's grandest achievement. Yet it is surely at Borgo San Sepolcro that the painter is best understood.

The Palazzo Comunale is sadly no longer entered from the Via Matteotti but from a side door. The visitor is advised to move briskly through the first rooms. Piero's polyptych of the *Madonna della Misericordia* was an early commission, although it was not completed until about 1460. The Madonna

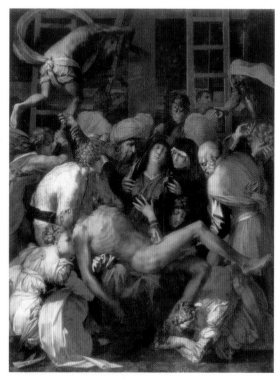

San Lorenzo: Rosso Fiorentino, Deposition.

is of an aulic beauty, and the spectator was not intended to doubt that the citizens and their women who sheltered beneath the mantle were right to trust to her protection. The flanking saints have, perhaps, a more tentative quality, and certainly lack the tension of the *Crucifixion* which originally surmounted the Madonna and is now at Naples. But it was only in the predella that Piero subcontracted to assistants.

The Resurrection is the symbol of Borgo San Sepolcro – the observant will already have noticed Niccolò di Segna's Ducciesque interpretation of this in his polyptych in an earlier room. Piero's celebrated fresco of the subject thus had an especial significance for the inhabitants of his town. Our eye moves upwards from the sleeping soldiers to Christ. He rises, as if by an inexorable force, from the sarcophagus, his face at once impassive and serene. Behind stretches the landscape that Piero knew so well, living and verdant on the right, desiccated like that he would have seen on the Bocca Trabaria to the left. Inexorable in logic and timeless in message, the *Resurrection* is Piero's absolute masterpiece.

Dazed, and perhaps humbled, the tourist leaves. The town has more to offer. Diagonally across the Via Matteotti is the cathedral, with an early copy of the *Volto Santo* at Lucca, a fine example of the early medieval pigmented wooden sculpture of which so much survives throughout Italy.

Borgo San Sepolcro is laid out on a grid plan. Leaving the cathedral, turn left and keep straight on, until forced a block to the right, passing a particularly fine crumbling palace and other substantial houses. At the opposite side of the town is San Lorenzo, a church that is sometimes closed, but where a nun from the adjacent monastery is usually in attendance.

On the altar is a picture that was as compellingly original as Piero's *Resurrection*, the *Deposition* by that visionary genius of the Florentine High Renaissance, Rosso Fiorentino. Like other major artists of his generation, Rosso gravitated to Rome. When it was sacked by the imperial forces in 1527 he withdrew to Umbria, designing altarpieces for Perugia and the miracle church at Castel Rigone, high above Lake Trasimene, and himself painting that of the cathedral at Città di Castello. The *Deposition* was painted in 1528–30. It is a deeply pondered drama, wrought to an extraordinary emotional pitch, for Rosso's charged colour is matched by the intensity of his figures. His was a restless spirit which found a supreme expression in this altarpiece, painted for a relatively obscure setting in a lesser provincial town. We are fortunate that it remains there. For the fervent dynamism of the *Deposition*, reflecting an inner turbulence that must have been sharpened by circumstance, only enhances our understanding of the spiritual confidence of the impassive *Resurrection*. Both pictures convey that sense of the inevitable which is a characteristic of the very greatest works of art.

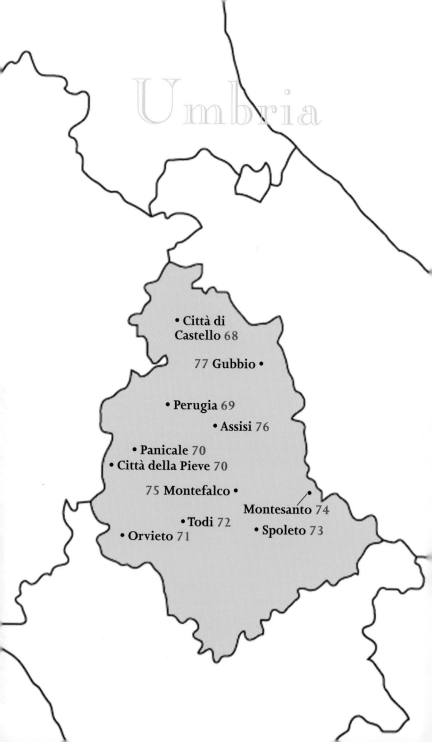

Umbria

• Città di
Castello 68

77 Gubbio •

• Perugia 69

• Assisi 76

• Panicale 70
• Città della Pieve 70

75 Montefalco •

•
Montesanto 74

• Todi 72 • Spoleto 73
• Orvieto 71

68

CITTÀ DI CASTELLO

❖

THE SUCCESSOR OF the ancient Umbrian Tifernate and the Roman Tibernium, Città di Castello was a commune, free at times but at others subject to the papacy, to Perugia and to Florence. Braccio Fortebraccio of nearby Montone took the city in 1422 and later the Vitelli family secured the *signoria*. Papal suzerainty was reasserted by Cesare Borgia, but the Vitelli remained in effective control for much of the *Cinquecento*. The place paid a heavy price during the French occupation, losing Raphael's *Marriage of the Virgin*, which was taken to Milan, and other masterpieces. But there is still much to see within the irregular rectangle of the brick city walls to the north-east of the river Tiber.

The civic and religious heart of Città di Castello is the Piazza Gabriotti. The gothic Palazzo Comunale of 1334–52 by Angelo da Orvieto was never completed, and is memorable not least because so much of the eroded rusticated masonry is original. Beside it is the much-remodelled Duomo, with a beautiful gothic sculptured portal on the north front facing the square. The interior was reconstructed during the Renaissance. The cathedral museum contains the remarkable twelfth-century silver-gilt altar front associated with Pope Celestine II, as well as early Christian silver found at Canoscio. Rosso Fiorentino's visionary *Transfiguration*, painted with evident haste after the Sack of Rome in 1527, formerly almost inaccessible in the transept, loses in impact now that it can no longer be seen from below.

Just within the southern line of the town wall is the Palazzo Vitelli alla Cannoniera, built for Alessandro Vitelli, who called in the younger Sangallo, between 1521 and 1532; it now houses the Pinacoteca Comunale. The museum used to be little visited, and the custodian got so accustomed to my turning up alone or with fellow guests that he just handed me the keys. Things now are very different. The collection is admirably displayed, and justice is done to some very remarkable things: the noble *Maestà* by one of Duccio's most intelligent associates, known appropriately as the Master of Città di Castello; a fine *Madonna* by Spinello Aretino; Signorelli's dramatic *Martyrdom of Saint Sebastian*;

Cathedral, north door (detail), relief of Mercy.

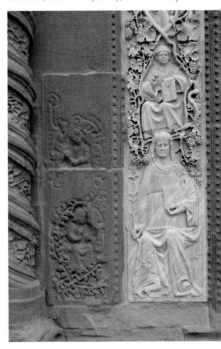

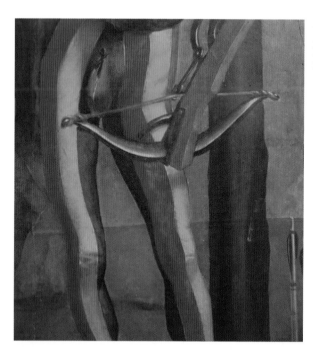

Pinacoteca:
Luca Signorelli,
Martyrdom of
Saint Sebastian
(detail), c. 1498.

and the standard that is the only one of the civic commissions awarded to the young Raphael to remain. Recent additions include the Ruggieri collection with de Chirico's *Piazza d'Italia*. Much of the original decoration of the palace survives, including a series of accomplished coastal landscapes set in *grotteschi* by Cristoforo Gherardi, who came from Borgo San Sepolcro, in the *salone*. The *sgraffito* decoration of the garden front is a rare survival.

Elegant as the palace is, it was evidently upstaged by the much larger Palazzo Vitelli a Porta Sant'Egidio, the city's main east gate, which was designed for Paolo Vitelli by Vasari. The Bolognese Prospero Fontana was called in to decorate the main *salone* with appropriately

pompous scenes from the history of the family. Altogether more congenial are the murals in a loggia of the annexed Palazzina, now used by a bank whose officials are, at least in my experience, tolerant of sightseers; these also are by Gherardi.

Those who are drawn to the area for the work of Piero della Francesco may wish to see the only signed panel by Giovanni da Piamonte, on the basis of which he has been identified as an assistant of the master at Arezzo. Dated 1456, this shows the *Madonna and Child between Saints Florido and Filippo Benizzi*. Generally covered as an object of veneration, this is in an oratory in the church of Santa Maria delle Grazie in the northern part of the town.

69

PERUGIA

LIKE SO MANY ancient cities, Perugia has long outgrown her early walls, and much of the new town is remorselessly ugly. For that reason, the most appealing approach is from the north-east, the steep ascent from Ponte Rio, which rises to the earliest of the great monuments of the city, the Etruscan Arch of the inner enceinte. Through this, climb the narrow street to the flank of the cathedral and the piazza on the further side which is the true centre of the city. This is an irregular space, sloping downwards from the lateral façade of the church. At the centre

is Giovanni Pisano's Fontana Maggiore, begun in about 1275 and one of the masterpieces of its age, and beyond is the vast medieval complex of the Palazzo dei Priori, long the administrative hub of the city. Like so many Italian cities in the Middle Ages, Perugia was fought over by internal factions and external powers. Her dramatic history is implied by the loggia added to the cathedral by Braccio Fortebraccio from Montone, who in the 1420s came so close to carving out an Italian kingdom for himself, by the external pulpit at which San Bernardino of Siena preached, and by the superlative bronze statue of 1555 by the Perugian sculptor Vincenzo Danti of Pope Julius III, symbol of the authority that for over three centuries exercised a firm political control.

Perugia, with Assisi below the Monte Subasio in the distance.

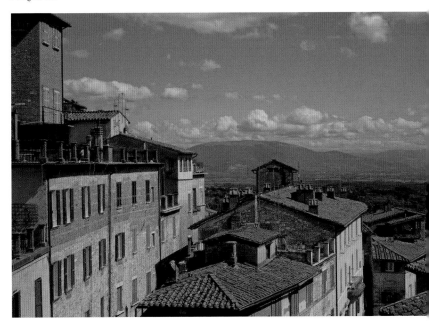

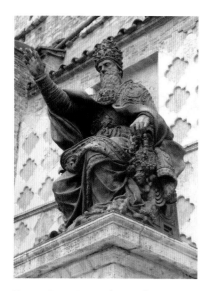

Vincenzo Danti, Pope Julius III, bronze, 1555.

Perugia is a palimpsest. A quietly baroque façade may mask a medieval building, which in turn might overlie an Etruscan structure – as the Palazzo Sorbello does the remarkable Etruscan well. The churches, too, have for the most part been adapted to successive waves of taste; and because Bonaparte's lieutenants had so clear an understanding of the importance of the greatest local painter, Pietro Vannucci, il Perugino, the city suffered grievously from their depredations. Thus it is that the two great altarpieces in the cathedral are both by outsiders, Signorelli from Cortona and Federico Barocci from Urbino, whose great *Deposition* must rank as one of the major masterpieces of the Counter-Reformation: their erstwhile companion, Perugino's *Marriage of the Virgin*, is now at Caen.

The French could not bear off Perugino's frescoes of the Collegio del Cambio,

just beyond the Palazzo dei Priori. The decoration of the Audience Chamber, with the *Nativity* and *Transfiguration* flanked by classical heroes and sibyls under a vault of *grotteschi* of classical deities, is complemented by the equally meticulous woodwork: the painter's direct and unpretending self-portrait in a fictive frame is set between his lines of heroes. High in the Palazzo dei Priori is the recently rearranged Galleria Nazionale dell'Umbria, which offers a matchless survey of painting in Perugia from the late thirteenth century. Nowhere else are such artists as Giovanni Boccati, Benedetto Bonfigli, Bartolomeo Caporali and Fiorenzo di Lorenzo so well represented, and the eight panels of miracles of San Bernardino painted in 1473 by Perugino, Pinturicchio and others are among the happiest achievements of the Umbrian *Quattrocento*. Masterpieces by artists from Tuscany, Duccio and Fra Angelico and Piero della Francesca, testify to the range of Perugian patronage, but the loss of so much to the Vatican and the museums of provincial France means that the story is incomplete.

From the central hill on which the Etruscans originally built, Perugia extended a tentacled grip over the ridges to north and south. From the Porta Sole – near the church of San Severo with Raphael's earliest extant frescoes – you can see the northern area of the city; the ground falls away to the walls and the Etruscan Arch. Opposite this is the large Augustinian church and then the long ridge beyond, with monasteries where nuns will show their treasures and the huge brick Porta Sant'Angelo near the – much restored – early circular church of that saint. The young Raphael placed Saint Jerome before this view in a drawing now at Oxford.

Perugia's most dramatic street is the narrow Via dei Priori that plunges northwards under the Palazzo dei Priori: there are medieval houses, the uppermost now shops; a few *palazzi*; the unexpectedly coherent baroque Chiesa Nuova with an unfamiliar masterpiece, Francesco Trevisani's *Annunciation*; the Oratorio of the Disciplinati di San Francesco, one of the confraternities by the membership of which the noblemen of Perugia set such store; a small Renaissance chapel, the Madonna della Luce designed by Giovanni Battista Caporali, painter and translator of Vitriuvius; and not least, nestling beside the pink and white mass of the former church of San Francesco al Prato, the Oratorio di San Bernardino. This was constructed in 1457–61 when the cult of the reformist Sienese monk was at its most fervent; its glory is the polychrome façade with reliefs by the Florentine sculptor Agostino di Duccio, who had learnt the precepts of his fellow Florentine, the architect and classical theorist Leon Battista Alberti, but interpreted them with his own lyricism of line.

Another memorable walk takes you from the piazza to its southern counterpart, the Piazza del Sopramuro (now Matteotti) flanked by the long fifteenth-century façade of the Palazzo del Capitano del Popolo. At the south-western corner a street twists downwards, lined now with shops, to the medieval façade of the church of Sant'Ercolano. This has hardly changed since it was depicted in Benedetto Bonfigli's mural of the mid-*Quattrocento* in the Palazzo dei Priori. Below this, you join the main artery leading south to the two grandest churches of the city. First comes that of the Dominicans, vast and rather bare. The east window boasts some of the most ambitious stained glass of its date – 1402 – in Italy; nearby is the

canopied gothic tomb of Pope Benedict XI. A truncated altarpiece by Agostino di Duccio and fragments of fourteenth-century frescoes show how rich the church originally was. The convent was of commensurate scale and now houses the Museo Archeologico. Etruscan funerary urns may pall, but the reconstruction of the tomb of the Cai Cutu family, found by chance in 1983, does not. And the sixth-century BC bronze fittings of a carriage from Corciano are exceptional survivals.

Further south is one of the least expected monuments of mid-fifteenth-century Perugia, the Porta San Pietro. Inspired by Roman example and designed by Agostino di Duccio, this was the most ambitious Albertian structure of the period in Umbria. Beyond, outside the walls, is the monastery of San Pietro, whose pencil-sharp hexagonal campanile designed by the Florentine Bernardo Rossellino (1463–8) is one of the landmarks of Perugia. The church is reached through an atrium. Basilical in plan, it is richly furnished. The narrative *intarsie* of the choir of 1536 by Fra Damiano da Bergamo are surpassed by none of their date in Italy. Of Perugino's large high altarpiece, only four predella panels remain, but otherwise the Benedictines were able to preserve most of their treasures. Eusebio da San Giorgio's *Adoration of the Magi* is the only major Peruginesque altarpiece to remain in any Perugian church, although, perversely, its predella is now placed under another picture. Canvasses by the Perugian Giovanni Domenico Cerrini, the Marchigian Sassoferrato, the Orvietan Cesare Sermei and the Roman Giacinto Gimignani remind us that despite firm papal control Perugia was not altogether a backwater in the seventeenth century.

70

PANICALE and CITTÀ DELLA PIEVE

❧

THE SMALL TOWN of Panicale crowns one of the chain of small hills to the south of Lake Trasimene. There are views down across the lake, with, to the left, the promontory of Castiglione del Lago with its cinquecento palace of the della Corgna, and, to the right, the Isola Polisena, whose church boasts the grandest of Perugian Renaissance cruci-fixes. But it is not for these, nor for the cluster of buildings round the hand-some Collegiata, that we have come. A little way to the east is the small church of San Sebastiano. Here in 1505 Perugino painted a fresco of the martyrdom of the saint. Much admired in the nineteenth century, this is hardly à la mode. Sebastian awaits his fate with a calm indifference; the tightly silhouetted archers are more elegant than menacing, balletic almost in their motions. Behind is an arcade of admirable simplicity through which

we see the lake framed by descending ridges.

Perugino's idealized forms were matched by his inspired response to the landscape he knew so well, and it was through this that his influence would endure for centuries. Born Pietro Van-nucci, the painter belonged to a mod-erately prosperous family of Castel del Plebis, now Città della Pieve, some twen-ty-five kilometres to the south-west. When age and changing taste meant that Perugino had fewer commissions from patrons elsewhere, he returned to work in his native territory. The best known of his frescoes at Città della Pieve is the rather laboured *Adoration of the Magi* set above *trompe l'oeil* wainscotting in the Oratorio dei Bianchi. More intriguing is what remains of the *Deposition* in the church of the Servites. Perugino him-self designed the composition, but asked the sculptor Andrea Sansovino to make a model for it, a rare survival now in the Victoria and Albert Museum. Con-scious no doubt of his weakening abili-ties, the veteran painter was nonetheless determined to give of his best. The early campanile of the Duomo is the only significant structure within the walls that Perugino would recognize. Oppo-site this is the handsome but unfinished sixteenth-century palace designed by Galeazzo Alessi for a papal nephew, Asca-nio della Corgna, who called in Niccolò Pomarancio to decorate some of the interiors. With its elegant stone door-case and window-frames, the palace stands out in what one might term the brickscape of the town.

Oratoria di Santa Maria dei Bianchi: Pietro Perugino and studio, trompe l'oeil wainscotting below the Adoration of the Magi, fresco, 1504.

71

ORVIETO

THE FIRST IMPRESSION of Orvieto is unforgettable. The city is perched on a high outcrop, defended by perpendicular cliffs which lour above the valley of the Paglia. The site inevitably attracted the Etruscans, but Orvieto was not, it seems, a town of importance until the sixth century. In the late medieval period, rival families and the papacy vied for control; only in 1450 did the latter finally prevail.

The great striped gothic Cathedral, which was begun in 1290 to celebrate a miracle of 1263, can be seen from the valley. But nonetheless the sheer façade comes as a surprise. The Sienese Lorenzo Maitani superintended the project from 1310 for two decades and oversaw the execution of the remarkable reliefs which encrust the pilasters of the lower tier. The much-restored rose window was designed by the great Florentine artist Andrea Orcagna.

No gothic interior in Italy is more exhilarating in its sense of space. In the left aisle is a frescoed Madonna and Child of 1425 by Gentile da Fabriano, most refined of the late medieval painters of central Italy: the Virgin's pale blue mantle cascades down over the topmost of the steps that relate her to the viewer's visual sphere. To the left of the crossing is the trapezoidal Cappella del Corporale, decorated like the choir with much restored murals by the local late fourteenth-century master, Ugolino di Prete Ilario; the altar used to house one of the great masterpieces of medieval metalwork, Ugolino di Vieri's reliquary of 1337–8, which

is now in the Opera del Duomo. That it cost the almost incredible sum of 1,274 florins demonstrates how much their possession of the Caporale it housed – the altar cloth on which the host was seen to bleed during a mass at Bolsena in 1263 – meant to the Orvietans.

The tourist of today comes to see the Cappella di San Brizio, the Cappella Nuova, on the opposite side of the cathedral. Work on this began in 1409. Fra Angelico was enlisted to decorate the chapel and in 1447 completed, with the help of assistants, two of the eight sections of the vault, Christ in Glory and Prophets, works of unprecedented scale in his oeuvre. The frate was then summoned to Rome and did not return to Orvieto. In 1489 Perugino received a contract to complete the scheme. He did nothing, and a year later his contemporary and erstwhile associate, Luca Signorelli, was called in.

While the scale and character of Signorelli's frescoes of the vault were influenced by those of Fra Angelico, his great wall murals must have seemed startling in their novelty. The Preaching of the Antichrist, the first compartment on the left wall, represents a development from the frescoes of the Sistine Chapel, in which the artist had collaborated: as in the Sistine murals there are obvious portraits. Signorelli's imagination astonishes in the detail of the End of the World, which flanks the entrance arch. The cycle continues at either side of the altar, with angels respectively despatching sinners to Hell and guiding the elect to Paradise; this concludes, in the second section of the left wall, with the Calling of the Elect to Heaven, in which the virtuous are marshalled by a cloud of airborne angels. Yet more extraordinary are the paired frescoes of the right wall, the

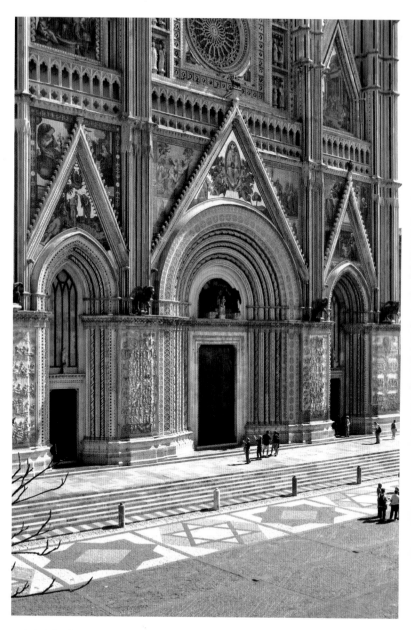

Cathedral, façade projected by Lorenzo Maitani, 1310.

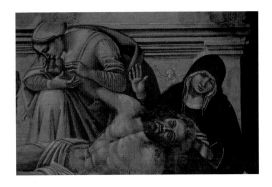

Cathedral: Luca Signorelli,
Lamentation, fresco (detail).

Resurrection of the Flesh and the Damned: in the first, two angels blast on their trumpets as the virtuous rise from the dead to their summons; in the second, devils are in undisputed control, the damned concentrated in a heaving scrum, their screams and laments in vain. No other painter of his generation could have acquitted himself on Signorelli's terms; and although few related studies survive, we know enough about his methods to be left in no doubt that every significant figure was carefully worked out from the human model. Signorelli, like Fra Angelico, was a visionary who understood that plausible observation would convince his audience.

The lower tier of the decoration of the chapel also calls for close examination. The elaborate dado includes half-length representations of poets, including Homer, Empedocles, Lucan, Horace, Ovid, Virgil and Dante. Each is surrounded by four grisaille roundels, which read as reliefs and have a spontaneous vigour. On the right wall is a recessed chapel with what is in effect a fictive sculptured altarpiece of the Lamentation flanked by two saints, Faustino and Pietro Parenzo, who were buried in the chapel. With characteristic acuity Signorelli shows Christ being carried to the sepulchre in the bas-relief in the background.

The Cappella di San Brizio is in every sense an overwhelming experience. Nothing else in Orvieto is on the same heroic plane. But there are other distinguished things to see. Beside the cathedral are the Palazzi Papali. These now house the excellent archaeological museum and the Opera del Duomo. Fine as Simone Martini's Monaldeschi polyptych is, this is outshone by the sculpture from the cathedral, and not least by the dramatic bronze of Saint George. On the opposite side of the town is San Domenico, with the partly reconstructed tomb of Cardinal Guglielmo di Braye – who died in 1282 – by Arnolfo di Cambio, greatest among the followers of the Pisano. At the north-east end of the town, by the castle, is the remarkable Pozzo Rocca. This great well was excavated at the order of Pope Clement VII, who took refuge in Orvieto in 1527–8 after the Sack of Rome. It was designed by the Florentine architect Antonio da Sangallo the Younger; there are two flights of stairs, each of 248 steps. Descending one of these, it is not difficult to understand why this most satisfying masterpiece of civil engineering took almost twenty years to complete.

72

TODI

✤

TODI, PERCHED ABOVE the Tiber, is the quintessence of an Umbrian hill town. At the high point of the site was the Etruscan walled town, its plan a reversed L: the walled area was extended to the

Cathedral, portal, acanthus decoration of pilaster.

east and south during the Roman era. In the thirteenth century three suburbs grew outside the Roman centre and from 1244 the line of the walls was greatly extended to enclose these. The main approach is through the Porta Romana in the outer circuit of the wall. The main street, the Via Roma which runs into the Via Cavour, climbs steeply, lined by houses many of which are medieval, to the rectangular Piazza del Popolo. On the right is the handsome Palazzo del Popolo, one of the earliest public buildings of the type in Italy which was enlarged in 1213 and heightened in 1228, and beside this the Palazzo del Capitano of 1293, which now houses the Museo Civico with a major altarpiece of 1511 by Lo Spagna. To the left, at the south end of the piazza, is the Palazzo del Priori, also medieval but altered in 1513 for Pope Leo X.

Opposite, up a wide flight of steps, is the Duomo, the thirteenth-century front of which was transformed by the insertion of the great rose window in 1515 and the following years. The twelfth-century apse happily survives unscathed. The interior is harmonious, despite the unexpected drama of the large fresco of the *Last Judgement* of 1598 on the entrance wall by the Ferrarese Ferrau Fenzoni, a homage to Michelangelo that respects the tenets of the Counter Reformation.

Todi's early importance is demonstrated by two other major churches that were respectively among the most impressive gothic and High Renaissance projects of the area. These are instructively seen in chronological order. Walk back, passing to the right of the Palazzo del Priori: the road bends to pass the steps below San Fortunato, a massive church begun in 1292 with a splendid façade begun in 1415 and notable not

least for the central portal of 1424–36. This is wholly gothic in taste, unlike the fragmentary fresco of the *Madonna and Child* on the wall of the right aisle by Masolino da Panicale – from the Tuscan rather than the Umbrian town of the name – which was stylistically the most advanced work in the medium of its time, 1432, in the area.

A path to the left of the church, from which there is a good view of the deep lateral buttresses and the fine campanile, runs downwards to a street leading to the Borgo di Porta Fratta within the medieval walls. To the west, beyond the Portal San Giorgio, is the great domed church of Santa Maria della Consolazione. This for Berenson was 'the best, though far from perfect, realisation of the Renaissance ideal' (*Rudiments of Conoisseurship*, 1902). Built to promote the cult of a miraculous image of the Madonna, this is surely the most impressive of Renaissance foundations of the kind. By the late sixteenth century, the name of Bramante had already been invoked in connection with the church and his influence on the design cannot be discounted. Construction began in 1508 under Carlo da Caprarola: Peruzzi was involved in 1518, and followed by Vignola and Ippolito Scalza. Given the massive size of the building, it is hardly surprising that the great dome was not completed until 1607. What is remarkable that despite this long time-span and the contribution of so many architects and craftsmen the building is wholly coherent. The masonry throughout is of the highest quality and the church is altogether worthy of its setting on a generous terrace below the town with commanding views to the south. To see it in the suffusing light of a late summer afternoon is an unforgettable experience.

73

SPOLETO

❖

SPOLETO WAS AN Umbrian settlement but fell to Rome in the third century BC and became a major city, as is shown by the remains of a temple, a theatre, an amphitheatre and an arch dedicated to the younger Drusus. Maintained by the Byzantines, Spoleto was sacked by Attila the Hun, but in 571 under the Lombards became the seat of a powerful duchy. A long rivalry for control between the Holy Roman Empire and the Church ended with the latter's absorption of the duchy in 1247. Papal rule only ended with the Risorgimento.

The size of Spoleto always comes as something of a surprise, the walls enclosing a large irregular area on the left bank of the Tessino. Approaching from the north, the visitor should pause at two remarkable churches on the opposite bank: San Salvatore is, most remarkably, a late Roman basilica remodelled under the Lombards and was much studied by Renaissance architects, while Romanesque San Ponziano has a fine crypt with an early *trecento* fresco of the Madonna by a local master.

The most powerful symbol of papal rule at Spoleto is the great Rocca (fortress) on a promontory falling away on two sides to the river at the eastern angle of the walls. This was built for the formidably effective Cardinal Albornoz by an equally remarkable architect, Matteo di Giovanello, il Gattapone. Below the Rocca is the Duomo, with an impressive Romanesque front to which a Renaissance portico was appended. From above the central door Bernini's bust of Pope

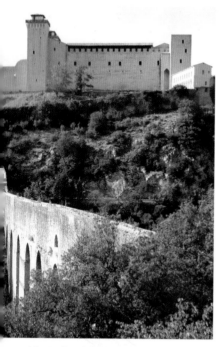

The Castle and the Ponte delle Torri.

Urban VIII surveys the interior, which was subtly transformed in 1785–92 by an architect of genius: Giuseppe Valadier. Treasures range from the signed *Crucifix* of 1187 by Alberto Sozio, the earliest picture by a named Umbrian painter, to the *Presentation* by Antonio Cavallucci, one of the last exponents of the tradition established by Carlo Maratti. The apse of the first chapel on the right, built for Bishop Costantino Eroli, was frescoed by Pinturicchio in 1497.

Thirty years earlier, when the authorities decided to commission a cycle of ambitious frescoes for the choir in honour of the Virgin (to whom the Duomo is dedicated), they called in not a local painter but the aged Fra Filippo Lippi from Florence. We think of Lippi as a painter of delicate Madonnas and altarpieces, sensitive and susceptible to female beauty. What distinguishes the Spoleto scheme from Lippi's earlier work is its overwhelming scale: the vast lunette of the *Coronation of the Virgin* vies with the apse mosaics of medieval Rome, and the *Annunciation*, *Dormition* and *Nativity* below are equally monumental in conception, although more restrained in colour. Even though he employed an *équipe* of assistants, including Fra Diamante, the project killed Lippi, but his was perhaps not an unworthy death.

Spoleto boasts a wealth of other churches and post-Renaissance palaces, but none of them quite matches three very different buildings in the vicinity. Below the city wall opposite the Rocca is the Ponte delle Torri, a majestic aqueduct-cum-bridge with ten gothic arches built for Albornoz. Whether or not this was also designed by Gattapone, it rivals as a work of engineering the aqueducts of ancient Rome, and was indeed assumed to be Roman by early travellers, many of whom visited the Temple of Clitumnus, some twelve kilometres to the north. Elements of the decoration of this elegant paleo-Christian structure were copied by Umbrian painters of the *Quattrocento*; and, as the late Giles Worsley observed, it was the model for the temple in Poussin's *Death of Phocion*, the ultimate *Seicento* classical landscape. The successor of the Roman Via Flaminia is now too close to the temple for comfort. In this respect fate has been kinder to the splendid Romanesque church of San Pietro on the flank of the Monteluco just south of Spoleto. The sculpture of the façade is of exceptional vigour.

74

MONTESANTO

❖

IT MAY SEEM eccentric to write about Montesanto. For the place as I first knew it is beyond recall. High on a gently sloping ridge above the valley of the Vigi, south-east of Casenove on the ancient road from Foligno across the Apennines, Montesanto was an outpost of the duchy of Spoleto. The crumbled medieval walls enclose a rectangular area originally laid out on a grid plan with two lateral streets. The Touring Club Italiano's guide devoted four lines to Montesanto. I was told of it by Marilena Ranieri di Sorbello, whose mother, Signora dei Vecchi, remembered that her family, the Orfini, migrated every summer from Foligno to what her friend Berenson described as their robber-baron's castle at Casenove, and then, when the heat became impossible, withdrew to Montesanto, which at 753 metres above sea level was always cooler. In extreme old age she asked to be taken back, and was surprised that what had been a day's journey took a mere half hour. But it was not for that reason that Marilena made me want to go.

Largely abandoned as Montesanto then was, for most of its inhabitants had long since left, there was still at the centre crossing a cluster of two or three houses of some consequence. Near these was the parish church. This retained the original late Renaissance and baroque furnishings, an earlier triptych and a number of altarpieces. The finest was a then little-known Nativity by Beccafumi, its tender subtlety, both in design and colour, only the more poignant in so remote a setting. Inevitably the panel seems a little less eloquent now that it is in quarantine at the museum in Spoleto. But at least it is safe. Montesanto is not, for it was not far from the epicentre of the devastating earthquake of 1996. The few houses were shattered and the front of the church fell away. I returned a few months afterwards, on a sharp winter's day, and wept.

The church has now been consolidated, but the Beccafumi will probably never return. So the sightseer must content himself with a late trecento fresco of the Madonna protected by a later tabernacle outside the small chapel of Santa Lucia below the church on the lower of the two streets. A dozen houses have been repaired but the ancient walls of others will continue to crumble. There is, however, still much for the patient visitor to see in the area. Just south of Casenove, at Serrone, is one of the most touching northern Caravaggesque pictures in Italy, the Holy Family in the Carpenter's Shop. Some miles south of Montesanto the Vigi flows into the Nera. The economic importance of the valley of the Nera as a route through the Apennines is shown by the fortifications at Borgo Cerreto and such local churches as the Romanesque San Felice di Narco.

Montesanto from the south-east.

75

MONTEFALCO

✿

THE VALLEY SOUTH of Assisi must always have been of strategic importance and supports a number of towns: Spello, with an imposing Roman gate and the church of Santa Maria Maggiore where Pinturicchio's frescoes in the Baglioni Chapel do honour to painter and patron alike; Foligno, where the palace of the Trinci still testifies to the ambition of a family whose *signoria* was brutally suppressed by the papacy in 1439; and, to the west, Bevagna, with its gothic Palazzo del Consoli and on the same piazza two unusually successful late Romanesque churches, San Silvestro, begun by Master Binello as is recorded in an inscription of 1195, and San Michele, where he was assisted by a collaborator, Rodolfo. On a hill to the south is Montefalco, which was held by the Trinci from 1383 until their fall, and then like Foligno under direct papal rule.

Walled in the fourteenth century, Montefalco boasted its own saint, the Augustinian Chiara di Damiano, whose life is recounted in a fresco cycle of 1333 in her eponymous church. The strength of the Augustinian presence is implied by the large gothic church of Sant'Agostino, but it is for its Franciscan church that the town is most memorable. Built in 1336–8 and now deconsecrated as a museum, San Francesco is an austere monument. On the right in the first bay is the chapel of Saint Jerome, frescoed in 1450–2 by Benozzo Gozzoli, who had previously acted as Fra Angelico's assistant in Rome; the fictive polyptych is a charming visual conceit, and the conviction of the

San Fortunato: Benozzo Gozzoli, Madonna and Child, *border (detail), fresco, 1452.*

scheme helps to explain why the artist was retained to decorate the choir with a cycle of scenes from the life of Saint Francis, also of 1452. Benozzo was no artistic protagonist, but his work at Montefalco was to have considerable local repercussions, as is so evident in the plangent mood of the emergent masters of the school of Foligno, Niccolò da Foligno and Pierantonio Mezzastris.

Less than half a kilometre south of the town, still rustic in setting, is the church of San Fortunato, who established Christianity at Montefalco. Benozzo worked here also, painting the beautiful lunette with the Madonna and Saints above the portal, and, within the church on the right, a more solemn fresco of San Fortunato himself enthroned as well as a *Madonna* of which a section has been lost. Outside the church is the Cappella di San Francesco (or Cappella delle Rose). This was decorated in 1512 with murals of Franciscan scenes and of saints by Tiberio

d'Assisi, who understood something of Perugino's spatial formulas. This is more than can be said for his uneven Montefalcan contemporary, Francesco Melanzio, whose very provincialism has ensured that most of his oeuvre remains in the several churches of his native town. Below the town to the south in the sanctuary of the Madonna delle Stelle, begun by the Perugian architect Giovanni Santini in 1862, is a *Visitation* by the German painter Friedrich Overbeck that expresses the reverence of the Nazarines for the Peruginesque.

76

ASSISI

❖

SEEN FROM AFAR, Assisi seems to hang from the Monte Subasio, stretched between the massive basilica at its northern angle and the two medieval fortresses high to the south, the Rocca Maggiore and the Rocca Minore. Controlling the most fertile part of the valley of the Assino and its mountainous hinterland, Assisi has long been a place of some consequence. The portico of the Roman temple, commandeered by an undistinguished church, still dominates the central Piazza del Comune.

Assisi: San Francesco from the north-west.

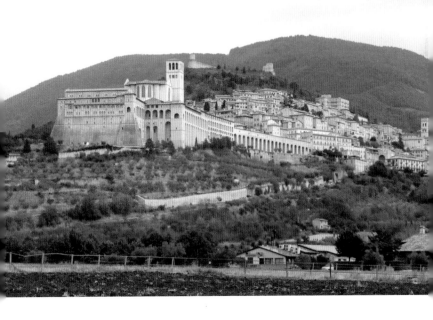

The wonderful front of the Romanesque cathedral of San Rufino east of the piazza implies the town's wealth in the eleventh century.

But Assisi as we know it owes its character to one man, Saint Francis. The son of a local noble, born in 1181/2, Saint Francis, after various vicissitudes, became a powerful champion of religious reform. The order that bears his name became a force throughout the western church. Canonization followed his death in 1226 by only two years. And the town was quickly established as a major place of pilgrimage. The saint, whose dual commitment to poverty and obedience was genuine, would doubtless have been dismayed by the scale of the monastery his successors created in his name. Built on massive foundations, the church is on two levels and was most probably designed by Fra Elia.

The pilgrim who walks up through the piazza below it enters the Lower Church by a side door and advances to find the body of it on the left. The church consisted originally of a single nave, from which pilgrims would descend to the crypt where the saint is buried; the side walls were frescoed, about 1270, by the so-called Master of Saint Francis with scenes from the life of the saint that established the iconography of future representations. The addition of lateral chapels means that much of the cycle is lost, but before considering these the visitor should proceed to the right transept and examine Cimabue's fresco of the *Madonna and Child with Saint Francis and Angels* – painted perhaps ten years later than the anonymous master's narratives – and then climb up to the Upper Church. Consecrated in 1253, this is a monumental, if austere, gothic structure. Frescoes on an almost unprecedented

scale must have been intended from the outset. Work began in the choir and the transepts, where the murals by Cimabue and others here have suffered severely in the past.

The nave was decorated in three tiers, the upper two with scenes from the Old Testament by Roman associates of Pietro Cavallini, the least familiar of the major innovative masters of the late thirteenth century. In the lower tier, the life of Saint Francis is narrated in a series of twenty-eight compartments, the rhythm of which is partly defined by the fictive cornices and hangings below them. The traditional view that most of the cycle is by Giotto has been questioned by several Anglo-Saxon art historians but would seem to be valid. The artist was keenly aware of his role as propagandist. His narration is clear and logical, his human forms solid and plausible, his settings subordinate and insubstantial. His rendition of the Temple of Minerva in the Piazza del Comune – before which the young Francis divests himself of his clothes – well illustrates this: the columns are etiolated, their number reduced. Buildings crumble, rooms confine. But it is the saint who holds our interest. Nowhere is this more perfectly expressed than in the celebrated fresco – to the right of the main door – of *Saint Francis preaching to the Birds*, his avian congregation perched on the hillside. The last four scenes on the left wall with their elongated figures are different in approach. The hand is clearly Florentine, that of the Master of Saint Cecilia.

Datable between 1288 and 1294, the Saint Francis cycle marked an epoch in the evolution of painting in central Italy. Later, Giotto would return to Assisi. The Magdalen Chapel to the right of the Lower Church was designed, and

presumably partly executed, by him; and his was the impetus behind the vault of the crossing of the Lower Church. It was, however, to Siena that the authorities at Assisi turned for further projects. The first chapel on the left, dedicated to Saint Martin of Tours, was assigned to Simone Martini. Partly because Simone also apparently designed the stained glass, the chapel is infinitely satisfying in its visual unity. Simone's refinement is extreme, and it is impossible to imagine a more elegant silhouette than that of the saint as he cuts his cloak in half to clothe the beggar. The Assisi chapel, more perhaps than any of his Sienese commissions, demonstrates why Simone became so attuned to courtly taste, whether in Angevin Naples or at papal Avignon.

Simone's contemporary, Pietro Lorenzetti, was enlisted for the left transept, where he painted scenes from the Passion, perhaps unfairly criticized by Berenson, and the huge *Crucifixion*, a narrative of almost unprecedented animation. But it is for the frescoes below this that Lorenzetti is more generally remembered, the niche with vessels used to celebrate mass and – above all – the poignant *Madonna and Child with Saints Francis and John*, intended for close – and tearful – contemplation. As an adolescent I was not surprised to notice that a survivor from an earlier age, Princess Marthe Bibesco, kept a postcard of it on her writing table.

Places of pilgrimage are meant to attract crowds. But if numbers become too oppressive, there are buildings nearby where one will not be disturbed. A hundred metres up the main street, on the right, is the Oratorio dei

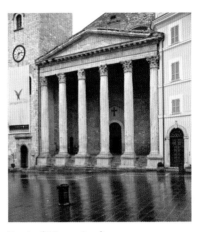

Temple of Minerva, late first century BC.

Pellegrini, where a nun still prays in the presence of frescoes by local painters of the later *Quattrocento*, Matteo da Gualdo, Pier Antonio Mezzastris from Foligno and, most probably, Perugino's early associate Andrea d'Assisi. Rather further away, below the walls, is the convent of San Damiano with murals by the Peruginesque Eusebio da San Giorgio in the cloister and an atmospheric candle-stained church, which the stipulations of the Lothian family have protected from tourist exploitation.

For tourism has its price. Saint Francis would still recognize the open downland of the Subasio. The rippling horizons he knew are unimpaired. But even since I first knew it in 1966, the valley below Assisi has been horribly scarred by unsightly development. Nonetheless, much of the town has hardly changed since the late Victorian painter William Blake Richmond wrote about it.

77

GUBBIO

❖

No GREAT ITALIAN city is more palpably medieval than Gubbio. The town stands on the southern flank of the Monte Ingino, commanding what must always have been a productive plain. Her Roman past is seen in the much restored theatre below the town and in the Eugubine tablets – laws recorded in both Umbrian and Latin on sheets of bronze – in the museum. But the city, as we see it, dates largely from the twelfth and succeeding centuries.

Entering by the Via Matteotti, you reach the Piazza dei Quaranta Martiri between the Loggia of the Arte della Lana, the wool guild, and the thirteenth-century monastery of San Francesco. Narrow streets rise steeply towards the centre of the town, where the great Palazzo dei Consoli is clearly visible on its terrace; but the main road turns to the left and then bends twice to the right to reach the Via dei Consoli, and its procession of medieval houses with their *porte degli morti* – doors of the dead – raised above the street level. The pink stone façades reveal their past, as one can see where doors and windows have been blocked and moved.

The Piazza della Signoria is the heart of the town, built out over a giant blind arcade. On the right is the Palazzo dei Consoli, emphatically masculine despite its elegant loggia high above. The palace was designed by Angelo da Orvieto and built in 1332. The door opens to a vast hall, from which a narrow stairway mounts to the upper floor, now the civic museum, with its unrivalled group of early *Trecento* pictures

Palazzo dei Consoli, south façade.

by Eugubine artists – for sadly there is nothing by Neri da Gubbio, the miniaturist whom Dante consigns to his Inferno. In the archaeological section, the Eugubine tablets have pride of place. On the north side of the piazza is the long Neoclassical brick front – oddly thought to be in the English taste – of the Palazzo Ranghiasci. Below this, a passage leads steeply up to the Duomo. An oddly unsatisfactory building, it is most notable for the decoration of a small chapel on the right by an underrated realist of the baroque, Antonio Gherardi da Rieti. Opposite and a little below the Duomo is the Ducal Palace. The Montefeltro family gained the *signoria* of Gubbio in 1384, and the palace rebuilt by Federico da Montefeltro was a smaller counterpart to that at Urbino. The courtyard remains a space of great elegance, with crumbling facings of grey *pietra serena*, but the marquetry of the *studiolo* is in New York, its pictures divided between London and Berlin. Still higher up the hillside is the medieval aqueduct, which can be followed for a mile or so as it curls round the flank of the Monte Ingino to the north-west. The views down over the tiled roofs of the town are memorable.

Gubbio produced one of the more engaging figures of the International Gothic movement, Ottaviano Nelli. His masterpieces are in two churches on the east of the town. In the *Madonna del Belvedere* at Santa Maria Nuova the Virgin and Child are seen with angels under a baldachin supported on thin spiral columns up which putti crawl. The fabrics are sumptuous. Nearby, but outside the walls, is Sant'Agostino, where Nelli frescoed the choir with episodes from the life of the saint. His narrative is discursive, and his depiction of potentates and

Sant'Agostino: Ottaviano Nelli, Life of Saint Augustine, *fresco* (detail).

their attendants tells us something of the extravagance of contemporary patrician taste.

With the extinction of the della Rovere line in 1624, Gubbio reverted to papal rule. Two churches below the town evoke this period. The elliptical Madonna del Prato, outside the Porta Romana, was decorated by the local painter Francesco Allegrini and has considerable charm. Eighteenth-century San Benedetto, below the Porta Castello, is of a different order. This too is elliptical. The original furniture is almost miraculously intact. And the high altarpiece, Agostino Masucci's *Immaculate Conception*, exemplifies the restrained classicism of early eighteenth-century Rome at its purest; the lateral altarpieces by Sebastiano Conca and Francesco Mancini are equally effective.

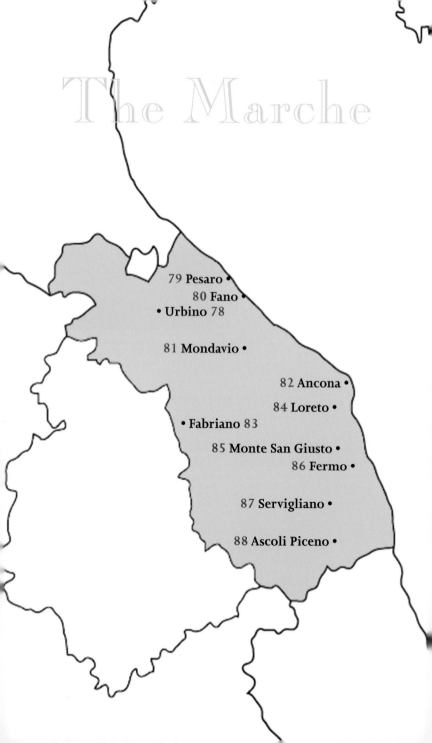

The Marche

79 Pesaro •

80 Fano •

• Urbino 78

81 Mondavio •

82 Ancona •

84 Loreto •

• Fabriano 83

85 Monte San Giusto •

86 Fermo •

87 Servigliano •

88 Ascoli Piceno •

78

URBINO

BALDASSARE CASTIGLIONE's *Il Cortegiano* of 1528 offers a uniquely vivid account of the world of Guidobaldo da Montefeltro; and, to an English audience, Urbino and Guidobaldo's father, Federico da Montefeltro, have been synonymous since the publication of James Denistoun's *Memoirs of the Dukes of Urbino* in 1851. It is not fortuitous that two of the great masters of the sixteenth century, Raphael and Federico Barocci, grew up in the shadow of the ducal court at Urbino.

The Montefeltro were granted Urbino in 1155. By the fourteenth century they also controlled the nearby towns of Fossombrone and Cagli on the Roman Via Flaminia, one of the key routes from Rome to the Adriatic and its ports. Equally significant was their dominance of the main road to Tuscany in the west across the Trabaria Pass. Most early visitors would have taken this, and then crossed the hills from Castel Durante, now Urbania, long famous for its maiolica. As Lord Clark observed, the backgrounds of Piero della Francesca's portraits in the Uffizi of the successful *condottiere* Federico da Montefeltro, hereditary Count of Urbino, and his wife, Battista Sforza, were inspired by the views from here. As the road curls downwards towards the city, the twin towers of Federico's palace come into sight – Barocci recorded them from the opposite angle in his astonishing *Entombment* at Senigaglia on the Adriatic coast.

Dominating its hinterland, the palace also looms large above the Piazza Duca Federico. Federico began to build about 1444. In 1465 Luciano Laurana was called in; he left in 1472, and subsequently the Sienese Francesco di Giorgio Martini took over the project. Work had progressed considerably before Federico was elevated as duke in 1474. The entrance from the piazza is relatively restrained. This leads to Laurana's arcaded courtyard, a concept of singular perfection, marred somewhat by the later addition of a third storey. At the north-eastern angle is the great staircase to the domestic apartments. Nowhere were the precepts of Albertian proportions more assiduously respected than in these. The harmony of the spaces is matched by a fastidious use of ornament. Alas, the possessions of Federico's della Rovere heirs left for Florence after the surrender of the duchy to the papacy in 1626. But the *intarsie* of his *studiolo*, masterpieces of *trompe l'oeil* deception, survive; so do some of the panels of philosophers by Joos van Ghent originally placed above these, although others are in the Louvre. Federico's artistic horizons are implied by chance survivals. Joos van Ghent's damaged *Institution of the Eucharist* shows how quickly that northern master responded to Italian influences when he entered the ducal service. Paolo Uccello's chilling predella with the scenes of the profanation of the host by a Jew reminds us that the morality of Renaissance civilization was very different from our own. Piero della Francesca's peerless *Flagellation* is a masterpiece of a different order; in recent decades no picture has inspired more self-indulgent iconographical speculation. Opposite is his later Senigaglia *Madonna*, remarkable not least for its subtle modulations of colour. Most characteristic of what we think of as Federico's world is the celebrated panel of

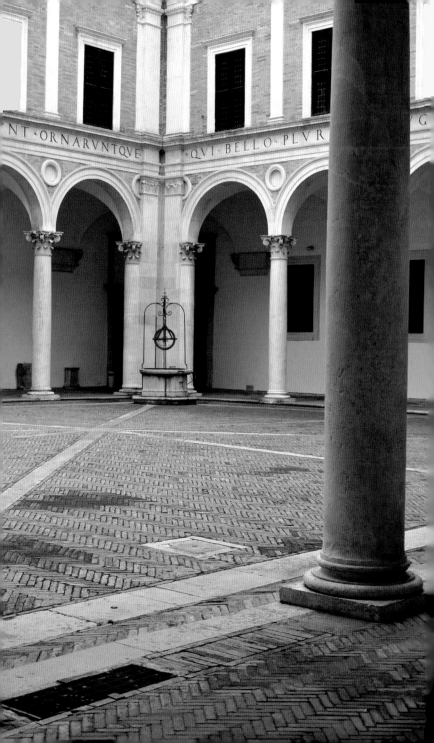

an ideal piazza; it comes as a surprise to realize that the only signs of life in this majestic architectural fantasy are the two doves who sit on a cornice.

Shorn of most of its indigenous contents, the palace makes a perfect setting for the Pinacoteca Nazionale delle Marche. Among the early pictures, the altarpiece by the Riminese Giovanni Baronzio stands out, not least for the unusual harmonies of green. The beautifully crisp polyptych by Alvise Vivarini hints at Venice's long economic and cultural influence on the cities of the Adriatic coast. The leading native painter of Federico's time was Giovanni Santi, Raphael's father; his smaller panels have a refinement denied to his more ambitious undertakings. Raphael himself is represented by a wreck once owned by Imelda Marcos and the panel of a lady, 'La Muta', too often underrated, which is in some ways the most sophisticated of the portraits of his Florentine phase. On the second floor are the later pictures. Here the hero is unquestionably Barocci. His early *Madonna di San Giovanni* is instant in appeal, while the late *Stigmatization of Saint Francis*, of 1594–6, with its nocturnal landscape, is a visionary statement.

To the north of the ducal palace is the cathedral, rebuilt after an earthquake of 1789 by Giuseppe Valadier. The respectable high altarpiece is by that underrated exponent of late Roman classicism, Francesco Unterberger, but it is for two pictures by Barocci that the building is memorable. The *Martyrdom of Saint Sebastian* on the second altar to the right is a precocious exploratory work, more

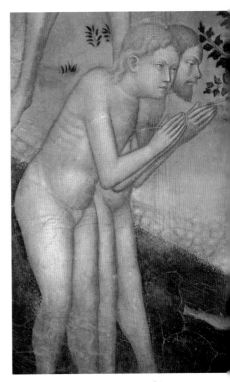

Oratorio di San Giovanni: Lorenzo and Jacopo Salimbeni, Saint John Baptizing, fresco (detail).

indebted to Correggio than to Raphael. The *Last Supper* in the chapel to the left of the choir is a considered masterpiece. Every element of the interwoven composition was worked out on paper. We are left in no doubt of Barocci's deep spiritual conviction.

On leaving the cathedral, follow the main street to the Piazza Repubblica, the hub of the city. Abutting this is the Franciscan church with another moving altarpiece by Barocci. The *Pardon of Saint Francis* was finished in 1576; the saint looks upwards in supplication to the

Opposite: Ducal Palace, courtyard by Luciano Laurana.

risen Christ. Almost opposite the church, to the right of Via Mazzini, is the narrower Via Barocci, which leads to two remarkable oratories. In the first, the Oratorio di San Giuseppe, is a beautiful stucco Nativity by Federico Brendani, Barocci's contemporary who was also responsible for notable plasterwork in the ducal palace and at nearby Piobbico, the fief of the Brancaleoni family. Beyond is the Oratorio di San Giovanni, one of the high points of the late Gothic in Italy. The interior was frescoed in 1416 by the brothers Lorenzo and Jacopo Salimbeni from San Severino. The Crucifixion of the altar wall expresses Lorenzo's vigour; no incident of the gospel narrative is omitted. The murals of the right-hand wall, illustrating the life of Saint John the Baptist, are compositionally more inventive, for the artists were less bound by precedent. Emphatically Italian, they bear us to a wonderland they knew, as it were, partly at second-hand, mediated through northern miniatures and French ivories perhaps, yet expressed with conviction in a southern range of colour. The brothers relished the courtly cavalcade and the brave show of contemporary fashion; they were also acute observers. Their Jordan has its complement of fish and a frog, while water pours down from the heads of the couple whom the saint has baptised.

79

PESARO

❧

PESARO IS THE successor of the Roman Pisaurium. Although occupied by the Goths and the Lombards, the town remained under the notional sovereignty of the Empire and subsequently of the papacy. In the thirteenth century Pesaro fell under the control of the Malatesta, who held it until 1445, when Galeazzo Malatesta sold it to Alessandro Sforza. His heirs were expelled by Cesare Borgia: subsequently Julius II appended it to the duchy of his nephew, Francesco Maria delle Rovere of Urbino. On the extinction of his line in 1631, Pesaro returned to papal rule. It is now perhaps best known as the birthplace of Rossini.

Unlike its neighbours, Rimini and Fano, Pesaro boasts no major Roman monument. The central Piazza del Popolo is now dominated by the much-restored Palazzo Ducale, begun for Alessandro Sforza and reconstructed under the delle Rovere. Little remains of the Malatestas' town, but the competitive architectural ambitions of the great religious orders of their day are seen in the elaborately decorated portals of three churches, all in easy reach of the piazza: that of San Francesco, with a lunette of the Madonna and statues of the Angel and the Virgin Annunciate, is of 1356–78; that of the deconsecrated Dominican church, just west of the piazza, is of 1395; while its counterpart at Sant' Agostino, on the Corso XI Settembre, is of 1413. The Cathedral, set back from the Via Rossini, is a disappointment, but this cannot be said of the Museo Diocesano opposite.

Museo Civico:
Giovanni Bellini,
St Terentius with a
model of the Rocca
(detail).

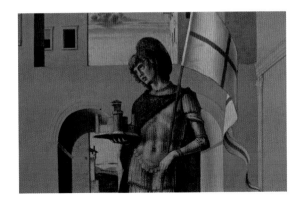

There is an ivory pyx made at Ravenna in the late sixth century and an outstanding eighth-century sarcophagus that would not be out of place at Cividale. An altarpiece, the *Magdalen with Saints Sebastian and Roch*, reminds one that even minor painters, in this case, Antonio Palmerini, can merit attention.

The well-arranged Museo Civico is in the Palazzo Tuschi-Mosca. This houses a very distinguished early collection of Renaissance *maiolica*, some notable sculpture, including a well-observed relief of Federico da Montefeltro and a small but varied collection of pictures, ranging from the unusual *Dream of the Virgin* by the Bolognese Michele di Matteo to an intimate *Madonna* by Beccafumi. But the star is inevitably Giovanni Bellini's sublime altarpiece, the *Coronation of the Virgin*, of towards 1475. Alessandro Sforza and his son Costanzo were both discriminating patrons of the arts. The father was portrayed by Rogier van der Weyden and commissioned the triptych by him now at Brussels, while the son was an early patron of Perugino. Bellini's altarpiece was an emphatic statement. The panel below the right-hand pilaster shows Saint Terentius holding a model of a castle that has been held to represent that built by Costanzo which still stands as the eastern bastion of the town. In the main panel Christ and the Virgin are shown on an open-backed throne, through which a great castle is seen in a landscape of ineffable beauty: He gazes at His mother, whose eyes, like those of the attendant saints are closed. We sense an intense calm. There are small standing saints in the pilasters of the original frame, the sides of which are decorated with *trompe l'oeil* marble panels. The five panels of the predella deserve the closest scrutiny. These are united by the character of the landscapes and the uniformity of the pale foregrounds. Saint Jerome prays before a crucifix beside a stream that issues from the rock—but his wilderness is in sight of a great city. In the *Stigmatization of Saint Francis* the saint and his companion are shown, as appropriate, near a rocky outcrop: but rather than a modest rustic shrine we see a substantial Romanesque church, the apse of which has windows with gothic tracery. Bellini was a magician in every phase of his career with a pioneering understanding of the artistic possibilities of landscape. But while he equalled he never perhaps surpassed his Pesaro altarpiece.

80

FANO

❧

IN ANY COUNTRY except Italy it would
seem extraordinary that towns as dis-
tinguished as Pesaro and Fano could
be less than eight miles apart. Fano was
founded by Augustus some three kilo-
metres from the position occupied by
his uncle Julius Caesar after he crossed
the Rubicon. Even after it was sacked
by the Goths, it remained a significant
Adriatic port. In the late thirteenth cen-
tury the Malatesta gained control. They
retained the *signoria* until 1463 when
Sigismondo Malatesta lost it after a siege
undertaken by Federico da Montefeltro
for Pope Pius II. Nearly a century and
a half of instability ensued until papal
rule was re-imposed under Clement VIII
(1592–1605).

The Malatesta well knew that they
had to defend the town. The substan-
tial Rocca Malatestiana at the north-
ern flank of the former town wall was
built for Sigismundo in 1435–52. What
survives of the former family palace,
the Corte Malatestiana, is in the heart
of the town next to the much-rebuilt
Palazzo della Ragione in the Piazza XX
Settembre. The Corte now houses the
town's museum. The pictures, although
not numerous, are of serious interest.
The altarpiece by Giovanni Santi antic-
ipates his son's early *Madonna of the Pink*
in London by showing the Child with
that flower. There are masterpieces by
both Reni and Guercino and an unri-
valled group of altarpieces by their still
underrated contemporary, Giovanni
Francesco Guerrieri.

The main street of the Roman town,
now the Via Arco d'Augusto, two blocks
north of the piazza leads to the Arch of
Augustus, of which the lower section
is largely intact. Just before this is the
refined Logge di San Martino of 1495,
built as an orphanage. The small church
of San Martino is immediately beyond
the arch. The restrained façade by Ber-
nardino di Pietro da Corona, completed
about 1504, bears a relief recording the
arch with its original superstructure
which had survived until the siege of
1463, an early example of a record of a
lost Roman building.

Negotiate the maze of streets behind
the church for the portico of Santa Maria
Nuova. The church was remodelled in
the eighteenth century but retains three
exceptional late *Quattrocento* altarpieces,
two of which are hung too high to be
fully appreciated. Start on the left with
the earliest, Giovanni Santi's *Visitation*
which reflects his respect for the work of
Joos of Ghent at Urbino. Over the next
altar is a key work of the late 1480s by
Perugino, the *Annunciation*. The setting is
an open loggia through which is seen
one of the most atmospheric of the
painter's landscapes. Opposite is a sec-
ond altarpiece by Perugino, the *Madonna
and Child enthroned with Saints*, the design of
the main panel of which was a develop-
ment from an earlier project and would
in turn be followed for Santa Maria delle
Grazie at Senigallia, Fano's neighbour to
the south. Here also the setting is an open
loggia. Exigencies of space explain the
form of the date on the step: 'MCCCC97'.
The vibrant narrative scenes of the pre-
della have persuasively been attributed to
the young Raphael and must therefore be
marginally later in date: in no respect are
these derivative or formulaic.

81

MONDAVIO

FOR THE SIGHTSEER who likes to see groups of related buildings or works of art, the Marche is rich in possibilities. Commissions of the rival courts of the Malatesta, the Montefeltro and the Varano can be seen in Rimini, at Urbino and at Camerino. And as such families well knew their need for defence, the area is equally rich in military buildings of the Renaissance.

The most celebrated of these is perhaps the Rocca at Sasso Corvaro, designed by Francesco di Giorgio but altered in the eighteenth century, that seems to float effortlessly above the little town at its feet, and owes its existence to the struggle between the Montefeltro and the Malatesta. Its owners, the Brancaleoni, adhered to the former and would a

century later remodel their ancient castle at Piobbico as a Renaissance palace. Sasso Corvaro's closest rival is the unfinished Rocca at Mondavio, begin in 1482 for Giovanni della Rovere, who sought to consolidate the *signoria* of nearby Senigaglia, which he had received from his uncle Pope Sixtus IV in 1474. Here brick was used by Francesco di Giorgio to brilliant effect. The carefully battered walls, intended to resist artillery, seem to have been cut from butter. How revolutionary the design was is suggested by comparison with the well-preserved walls of nearby Corinaldo, begun in 1366, which had to be reinforced in 1484–90.

For all its originality Mondavio seems almost puny by comparison with Giovanni della Rovere's massive quadrangular fortress at Senigaglia. Begun by Luciano Laurana and completed by Baccio Pontelli, this incorporated part of the structure of the town wall of the Roman port and is an emphatic statement of dynastic power and ambition.

Mondavio, Rocca, begun 1482.

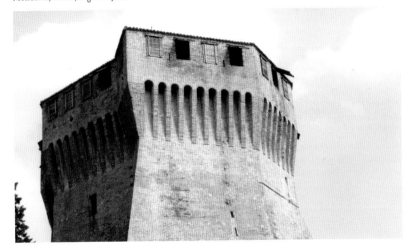

82

ANCONA

❖

ANCONA HAS LONG been the dominant city in the Marche, which indeed was termed the March of Ancona. The natural harbour encouraged colonisation from Siracusa in the fourth century BC; and under the Romans Ancona was of both military and commercial importance. The Byzantines were succeeded by the Lombards. Subsequently the city recognised papal suzerainty. Besieged at intervals in the medieval period, Ancona fell to the Malatesta in 1348. The fall of Constantinople in 1453 had a detrimental economic effect. A period of changing alliances and local rivalries followed, but in 1532 Pope Clement VII established papal control.

Geography determined the siting of Ancona, and also the pattern of its early

Duomo: Lion by the main portal.

growth. A ridge that is the northern outlier of the Monte Conero constrained the city's development; and as a result the evidence of the past is, even by Italian standards, unusually impacted. Moreover, that Ancona remains a functional port inevitably influences its character. The visitor knows he is approaching the city proper when he sees the five-sided mole devised by the architect Luigi Vanvitelli for Pope Clement XII from 1733 and the Porta Pia of 1787–9, an extravaganza that neither Pius VI nor his successors would have been able to contemplate building a few years later.

A substantial area of the Roman port has been excavated and a number of early buildings survive on the margin of the harbour. By far the most significant is the admirably preserved Arch of Trajan attributed to the architect Apollodorus of Damascus. Built of fine diagonally veined marble, with gleaming Corinthian pilasters the flutes of which were intended to be caught in shadow, this is much taller in proportion than other Roman triumphal arches. It was built to celebrate Trajan's work on the harbour which in turn was necessitated by his projects for the eastern expansion of his empire. Beyond is the comparatively modest Arco Clementina of 1738 by Vanvitelli.

On the summit of the ridge above, in the place of a Roman temple, is the Duomo dedicated to Saint Cyriacus, a massive Romanesque cruciform structure with an elaborately decorated portal attributed to Giorgio da Como, the columns of which rest on two lions in red Veronese granite. The Victorian historian E.A. Freeman not unfairly regarded it as 'a pure, if not very rich, specimen of the Italian Romanesque at its best point', and, although it suffered in both world wars, nothing jars. The central dodecagonal

dome is vaulted, but the other roofs, of late medieval date, are of wood. South of the Duomo are the substantial remains of the Roman amphitheatre which was ingeniously inserted between two protuberances of the ridge. Below this is the thirteenth-century Palazzo del Senato with arched windows on two levels opposite the ambitious domed baroque church of San Pellegrino. This adjoins the Palazzo Ferretti, now the Archaeological Museum: exhibits range from a small palaeolithic human sculpture found in the Fracasi caves, by way of gold coronets of leaves and flowers of about 220–200 BC and terracotta reliefs of Dionysiac subjects from Civitalba to an exceptional head of Augustus found in the palace itself.

Further along the Via Ferretti is Vanvitelli's curvilinear front of the Gesù, which overlooks the Palazzo degli Anziani, the infilled medieval arches of which can be seen between the window cases introduced in 1647. Much of the early structure of the palace can be seen in the lower levels of the reverse, east, side, hanging over the lower ground above the port. Nowhere is one more aware of the ingenuity with which the builders of Ancona overcame the challenges of the steep slope up which the early town spread. The road continues, as Via Pizzecolle, to the piazza below San Francesco delle Scale, with its magnificent carved portal by Giorgio Orsini. The church was heightened in the eighteenth century and as a result Lotto's high altarpiece, the *Assumption of the Virgin*, seems a little lost. Further down, the road continues through the courtyard of the much-restored Palazzo del Governo to the Piazza del Plebiscito, which is dominated at the higher, east, end by Carlo Marchioni's San Domenico. Two streets at the lower end lead down to the Via del Loggia, more or less opposite

the early Renaissance Loggia dei Mercanti. A little to the north is the most beautiful of Ancona's churches, Santa Maria della Piazza, with a marvellously decorated Romanesque façade and a most satisfying calm interior.

The narrow street immediately to the north leads to the lower entrance to the Pinacoteca Civica in the Palazzo Bosdari, which, as in other vertiginous palaces on the hillside, is four floors below what was originally the main entrance on the Via Pizzecolle. Given its complicated plan, it is not surprising that the arrangement of the museum seems eccentric; and there are some odd juxtapositions. But be patient. Among the pictures there is a group of works by Oliviero di Ciccarelli, formerly assigned to Carlo da Camerino, and exemplary altarpieces by Guercino and Maratta, who came from nearby Camerano. But pride of place goes to three Venetian altarpieces: one by Lotto – who never used shadows more effectively than in his *Madonna and Child with Saints* – and two by Titian. The Gozzi altarpiece of 1520 shows the Madonna and Child appearing to Saints Francis and Aloysius, patron of Ragusa across the Adriatic which had a long trading relationship with Ancona. Lest the viewer forgot the place of Venice in the trading patterns of the Adriatic, the composition is anchored on the Campanile of St Mark's. Beautiful as this luminous picture is, it must yield to the *Crucifixion* in which Saint Dominic clasps the Cross. A late work, this is realised with a commanding freedom and unfaltering control: the light drains from the sky yet still illumines Christ's form. Rather remarkably, Titian reverts to the Byzantine tradition of showing the Cross straight on but with its right side seen as if in perspective.

83

FABRIANO

❁

FABRIANO IS, I think, the only Italian town I have visited without any form of preparation. Mary Egerton had driven to Gualdo Tadino so I could see the pictures by Matteo da Gualdo and we realised that there was time to go on elsewhere for lunch. A new road – this was in 1969 – speeded us to Fabriano, where we soon found ourselves in the central piazza, without the aid of the Touring Club Italiano guide, still less the model book on the town by Bruno Molajoli.

Fabriano is a relative newcomer among the cities of the Marche, the successor of two early feudal fortresses. Initially a free commune, it became the signoria of the Chiavelli, after whose sanguinary fall in 1435 it passed to Francesco Sforza and then to papal control. Sacked by unpaid Spanish troops in the papal service in 1517, the town rebelled but was firmly repressed in 1519 when Leo X appointed his nephew Giulio de' Medici, later Pope Clement VII, as governor. From the medieval period onwards Fabriano, with its ready supply of water from the river Giano, was a major centre of paper production. Happily the industry survives.

At the heart of the city is the long Piazza del Comune, with at its northern end the Palazzo del Podestà originally of 1255 which was efficiently restored to its early gothic form in 1912: this is carried across the main road on a massive arch, the vault of which is adorned with murals of varying date. In front of the palazzo is the Fontana Rotunda,

originally of 1285, which was modelled on its counterpart at Perugia. The piazza is flanked on the east by the raised Loggia di San Francesco, opposite which is the façade added in 1690 to the late medieval Palazzo Municipale: this was originally the curia of the Chiavelli. A steep road between this and the Palazzo del Podestà leads up to the small Piazza del Duomo.

Dedicated to San Venanzo, the Duomo was largely reconstructed from 1617 onwards. The lateral chapels offer a microcosm of seicento taste, with works by Claudio Ridolfi, Orazio Gentileschi, Giovanni Francesco Guerrieri, Simone Cantarini, Salvator Rosa and Lazzaro Baldi, of whom only Guerrieri was Marchigian. Gentileschi's noble Crucifixion with the Magdalen is in the fourth chapel on the left, his murals on the lateral walls and vault of which are equally remarkable; while Rosa's canvasses in the first chapel on the right, a Riberaesque Saint Jerome and a more personal Saint Nicholas of Tolentino are among his more successful religious commissions. Happily the structure of the fourteenth-century polygonal choir survived the remodelling. A door on the right of the presbytery leads to the former Cappella di San Lorenzo, only rediscovered in 1906, with what survives of a cycle of frescoes representing the life of Saint Lawrence by the great master of trecento Fabriano, Allegretto Nuzi.

Opposite the Duomo, in the former Ospedale di Santa Maria del Buon Gesù founded by the austere San Giacomo della Marca in 1456, is the Pinacoteca Civica named after Molajoli. The earliest major work is the crucifix by the Spoletan Rinaldo di Ranuccio if the 1250s. Although there is no example of the great master of the Fabrianese School, Gentile, his predecessors can be studied as nowhere else, with several panels by

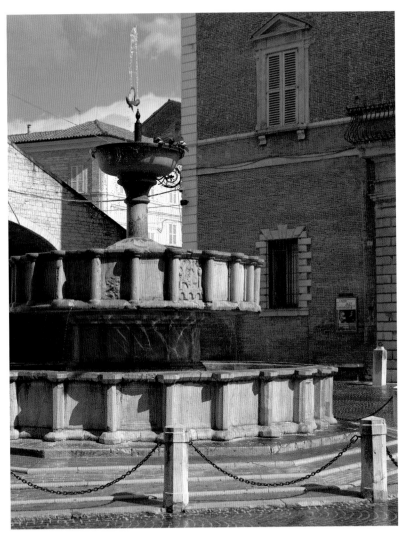

Fontana Rotunda, 1285 and later.

Allegretto Nuzi and the name piece of his associate, the Master of the Fabriano Altarpiece, now identified as Puccio di Simone and panels by Francescuccio di Cecco Ghissi. Equally remarkable is the carved and pigmented group of the Magi by their less familiar younger contemporary Fra Giovanni di Bartolomeo, who clearly owed much to Nuzi. An artist of a very different stamp was the Master of

San Biagio in Caprile, whose detached fresco of the *Crucifixion* of 1345 is almost overpoweringly emotional. There is a fine *Death of the Virgin* by the last major painter of renaissance Fabriano, Antonio da Fabriano. Diagonally opposite the museum is the Museo Diocesano, with more panels by Nuzi and the earliest certain work — of 1498 — by a Perugian eccentric, Bernardino di Mariotto, who had already 'gone native' in the Marche.

Fabriano is rich in its churches. Two of the finest of these are now closed because of earthquake damage: the gothic brick Santa Lucia, otherwise San Domenico; and Sant'Agostino, high at the eastern end of the town, originally built for Gualtiero Chiavelli, which retains a fine late Romanesque door that dominates the steep approach from the centre. In San Benedetto there are altarpieces by both Gentileschi and that Sienese magician, Francesco Vanni. Guercino was commissioned to paint his large *Saint Michael* for San Nicolò, across the river on the northern rim of the town. The beautiful Baroque Santi Biagio e Romualdo houses a characteristic altarpiece of 1750 by the still underrated Francesco Mancini; while his younger contemporary, Giuseppe Cades, painted an early Neoclassical masterpiece, the *Beato Francesco Venimbeni*, in Santa Catarina.

No-one should miss the small Santa Maria Maddalena, originally well outside the walls to the west of the town. The only altarpiece, of the saint in penitence, is perhaps the finest of the canvasses Gentileschi supplied for Fabrianese patrons. On the right-hand wall are two frescoed scenes by the Master of San Biagio in Caprile, a *Crucifixion* and an admirably inventive *Annunciation*, in which the Angel approaches from the right, as if through the door of the church itself.

84

LORETO

❀

A FIRST VIEW of the great sanctuary at Loreto even now takes the breath away. This extraordinary complex, to which many of the great architects and painters of the Renaissance contributed, is as remarkable as the legend it celebrates. In 1291, as the Crusaders lost their hold on Palestine, the house in which the Virgin had been born and in which Christ was brought up after the return from Egypt was miraculously carried by angels to a hill near Fiume. On 10 December 1294 this was borne across the Adriatic to a laurel wood near Recanati, from where it was flown onwards to a farm owned by two brothers; their competing claims led to a final migration to the crest of a ridge on what was a public road, which after all was a not inappropriate site for a place of pilgrimage.

The small town that grew up on the approach to the sanctuary was incorporated within the splendid defensive walls built for Pope Leo X to the design of the younger Antonio da Sangallo and Andrea Sansovino, among others: these would no doubt have complicated the work of the English force which Sir John Vanbrugh's father suggested should be sent to sack the shrine in revenge for the Popish Plot had King Charles II been silly enough to accede to the idea. Enter by the Porta Romana and follow the main street to the Piazza della Madonna, with a central fountain of 1604–14. On my first visit this was crowded with pilgrims, many in wheelchairs; Ursula Corning, who had worked in the New York hospital she helped to re-endow,

looked on with a professional interest, trying to work out how many of the sick really believed they might be cured. The presence of ailing pilgrims reminds us that Loreto is in every sense a working shrine.

On the left of the piazza is the colonnaded Palazzo Apostolico, begun by Bramante and worked upon by a sequence of later architects from Sangallo to Luigi Vanvitelli. Ahead, flanked on the left by Vanvitelli's campanile of 1750–4, is the rich façade of the basilica itself, begun in 1571, and notable above all for the bronze reliefs of the doors; that in the centre is by the Lombardo brothers, that on the left, of 1596, by Tiburzio Vergelli and an assistant, while its counterpart was begun by Antonio Calcagni from Recanati and finished by other local masters in 1600.

The church is cruciform in plan. It was begun in 1468, and from 1476 the Florentine Giuliano da Maiano was in control, carrying the walls to full height. These were, however, reinforced for defensive purposes for Pope Innocent VIII, under whose Borgia successor, Alexander VI, work began on the octagonal dome designed by Giuliano da Sangallo, but strengthened by Francesco di Giorgio. Further work of consolidation was entrusted to Bramante (1509–11) and to Andrea Sansovino. Within the church it is the white marble Santissima Casa under the cupola that dominates the central axis. Encasing the original building, this was designed by Bramante, and is remarkable for its sculptured decoration. The large narrative reliefs of scenes from the life of the Virgin should be read from the left, north, wall. The most

The Sanctuary, from the north-east.

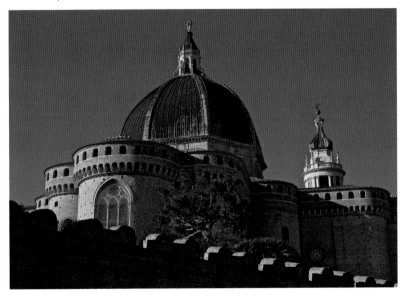

Basilica, Sacristy of San Giovanni:
Above: associate of Luca Signorelli, putto supporting the arms of Cardinal Girolamo Basso della Rovere, fresco (detail).

Below: Luca Signorelli, Evangelists and Doctors of the Church, with Angel Musicians, *fresco* (detail).

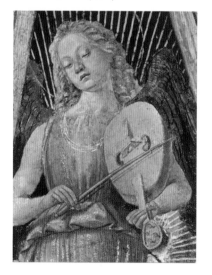

beautiful perhaps are those by Sansovino, the *Annunciation* of 1523 facing the nave and his *Nativity* on the south wall. The bronzes of the doors, by the Lombardo, Vergelli and Calcagni, are also distinguished.

At the angles of the crossing are four octagonal sacristies. That to the south-west, dedicated to San Marco, was frescoed from 1477 by Melozzo da Forlì. In the centre of the vault are the arms of Cardinal Girolamo Basso della Rovere, surrounded by bands of decoration, including eight compartments with angels holding musical instruments and symbols of the Passion, and below these eight more with prophets. The angels are perhaps Melozzo's happiest

achievements. Only one of the projected frescoes of the walls was painted, the Triumphal Entry to Jerusalem, much of which is by the young Marco Palmezzano. The south-east sacristy, dedicated to Saint John, is perhaps yet more memorable. Here the cardinal, who was responsible for the church from 1476 until 1507, called in the young Luca Signorelli. His arms once again are at the centre of the octagonal vault, in the segmental compartments of which are the Evangelists and the Doctors of the Church, each seated below a beautiful music-making angel. Below are the Conversion of Saint Paul, Christ and Saint Thomas, and pairs of Apostles. The cardinal's arms, supported by paired putti, appear again in elegant grisaille above the door. Signorelli's work at Loreto was no doubt the springboard that led to his selection to contribute to the Sistine Chapel.

A door from the left transept leads to the Treasury, housed in the large Sala Pio XI, whose ceiling, frescoed in 1605–10, is the most ambitious work of that genial late Mannerist painter, Cristoforo Roncalli, il Pomarancio. Although the buildings are annexed, it is necessary to return to the piazza to enter the museum in the Palazzo Apostolico and see the large group of late works by Lotto, who retired as an oblate to Loreto and was buried in the church. The sequence culminates with his Presentation, the personal and deeply moving last work of a great artist who clearly did have the conviction of his faith. Less appealing perhaps, but also remarkable, is the massive collection of maiolica from the workshop of Orazio Fontana presented to Loreto by Guidobaldo II della Rovere, Duke of Urbino. Two of the museum's greatest treasures arrived as gifts in the eighteenth century, major cartoons for key commissions by Annibale Carracci and Domenichino.

85

MONTE SAN GIUSTO

❖

THE CITIES AND towns of the Marche have enjoyed a long yet quiet prosperity. A succession of snaking valleys descend gently towards the Adriatic, Venetian dominance having left an extraordinary legacy in the Bellinis at Pesaro and Rimini, and the Titians at Ancona and Urbino. No Venetian recognized the potential of Marchigian patronage more clearly than Lorenzo Lotto. And its legacy endures. One can follow his career from the Recanati polyptych of 1508, by way of the Jesi Entombment of 1512, the incomparable Saint Lucy altarpiece of 1532 also at Jesi and the visionary Madonna of the Rosary of 1539 – with its scattered rose petals – at Cingoli, to the later canvasses at Loreto. The Recanati Annunciation, with its cat, is the most familiar of the Marchigian Lottos, but the most prodigious must be the Crucifixion of 1531 at Monte San Giusto.

The town stands high above the valley of the Chienti. Like others in the area it is built largely of brick. At its centre is the Palazzo Bonafede built for Niccolò Bonafede, Bishop of Chiusi, between 1504 and 1524. The nearby church of Santa Maria in Telusiano was remodelled by the bishop as his mausoleum, and he was buried there in 1534. The modest brick façade offers no hint of the interior. This is dominated by the high altarpiece, Lotto's great arched Crucifixion in the original gilded frame. Modern lighting means that it is easy to savour the dazzling use of colour that has so important a part in the visual drama. In the foreground is the swooning Virgin, supported by

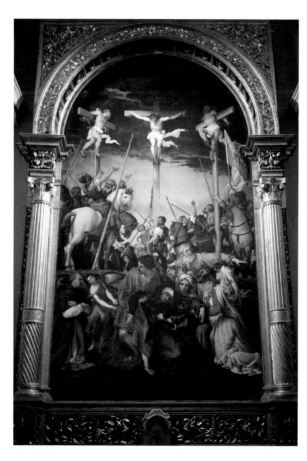

Monte San Giusto, Santa Maria in Telusiano: Lorenzo Lotto, Crucifixion, 1531, in the original frame

Saint John – who seems almost to project from the painted space – and the attendant Maries. Saint John looks to the left, towards the kneeling bishop. Bonafede's arms are crossed in prayer, his massive head almost disturbingly larger than that of the angel who acts as intermediary. The eye is drawn upwards. The crosses stand out against the evening sky, a dark cloud silhouetting Christ with his billowing loin-cloth, and the thieves, good and bad, their arms tied behind the crossbars. Below is a noisy pell-mell

of soldiers, each carefully characterized. Lotto is so individual that one is not at first aware of the range of pictorial experience on which he draws: the clarity of the Venice of Bellini, the classical rhetoric of the mature Raphael, prints by Dürer and other northern prototypes. His digestive power was matched, however, by his visual independence of mind, by an unfailing narrative conviction, and by an almost miraculous sense for colour. The *Crucifixion* is at once deeply moving and breathtakingly beautiful.

86

FERMO

✤

THE ARTISTIC RICHES of the Marche can be experienced in microcosm at Fermo, the successor of the Roman Firmum Picenum, set on a hill some five miles inland from the Adriatic shore.

High above the centre of the town is the Duomo; the front with an elaborate portal survives from the structure of 1227 designed by Maestro Giorgio da Como, but the interior was reconstructed from 1781 onwards. To the right of the entrance, in the surviving west bay of the early church, is Tura da Imola's signed monument to Giovanni Visconti di Oleggio (d. 1366), one of the series of noblemen who held the *signoria* of Fermo in the late medieval period. In a chapel on the right is a much revered eleventh-century Byzantine icon of the Virgin, but the most appealing altarpiece is that of the Cappella del Sacramento, the *Circumcision* by the late *cinquecento* Florentine Andrea Boscoli, whose melting forms and subtle sense of colour secured him a number of commissions in the area. The great treasure of the Duomo, now in the adjacent Museo Diocesano, is the so-called chasuble of Saint Thomas of Canterbury, which, as an Arabic inscription attests, was made at Almeria in Spain in 1116.

Fermo's churches and brick palaces cluster happily. And the central Piazza del Popolo is particularly appealing, with the Loggiato of San Rocco of 1528 and, at the north end, the handsome baroque Palazzo degli Studi opposite the Renaissance Palazzo Comunale, which houses the Pinacoteca. The patrons of medieval Fermo had to look to artists from outside their town: the polyptych of 1369 was supplied by a diligent itinerant, Andrea da Bologna, while the *Madonna of Humility* is by that delicate Fabrianese magician, Francescuccio Ghissi. The eight scenes from the life of Saint Lucy of about 1410–12 by the Venetian Jacobello del Fiore are among the narrative masterpieces of their age. The surprise of the museum is the *Nativity* of 1608 by Rubens. Near this is a *seicento* masterpiece, Lanfranco's contemplative *Pentecost*.

Duomo, west door (detail).

87

SERVIGLIANO

❖

MANY VISITORS TO the Marche search out medieval and Renaissance monuments. And this is wholly understandable. But there is also much of later periods to see. Thus, if the beautiful Barocci at Senigaglia is inaccessible, we can always linger in Pietro Ghinelli's circular Foro Annonario, the Neoclassical master-piece of an obscure local architect.

Sometimes it is the less grandilo-quent that takes us most surely to the spirit of a lost age. So it is at Penne San Giovanni, birthplace of the still-life painter Mario Nuzzi dei Fiori, where a handful of patrician families supported the *settecento* theatre, a happy survival with its prettily decorated boxes, hardly larger than a drawing room. Penne is on a ridge above the valley of the river Tenna. Below, and on the opposite (right) bank, is an unexpected apparition, a small eighteenth-century town. In 1771 the town of Servigliano, a few kilometres to the south, was destroyed by a landslide. A year later Pope Clement XIV ordered that a new town, Castel Clementino, be founded on a lower and less vulnera-ble site. Work was continued under his successor, Pope Pius VI. In 1863, after the reunification of Italy when it was no longer fashionable to celebrate the legacy of papal rule, the new town was given the name of its predecessor.

Servigliano is a textbook model town of its period, square in plan, entered by three elegant gates, with two main streets that intersect in a generous piazza in front of the handsome church. It boasts no great work of art; it can claim no individual building of particular importance. But it has the merit of being largely intact, and is moreover acces-sible in the early afternoon when even the most determined sightseer will not be able to gain access to the wonderful polyptych by Carlo Crivelli at nearby Massa Fermana, or those by his son Vit-tore at Monte San Martino diagonally across the valley.

View northwards from the south gate, with the church on the right.

88

ASCOLI PICENO

✿

THE PICENO WAS the Roman name for what is now the southern half of the Marche, and Ascoli was a stronghold of the Piceni who controlled much of this area long before Rome's conquest in 286 BC. Some twenty-eight kilometres from the Adriatic, the city is on a promontory above the confluence of the river Castellano with the Tronto. The Ponte di Solestà across the latter was built early in the imperial era, and much of the plan of the Roman town survives in the tight grid of the existing streets. But is it for its Romanesque churches, built of travertine stone, and her many later palaces that Ascoli is now remarkable.

The Renaissance arcaded Piazza del Popolo lies at the centre of the town. This is dominated on the west by the Palazzo del Capitano del Popolo, a medieval structure which was altered to the design of the local painter Cola dell'Amatrice in 1520 and partly remodelled in 1535; Cola's rusticated door-cases on the west façade are particularly striking. To the north is the flank of the major gothic church of San Francesco. A circuit beyond this might take in no fewer than four of Ascoli's Romanesque churches, Santa Maria inter Vineos, Santi Vincenzo e Anastasio, San Pietro in Castello and San Pietro Martire, en route for the Ponte di Solestà. Two hundred and fifty metres west of San Francesco is another late Romanesque church, Sant'Agostino, with the fourteenth-century Fabrianese Francescuccio Ghissi's *Madonna of Humility* on the right. A block to the south is another Romanesque church, San

Venanzio, incorporating the south wall of a Roman temple, with a cerebral if little-known masterpiece of the Roman baroque, Baciccio's *Death of Saint Francis Xavier*. South of the Piazza del Popolo is the smaller Piazza Roma, dominated by the dignified façade of Santa Maria della Carità, begun in 1532 to the design of Cola dell'Amatrice.

The Piazza Roma is linked to the east by the Via XX Settembre to the Piazza Arringo. On reaching this, turn right, up the narrow Via Tornasecco, to San Gregorio, another Roman temple recast as a Romanesque church. At the further end of the piazza is the Duomo and, on the right, the Palazzo Comunale and the Palazzo Vescovile. The former, an agglomeration of earlier structures, was refronted in the seventeenth century and houses the Pinacoteca Comunale with a notable holding of local works and one exceptional treasure, the *opus anglicanum* cope. This was given to the Duomo by Pope Nicolas IV in 1288; stolen in 1902 it was returned to Ascoli by the American philanthropist J. Pierpont Morgan three years later. The animated embroidered designs stand comparison with the finest English illuminations and stained glass of their date, soon after 1265. The collection of pictures ranges from the masterpiece of the *quattrocento* Paolo da Visso by way of a tender *Annunciation* by Reni to an *Assumption* by the nineteenth-century Domenico Morelli. In the Palazzo Vescovile, whose projecting wing has also been attributed to Cola, is the Museo Diocesano with more Marchigian pictures. Across the piazza is the exemplary Museo Archeologico with exceptional Iron Age metalwork.

The Duomo was enlarged in 1482; the massive façade was constructed to

Palazzo del Popolo, west façade by Cola dell'Amatrice.

the design of Cola in 1529–39. On the left is the free-standing octagonal Roman-esque Baptistery, crowned by a loggia. The scale of the church is impressive; the gothic choir stalls are fine, but much else is best forgotten. In the Cappella del Sacramento, on the right, however, is the splendid polyptych of 1473 by the most eccentric of late fifteenth-century Italian painters, the Venetian Carlo Crivelli, who had settled at Ascoli some years earlier and remained there until his death in 1494/5. This was originally on the high altar and retains its intricate gothic frame. The main tier shows the Madonna and Child between Saints Peter, Jerome, Emidius – the patron of the city – and Paul; above is the Pietà and further saints, and below, in the predella, Christ and the apostles. Crivelli's Paduan training is tempered by experience of local painters from Camerino and Foligno. None of his contemporaries knew

better how to paint fruit realistically, but realism was not Crivelli's prime objective. His Madonna is at once elevated and poignant, his Child aware – not only from its weight – that the enormous apple he holds is the symbol of the Passion and of mankind's subsequent redemption. As if to intrude on the spectator's space, the left feet of both Saint Peter and Saint Paul project beyond the platform on which they stand. It is unfortunate that this masterpiece is placed too high to be fully appreciated.

The patrons of the Marche were dazzled by Crivelli's proficiency – and by his colours. Until his death in 1495 he had no challenger; his brother Vittore and close follower Pietro Alemanno would adhere to his model until the end of the century. Ascoli is fortunate that its greatest altarpiece survived both the depredations of revolutionary France and later Anglo-Saxon shopping.

Bolsena 89

90 Viterbo

93 Tuscania

• Bagnaia 91

• Caprarola 92

• Tarquinia 94

Cerveteri 95

• Tivoli 99

• Rome 96 • Subiaco 100

• Ostia 97 • Anagni 101

Frascati 98 • Ferentino 102

Lazio

89

BOLSENA

✿

THE GREAT PILGRIM route from France to Rome followed the ancient Via Cassia. The first substantial town south of the Tuscan frontier was Acquapendente. Two other significant towns were on the route south to Viterbo: Bolsena and Montefiascone.

Bolsena beside the lake that bears its name is the successor of the Etruscan Velsna, the Roman Volsinii. It passed to papal control in the seventh century, but was held by Orvieto from 1186 until 1267 and again from 1294 until 1375: the quadrilateral castle, so conspicuous from afar, was built under Orvietan rule. In 1263 a priest, Peter of Prague was in Bolsena on his way to Rome. He had entertained doubts about the doctrine of transubstantiation, but when celebrating mass in the shrine of the martyred Santa Cristina saw blood oozing from the host. The miracle led Pope Urban IV, then resident at Orvieto, to institute the Feast of the Corpus Domini on 11 August 1264.

The elegant and lavishly decorated façade of the church of Santa Cristina was erected for Cardinal Giovanni de' Medici in 1492–4. Naturally he employed Florentine artists. The façade has been attributed to Francesco and Benedetto Buglioni, and the latter was almost certainly responsible for the glazed lunette over the door and that of the oratory of San Leonardo on the right. Within, the Romanesque church consecrated by Pope Gregory VII in 1077 is substantially intact. On the high altar there is a characteristic polyptych by Sano di Pietro above a predella by a fellow Sienese artist of the following generation,

Benvenuto di Giovanni. To the right of the presbytery is the chapel of Santa Lucia, with a glazed terracotta statue of Santa Cristina attributable to Buglioni. A passage to the left of the presbytery leads to the Chapel of the Miracle of 1693 with an altarpiece of the miracle by Trevisani. Beyond this is the Grotto of Santa Cristina, with a substantial altarpiece by Giovanni della Robbia in the chapel to the right and a *Crucifixion* given to Buglioni. Ahead is the entrance to the catacombs, excavated into the hillside. Perhaps because it is modest by comparison with many shrines, the whole complex is oddly moving.

Diagonally across the Piazza Santa Cristina is the restored gothic Palazzo Ranieri of 1299. Further north on the larger Palazzo Matteotti is the Franciscan church, now a theatre, with a handsome portal. Further on is the narrow straight spinal street of the fortified town, which was laid out on a grid beside the castle. This houses the small Museo Comunale, with a good Roman sarcophagus and lesser local finds.

Montefiascone is also of interest. Hard by the main road is San Flaviano, an unusual twelfth-century structure on two levels. The lower church contains a substantial number of frescoes of varying date by local artists, many unidentified. Higher up in the town, much of the early fabric of which survives, is the vast Duomo. The project, attributed to the Veronese Michele Sanmicheli, seems to have been initiated by 1519, but work understandably proceeded rather slowly and the interior was only completed late in the seventeenth century under Carlo Fontana, whose great dome is a key landmark of the northern Lazio.

Opposite: Bolsena, Santa Cristina, attributed to Benedetto and Francesco Buglioni, 1492–4.

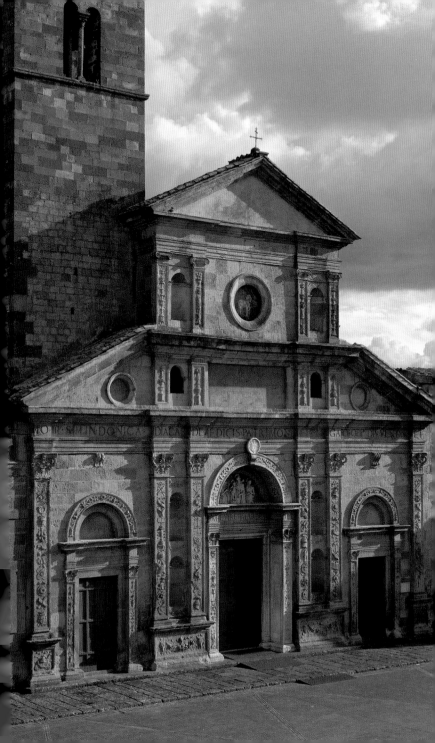

90

VITERBO

❖

VITERBO IS THE major city of northern Lazio. There had been an Etruscan settlement, but the place was of little importance until it was fortified in 773; five years later it was granted by Charlemagne to the papacy. Work on the ambitious circuit of the walls, which largely survive, commenced in 1095, and in the thirteenth century Viterbo was the second capital of the popes in their long struggle with the Hohenstaufen, as we are reminded both by the Palazzo Papale and the tombs of Popes Clement IV and Adrian V, who died respectively in 1268 and 1276, in the austere Franciscan church. Thereafter the city dwindled in importance, and as a result much of its medieval core survives. By coincidence Viterbo has two links with the English royal house: in

Palazzo Papale, the Loggia, 1255–66.

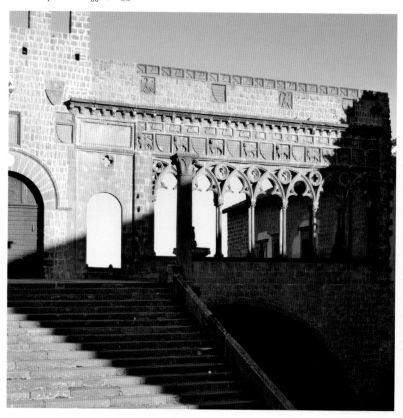

1271 Henry, Earl of Cornwall was murdered in the church of the Gesù, and Henry VIII's kinsman Reginald Pole was bishop from 1541 until 1554.

The administrative centre of the city, now the Piazza del Plebiscito, is surrounded by public buildings. From its south-eastern angle the Via San Lorenzo winds upwards, crossing the partly Etruscan Ponte del Duomo and passing the early *quattrocento* Palazzo Farnese, to the Piazza San Lorenzo. Ahead is the cathedral and to the north the Palazzo Papale, begun between 1255 and 1266, with an elegant open loggia overlooking the lower part of the city. The *cinquecento* front of the cathedral masks a handsome twelfth-century structure, with a wide nave separated from the aisles by colonnades. On the left wall there is an altarpiece of exceptional interest, Girolamo da Cremona's *Christ and Four Saints* of 1472, with a trenchant profile of the donor, Bishop Settala. We think of Girolamo as a miniaturist of genius, and in this altarpiece see that he was a key figure in the interplay of artistic ideas at a decisive moment.

Cross back over the Ponte del Duomo and make to the right for a fine early church, Santa Maria Nuova, and then cut eastwards through the atmospheric medieval quarter that preserves much of its twelfth-century character. Walk round to the Fontana Grande of 1206–79. From here the Via Garibaldi runs to the Porta Romana, to the left of which is another good Romanesque church, San Sisto. Outside the gate, turn left and follow a stretch of the well-preserved walls, which now serve to protect the city from a modern enemy, traffic pollution, for some 250 metres, to Santa Maria della Verità. This suffered gravely in the war. On the right is the gothic

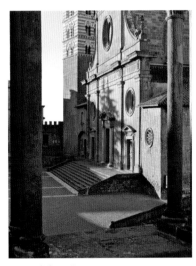

Cathedral from the Loggia.

Cappella Mazzatosta, justly celebrated for the remarkable cycle of frescoes of 1469 by a short-lived local master, Lorenzo da Viterbo. Although they have had to be detached and thus have lost something of their original power, we are left in no doubt that Lorenzo studied Piero della Francesca's lost frescoes in Rome. But Lorenzo was more than a mere imitator; he had a compelling artistic integrity of his own.

Beside the church is the Museo Civico. The archaeological collection is extensive, but the pictures are of more general interest. Among those by local artists is a more than competent *Nativity* of 1488 by Antonio da Viterbo, the Viterbese follower of Perugino who assisted Pinturicchio in the Borgia Apartments of the Vatican. The *clou* is Sebastiano del Piombo's *Pietà*, a lapidary masterpiece which exemplifies the artist's close association with Michelangelo.

91

BAGNAIA

✥

PROXIMITY TO ROME means that Lazio is rich in the great houses built for prelates and princely families. Some seek to dominate their territory. The Villa Lante, by contrast, is almost casual in its

relation to the small town of Bagnaia, just east of Viterbo, whose inhabitants still seem to live in their narrow streets despite the intrusion of a busy road.

Cardinal Giovanni Francesco Gambara, who became Bishop of Viterbo in 1566 and died in 1587, was clearly a man of subtle taste. For his summer residence he, like his all-powerful neighbours the Farnese at Caprarola, called in an architect of genius, Jacopo Barozzi

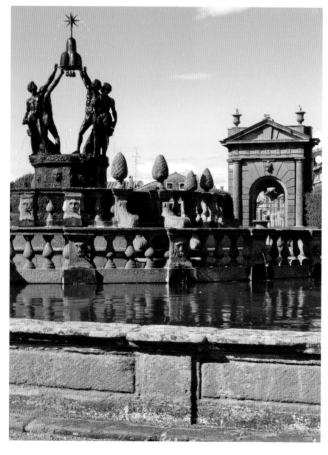

Villa Lante: the Fontana dello Quadrato.

da Vignola. Work on the formal garden was begun in 1568 using craftsmen previously employed at Caprarola, but not completed until ten years later, when Vignola himself was dead. The design took full advantage of the sloping site, with a sequence of fountains and channels framed by hedges set on three terraces among trees. The contrasts of architectural formality and the inherently informal – water and trees – express the spirit of the Renaissance garden, and the sound of the water is omnipresent. Below are the twin pavilions that constitute the villa. The first – on the right – is contemporary with the garden and was also projected by Vignola; this was Gambara's retreat. Its counterpart, faithfully copied from Vignola's design, was built for Gambara's successor, Cardinal Alessandro Montalto, who held Bagnaia from 1590 until 1612.

The Villa Lante is a magic place. It is difficult to tear oneself away. But many visitors will wish to visit the very different and slightly earlier garden at Bomarzo, some thirteen kilometres to the east. This was conceived by Vicino Orsini, who inherited the cliff-top castle that still dominates the valley in which he laid out his 'sacro bosco'. The site was scattered with natural outcrops of volcanic stone (*peperino*) from which bizarre statues of giants, monsters and animals and other subjects were carved. The modern entrance is unworthy, and the place is disturbing, even oppressive. It is the creation of an eccentric who was touched with genius.

92

CAPRAROLA

❧

OF PAPAL NIPOTI of the *Cinquecento* none had more ruthless political or demanding artistic ambitions than the Farnese, descendants of Pope Paul III. His son Pier Luigi was successively invested with the duchies of Castro and of Parma and Piacenza, which would pass to his own second son, Ottavio. Pier Luigi's eldest son, Cardinal Alessandro (1520–89), was the greatest patron of the line, and at Caprarola we still can sense his forceful personality. Jacopo Barozzi da Vignola's plans for the palazzo were finalized on 31 March 1559, and as you proceed up the spinal street of the small town you are inescapably aware of the magnitude of the cardinal's intentions.

The villa crowns the ridge as if to challenge the prospect it commands, with the volcanic cone of Mount Soracte rising from the plain and the distant peaks of the Gran Sasso. A great double stair rises to the door in the five-sided substructure, military in aspect, that respected the foundations of the palace which the younger Antonio da Sangallo had begun for the cardinal's grandfather before his election to the papacy. Vignola's genius was to create the towering palace above this. The nine-bay main façade, in which the contrasting colours of brick and stone are exploited to signal effect, is answered by lateral bays that echo the angle bastions of the Sangallo scheme.

The ground floor is entered though the vestibule, where Federico Zuccaro's decoration includes the cardinal's arms and views of the villa and other Farnese

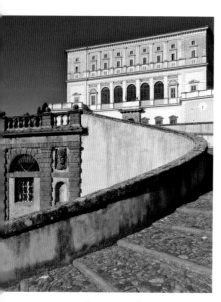

Jacopo Barozzi da Vignola, Palazzo Farnese.

possessions. Ahead is the door to Vignola's masterly circular court at the centre of the building; this is arcaded on two levels, the masonry below channelled while the piers between the upper arches are enriched with paired Ionic pilasters. The door on the left wall of the vestibule opens to Vignola's beautifully controlled circular staircase, supported on paired columns, the Scala Regia. Decorated in 1580–3 under the supervision of Antonio Tempesta, this leads to the sumptuous apartments of the *piano nobile*.

The sequence begins with the Salone di Ercole, above the vestibule, with its five arches that are so conspicuous an element of the façade. The arches are answered in the decoration of the room, whose murals are by members of the *équipe* brought in when Federico Zuccaro took over the project after the death of his more gifted elder brother, Taddeo,

in 1566. Next comes the circular domed chapel, where the frescoes are largely by Federico himself. Beyond is the celebrated Sala dei Fasti Farnesiani, devised by Taddeo at the very end of his life, with scenes celebrating the history of the Farnese, the largest of which show the *Troops sent by Paul III to combat the Protestants* and *King François I receiving the Emperor Charles V and Cardinal Farnese in Paris*, with several readily recognizable portraits. The glorification of the Farnese is continued in the adjacent Anticamera del Concilio, with Taddeo's *Proclamation of the Council*, which is arguably his most sophisticated fresco in the palazzo. Beyond is the Summer Apartment, hanging over the garden to the north, beginning with the cardinal's bedroom, the Sala di Aurora, decorated, like the two rooms that follow, by Taddeo to a programme devised by Annibale Caro. The northern Bartholomäus Spranger worked in the projecting Tower Room at the northern angle of the palace. The Summer Apartment is balanced by that intended for winter use, the Appartamento del'Inverno, with three rooms decorated by Jacopo Bertoia. There follows the Sala degli Angeli, frescoed by two of the most appealing of Mannerist masters, Giovanni dei Vecchi and Raffaellino da Reggio. Both painters also worked with a specialist in cartography, Giovanni Antonio da Varese, in the large Sala del Mappamondo, with maps of the world and territories recently claimed for the Faith, that concludes the sequence of the rooms.

Behind the palazzo a commensurate garden was laid out, with an elegant loggia'd Palazzino del Piacere from which a runnel of water descends to a basin flanked by flights of steps. Grand as this is, the garden must always have lacked the charm of that at Bagnaia.

93

TUSCANIA

✤

TUSCANIA IS IN several ways outshone by her larger neighbour Viterbo; the town boasts no celebrated papal palace and fostered no local school of painters. Yet of the two cities it is perhaps Tuscania that draws one back. The Etruscan Tuscana was absorbed by her Roman successor, which was in turn occupied by the Lombards in 574. It is to their rule, which ended in 774, that the glory of Tuscania, San Pietro, is due. Tuscania's subsequent history was complicated, but in 1443 Cardinal Vitelleschi finally enforced papal control.

Tuscania's importance diminished, and the medieval city – its confines marked by the extant walls – was larger than its immediate successor. There is abundant evidence of the strata of the town's history – the restrained late Romanesque façade of Santa Maria della Rosa, the medieval Palazzo Spagnoli and the *quattrocento* Palazzetto Farnese nearby. The commercial acumen of the painters of Siena is implied by a polyptych by Andrea di Bartolo in the rebuilt Duomo, while the one surviving chapel of San Francesco – whose nave is now an open-air restaurant – was frescoed in 1466 by the brothers Sparapane from Norcia, provincial masters who here reveal an unexpected affinity with the Sienese Giovanni di Paolo. Memorable in a very different way is the stuccoed Supercinema of 1928 with an inscription to remind us that it was built in the sixth year of the Fascist era.

To the south of the town are the two churches that even in the nineteenth century drew visitors to Toscanello, as it was then known. Santa Maria Maggiore is set below the walls, its façade opposite a massive bell-tower. Originally the eighth-century cathedral, the church was largely reconstructed in the twelfth century and reconsecrated in 1206. It is built in a greyish tufa, but white marble was used to effect on the façade. This is enriched by a central lunette with the *Madonna and Child* surmounted above a blind arcade by a superb rose window. The lateral portals also are richly decorated. Despite the earthquake of 1971 that damaged so many of the monuments of Tuscania, the interior has a timeless quality. For there is nothing to distract us from the early font, the reconstructed pulpit and the partly frescoed ciborium. The whole is dominated by the frescoed *Last Judgement* above the arch of the central apse.

San Pietro.

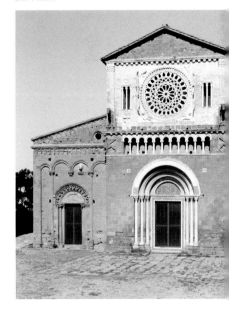

Further south, on a hill upon which the Romans built over the Etruscan settlement, is San Pietro. The way climbs steeply, allowing the eye to linger on the apse, which like that of Santa Maria Maggiore faces north. The visitor passes the complex and then turns into the enclosure. The façade of the church is set back, flanked on the right by the annexed range of the former episcopal palace, which is balanced to the west by two tall towers. Although restored in 1876, the early thirteenth-century façade is thoroughly convincing. The central portal is surmounted by a rose window with symbols of the Evangelists and reliefs which include a particularly disturbing demon. The interior is essentially an eleventh-century remodelling of the original eighth-century Lombard structure, thus fusing post-Roman with Romanesque forms. The great indented arches of the nave are borne on capitals, some of which were evidently reused – Corinthian, a bastard Ionic and composite – and high above these runs a blind arcade. The late twelfth-century Cosmati floor is unusually well preserved and complements the two earlier *ciboria* and the intricately decorated marble panels of the screen, survivors of the Lombard scheme. Below the presbytery is the crypt, with an ordered copse of reused Roman columns. Despite the earthquake, San Pietro remains a wonderfully satisfying building.

94

TARQUINIA

❖

THE 'NOBLE HOUSE of Tarquin', as Thomas Babington Macaulay termed it, may never have ruled in Tarquinia. But there is no doubt as to the nobility of the necropolis of the former Etruscan city of Tarxuna, or Tarxna, that sprawled over a now bare hill set well back from the coast above the river Marta. The city fell to Rome in 308 BC. A millennium later, after a long period of decline, the site was abandoned, some of the inhabitants moving westwards to the northern tip of the ridge that had served as the necropolis, to found the city of Corneto. The associations of the former name had an irresistible appeal to Italian patriots, so the place was renamed Corneto Tarquinia in 1872 and Tarquinia, *tout court*, in 1922.

Although evidence of their activity is omnipresent in the swathe of central Italy they once controlled, the Etruscans are in some ways an oddly elusive people. This is partly because they chose the sites of their cities so well that their successors continued to occupy them. At Volterra the circuit of their walls impresses, and at Cervetri their great necropolis haunts the imagination. In the archaeological museums of Florence and Volterra, of Chiusi and Rome, we can see something of the artistic vigour of their civilization. But it is perhaps most readily understood at Tarquinia, where the rich holdings of the Museo Nazionale Tarquiniese can be seen in conjunction with the lavish decoration of so many of the excavated tombs.

Begin in the museum, which is housed in the remarkable late gothic Palazzo Vitelleschi on the north side of the Piazza Cavour. Cardinal Giovanni Vitelleschi, for whom it was begun, was a patron of considerable taste, as the frescoes in the *studiolo* on the first floor confirm. The building lends itself admirably to the display of the archaeological collection. The sculpture is for the most part of little sophistication. *Sarcophagi* with recumbent portraits pall, but in a small relief of the *Suicide of Ajax*, for example, evident energy is matched by a degree of refinement. Pride of place goes, on the second floor, to two fragmentary winged horses made in earthenware that flanked the approach to the main shrine in the Etruscan town. Nearby are murals salvaged from three of the tombs in the necropolis, notably the Tomb of the Olympiads, datable to the late sixth century BC, and the early fifth-century Tomb of the Triclinium.

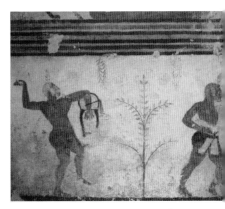

Museo Nazionale Tarquinese: Baccanti Tomb.

The collection is rich in smaller items – the mirrors are of interest, as well as the local ceramics. But it would be perverse not to admit that the latter are crude by comparison with the decorated black figure wares from Athens for which the Etruscan plutocracy had an understandable predilection. These are arranged by subject matter: war, sport and sex. And we are left in no doubt of both the visual preoccupations of the Athenian potters and the tastes of the Etruscan consumers who chose to be buried with such luxury goods.

The necropolis lies to the south-west of the town, an easy walk. Over six thousand tombs have been found, some sixty with substantial decorative schemes. Only a dozen or so are open at any given time. Flights of steps lead down to the tomb chambers, which for conservation reasons are sealed with glass. The repertoire is varied: swarthy dark-haired men feast with, and less frequently make love to, fair-skinned women; they are seen wrestling and hunting; furniture and trees serve as props and animals abound. Intelligent labelling helps the visitor to make sense of the chronology of ancient painting, so much of the evidence for which is due to the very survival of the Tarquinia tombs.

Medieval Corneto should not be overlooked. On a spur at the north-western angle of the walls is the splendid and superbly sited church of Santa Maria di Castello, begun in 1121 and consecrated in 1208. The road to the left of the Palazzo Vitelleschi, Via Cavour, descends to the restrained front, which is flanked on the left by a handsome campanile. The interior has been responsibly restored and original fittings, including the font, the pulpit and a ciborium, are in place.

95

CERVETRI

✤

NO ETRUSCAN SITE is more mesmerising than the great cemetery at Cervetri. The Etruscan Kysry, Agylla to the Greeks and Caere to the Romans, became a major city in the seventh century BC: it was already a significant power by 560 BC when its fleet in alliance with that of Carthage forced the Greeks to withdraw from Corsica. Yet, as grave goods found in the tombs prove, the rich of Kysry had a refined taste in Greek exports. Their city submitted to Rome in 358 BC. Decline accelerated in the imperial and early medieval periods so that only a small area of the former city, Caere Vetus, continued to be inhabited.

The necropolises, which are on lower ground north of the present town, were systematically excavated from 1834 onwards. The visitor to the main necropolis arrives at the west end of an ancient road, the Via Sepolcrale Principale: to the right tombs are cut back into the rock, while on the left there are numerous circular tombs, partly rock-cut, partly built, the first of polygonal blocks. Further on two larger tumuli house multiple tomb complexes: in one of these, the so-called Tomba dei Vasi Greci, a significant group of Attic black-figure vases was found. Beyond the second of the tumuli, steps lead down to the Tomba Bella of the Matuna family with reliefs in painted stucco of their possessions.

Ahead the road splits. The first section of that which forks to the left, its tufa surface rutted by centuries of wheeled traffic, is closed off: so take the road to the right, but – should you have a taste for audio-visual displays – only after going off to the right to the Tomba a Quattro Camere. Numerous tombs are cut into the rock at either side and there are clusters of circular monuments between the two streets. The largest and arguably most impressive is the Tumulo

Via Sepolcrale Principale.

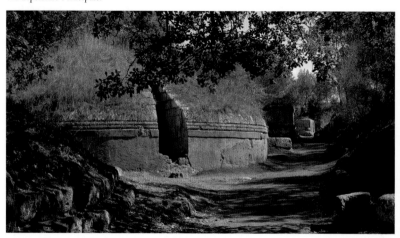

Mengarelli and its marginally smaller neighbour with four tombs including the so-called Tomba del Colonnello. The video displays in a building north of the tombs may help visitors to comprehend the world of the Etruscans – for which we have so little written evidence. But the magic of the necropolis is to be able to wander at will, as the sun penetrates the pine wood and catches the hills beyond.

Finds from the necropolises are shown in the Museo Nazionale Cerite in the handsome Rocca at the centre of the former Caere Vetus, opposite the Palazzo Ruspoli and an undistinguished church of Santa Maria, behind which is its beautiful Romanesque precursor. The fortress lends itself perfectly to its new role. The evolution of Etruscan ceramics can be followed from the eighth century BC onwards. But inevitably it is the Attic black-figure vases that linger in the memory. Two are among the absolute masterpieces of the genre. Both are signed by Euphronius, perhaps the greatest Athenian exponent of the medium: the admittedly fragmentary vase, the surviving portions of which are of surpassing precision, and the man's masterpiece, the large krater illegally excavated at Cervetri and after much prevarication returned by the Metropolitan Museum of New York. The Etruscan owner must have regarded it as a trophy, and so, as we know, did the opportunistic museum director who obtained it. But however much we object to the way the American tax system has been used appropriate the artistic inheritance of less rich nations, those of us who believe that great works of art should ideally remain where these are found should perhaps not forget that fewer people have access to the krater in Cervetri than in New York.

96

ROME

❧

NO OTHER EUROPEAN city can be compared with Rome. For none has enjoyed so long – or absolute – a pre-eminence. Founded, it is said, by Romulus and Remus in the eighth century BC, Rome gradually came to dominate its neighbours, a monarchy succeeded by the republic. Rome's territorial ambitions, in Gaul and elsewhere, were matched by the steady expansion of the great walled conurbation that sprawled over the seven hills between which the Tiber curves so majestically. Caesar's astute nephew Octavian became, as Augustus, leader of an empire that ruled the Mediterranean and beyond, and Rome was vastly enriched under him and his successors. The Emperor Constantine (AD 306–37), who recognized Christianity as the official religion of the empire, transferred his capital to Byzantium, but Rome remained the seat of what was to become the western empire, her importance reinforced by the spiritual primacy of the bishops of Rome, the popes.

The western empire was effectively destroyed when Rome was sacked by Alaric the Goth in 410. But Rome remained the seat of the papacy and a major place of pilgrimage. Roman monuments which had been adapted to Christian purposes, or – like the great girdle of the city walls – remained of use, survived while others mouldered. Major religious buildings continued to be constructed and adorned, their design and decoration echoing in varying ways that of classical Rome or Christian Byzantium.

The medieval papacy was a great power in western European political life, and from the fifteenth century a new age of construction began, driven largely by the aspirations of successive popes and their families, della Rovere and Borgia, Medici and Farnese in the Renaissance, Borghese and Pamphilj among others in the *Seicento*. Despite the more quiescent role of the papacy in the eighteenth century, Rome remained a major cultural centre where artists and archaeologists made vital contributions to the nascent Neoclassical movement. The French invasion of 1798 was followed by a generation of Gallic bureaucracy, but in 1815 papal rule was reinstated. In 1871 Rome became the capital of the new kingdom of Italy, but it was only with the Concordat of 1929 that state and church were reconciled. Strict conservation rules have meant that the exponential growth of recent decades has largely spared the heart of the ancient city.

Rome, it is said, was not built in a day. The visitor with less than a month on his hands, as I had on my first visit in 1966, has to be selective. He would be advised to stay in the centre of the town, ideally near the Pantheon. And if you want to see the key sights, go off-season, in November perhaps or February. The Vatican in particular is not to be ventured upon at busy times. The layers of Rome are impacted, the ancient inextricably entwined with the modern – which in Roman terms means the post-imperial. Yet to some extent, it does make sense to take in the ancient and the modern cities separately, rather as the watercolourist Samuel Palmer did, surveying the first from the Capitol and the second from a point above the Piazza del Popolo where most visitors from the north traditionally arrived.

There is still no better way to get your bearings than to enter through the Porta del Popolo and find yourself in the piazza that owes its present form to the great Neoclassical architect Giuseppe Valadier, confronted by the great Flaminian obelisk, with the paired churches flanking the central Corso beyond. But pause to enter the church of Santa Maria del Popolo. At close quarters there are works by Pinturicchio, by Raphael, by the sculptor Sansovino and by three of the great spirits of post-Renaissance Italian painting, Annibale Carracci, Caravaggio and Maratta.

From the piazza, the Corso – where Dickens saw the carnival crowds being bombarded with sugar plums – runs straight, lined by the façades of churches and palaces. In a piazza on the right is the triumphal column of the Emperor Marcus Aurelius, who died in AD 180, with the unfolding bas-relief of his campaigns in North Africa. The Corso debouches in the Piazza di Venezia, with the Renaissance Palazzo Venezia on the right, and, ahead, the Vittorio Emanuele Monument, the overblown pretension of which is shown up by the column below it commemorating the campaigns of a real conqueror, the Emperor Trajan. Leave this on the left and climb the great flight of steps to the Campidoglio. Ahead is the Palazzo Senatorio, with on either side the prodigious palaces that adhere more or less to Michelangelo's design and are now museums. In the centre is a cast of the celebrated bronze equestrian monument of Marcus Aurelius, preserved in the Christian era as it was thought to represent Constantine; the

Trajan's Column in the Forum of Trajan,
AD 107–13.

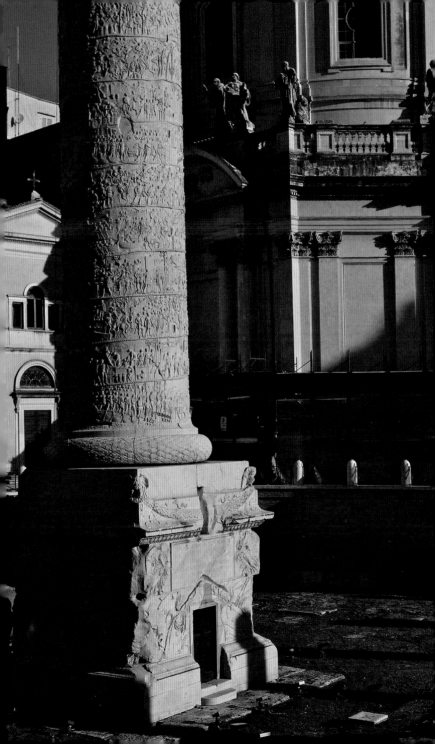

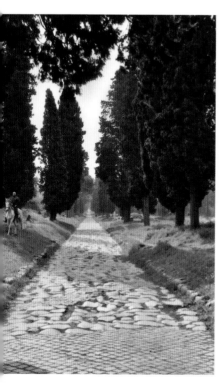

Via Appia Antica.

original has responsibly been moved to the Palazzo dei Conservatori on the right. The Capitoline Gallery in the same complex houses the outsize masterpiece of Guercino, the *Martyrdom of Saint Petronilla* completed in 1623, in which the young master from Cento proclaims himself one of the most brilliant artists of his century. The Palazzo Senatorio is more notable for its dramatic flight of steps. From the garden behind, look down on the Forum, the heart of ancient Rome, before returning to the Campidoglio itself to gaze over the centre of post-classical Rome, with its domes and roof terraces.

How you plan your Roman sightseeing must depend on opening hours – most churches close at 12 and only reopen after 4 – the availability of timed tickets to the Vatican museums and the Villa Borghese, for example, and of course the weather. There is a case for a chronological approach. Given a perfect morning, this might begin in the Forum, with the triumphal arches of Septimius Severus and Titus, and the Basilica of Maxentius which haunted Canaletto's imagination long after his only visit. To the west is the ruin-strewn Palatine Hill, still a wonderfully atmospheric place to walk. Emerging at the southern exit of the Forum, you reach the most sophisticated of the triumphal arches of Rome, that of Constantine. The narrative reliefs are of particular distinction. The arch is dominated by the vast bulk of the Colosseum behind, more beautiful in ruin that it can ever have been in its original state. Nearby is the Domus Aurea, the 'Golden House' of the Emperor Nero, which is the best preserved of the palaces of ancient Rome and has recently been reopened. Ten minutes south-west of the Colosseum is the greatest of Rome's thermal complexes, the brick Baths of Caracalla, prodigious in scale. One can walk back to the centre through the Circus of Maxentius, passing the splendid curved façade of the Theatre of Marcellus. If, at a later stage of your visit, you wish for a longer walk, make for Via Appia, the great Roman road south to Capua. From the Porta San Sebastiano a well-preserved section stretches southwards, shaded by pines. There are a number of Christian monuments, including the catacombs of Saints Calixtus and Sebastian, and numerous Roman tombs, some with portraits in high relief. The most celebrated is the circular Tomb of Caecilia

Metella, which almost rivalled the vastly bigger Mausoleum of Hadrian, now the Castel Sant'Angelo, in popularity with landscape painters from the seventeenth century onwards.

The greatest single monument of classical Rome is the Pantheon, the wonderful porticoed domed rotunda built in 27 BC by Augustus's associate, Agrippa. A miracle of structural engineering, made possible by the Romans' use of cement, with relieving arches that support a splendid coffered roof rising to the open oculus, the Pantheon was appropriated by the Church and owes to this its remarkable state of preservation. Monuments to Raphael and to the kings of Italy, among others, sink into insignificance in the majestic space of the Pantheon. Panini chose to depict this when a beam of sunlight bursts through the oculus, but the building is perhaps even more atmospheric when rain falls through this.

The Pantheon remains a pagan place. Yet the debt of the early Church to classical civilization cannot be overemphasized. One sees this in the fourth-century mosaics at Santa Costanza on the Via Nomentana, and in the great circular arcaded church of San Stefano Rotondo on the Coelian Hill. Nearby is Santi Quattro Coronati, with its well-preserved frescoes of 1246, murals that draw much of their artistic sustenance from the long tradition of mosaics inspired by Byzantium. This tradition was never forgotten in Rome. It can be experienced still in the narrative compartments of the frieze of the great basilica of Santa Maria Maggiore, and through the copies of the mosaics damaged in the tragic fire of 1823 in the second church of Rome, San Paolo fuori le Mura. It endured in the mosaic copies after the great masters of baroque Rome at St Peter's.

But before visiting that greatest of Catholic shrines itself, the visitor should come to terms with the strata of Christian Rome. The many catacombs that can be visited reveal not only the confidence of the early Christians in their faith but also the fact that increasingly they were individuals of influence or wealth. These are moving places. I prefer the smaller complexes, such as that at Sant'Agnese near Santa Costanza east of the Porta Pia, where there are fewer visitors. At San Clemente, beyond the Colosseum, you can descend to the original church mentioned by Saint Jerome that underlies the existing medieval church with the frescoes by Masolino that heralded the arrival of what we now think of as the Florentine Renaissance in Rome.

There is, of course, no better way to explore Rome than on foot. Start perhaps in Trastevere, with the mosaic-fronted church of Santa Maria in Trastevere, where the mid-twelfth-century apse mosaics are true to the taste of Byzantium, while Pietro Cavallini's narrative scenes below announce the revolution that was wrought in the last years of the following century. Hardly five minutes away is the church of Santa Cecilia with the extraordinary, if fragmentary, fresco of the Last Judgement of 1292 by Cavallini. Cavallini's forms are true to the conventions he inherited, but have a largeness of scale and a humanity that parallels the art of Giotto. Beside Santa Maria in Trastevere a narrow street leads to the steps that mount to the church of San Pietro in Montorio on the hill above. To the right of the church is the small courtyard with Bramante's diminutive tempietto, an exquisite microcosm of the architectural revolution of the late Quattrocento. In the church, on the right, is the chapel with

Michelangelo, Porta Pia, 1561–4.

frescoes of the *Flagellation* and prophets by the Venetian Sebastiano del Piombo, for whom Michelangelo supplied drawings. These too are revolutionary, challenging the Peruginesque conventions of earlier murals in the church.

On Sundays the churches of Trastevere are crowded, not least San Francesco a Ripa, a few minutes from Santa Cecilia. This is worth a detour for Gian Lorenzo Bernini's deeply moving statue of the Beata Ludovica Albertoni. Trastevere remains a working-class district. But it was not always so. A few minutes walk to the north is the Farnesina, the villa built by Agostino Chigi, a Sienese banker who employed a number of very distinguished artists in its decoration. Raphael's *Galatea* is in a class of its own, but the frescoes of Sodoma and Baldassare Peruzzi are also impressive.

Bernini was the universal genius of seventeenth-century Rome – sculptor, painter, architect, impresario – and Borromini his equal in imagination. Neither should be studied in pedantic isolation, and a short walk helps to set their contribution in context. Set out early for the Porta Pia, the admirably astringent eastern gate designed by Michelangelo and built in 1561–4, which will happily outlive Sir Basil Spence's nearby British Embassy, the travertine facings of which look like diseased concrete. Take the Via XX Settembre westwards towards the centre of Rome. After 600 metres, on the right, is Santa Susanna with, on the last altar to the left, Bernini's celebrated *Saint Teresa in Ecstasy*, which epitomizes the fervency of *seicento* Rome. In morning light the very marble seems alive.

Continue to the major crossing, the

Giovanni Lorenzo Bernini, Sant'Andrea al Quirinale, portico, 1658–71.

Quattro Fontane. As traffic roars nearby it is sobering to think that in the palace on the left, as recently as the 1920s, the daughter of the house, then Anna Maria Volpi, was regularly woken by the sound of sheep being driven along the cobbled street to market. On the far left corner is one of the architectural miracles of Rome, Borromini's San Carlo alle Quattro Fontane, begun in 1637. The ingenious façade does not prepare you for the subtle movement of the elliptical space within. Further on, as if conceived in direct competition, is Bernini's Sant'Andrea al Quirinale, built in 1658–61 for Cardinal Camillo Pamphilj. In the oval interior, marble and stucco are used to brilliant effect. On the first altar on the right is a moving late work (1676), the *Death of Saint Francis Zavier*, by the Genoese Giovanni Battista Gaulli, il Baciccio, who

was the most dramatic painter of late baroque Rome. Heading on for the centre of the city, one route passes the Trevi Fountain, whose baroque theatricality is evidently timeless in appeal.

The greatest of the fountains of Rome is Bernini's stupendous Fontana dei Fiumi of 1651 in the centre of the Piazza Navona, west of the Pantheon, the successor of the Stadium of Domitian. The piazza, crowded now except in the early morning, is one of the most satisfying urban spaces in Italy, with its three fountains and the concave façade added by Borromini to Rinaldi's Sant'Agnese in Agone on the west side.

The Piazza Navona is the ideal starting point for a circuit of churches which boast masterpieces that define the course of painting in Counter-Reformation Rome. Strike south for the Corso Vittorio

Emanuele. Three hundred metres west, on the north side, is the Chiesa Nuova, the church of the Oratorians. The vast ceiling was frescoed by Pietro Berretini da Cortona, Bernini's only rival in the range of his gifts as both painter and architect. On the fourth altar to the left is the *Visitation* by Federico Barocci, a picture which profoundly moved the church's austere founder, Saint Filippo Neri. Beyond, in the left transept, is Barocci's incomparably lovely *Presentation of the Virgin* of 1594. On the high altar is a revered Madonna surrounded by cherubs and angels by Rubens, whose flanking groups of saints of 1606–8 express the artist's excitement at receiving a major Roman commission.

Rubens admired Barocci but, as it happened, took little if any notice of the most revolutionary painter of the previous years in Rome, Michelangelo Merisi, il Caravaggio. Two hundred metres apart, to the north-east of the Piazza Navona, are two of Caravaggio's most arresting works. Of these the later in date is the *Madonna dei Pellegrini* of 1605 at Sant'Agostino; the kneeling spectator looks up from the worn feet of the elderly peasants to the celestial purity of the Virgin. Caravaggio's three canvasses in the chapel of Saint Matthew at San Luigi dei Francesi were painted between 1597 and 1602. Seeing these by artificial light we do not appreciate immediately how intelligently Caravaggio allowed for the natural illumination of a north-facing space. His majestic tenebrous compositions found classical reposts diagonally across the church in Domenichino's frescoes of scenes from the life of Saint Cecilia, executed in 1616–17.

Why Domenichino's was to be the defining influence of early *seicento* Rome is well demonstrated at Sant'Andrea della Valle, hardly 400 metres away. Follow the

south side of San Luigi and turn left on the Corso del Rinascimento. On the left is the sixteenth-century Palazzo della Sapienza; across its majestic courtyard is Sant'Ivo, most idiosyncratic of Borromini's fantasies. There is little of fantasy in Rainaldi's imposing façade of Sant'Andrea across the Corso Vittorio Emanuele. Inside, we are impelled to advance to the domed crossing, with Domenichino's celebrated pendentives of the *Evangelists* (1621–8) and, above, Lanfranco's luminous *Paradise*, finished in 1625. The vault of the presbytery was decorated in 1624–8 with scenes from the life of Saint Andrea by Domenichino, dynamic in their classicism and impressive in their narrative legibility. By comparison the large murals below by the Neapolitan Mattia Preti seem overwrought.

On leaving Sant'Andrea, follow the street to the right of the church until it ends and then turn left: fifty metres away is San Carlo ai Catinari. Domenichino's *Christian Virtues* in the pendentives of the dome are of 1630; beautiful in colour, these are among the most satisfying creations of the Roman baroque. On leaving the church, turn left and left again to regain the Corso Vittorio Emanuele and make east for the Gesù, the main Roman church of the Jesuits, begun by Vignola and continued by Giacomo della Porta. The church might already have seemed somewhat old-fashioned when in 1672 Baciccio embarked on the decoration of the vault of the nave with the *Triumph of the Name of Jesus*, as well as the cupola and the tribune. The Genoese painter's innate sense of drama, fortified by experience of contemporary sculpture, animates what was by any standard an ambitious scheme.

The palaces of baroque Rome are less accessible then the churches. No

tourist should fail, however, to see the Galleria Doria-Pamphilj on the Corso, entered from the Piazza del Collegio Romano. It is in a section of the palace reconstructed by Gabriele Valvassori in 1731–5 and contains the remarkable family collection, with major works by Titian, Caravaggio and Claude, as well as Velasquez's arresting *Portrait of Pope Innocent X* (Pamphilj), whose uncompromising realism inspired Francis Bacon, and Bernini's more benign bust. For eighteenth-century visitors, the Galleria of the Palazzo Colonna, open less frequently, was a highlight of their Roman experience. And in its orchestration of pictures, notably landscapes, this still has no equal.

Rome boasts other remarkable collections of both sculptures and pictures. Pride of place must go to the Villa Borghese, built originally for Cardinal Scipione Borghese. It was redecorated for Marcantonio Borghese in the final decades of the *Settecento* by Antonio Asprucci. There was no pedantry in his neoclassicism, and the interiors he created constitute the perfect setting for a impressive dynastic collection. On the ground floor are the Roman marbles, outshone by a series of masterpieces by Bernini – of which *Apollo and Daphne* is inevitably the most celebrated – and Canova's horizontal *Princess Pauline Borghese*, Italian counterpart to Goya's *Duchess of Alba*. Here too are the magnificent Caravaggios secured by the Borghese. Upstairs is the picture collection with two of the most significant milestones of the High Renaissance, Raphael's Baglione *Entombment*, appropriated from Perugia, and Titian's miraculous *Sacred and Profane Love*, both key early works of the artists.

Since 1929 the Vatican has theoretically been an independent state. Mussolini's decision to open the Via del Conciliazione means that St Peter's no longer takes the visitor by surprise. But the approach remains awe-inspiringly spectacular as the pilgrim or tourist advances into the vast piazza flanked by Bernini's prodigious colonnades. Ahead is Maderno's façade, finished in 1614, masking the church to which so many of his predecessors, including Bramante, Raphael and Sangallo, had contributed, crowned by the great dome begun by Michelangelo but completed by della Porta, who also built the two lower domes. Within, it is the baroque that dominates: Bernini's baldachin; the mosaics after Domenichino, Sacchi, Maratta, Cortona and others; the sequence of papal tombs – among which Bernini's to Popes Urban VIII and Alexander VII are of particular distinction. Canova's monument to the last Stuarts in the left aisle was, rather touchingly, paid for by their kinsman King George IV. The tour parties inevitably cluster round Michelangelo's peerless early *Pietà*.

The Vatican Museums are, even out of season, under siege. The new visitor centre is dire. But persevere. Most tourists head for the Sistine Chapel, where it is now virtually impossible to study, still less to enjoy, the frescoes by Perugino and his assistants, the epoch-making ceiling by Michelangelo or his great *Last Judgement* of the altar wall. It is easier to do justice to the equally cerebral frescoes in the Stanze di Raffaello, commissioned like Michelangelo's ceiling by Pope Julius II; the *School of Athens* is perhaps Raphael's most extraordinary achievement. The force of numbers means, alas, that one can no longer enter the small chapel of Saint Nicholas decorated by Fra Angelico. This opens off the Sala dei Palafrenieri, from which is reached the Loggia di

Raffaello, with the fifty-two biblical scenes devised by Raphael and his associates which exercised an immense influence on later iconography. The circuit of the palace continues with the Borgia Apartments, decorated at speed by Pinturicchio with the help of a troupe of assistants for Pope Alexander VI; here the sightseer has less competition.

The Vatican's holding of antiquities is extraordinary. No visitor should miss the Courtyard of the Belvedere, transformed in 1773, which houses what were for some centuries many of the most famous classical sculptures in the world, including the Laocoön, discovered in 1506, the Apollo Belvedere and the Hermes. But the Museo Pio-Clementino also deserves a coup d'oeil, for it is the most complete such museum installation of the eighteenth century to survive, its collections due to a very proper wish on successive pontiffs' part to preserve the archaeological inheritance of their state.

The Pinacoteca Vaticana, by contrast, celebrates the artistic tastes of the French. When in 1815 Canova recovered the pictures Bonaparte's agents had appropriated from the Papal States for the Louvre, they were retained in Rome. In some instances – for example, the two predella panels taken from the otherwise complete Fra Angelico altarpiece at Perugia – the decision seems deplorable and should surely now be reversed. But it is nonetheless fascinating to see how systematically the towns of central Italy were raided. Raphael was high in the sights of the French, and is represented by three great altarpieces, the early Oddi Coronation of the Virgin from Perugia, the mature Madonna di Foligno with its breathtaking landscape and the late Transfiguration, so long regarded as one of the key masterpieces of western art. Almost equally revered was Domenichino's Communion of Saint Jerome. A modern audience may be more moved by Caravaggio's powerful Deposition. These pictures were all major public statements. Leonardo's Saint Jerome may, to judge from the unprecedented prominence of the lion, have had a more personal message. Unapologetically old-fashioned in its arrangement, the Pinacoteca remains an oasis of near calm which no one interested in Italian painting can miss. Appropriately, it also houses Lawrence's portrait of King George IV, who paid for the return of the works of art retrieved by Canova.

97

OSTIA

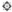

EVIDENCE OF THE classical world is omnipresent in the hinterland of Rome. Ancient and modern coexist. But the tourist who arrives at the Aeroporto Leonardo da Vinci at Fiumicino may not be aware that only a few miles away is the former port of Ostia. The site, by a bend of the Tiber, was well chosen. A fortress was constructed in about 338 BC, and the town grew steadily in importance, with no fewer than a hundred thousand inhabitants in its heyday. Silting of the Tiber led to the creation of a large artificial harbour under the Emperor Claudius, which was supplemented by a smaller one in the reign of Trajan. The centre of the city was substantially redeveloped under Domitian and in the second century AD. Decline set in during the following century, when much of Ostia's trade passed to Portus, on the right bank of the Tiber, and accelerated with the relative eclipse of Rome in the fourth century. That Saint Monica, mother of Saint Augustine, died there when the port was blockaded in 387 was a portent of what was to follow. The site was abandoned and the episcopal see transferred to Velletri; in 830 Pope Gregory IV founded his small town of Gregoriopoli half a kilometre to the east. Here, in 1483–6, the Florentine architect Baccio Pontelli built a state-of-the-art fortress for Cardinal Giuliano della Rovere, the future Pope Julius II.

Much of the town wall can still be traced. From the Porta Romana, the *decumanus maximus* runs to the south-west. This is flanked by the remains of the obligatory public buildings – no fewer than eighteen temples and sanctuaries, public baths, a palaestra and barracks – as well as numerous residential areas. The masonry is largely of brick, and it is the ensemble rather than the calibre of any individual building (with the exception of the Hadrianic Capitolium) that impresses. The shadows cast by the pines ensure that even in the heat of the summer it is a pleasure to walk and search out the grisaille mosaics that make the Roman world seem surprisingly close. One, in the Baths of Neptune, shows the winds of the provinces with which most trade was conducted: Sicily, Egypt represented by a crocodile, Africa with an elephant, and Spain. Others, in the portico surrounding the so-called Piazzale delle Corporazioni, illustrate aspects of Ostia's trade. Looking down on a mosaic of a ship under sail, we are left in no doubt of Ostia's vital importance to the economy of imperial Rome. It was through Ostia that the city received her tribute of oil from Africa and the grain of Sicily and Egypt on which her population depended. Where better to escape when stranded for a few hours at the airport?

Portico of the Piazzale of the Corporations: a ship, mosaic.

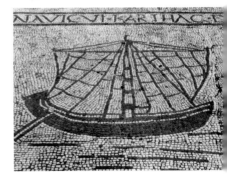

98

FRASCATI

❧

ON THE NORTHERN flank of the Alban Hills, Frascati was a place of little account until 1191, when it absorbed the surviving inhabitants of nearby Tusculum which had been destroyed. The episcopal see of the earlier town was transferred to Frascati. In very different times Prince Henry Benedict Stuart, Cardinal Duke of York, younger son of the titular King James III of England, 'the Old Pretender', was appointed Bishop of Tusculum in 1761.

Although Frascati was severely damaged in the Second World War, Cardinal York would still recognise his cathedral with its elegant façade of 1698–1700 by Girolamo Fontana, that architect's elegant fountain in the piazza over which this presides and the nearby church of the Gesù with a most handsome front of travertine stone. His brother, Prince Charles Edward Stuart, 'the Young Pretender', was buried in the cathedral.

The cardinal must have been uncomfortably aware that his episcopal residence was far upstaged by several of the villas which great Roman families had built above the town. The most palatial is the Villa Aldobrandini, built to a design by Giacomo della Porta in 1598–1602 for Cardinal Pietro Aldobrandini, nephew of Pope Clement VIII, and completed in the ensuing years by two equally distinguished architects, Carlo Maderno and Giovanni Fontana. The villa, with its towering central section, is set on a terrace from which the park descends to the town, with commanding views of Rome to the north. The more inventive back front overlooks the Teatro delle Acque, an ambitious nymphaeum adorned with appropriate sculptures which was fed by an ingenious hydraulic system devised by the appropriately named Fontana. With its ancient plane trees, hollowed out by time, and its failing stucco, the place has a timeless magic.

The Villa Torlonia immediately to the west was destroyed in the war, but Maderno's Teatro delle Acque happily survives in what is now a municipal park.

Villa Aldobrandini.

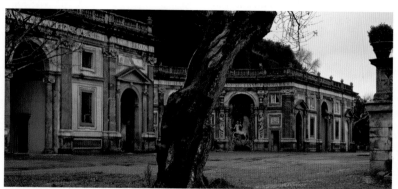

99

TIVOLI

❖

THE ROMAN CAMPAGNA has, alas, been steadily encroached upon since the late nineteenth century. But the great aqueduct that draws water from the river Anio, so beloved by the young Corot, survives, and on a fresh morning or a cloudless evening one can still see the world as Claude did. Until very recently popes continued to retreat to Castel Gandolfo and numerous villas and gardens survive. But if the visitor to Rome has time only for a single excursion, Tivoli must win.

The town hangs above the west bank of the river as it breaks through a barrier of rock to plunge into a deep gorge. The drama of the setting and the splendour of the views down over the *campagna* were clearly admired in ancient times, and from the seventeenth century few landscapes were painted more often.

Of the Roman town the outstanding survivor is the circular Temple of the Sibyl (or Vesta) that overhangs the falls of the Anio. This owes its exceptional state of preservation for a monument in so exposed a place to its adaptation as a church in the medieval period. Within the town, several early churches survive. The finest is perhaps the Romanesque San Silvestro on the picturesque Via del Colle, to the south-west of the late Duomo, which contains a notable thirteenth-century carved group of the *Deposition*. Late Romanesque Santa Maria Maggiore adjoins the greatest monument of the town, the Villa d'Este.

Cardinal Ippolito d'Este was appointed governor of Tivoli in 1550, and proceeded to replace his official residence with a spectacular villa designed by the Neapolitan Pirro Ligorio, who was in so many ways the artistic heir of Giulio Romano. The architecture is magnificent and the villa retains much of its frescoed decoration. But the glory of the Villa d'Este is the garden laid out on the sloping ground below, with cascading terraces that offer, as it were, a formal counterpoint to the natural falls of the Aniene nearby. Ligorio himself was responsible for much of what survives, including the Fontana dell'Ovato and the Fontana dei Draghi (dragons), supposedly thrown up in a single night in honour of Pope Gregory XIII's visit in 1572. The garden was quickly recognized as the *ne plus ultra* of Renaissance design,

Villa Adriana: the north wall of the Stoa, AD 118–34.

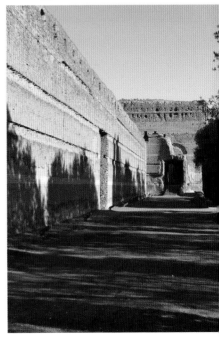

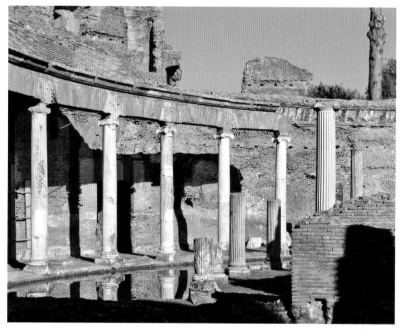

Villa Adriana: the villa of the island, AD 118–34.

and its echo can be sensed in many later schemes as far afield as Jacobean England.

The second of the great gardens of Tivoli is very different in character. The Villa Gregoriana is opposite the Temple of the Sibyl, entered from the Largo Sant'Angelo at the eastern end of the Ponte Gregoriano, built for Pope Gregory XVI (1831–46). The area had been built on in Roman times, but the garden, which has recently been restored, is a late creation of the Romantic movement. The circuit is punctuated by grottoes – that of Neptune was once a channel of the river – and the Belvedere, placed for the spectacular view of the Great Cascade.

At the foot of the valley into which the Aniene falls are the ruins of the vast complex of the Villa Adriana, built between AD 118 and 134 for the Emperor Hadrian. He travelled extensively for strategic reasons, and monuments in Alexandria and Greece were among those he sought to evoke in what Robin Lane-Fox has recently described as a theme park. The villa was first explored in the sixteenth century and received much attention from eighteenth-century excavators in pursuit of statues. The small site museum only houses those found since 1951. For the non-archaeologist, the charm of the site owes much to the juxtaposition of the ruins and the wooded hillside, whose contours were so intelligently exploited by the emperor's builders.

100

SUBIACO

❖

SUBIACO OWED ITS ancient name, *Sublaqueum*, to the lakes created when the Emperor Nero, who had a villa nearby, dammed the Anio. It was, however, to a man of a very different stamp that its interest to posterity is due. The young Saint Benedict lived for three years as a penitent in a cavern in the flank of the Monte Teleo above the town: the order he was to found would have a transformative influence on western monasticism.

The castle perched above Subiaco which was granted to the monastery of Saint Scolastica – Benedict's twin – in 937 is visible from some distance. Below the town, a road crossed the river to the monastery of San Francesco on a bluff above the valley. Visiting the gothic church accompanied by a veteran nun one is borne back to the Italy of half a century ago. The main altarpiece, dated 2 October 1467, is the key early masterpiece of Antoniazzo Romano.

Beyond the town is the huge monastery of Santa Scolastica, originally dedicated to Pope Silvestro, the only survivor of the thirteen establishments founded by Saint Benedict before he moved to Montecassino in about 529. The monastery was damaged in the Second World War but is still dominated by the noble Romanesque campanile: the third of the three cloisters was worked on by three generations of the Cosmati family and survives unscathed, while the spacious church is by contrast a disciplined early Neoclassical project by Giacomo Quarenghi who would later achieve such success at St Petersburg.

The Sacro Speco, or Monastery of Saint Benedict, is higher up the valley. This was constructed in stages from the twelfth century round the cave, in reality little more than an overhang, to which Benedict had withdrawn. It remains one of the most compelling religious sites in Italy. A path leads upwards though holm-oaks to the side of the cliff. A modest gate opens to a corridor, set back into the rock, at the end of which there is a door, surmounted by a beautiful fresco of the Madonna once attributed to Ottaviano Nelli. Beyond is the wider Old Chapter Room, with routine murals by a Roman follower of Perugino. Ahead is the lobby to the Upper Church, the two sections of which are given visual unity by the magnificent Cosmati floor. The first, and higher, section was frescoed by an Umbrian artist of the mid *trecento* under strong Sienese influence, the Master of the Subiaco Reredos, and his associates with scenes from the Passion: the most impressive is the *Crucifixion* above the wide arch to the second section. The early fifteenth-century murals in this are of scenes from the life of Saint Benedict. The Cosmati altar is original. To the right two linked chapels constitute a transept. The better-preserved murals, including the *Last Meeting of Saints Benedict and Scolastica*, the *Benedict in Penitence* below this, and further on, the *Martyrdom of Saint Placidus* and *Saints Peter and John healing the Cripple*, long given to Nelli are among the more inventive narratives of the later international gothic taste in central Italy.

Steps lead down to the atmospheric Lower Church, which consists of a substantial unitary space on two levels and associated chapels. The door through which one enters is flanked on the left by a fresco of Pope Innocent III with the bull of 1203 making a grant to the

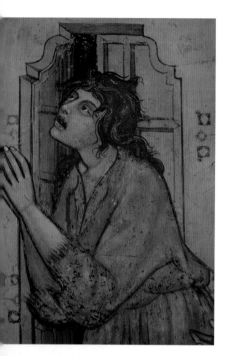

Umbro-Marchigian School, Saints Peter and John healing the Cripple, the cured cripple *(detail)*, c. 1440.

monastery and in a niche on the right by a damaged *Madonna and Child with Angels* which is signed by 'Magister Conxolus', who was evidently active in Rome about 1270–80. Most of the other frescoes of Benedictine subjects in the church are also by Consulus, although that on the left wall, *Saints Stephen, Thomas of Canterbury and Nicholas*, is by an earlier hand. To the right is the Chapel of San Romano. A further flight of steps leads down to the second section of the lower church. On the right is the entrance to the Sacro Speco itself. A white marble statue of the adolescent Benedict of 1657 by Antonio Raggi is perched against the rock wall. A piece of silver protects one foot from the

faithful, so the solitary pilgrim who was there on my last visit solemnly kissed the saint's cheek instead.

Beyond the entrance to the Sacro Speco is the Scala Santa, to the right of which a narrow spiral stair mounts to the atrium to the small Chapel of Saint Gregory. At the top of the stair is Consolus' fresco of *Chelidonia fed by Crows*. Of the other murals in the atrium, the most distinguished is to the right of the door to the chapel, showing Saint Gregory enthroned and a very depressed looking Job. This is clearly by the same hand as the remarkable portrait of Saint Francis on the reverse of the same wall in the chapel: this is the only contemporary likeness of the saint who visited Subiaco in 1223. The artist was also responsible for the other *trecento* frescoes in the chapel.

The Scala Santa – which follows the route by which Saint Benedict would have climbed up to his cave – is largely rock cut. The frescoes are by the Master of the Subiaco Reredos. Two have a strong cautionary message: the *Triumph of Death* and the *Hermit Macarius showing three youths the consequences of Death*. Further on are scenes from the infancy of Christ and compartments of saints. That these are precisely coeval with the excavation of the stair is suggested by the fact that the stones with which Saint Stephen was martyred are protrusions from the rock that must have been left for the purpose. The adjacent Chapel of the Madonna was frescoed by the same painter and his Perugian contemporary, the Master of the Montelabate Reredos. From here the stair leads down to the Grotto of the Shepherds opening on to a small garden from which there is an unrivalled view of the monastery and the great brick arches that support this.

101

ANAGNI

✦

DESPITE THE PROXIMITY of Rome, or per-haps because of it, the ancient cities of the southern Lazio are less well known than they deserve to be. None perhaps is of greater interest than Anagni. The place was taken by the Romans in 306 BC, but little survives of their ordered plan. The town even now has a medie-val air. Long controlled by the Caetani, Anagni had its period of glory in the thirteenth century. Three members of a prominent family, the Segni, were elected to the papacy, the formidable Innocent III (1198–1216), Gregory IX (1227–41) and Alexander IV (1254–61), while Benedetto Caetani, Pope Boniface VIII (1294–1303), maintained a close association with the town.

Anagni lies at the centre of the pros-perous Valle Latina, and I am glad I first saw it on market day crowded with

Palazzo of Pope Boniface VIII: Sala degli Ocche, fresco (detail).

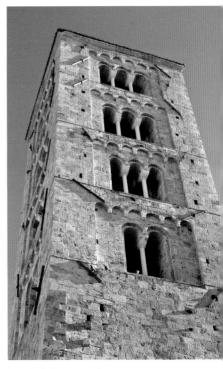

Cathedral, the Campanile.

vendors who almost blocked the nar-row streets. In the northern section of the town it is worth seeing a stretch of the early town wall and glancing briefly at the Casa Barnekow, a restored four-teenth-century house. Further on is the restrained, but also much restored, Palazzo Comunale of 1159–63, which has been attributed to Giacomo da Iseo. Higher up are a number of medieval pal-aces with later accretions. More remark-able is the palace of Boniface VIII, which was in fact built for Gregory IX, who was visited there by the Emperor Frederick II in 1230; it was here that Pope Boniface was seized by supporters of Philippe le Bel of France in 1303, only to be freed

after two days by his local supporters. Two rooms retain sections of contemporary decoration, including the Sala delle Ocche (geese) with depictions of geese and other birds in lozenges arranged diagonally.

Nearby, at the south end of the town, is the Romanesque cathedral, largely built under Bishop Pietro between 1077 and 1104, but remodelled in the following century. It was here in 1160 that the intemperate Pope Alexander III formally excommunicated Frederick Barbarossa, a decisive moment in the long struggle between the Church and the Holy Roman Empire. The campanile is particularly satisfying, and the interior of the church is remarkable by any standard, with the pavement of before 1227 by Cosma di Jacopo, protagonist of the Cosmati family, a handsome ciborium, and an exceptional paschal candelabrum signed by Vassalletto, who also made the bishop's throne of 1263. Two flights of steps lead down to the crypt, its nave screened by columns from the flanking aisles. The pavement of after 1231 is by Cosma and his sons, Luca and Jacopo. The frescoes of between 1231 and 1255 include scenes from the Old Testament and the Apocalypse, and are among the finest of their date in southern Italy, robust in colour and forceful in design. Off the crypt, with murals of the same period but of more routine calibre, is the chapel of Saint Thomas à Becket. Becket's cult was strongly encouraged by Innocent III and his successors, as he had so strenuously supported the pretensions of the papacy to control religious appointments in England. A contemporary Limoges reliquary of the saint is in the treasury of the cathedral. Equally remarkable are the vestments associated with Innocent III and a cope with New Testament scenes now thought to be from Cyprus, presented by Boniface VIII in 1295. At Anagni, perhaps more than anywhere else, one can still sense something of the frisson between the religious and secular in medieval Italy.

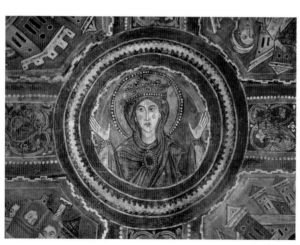

Cathedral, crypt:
Virgin, fresco (detail
of vault), after 1231.

102

FERENTINO and ALATRI

❖

BOTH FERENTINO ON its hill overlooking the Valle Latina and its neighbour Alatri, on an outlier of the Monti Ernici, were places of importance under the Ernici before Rome imposed its rule on its neighbours. Both towns flourished under Rome and were sacked by Totila. Ferentino passed to papal control in the eleventh century, Alatri following only in 1389.

Much of the fabric of medieval Ferentino survives within the well-preserved circuit of the town wall. From the Porta Montana on the north the Via Morosini curls round to pass an unexpected survival, a Roman market with booths opening off a barrel-vaulted hall. Further on is the austere Romanesque Duomo which was consecrated in 1108 and restored too aggressively in 1905–6. Happily its interior was not compromised. The Cosmati pavement in the presbytery is of 1116, while that of the rest of the church by Jacopo Cosmati is of 1203. The fine ciborium by Drudas de Trivio was commissioned by a noble from the town who became Archdeacon of Norwich and no doubt thought he had put the revenues of his office to appropriate use. The beautiful spiralling candelabrum also incorporated Cosmatesque decoration. The Duomo now crowns the acropolis of the Ernici, constructed of massive blocks, which dominates the centre of Ferentino, and is particularly impressive when seen from the west.

Alatri is a place of less charm. But its trapezoid acropolis is the finest surviving fortress of the kind. The walls of

Alatri, wall of the Acropolis.

polygonal masonry can be followed in their entirety. Entering by the Porta Areopago with its cyclopean blocks one registers that the lower level of the walls are up to sixteen paces wide. On the opposite, south, side the masonry suggests at least a dawning recognition of the concept of the relieving arch.

The Duomo on the acropolis is unworthy of so majestic a setting. Santa Maria Maggiore, from which the main piazza takes its name, is altogether more interesting. The rose window of the front is of unusual design. The nave and aisles open off a high narthex. In the first chapel on the left are gathered the key treasures of the church: the so-called *Madonna di Costantinopoli* of about 1200, with contemporary carved wings; and a triptych by the retardataire local painter, Antonio da Alatri. The civic museum is in the substantial thirteenth-century Palazzo Gottifredi which must indeed have been a building of startling ambition.

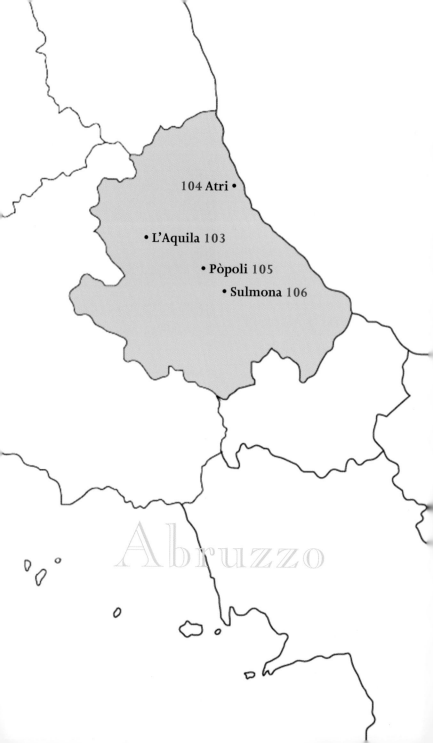

103

L'AQUILA

FEW CITIES ARE so majestically placed as L'Aquila. It is backed to the north by the dramatic mass of the Gran Sasso and has long been the major town of Abruzzo. On a roughly triangular site that falls steeply on two sides, the city was founded in 1254, apparently with the approval of the Emperor Frederick II, and reconstructed in 1265 for Charles of Anjou. Although challenged by rebellions and interrupted by invasions by, among others, Braccio Fortebraccio, not to mention the French occupation of 1798–1814, Neapolitan rule endured until the Risorgimento. In 2009 a severe earthquake shattered the ancient city; little is beyond recovery but it will take many years before all the monuments are fully in commission.

L'Aquila is rich in medieval churches: Romanesque Santa Maria di Paganica, with the vigorous reliefs of its portal; gothic San Silvestro, for which Raphael's *Visitation* now in the Prado was painted; San Domenico founded by Charles II of Anjou in 1309; and a half-dozen more. All yield in ambition to the great Romanesque church of Santa Maria di Collemaggio south-east of the walls. This was founded in 1287 by Pietro da Morrone, who was crowned here as Pope Celestine V in 1294. The slightly later polychrome façade is striking, and there is an exceptional portal on the north front. In the chapel to the right of the choir is the Renaissance tomb of San Pietro Celestino by Girolamo da Vicenza (1507).

By the time this was commissioned, the church had been overtaken as a place

Cola dell'Amatrice, San Bernardino.

of pilgrimage by the basilica of San Bernardino, to the east of the junction of Via Roma with the Corso Vittorio Emanuele in the heart of the town. Saint Bernard of Siena died at L'Aquila in 1444 and the church was begun ten years later. The confident classical façade, devised by Cola dell'Amatrice, was not built until 1524, and the interior was subsequently remodelled in the baroque taste. On the right is the chapel of San Bernardino, with the saint's mausoleum by the outstanding local sculptor Silvestro dell'Aquila, whose earlier monument of 1496 to Maria Pereira and her daughter on the left wall of the choir reflects both Florentine and Roman models.

The most assertive building of L'Aquila is the enormous castle at the north-eastern angle of the town, which seems to defy the Gran Sasso that serves as its backdrop. This was built after a rebellion of 1529 to the design of the military engineer Pier Luigi Scrivà, but only completed a century later. The plan

The castle walls

is quadrangular, with formidable angle bastions. The castle now houses the Museo Nazionale d'Abruzzo, with comprehensive collections of both sculptures and pictures from the region. There are no outstanding masterpieces, but local artists such as the Master of Beffi and Andrea Delitio deserve to be more widely known.

The most idiosyncratic of the Abruzzesi of the Renaissance was the beautifully named Saturnino de' Gatti. The pictures by him in the Museo Nazionale do not prepare us for the enchantment of his frescoes of 1494 in the parish church at Tornimparte, eighteen kilometres southwest of L'Aquila – and best approached by the ordinary road rather than the autostrada. The choir is decorated with Passion scenes from the *Arrest of Christ* to the *Resurrection*, the vault with a vision of Paradise teeming with angel musicians. Saturnino is an artist of ingenuous charm – and I shall always be grateful to Everett Fahy for encouraging me to visit this 'Sistine Chapel of the Abruzzi'. Happily, the church was not affected by the 2009 earthquake.

Medieval prosperity means that there are many fine early churches in the hinterland of L'Aquila, some of which boast early murals. But the most atmospheric site in the area must be the medieval castle of Ocre, fifteen or so kilometres south-east. Begun in 1222, it is surrounded by a well-preserved wall. Within is a chaos of shattered buildings. From the eastern section of the walls one looks directly down on the township of Fossa some 290 metres below: it was over this precipice that San Massimo, the patron saint of L'Aquila, is said to have been hurled in AD 210.

104

ATRI

❖

ATRI STANDS BACK from the Adriatic, surveying a wide swathe of the coastal plain. The ancient Roman town commanded the road to Pescara and the place continued to have a certain importance. With the disintegration of the empire of the Hohenstaufen, Atri was subsumed by the duchy of Spoleto and then taken by other local powers. But in 1395 the *signoria* passed to the Acquaviva family, who would retain it until 1775 when Atri was absorbed into the kingdom of Naples. It is to the Acquaviva dukes that Atri owes many of the monuments that make it one of the most interesting towns of its size in southern Italy.

The much remodelled palace of the Acquaviva now serves as the Municipio. The elaborate portal of the church of Sant'Agostino, attributed to Matteo da Napoli, reflects the late Gothic of that city. But the building that most completely expresses the ambition and taste of the ducal line is the cathedral of Santa Maria Assunta, which overlies a Roman cistern that can be reached through the Museo Diocesano. This austere structure of Istrian stone with an elegant west entrance and three differing gothic doors on the south side was rebuilt from c.1280 onwards, and is overlooked by the splendid campanile constructed in 1502–3 by Antonio da Lodi, the Milanese architect who had completed the comparable campanile of the cathedral at nearby Teramo in 1493.

The remarkable cycle of frescoes in the choir represents the high point of

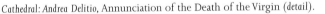

Cathedral: *Andrea Delitio*, Annunciation of the Death of the Virgin (detail).

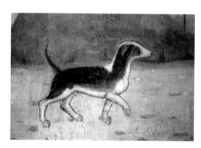

Cathedral: Andrea Delitio, Annunciation of the Death of the Virgin *(detail).*

Abruzzese *quattrocento* painting. Andrea Delitio is an elusive artist, recorded between 1450 and 1473. He clearly knew the work of that subtle Umbrian counterpart of Sassetta, Bartolomeo di Tommaso da Foligno; he had some knowledge of Uccello and other Florentines of the mid-century; and his delight in colour implies an awareness of the late gothic painters of Venice, who had so many patrons on the Adriatic coast. Delitio was a narrator of genius, with an instinctive love of anecdote. An almost excessive enthusiasm for perspective characterizes the vault frescoes with saints and virtues – Saint Luke painting an emphatically *quattrocento* half-length Madonna, Saint Ambrose seated at an disconcertingly insubstantial table.

It was when Delitio progressed to the narrative sequences of the walls that his full genius is expressed. These are treated in four tiers, commencing with the story of Joachim and Anna in the lunettes and continuing with the life of the Virgin and the childhood of Christ, concluding with the *Annunciation of the Death of the Virgin,* her *Dormition, Assumption* and *Coronation.* Federico Zeri fairly commented that the cycle is 'enlivened by a rich and appealing humour'. The viewer is transported to a world that Delitio's contemporaries would have recognized, with richly detailed architecture and a wealth of subordinate incident. Castles erupt from the hills behind the cavern that serves as stable in Delitio's *Nativity*; the train of the Magi moves through a rippling landscape of rounded hillocks; and the Holy Family sets out on the journey to Egypt from a ridge not unlike that on which Atri stands, followed by a heavily laden peasant woman who pays no attention to the eroded ridges that descend precipitously towards the fortress-protected roadstead, in which ships are ready for the voyage. The Virgin is born in a chamber with a chimneypiece of ducal scale and a later scene embroiders under an arcade with a classical festoon. Most extraordinary of all is the fresco of the Annunciation of her death, a concertinaed jumble of architectural components enriched with marble facings, in which Delitio distinguishes, for example, between the rendered front of the distant church and the rough-hewn wall adjoining it; the Virgin's attendants are caught in arrested motion and only the dog is unaware of the solemnity of the occasion. In four fictive openings above the arches that flank the choir there are startlingly realistic portraits: the Acquaviva – if such they were – are unexpectedly animated. And it is not difficult to understand why they employed Delitio, whose own portrait looks across at theirs and whose frescoes are the enduring legacy of their long-lived *signoria*.

A few miles to the north of the city in the valley of the Vomano there is a cluster of three fine medieval churches, beautifully sited Santa Maria di Propezzano and San Clemente al Vomano, both Romanesque, and San Salvatore at Morro d'Oco, built in 1331.

105

PÓPOLI
and Churches in the
Valley of the Pescara

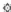

THE ABRUZZO IS rich in medieval mon-
asteries and nowhere is this more evi-
dent than in the valley of the Pescara.
The town of Pescara, where the epo-
nymous river drains to the Adriatic is
of limited interest. Chieti, a few miles
inland, high to the south of the river,
is more appealing, with substantial evi-
dence of its Roman past and the fine
campanile of the Cathedral completed
in 1498 by Antonio da Lodi, builder of
its counterpart at Atri.

Proceeding inland, beyond the unap-
pealing township of Manoppello Scala,
on a rise to the left is Santa Maria Arabona

begun in 1208, the earliest Cistercian
house in the area. Money ran out before
the nave was completed, so what we see
is the crossing, transepts and choir of the
rigorously designed early gothic struc-
ture. Decoration was kept at a minimum,
except in the delicate tabernacle in the
choir and the astonishing candelabrum
beside this, on a base with two dogs and
a lion whose companion is lost.

Some twenty kilometres up the valley
is the abbey of San Clemente a Casauria,
founded in 871 by the Emperor Louis II.
The existing church, consecrated in 1105,
is preceded by a monumental entrance,
the central doorway of which is carved
with scenes recording its foundation.
Bronze doors were installed in 1192. Fit-
tings include a pulpit by Fra Giacomo da
Pópoli, a candelabrum and a ciborium.
The complex is well maintained as a
museum. But as a result lacks the charm
of Santa Maria Albona where the hand of
officialdom is lighter.

Basilica Valvense, with the Oratorio di Sant'Alessandro, from the south-west.

Ten kilometres further on, when the valley widens, is Pópoli, the lordship of which was granted to the Cantelmo by Charles I of Anjou in 1269 and held by them until 17000. The central piazza of the old town, the Piazza della Libertà, is dominated by the Renaissance front of San Francesco which unfortunately was heightened in 1688–9. Off the piazza, on the Via Garibaldi, is the small Taverna Ducale, founded by Giovanni Cantelmo, fourth *signore* of Pópoli, in the mid-fourteenth century to process the goods he received from his tenants: the shields are of his arms and those of Anjou, the Aquaviva and other local families. High above the town is the castle from which the Cantelmo controlled the valley and its traffic.

Five miles to the south was the Roman city of Orvinium, the name of which was revived under Mussolini for the town that had grown up behind its theatre. West of Orvinio, near two eroded Roman *mausolea*, is the Basilica Valvense, dedicated to a local martyr, San Pellino, which was originally the cathedral of the diocese of Valva. The austere façade offers little hint of the ambition of the interior. From the right aisle a door opens to the long Oratorio di Sant' Alessandro: datable between 1075 and 1102 this has a generous apse in the middle of its long south side. Returning to the church, the ambo on the fifth pillar on the right is very like that at San Clemente. For inevitably medieval patrons like those of our own times are aware of what their rivals do. That three great churches are concentrated in the Pescara valley is eloquent of the strength of medieval faith: but this also reflects the wealth of the kingdom of Naples and – in the case of Orvinio – the availability of reusable building materials.

106

SULMONA

✤

OVID, WHO WAS born at Sulmona in 43 BC, believed that his city was founded by Solimo, a companion of Aeneas. He exaggerated. But Sulmona was a significant Roman town and the seat of a bishopric by the fifth century. The Emperor Frederick II favoured the place which flourished as a result and long remembered its loyalty to the Hohenstaufen. When Charles of Durazzo established his claim to the crown of Naples, Sulmona became his chosen residence. In 1526, Charles V made the city an independent principality for Charles de Lannoy and later it passed to the Borghese.

The traveller from the north crosses the Vella to reach the Cathedral. On the site of an ancient temple this was well outside the city walls: although much rebuilt it is worth visiting for the powerful thirteenth-century wooden crucifix in the right aisle – in which the flesh seems to fall away from the emaciated ribcage – and a yet earlier relief of the Madonna and Child in the Byzantine taste from a chapel near the Porta Romana, now in the left transept.

Ahead, beyond a park, the Corso Ovidio is the spinal cord of the town. On the right is the beautiful Annunziata complex, founded in 1320. The façade was built in phases, in which the late Gothic melts into Renaissance classicism. The left door, with a lunette of the Madonna is dated 1415, that in the centre is of 1483, while its slightly less elaborate counterpart to the right is of 1522. What unites these, and the sculpture and the decoration of the friezes

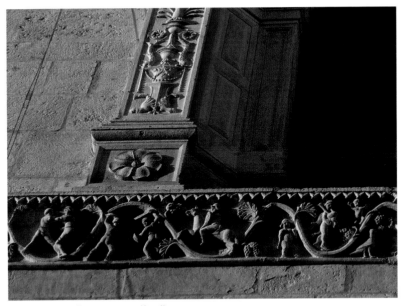

Annunziata: central section, 1450 (detail).

and window frames, is their consistently refined quality. The town's archaeological museum is housed off the courtyard. Continue on the Via Ovidio, turning briefly to the right leads for San Francesco della Scarpa with a fine gothic door, to the Fontana del Vecchio of 1474, decorated with the arms of the city and of Aragon with two putti. This was fed by the celebrated aqueduct finished in 1256, the tall gothic arches of which stride unforgettably across the Piazza Garibaldi beyond. To the right is the original Romanesque door of San Francesco and part of the former apse. The Piazza itself is dominated as much by the mountains to the east as by the aqueduct. It also boasts two churches. The more distinguished is Santa Chiara, the monastic buildings of which house the Museo

Diocesano, with a significant number of the wooden sculptures for which the area is celebrated: a fifteenth-century crucifix with painted outer elements is particularly fine. South-west of the piazza is Santa Maria della Tomba. The restrained late fourteenth-century façade is enriched with a fine rose window and the main door retains traces of the original coloured paint as well as a fresco of the Madonna. A beautiful terracotta of the Madonna and Child in the style of Silvestro dell' Aquila is in the left aisle.

Sulmona proclaims itself a 'città d'arte'; and is unquestionably remarkable for its architecture. No visitor will forget the charm of the place, whether in the heat of summer or when snow lingers on the crests of the surrounding mountains.

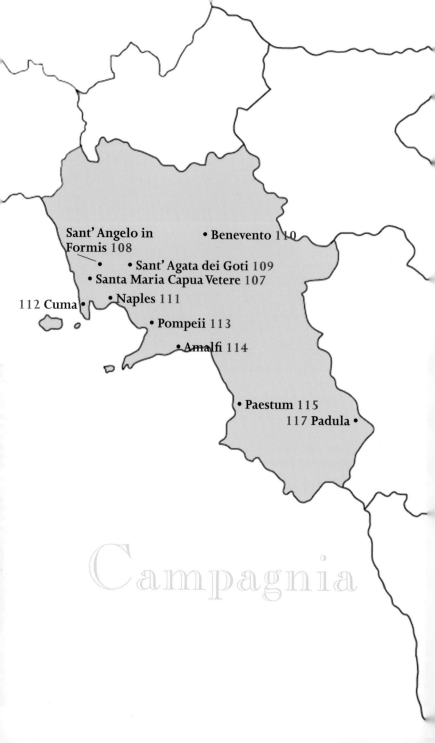

Sant' Angelo in
Formis 108

• Benevento 110

• Sant' Agata dei Goti 109

• Santa Maria Capua Vetere 107

112 Cuma • • Naples 111

• Pompeii 113

• Amalfi 114

• Paestum 115

117 Padula •

Campagnia

107

SANTA MARIA
CAPUA VETERE

❖

THE TOWN OF Santa Maria Capua Vetere is the successor of the Etruscan Volturnum, which in 438 BC fell to the Sannites. Despite an early alliance with Rome, Capua – as the city had been renamed – defected in the Second Sannite War and again after the Roman defeat by Hannibal at Cannae, only to be conquered by Rome in 211 BC. Favoured by both Caesar and Augustus, Capua flourished: by the fourth century it was ranked as the eighth city in the Roman empire, with numerous temples, two theatres and, of course the majestic Amphitheatre.

Equal in ambition to the Colosseum of Rome, the amphitheatre was built after Capua was elevated as a *colonia* by Augustus, but was subsequently altered under Hadrian in AD 119 and then under Antoninus Pius. Sacked after the fall of the empire, the amphitheatre was adapted as a fortress under the Lombards – in much

Amphitheatre.

the way that its great counterpart at El Djem was by the Byzantines. In medieval times it was used as a convenient quarry for other buildings, most notably the Duomo in the nave of which fifty-one ancient columns were redeployed. The process continued in the sixteenth-century, when keystones with reliefs of deities from the arcades were installed in the façade of the Palazzo del Municipio of 1571 in the new Capua, which had been founded in 850 on the site of its Roman namesake's lesser neighbour, Casilinum, five kilometres to the north.

Despite such vicissitudes, the amphitheatre remains a compelling place. Never claimed for Christianity in the way the Colosseum was, one senses in its internal passages and terraces the menace of the building's intended function. It has been responsibly restored. Happily vegetation still encroaches upon the much robbed perimeter wall to the north to give one a sense of what earlier generations of sightseers experienced.

Two other distinguished monuments of Roman Capua survive in the modern heart of Santa Maria: the well-preserved Mithraeum with a mural of Mithras slaying the bull; and the much-eroded Arch of Hadrian on the Corso Umberto. In addition there are two handsome mausoleums to the east of the town.

The new Capua was on the Via Appia where the Volturno was crossed by the great Roman bridge that was destroyed in 1943 and subsequently reconstructed. Its founders evidently recognised the defensive possibilities of the site on the south bank which was protected by a looping bend of the river. And the fall of Capua to the Normans was a key moment of their conquest of the south. Frederick II built a fortress at Capua: and later both Braccio Fortebraccio and Cesare Borgia – who killed five thousand of its inhabitants – knew that the city was worth fighting for. It was also worth defending as we see in the splendid bastions that flank the fine Porta Napoli designed in 1515 by the engineer Antonello da Trani and subsequently reinforced, most recently in 1732.

The major monument of the new Capua is the much-altered Duomo, founded only six years after the city itself. Rebuilt in 1724, this was severely damaged in 1943. The campanile, incorporating three reliefs from the amphitheatre, happily survived. The great treasure of the church is the thirteenth-century Easter candelabrum. To the east of the Duomo is the Palazzo Antignano with an unusual fifteenth-century door frame in the Hispano-Moresque style: this now serves as the Museo Campano, with a substantial archaeological collection and a number of sculptures from Frederick II's castle.

108

SANT'ANGELO IN FORMIS

THE BASILICA OF Sant'Angelo in Formis, four kilometres east of Capua, built on the flank of the Monte Tifata on the site of the Temple of Diana Tifatana, is one of the most remarkable churches in southern Italy. Its name, from 'in (or ad) formas' was due to the proximity of aqueducts taking water to Capua. The place was granted to the Benedictines of Cassino in the early tenth century, but later reverted to the diocese of Capua, whose bishop conveyed it in 1065 to the Norman, Robert I, Prince of Capua and Count of Aversa. He returned it to the Benedictines in 1072 and in the following year Desiderio, Abbot of Montecassino, embarked on the construction of the existing church.

The visitor walks up from the south, to pass the massive campanile, built of finely cut blocks from the cella of the demolished temple with a brick superstructure, and reach the terrace that stretches in front of the church. This is preceded by an arcade, with a tall central opening and lower lateral ones with pointed tops inspired by Islamic precedents, supported on four columns with refined Corinthian capitals also recycled from the temple. In the lunette above the door is a contemporary fresco of Saint Michael, and above this one of the *Virgin in Prayer*. The murals on either side are of the thirteenth century.

The church is of basilica plan, with a central nave and narrower aisles, all

Sant'Angelo in Formis, apse: Archangel, late eleventh century.

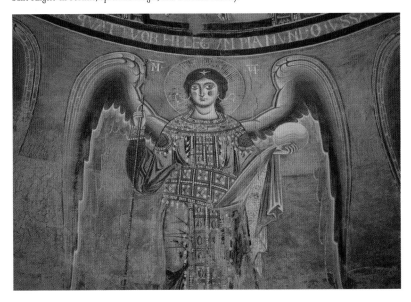

with apses. Part of the pavement, datable to 74 BC, is another survivor of the temple. The pulpit to the left of the altar is contemporary with the building. Very remarkably much of the original frescoed decoration of the church is extant. Ahead, in the main apse, below the Dove is the enthroned Christ surrounded by the symbols of the Evangelists, with below Abbot Desiderio holding a model of the church the three Archangels and Saint Benedict. The arches of the nave are decorated with figures of the prophets and others. Higher up is a sequence of scenes from the life of Christ from his visit to Zacchaeus to the *Ascension*: of the two upper registers of scenes only those from the childhood of Christ in the topmost tier on the left can be identified. On the west wall, over the door, is the *Last Judgement*. In the eroded mural in the right apse, the Madonna is seen with the Child, who is blessing, and two angels, below whom were six saints, not all of which survive. A cycle of Old Testament scenes partly survives in the aisles. Taken together, the murals at Sant' Angelo in Formis are the most substantial pictorial achievement of their date in southern Italy. Their iconography owes much to Byzantium, but such details as the plants in the left aisle express the taste of the Romanesque in the west.

Ironically Sant'Angelo in Formis owes its survival unscathed to the relative decline of the monastery, which passed to the Carafa family in 1417. Although a Roman altar was commandeered as a holy water stoop in 1564 and the obscure Cesare Martucci painted a fresco of three saints against an almost lurid sunset sky in the left aisle four years later, the place happily was left alone. Try to be there in the afternoon when sunlight filters through the church.

109

SANT'AGATA DEI GOTI

❖

OF THE INLAND towns of Campania none has perhaps more charm than Sant' Agata dei Goti, high on its narrow promontory between the two tributaries that descend to the deep valley of the river Isclera. The site was inhabited in early times, but the town takes its name from the Goths who obtained it after 553. Subsequently controlled by the Lombards of Benevento and the Byzantines, by the Normans and from 1220 by the church, Sant'Agata was held by a sequence of great families ending with the Carafa, who acquired it in 1696.

While there has inevitably been some recent building nearby, its narrow site has protected the town from inappropriate development. The first view, from the bridge across the ravine on the approach from the west, is unforgettable: the town crests the cliff, its silhouette dominated by the towers of three churches, the approach controlled by the formidable castle at its southern end.

Below this, and thus just outside the original urban area, is the church of the Annunziata. The rich marble front of 1563 does little to prepare one for the gothic interior, begun in 1238. The entrance wall was frescoed about 1415 with a forceful and imaginative *Last Judgement*, which with the murals at Galatina is a high point of painting of the time in southern Italy. Rather remarkably this, like the contemporary frescoes in the choir, was brought to light as the result of a programme of restoration due to the present priest. A key late *quattrocento* Neapolitan altarpiece, the *Annunciation* by Angelillo Arcuccio, is

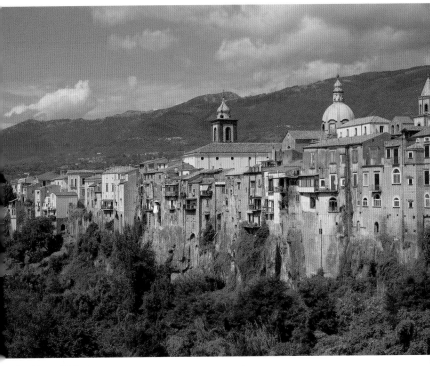

Sant'Agata dei Goti.

in the first chapel on the left: the rich brocade of the Angel's mantle is unusually lavish, and as so often in the south there is an echo of Netherlandish taste.

Opposite the church, and a little higher up, is San Menna, built for Robert I of Capua and consecrated in 1100. Here also the façade gives little hint of what follows, a luminous and coherent early Romanesque masterpiece: the nave is flanked by antique columns of varying colour and separated from the presbytery by screens which like the equally satisfying pavement are faced with porphyry and other ancient marbles.

The Duomo is at the heart of the town. The ambitious Romanesque portico, also with reused Roman columns and now almost disturbingly out of the perpendicular, was capped in a project to modernize the structure from 1728, when the body of the interior was skilfully adapted to contemporary taste, but the early crypt was happily retained.

Much of the fabric of the town survives. It is worth wondering round this, to follow the road on the eastern flank, which passes through a few defensive towers and commands views over the subsidiary valley up to the wooded hills.

110

BENEVENTO

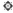

BENEVENTO, ORIGINALLY MALEONTON, at the confluence of the Sàbuto with the Calore, a tributary of the Volturno, has been a place of consequence since the time of the Sannites. Their Apulian allies were defeated near the town in 297 BC by the Romans in the Third Sannite War; in celebration of a subsequent victory it was renamed Beneventum when it became a *colonia* in 268 BC. Benevento thrived partly because of its position on the Via Appia and became even more important with the construction of the Via Traiana, leading to Brindisium and thus to Rome's territories in the east: the great arch that is the signal monument of Benevento marks the start of the road. The importance of the place is implied by the size of the theatre, built under Commodus (180–92). Benevento was inevitably affected by the fall of the western empire. In 571 it became the seat of a Lombard duchy and, from 774, a principality controlling much of southern Italy. The principality was divided in 839 and came to an end in 1033. Subsequently fought over by the Papacy, and by the Normans and their Hohenstaufen heirs, Benevento was restored to the church by Charles of Anjou in 1267. With brief interruptions it was to remain under papal control until 1797, when it fell to the French. In 1806 Napoleon created his brilliant if controversial foreign minister, Talleyrand, Prince of Benevento. Restored to the papacy in 1815, Benevento was absorbed by the new kingdom of Italy in 1860. Severely damaged in 1943, it has grown considerably in recent decades.

The town itself has a limited magic. But its key monuments express its historic importance. The Duomo, rebuilt by Prince Sicone in the ninth century was reconstructed in the twelfth. Until the bombardment of 1943 it was one of the more distinguished churches of southern Italy, but only the elaborately decorated façade with its blind arcade and, rather miraculously, the campanile beside this, begun in 1279, survived the bombardment. Fragments of the pulpit in the Museo del Duomo and the Museo del Sannio hint at what has been lost.

Head westwards for the large, if restored, Roman theatre, but then return to the Duomo and walk up the central Corso Garibaldi, turning left on Via Traiana to descend to the Arch of Trajan which was dedicated in AD 114. Faced in marble from Paros, this is the most lavishly decorated and best preserved of Roman triumphal arches. The reliefs celebrate the work of the emperor. Those on the west side, facing the centre of the town, represent Trajan's achievements as a ruler; while their counterparts on the east front document his successful campaigns to stabilize Rome's position in Germany. The two large panels under the arch commemorate his sacrifice at Benevento when his great road was begun in 109 and his extension to the city of the charity for poor children founded by Nerva. These are among the masterpieces of Roman sculpture.

Continuing up the Corso Garibaldi, on the right, is the elegant baroque Basilica di San Bartolomeo, consecrated in 1729, which replaced an earlier church destroyed in an earthquake of 1702. The architect, the Neapolitan Filippo Raguzzini was also responsible for the rococo Palazzo Terragnoli of nine bays also on the right. Ahead is the Piazza Matteotti,

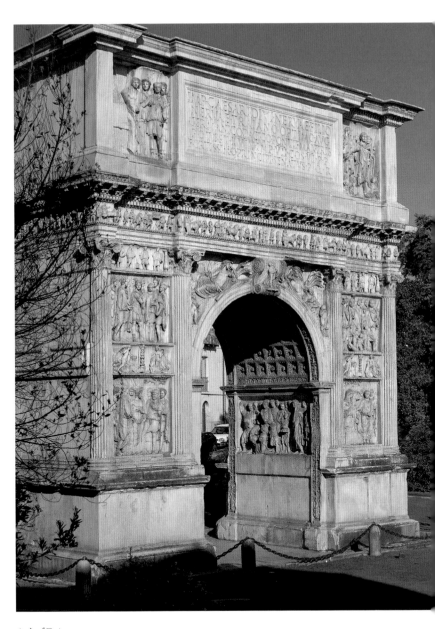

Arch of Trajan. AD 114.

which owes much to Talleyrand. On the left is Santa Sofia, founded in 762 by Arechi II, subsequently duke and first prince of Benevento. Partly rebuilt in the twelfth century and again after an earthquake of 1688, this was 'restored' in the 1950s. The interior adheres to the original plan, with a central dome supported on an arcade of six large columns which are in turn supported on a ring of eight pilasters and two Corinthian columns, the last aligned on the door. To the left of the church is the wonderful early twelfth-century cloister with fine carved capitals supporting the subsidiary arches of the arcade. Because of its position in relation to the church the bay nearest to this is stepped into the central space, an arrangement comparable with that at Monreale. The capitals illustrate the range of experience and imagination of the times: a knight catches a boar; mounted archers charge; two men ride elephants and another guides a camel; animals fight with a brutal energy and mounted dragons are entwined; while bunches of grapes and vine leaves are meticulously observed.

The extensive monastic buildings now serve as the Museo del Sannio, with substantial archaeological holdings and, on the first floor, a modest picture collection. More interesting is the sculpture. A remarkable panel from the destroyed pulpit of the Duomo shows the sculptor, Nicola da Monteforte kneeling before a crucifix, while a late quattrocento relief of the Madonna with two angels implies the influence of the north. The historical section of the museum is in the much-restored Rocca dei Rettori higher up the corso, the left-hand section of which was built – inevitably with Roman spoil – by the then governor of the city in 1321.

III

NAPLES

❖

NEAPOLIS, THE 'NEW' city', was one of the major centres of the ancient world, and the tight grid of streets at the heart of the conurbation preserves that of the Greco-Roman town. Naples flourished as a major port, supported by the fertile volcanic soil of the hinterland over which Vesuvius broods so majestically to the east. In the sixth century the city became a Byzantine outpost, achieving independence as a duchy in 763. With the Norman conquest of 1139, her significance waned. Charles of Anjou, who seized the kingdom of Sicily in 1265, made Naples his capital. Under his successors, Angevin and Aragonese, Spanish and Bourbon, the last supplanted by the French in 1798 and 1805–15, Naples retained this status until 1860, when the kingdom which had controlled the south of Italy from the river Garigliano in the west to the Abruzzi in the east was annexed to the new kingdom of Italy. Medieval Naples was already one of the larger cities of the Mediterranean, and by the mid-seventeenth century with a population of 450,000 the city was, in this respect, the biggest in Europe.

Despite the best efforts of the Savoys, Naples was in many ways a victim of the Risorgimento. But almost heroic work in recent decades by the state, the region and such private bodies as Napoli Novantanove has transformed the visitor's experience of the city. The demands of a large population on a restricted site has meant that the development of Naples has been densely packed.

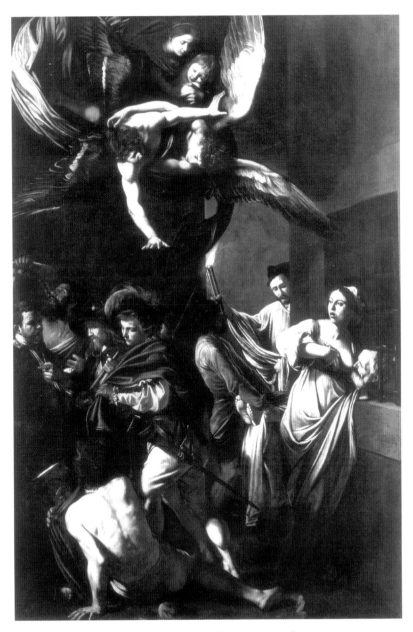

Chiesa di Pia, Monte della Misericordia: Caravaggio, The Seven Acts of Mercy, 1607.

The patron saint of Naples is San Gennaro (Saint Januarius), whose great cathedral was built by Charles II of Anjou to the eastern section of the former Roman town. The building is now a palimpsest. What draws the pilgrim is the saint's chapel, the second on the right, a great domed space designed by the architect Francesco Grimaldi. Its decoration was one of the major projects of *seicento* Italy. Domenichino began work on his frescoes in 1631, and these constitute a glorious and cerebral climax to his career, astonishing still in their clarity of colour. He died in 1641, enervated by artistic rivalries, and two years later was followed by Lanfranco, whose *Paradise* in the cupola is of visionary conviction. The splendid altar, sculpture and furniture play their part in a consistently impressive programme. There is much else in the cathedral, but it is to the chapel that one inevitably returns.

Leaving the cathedral, turn left – south – and take the first street to the left. After a hundred metres on the right is the Monte della Misericordia, in the church of which is a seminal masterpiece of Caravaggio. Painted in 1607, the *Acts of Mercy* still astonishes, a manifesto of Christian charity by one of the most deeply committed and visually persuasive of religious artists. A whole generation of Neapolitan painters, notably Giovanni Battista Caracciolo and Mattia Preti, were galvanized by Caravaggio's example.

Return to the Via del Duomo and continue, to turn right at the first significant intersection, the Via San Biagio – the 'Spaccanapoli', successor of the ancient *decumanus*, narrow and atmospheric. Palace follows palace, and side streets entice you to others. On the left is the small Sant'Angelo a Nilo, with the

Brancaccio monument by Donatello and other Tuscan sculptors. Almost opposite is the Piazza San Domenico Maggiore, off which is the Cappella Sansevero, famed for its veiled statues by Antonio Corradini and Giuseppe Sammartino, virtuoso high-points of the Neapolitan late baroque. Further on, the Spaccanapoli reaches the Piazza Monteoliveto, with a quintessentially southern *guglia* of the *Immaculate Conception* of 1747–50. To the south is the vast mass of one of the great monuments of Angevin Naples, Santa Chiara, with its gothic dynastic tombs. To the north, appropriating the diamond-studded façade of the earlier palace of the Sansevero, is the Gesù Nuovo of 1584–1601, with a constellation of baroque pictures and, on the entrance wall, Francesco Solimena's energetic *Expulsion of Heliodorus*. The Spaccanapoli continues, to intersect the main street of the old town, the Toledo, named after the Spanish viceroy who caused it to be constructed on the line of the former moat outside the Angevin walls.

The heart of Naples with its teeming churches and spectacular palaces deserves to be explored in detail. Major works by such artists as Mattia Preti, Francesco Solimena and Sebastiano Conca are to be found in context. One is always aware of the proximity of the sea, and the importance of the port explains why Charles I of Anjou built his Castel Nuovo beside it. Most impressive from the outside, this was reconstructed by Alfonso I of Aragon. His entry to Naples in 1443 is celebrated in the reliefs of the triumphal arch above the main entrance. To the west is the ponderous Palazzo Reale, whose façade is answered – in a particularly happy example of Neoclassical urban design – by the basilica of San Francesco di Paola.

The perfect vantage point from which to survey Naples is the Certosa di San Martino, to which the energetic can walk from the Toledo. The visitor comes first to the church, completed by Cosimo Fanzago, which was adorned by some of the greatest masters of *seicento* Naples. Above the entrance is Massimo Stanzione's noble *Deposition* of 1638; the vault frescoes are by Lanfranco, while the *Prophets* between the side chapels are by the Spanish-born Jusepe de Ribera. Stanzione was also responsible for the second chapel on the left. In the presbytery is Reni's late unfinished *Nativity*, wonderful not least in its tonal restraint. To the left is the sacristy, through which one reaches the Chapel of the Treasury with Ribera's deeply felt *Deposition*, and on the ceiling Luca Giordano's enchanting and airy *Triumph of Judith*. Further rooms to the right of the presbytery lead to the Great Cloister that seems to overhang the city; its core is literally laid out at the spectator's feet, the port to the right, the wide silhouette of the volcano beyond. There could be no more appropriate place to house the museum of the city of Naples.

Naples has long been famed for its museums. The Museo Archeologico Nazionale is on its eponymous piazza off the northern continuation of the Toledo. This houses two collections of major importance: the Roman marbles inherited by the Bourbons from the Farnese, including the *Bull* and the *Hercules*, which exercised so profound an influence on post-Renaissance masters; and the extraordinary haul of Roman finds yielded by the royal excavations at Pompeii and Herculaneum, finds that transformed the Enlightenment's understanding of classical art. The bronzes, the detached murals and, not least, the remarkable mosaic of the *Battle of Alexander* which was inspired by a Hellenistic prototype are of the finest quality, while the more intimate objects are of equal interest.

The royal palace of Capodimonte is, as its name implies, on a hill, to the north of the city, set in a splendid park, begun in 1735 and only completed a century later. It is built round three linked internal courtyards. On the first floor is the major sequence of staterooms, with portraits of the Bourbons and indigenous furniture. The collection of pictures falls conveniently into two sections. The Bourbons inherited the Parmese collection of the Farnese, including

Castel Nuovo.

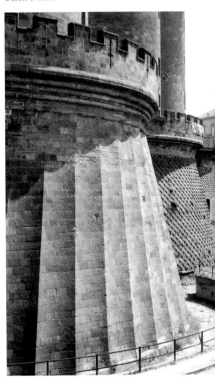

Correggio's *Zingarella* (the *Gipsy Madonna*) and an unrivalled group of Parmigianinos, as well as nine Titians, of which the disturbing portrait of Pope Paul III with his nephews is the most remarkable. The Farnese also owned Bellini's breathtaking *Transfiguration*. Capodimonte's holding of Neapolitan pictures and those painted in or for Neapolitan patrons is without rival, ranging from Simone Martini's *Saint Louis* to a constellation of *seicento* masterpieces: Caravaggio's late *Flagellation*, Bernardino Cavallino's *Saint Cecilia* and remarkable holdings of both Preti and Giordano.

Capodimonte is a ponderous structure. So too is the great palace begun in 1752 for King Charles III by Luigi Vanvitelli at Caserta, magical as is its park. It is an earlier, if unfinished, palace that haunts the imagination, Fanzago's Palazzo di Donn'Anna, built about 1642 for Anna Carafa, wife of the viceroy Felipe Ramiro Guzman. Most Claudian of architectural conceptions, hanging above the sea, this is best viewed from the Via di Posillipo to the west of the city, begun in 1812 by the adventurer Joachim Murat, whom Napoleon had installed as King of Naples, but only completed after his expulsion.

112

CUMA

❂

THE MODERN VISITOR to Naples goes inevitably to Pompeii. For our eighteenth-century predecessors the Roman sights west of Pozzuoli held an equal priority. These used to be best explored on foot, as I discovered some years ago when it proved impossible to hire a car at short notice. A suburban train stops at Baia, near the so-called Temple of Diana, in reality part of the huge, partly excavated complex of an imperial palace. I headed west, across a low ridge, to descend to Lago Fusaro, which is separated by a narrow spit of land from the sea. Across the lake is Vanvitelli's Casino Reale, built in 1782 for King Ferdinand IV of Naples, floating as it seems on the surface of the water, and to the south looms the dramatic silhouette of Ischia.

Turn north for the road to Cuma. After about three kilometres you reach the amphitheatre which is cut into the hillside; an arcade, much eroded, presided over the terraces and fields of the nearby farm, but is now officiously fenced off. Further on is the site of the Roman town, and beyond this are the ruins of the sanctuary of the Cumaean Sibyl on the flank of the ancient acropolis above the coast. The metalled road goes directly to the official entrance, but it was more satisfying, 200 metres or so from the turn, to cross a field on the right to the insubstantial remains of a temple and then follow the Cripta Romana, the impressive tunnel which cuts through the hill from east to west. Of the Roman road tunnels in the area, this was the most readily accessible and

few classical structures are more suggestive. While I trust it may long be spared the restorer's attentions, and echo to the sounds not of tourists but of birds unaccustomed to unwanted disturbance, it is frustrating that access is now all but impossible.

The Sibyl was venerated by the Greek colonists who settled at Cuma, and it was they who in the sixth century BC embarked on the elaborate excavations of the rock which were extended some 200 years later. A gallery, over 130 metres long, was cut through the soft tufa. This is lit by windows on the west looking out to the sea. There are subsidiary arms to the gallery, and at the end is the rectangular room with three niches in which the Sibyl made her oracular pronouncements. To the north stretches the terraced acropolis, with the podium of tufa blocks of the Temple of Apollo and scattered vestiges of numerous other buildings; a road with Roman paving leads up to the husk of the Temple of Apollo fringed by ilexes on the summit. The drama of the place inspired Salvator Rosa's *Landscape with the Cumaean Sibyl* in the Wallace Collection, London, and the views over the coast are astonishing, not least in the benign sunlight of a spring afternoon. But it is time to turn inland. Make for the Arco Felice, built under the Emperor Domitian (AD 81–96), a viaduct for the road from Rome to Pozzuoli. One again is reminded how ordered was the infrastructure of ancient Rome.

Alas, it is no longer possible to follow the Roman road to Pozzuoli by the Grotta di Cocceio – named after Cocceius, the architect who built it under Agrippa, the Emperor Augustus's associate – the tunnel a kilometre in length that cuts through the Monte Grillo to Lake Avernus. So the pedestrian must make a long detour by way of the smaller Lake Lucrinus. Lake Avernus is a perfect example of a volcanic crater, circled almost completely by steep wooded slopes. The place must always have exercised its spell upon the human imagination. Virgil regarded it as the entrance to the Underworld; Richard Wilson and other eighteenth-century painters responded to its magic. Few Roman remains are more beautifully placed than the so-called Temple of Apollo on the eastern flank of the lake, originally part of a bath complex, with a substantial circular chamber set in an octagonal structure. The reflections of the building stretch across the glassy surface of the water in the failing evening light.

Approach to the Grotto of the Sibyl.

113

POMPEII

❧

WHEN HE DESCRIBED the catastrophic eruption of Mount Vesuvius on 24 August AD 79, the elder Pliny had no notion that this would actually preserve the fabric of so many of the buildings it overwhelmed. Pompeii, a significant town with a population of perhaps twenty thousand, was smothered by ashes: her smaller neighbour, Herculaneum, was entombed by the lava flow. The latter is in many ways the better preserved, but it was Pompeii, systematically excavated for the Bourbon kings, that captured the European imagination. It inspired the best known of Lord Lytton's novels, *The Last Days of Pompeii*, and the most dramatic canvas of the greatest Russian Romantic painter, Alexandre Brullov – before which Sir Walter Scott sat for an hour in silent admiration.

The tourist is unlikely to find silence in the centre of Pompeii itself, even out of season. But then the town would not have been silent in its bustling heyday. Rather than follow a fixed route, it is best to wander, dodging the coach parties. While the public buildings deserve attention, what is exceptional about Pompeii is the number of private houses that survive. Guards will encourage you to visit those in their control, but after half a dozen interest can flag. It should, moreover, be remembered that many of the finer murals and the more significant finds are in the Museo Archeologico at Naples. The usual entrance is the Porta Marina to the southwest of the town, the gate nearest the forum, the centre of religious and civic life. Here are the impressive basilica, two temples and a covered market. Further east, off the Strada dell'Abbondanza, are the Stabian baths, with a striking section of stucco decoration and well-preserved interiors: nearby are the theatre and the smaller odeon. The very much larger amphitheatre is at the eastern angle of the walls. Built about 80 BC, this could seat twelve thousand: a mural now at Naples shows it in use. Beside the amphitheatre is the large palaestra, or gymnasium. Everywhere, one is conscious of the menacing cone of Vesuvius.

While one of the finest houses, that of Loreius Tiburtinus, notable for its garden,

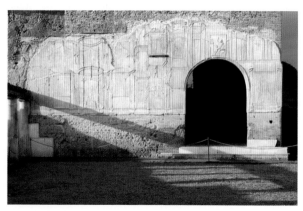

Stabian baths: stucco decoration

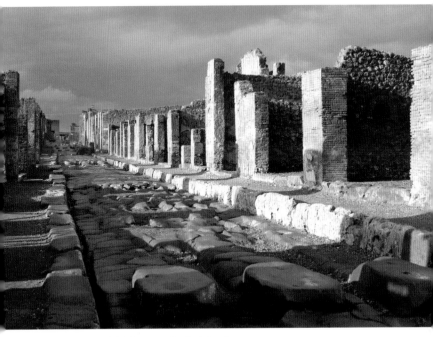

Characteristic street, with blocks to impede wheeled traffic.

is opposite the palaestra, most are in the north-western section of the town, many off the Strada di Nola. Among the more interesting are the Casa del Poeta Tragica, described in Lytton's novel, and the Casa del Fauno, with two atriums and two peristyles; from a room between these comes the mosaic of the *Battle of Alexander* at Naples. A block to the north are the Casa dei Vettii, a prosperous merchant's ambitious residence, and the Casa degli Amorini Dorati, both with excellent decoration. Yet more memorable are the murals of the large Villa dei Misteri, which lies outside the walls to the north-west. The Dionysiac scenes in the Sala del Grande Dipinto, which dates from about the turn of the Christian era, represent a high point of Roman painting.

Although Roman decorative murals had been known – and copied – since the Renaissance, the discovery of a large number of such schemes had an enormous influence on the direction of taste in the Neoclassical era. Others have been discovered since. Particularly fine are those of the villa of Oplontis, in the immediate shadow of Vesuvius, not far from Herculaneum. No single complex gives a better notion of the sophistication of the most luxurious Roman villas or of the world of the Plinys, uncle and nephew, and their friends. After its discovery the villa was impeccably restored, but on my last visit it looked rather run down, its state paralleling the plight of the numerous *ville vesuviane* of the Bourbon era, classical in very different terms, that disintegrate nearby.

114

AMALFI

❧

A<small>MALFI IS NOW</small> so much a tourist town, with the hotels and shops this implies, that it takes some effort of the imagination to realize that in its heyday it was one of the major ports not just of Italy but of the Mediterranean. The area was recovered from the Goths by the Byzantines in 573, but distance from Byzantium meant that with time the Amalfitans gained *de facto* independence. The poverty of the local soil must have encouraged Amalfi's development as a naval and commercial power. In 812 her sailors achieved a significant victory over the Saracens, but the place was sacked in 838 by the Prince of Benevento, who controlled Salerno. A year later the Amalfitans returned. Their republic was ruled first by prefects who were selected annually and later by an elected doge. The Normans seized Amalfi in 1073, but it was briefly once again a free republic until 1101 and remained a significant maritime power. The Amalfitans' rivals, the Pisans, sacked the town in 1135 and 1137. Their town did not recover. In subsequent centuries it was to be controlled by the kings of Naples.

The Monti Lattari and the Sorrentine Peninsula rise steeply from the Gulf of Salerno. The coastal road as it winds above the shore westwards from Vietri is, even now, not for the faint-hearted. It passes Atrani, crowded within its narrow valley, and then twists down to Amalfi. The Piazza Gioia is on the waterfront; near this, from the Via Camera, you can look into the surviving portion of the Arsenale della Repubblica, an early

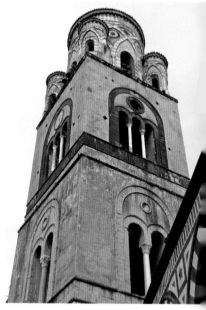

Cathedral, Campanile, after 1203.

medieval covered dockyard in two sections, recently restored as a museum. From the piazza walk north to the Piazza Duomo, overhung by the Duomo to which a flight of steps ascends. The front is a reconstruction of after 1875, but the beautiful campanile on the left is original; begun in 1189, it was finished in 1276. The church is justly celebrated for its bronze doors, made in Byzantium before 1066 by Simone da Siria and presented by Pantaleone di Mauro, who in 1087 – the year in which he commanded the Amalfitan fleet in alliance with Pisa and Genoa against the ruler of Tunisia – gave a similar pair to the church of San Salvatore de' Bireto at Atrani. On the north of the Duomo is the small but singularly distinguished Chiostro del Paradiso of 1266–8,

intended as a cemetery. There is a strong Arab influence, with unexpectedly tall and narrow interlaced arches rising from the columns. The adjacent rooms house the museum.

The main street continues northwards from the piazza. A minor church apart, there is no building of particular interest, but the cumulative effect is compelling: every available piece of land on which it was practical to build was exploited.

High above Atrani is Ravello, which by the ninth century was subject to Amalfi, but in the eleventh sought to shake off its too powerful neighbour by supporting the Normans. With the eclipse of Amalfitan power, Ravello grew in both wealth and importance, and it is said to have had a population of thirty-six thousand in the thirteenth century. The road from the coast writhes upwards, passing the Romanesque church of Santa Maria a Gradillo. Abandon your car as soon as possible, to walk up to the main piazza, which is overlooked by the Duomo; this was founded in 1086 when Ravello became a bishopric. The austere façade has been restored. In 1179 Barisano da Trani supplied the bronze doors with compartments including scenes from the Passion and representations of saints. Equally remarkable are the *ambone* decorated with mosaic panels, commissioned in 1130 by the then bishop, and the pulpit of 1272 by Niccolò di Bartolomeo da Foggia.

Across the piazza is the Villa Rufolo, begun in the late thirteenth century for the prominent family of that name, one of whom is mentioned in Boccaccio's *Decameron*. The villa was purchased in 1851 and subsequently restored by a Scot, Francis Neville Reid: the most satisfying element is the courtyard with loggias on

two levels. The terraced garden is reasonably well maintained. Higher up in the town is the church of San Giovanni del Toro, with a good twelfth-century pulpit by the obscure Alfano da Termoli. The presence of works by artists not only from Byzantium but also from the Adriatic ports of Trani and Termoli reminds us of Amalfi's former importance as a trading power.

Cathedral, Chiostro del Paradiso, 1266–8.

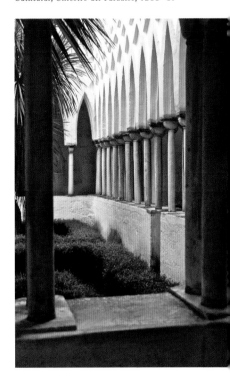

115

PAESTUM

❧

AS THE SURVIVAL of so much at Pompeii is due to the eruption of Vesuvius, so that of the great temples at Paestum is owed to a more gradual scourge: malaria. Paestum, at the southern end of the once rich plain of Sale on the Gulf of Salerno, was colonized by Greeks in the seventh century BC. The original name, Poseidonia (city of Neptune), implies her importance as a port. In about 400 BC the city fell to the Lucanians, who were driven out by other Greeks in 332, only to return in 326. The Romans, who took the city in 273, renamed it Paestum. Their city flourished in its turn. In AD 370 no less a relic than the body of Saint Matthew was brought to Paestum, but in the centuries that followed malaria took hold and the site was gradually abandoned. The Norman king, Robert Guiscard, removed marble from the surviving edifices for use in his great cathedral of 1076–85 at Salerno. Shielded by woods, the temples were known to scholars, but it was only in the eighteenth century, when Antonio Joli and others depicted them, that Paestum came to wider notice.

However it is approached, the visitor comes first to the walls, 4,750 metres in circuit, which enclose an area roughly oblong but cut diagonally across the north-western corner to follow a stream. The Greek line of the walls was restored by the Lucanians and the Romans. They are of large limestone blocks and stand to a height of up to seven metres, reinforced by a series of flanking towers. The circuit can be followed by road or on foot; there is less traffic on the north-western section.

It is, of course, the temples that draw the tourist. These lie in the centre of the town, west of the modern road that cuts across it from the Porta Aurea on the north. The entrance to the site is opposite the group of modern buildings and near the northernmost of the three extant Doric temples, the so-called Temple of Ceres. But before examining this it makes sense to walk to the southern end of the architectural area to examine the so-called Basilica, the oldest of the temples, built soon after 550 BC, and originally dedicated to Hera. The order is Doric, and all fifty of the original columns survive. A little to the north is the larger and yet more splendid Temple of Neptune. This was constructed in about 450 BC and is among the best preserved of all Doric temples, majestic in its discipline, both of proportion and detail. The honey-coloured travertine stone is of a particular beauty, responding to the natural light – in September when the sun sets almost directly to the west one can imagine that it is on fire.

Further north is the area of the Roman forum with the small Italic temple, built at the time of the Roman conquest and partly despoiled by the Normans. The other Roman buildings are for the most part poorly preserved, their charm due to the beauty of the place with its shading trees. The forum is crossed by the *decumanus maximus*. Continue north, following the Via Sacra, back to the Temple of Ceres, which was originally dedicated to Athena. This was built not long before 500 BC and in many respects adhered to the style of the Basilica. Its smaller scale may in part explain why the temple was converted into a church in late Roman times.

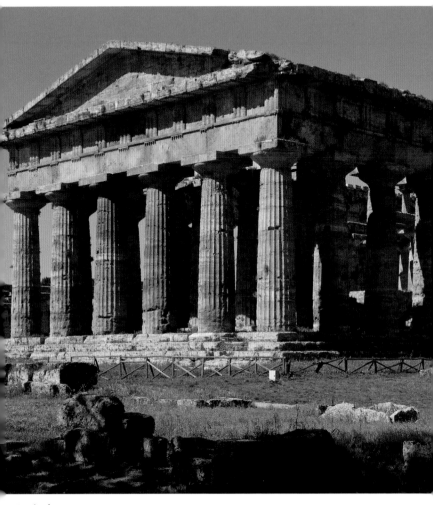

Temple of Neptune, c. 450 BC.

Across the road from the site is the excellent Museo di Paestum. Of particular importance are the metopes and the archaic frieze from the nearby sanctuary of Hera. The finds from Paestum itself are of considerable interest. And the extraordinary depiction of a boy diving on the lid of the so-called Tomb of the Diver is among the most vivid images to survive from antiquity.

Because Paestum was so effectively pillaged for its benefit, Robert Guiscard's Duomo at Salerno is a fitting sequel for the sightseer. The great campanile is a

masterpiece of the Norman Roman-esque. The Normans' exploitation to the ruins of antiquity is seen not only in the columns used for the atrium of the Duomo and in the *sarcophagi*, many adapted as tombs with inscriptions or coats of arms, ranged round the colon-nades of this and in the church itself: for the lavish use of porphyry and other pre-cious marbles in the two pulpits, the fine candlestick and other early fittings was made possible by the ready availability of spoil from Roman monuments. The substantial crypt is notable for the fres-coes of scenes from the life of Saint Mat-thew of 1643 by the Neapolitan Belisario Corenzio, who exploited the irregular compartments of the vaults with much ingenuity.

The Museo Diocesano behind the Duomo is justly known for the remarka-ble series of ivory panels, including for-ty-four biblical scenes and representa-tions of apostles and other saints. Their original arrangement is as yet to be established. What is not in doubt is that these were produced in a local work-shop about 1120–40. Among the pictures are the only signed work by the main Neapolitan follower of Giotto, Roberto Oderisi, his *Crucifixion* from San Franc-esco at Eboli, and the *Deposition* which has some claim to be the most sophisticated panel by Andrea da Salerno, the leading High Renaissance painter of the area.

116

VELIA

❖

NO EARLY CLASSICAL site in southern Italy can vie with Paestum. But in some ways we feeler closer to the world of the Greek settlers and their contempo-raries in lesser places: the Lucanian city walls near Roccagloriosa, high above the Gulf of Policastro, for example; or Velia, the Greek Elea, on the Tyrrhenian coast.

Elea was founded about 540 BC by colonists from Phocea who had been driven from Corsica by an alliance between Carthaginians and Etruscans. A port of some consequence as the scale of the walls show, the city was open not only to trade but also to ideas. Xenophon of Colophon in Ionia is said to have set-tled at Elea, founding the Eleatic school of philosophy which was carried on by his follower Parmenides and then in turn by Zeno, whom Aristotle regarded as the inventor of dialectic and was eventually murdered by the local tyrant. Under Rome, of which it became an ally in about 272 BC, Velia became a summer resort, where Cicero stayed and Horace was advised to take a cure.

Too much of the low-lying land on the Campanian coast has been 'devel-oped', but happily Velia has been largely spared. The shoreline has receded, so the small acropolis, crowned now by the ruin of a modest Angevin fortress, that extends from a higher ridge, is now some way inland. The original town was

Opposite: Porta Rossa, late fourth century BC

on the southern flank of the ridge, but in the fifth century BC this was considerably extended southwards and on the north side of the ridge: it was protected by walls running from a high point of the ridge, the Castelloccio, enclosing a roughly triangular area bisected by the substantial wall that descends the ridge towards the acropolis.

In the Roman era, the inhabitants of Velia naturally aspired to the necessary appurtenances of a Roman town: the excavators have exhumed a bath complex and other public buildings in the centre of the town near the South Marine Gate. A path leads up to the so-called Porta Rossa which is the outstanding monument of the town. The great late-fourth-century BC arch in beautifully graded bossed blocks was appended to an earlier gate below the city wall on the ridge and served as the major thoroughfare between the northern and southern parts of the city. Its survival must be partly due to the handsome relieving arch above the opening.

Velia's charm owes much to its position between the rough hills and the shore, and the abundance of wild flowers. To search out every exposed building and follow the lines of the walls would take many hours. But if time is pressing, after inspecting the Porta Rossa from the north side, make downwards for the acropolis hill. Beside the circular medieval tower are the remnants of the podium of what must have been a fine and nobly placed Ionic temple. A little way below this is the eroded theatre, Hellenistic in date, aligned on the coast to the south-east: the stage building was inevitably altered to meet Roman specifications. Further down are the remains of a few early domestic buildings in polygonal masonry.

117

PADULA

❖

AMONG THE MOST imposing monastic complexes in southern Italy is the Certosa di San Lorenzo at Padula. Founded in 1306 by a loyal servant of the Angevins, Tomaso Sanseverino, Count of Marsico, this was largely reconstructed in the baroque period, and offers a remarkable sense of the power and pretension of the Church at the time. The Carthusians were expelled by the French, who used the certosa as a barracks for 20,000 soldiers, but returned after 1815. The monastery was finally suppressed in 1866, and served as a prison in both world wars; Allied soldiers captured in North Africa were held there before being transported to northern Italy when the Germans retreated in 1944. Padula only came to more general notice after a major programme of restoration was underway in the 1980s. For two or three years almost every Italian seemed to have just been to or to be on his way to Padula, which is in easy reach of the autostrada and in a beautiful open setting.

The rectangular atrium precedes an elegant façade of 1718, the corridor beyond leading to the west side of the small Renaissance courtyard, from which the church is reached, and continuing past the main monastic rooms on the right to the west loggia of the spectacular Chiostro Grande with a double arcade projected in 1680. The corridor ends with the celebrated elliptical staircase built by the little-known Neapolitan Gaetano Barba in 1761–3. Twin flights curl upwards to the top floor.

Padula, atrium.

One treads on air, so beautifully does the clear sunlight filter though the structure. Grand but not ponderous – as, say, the Bourbons' Caserta is – the staircase is in many ways akin to theatrical projects of the period.

The Soprintendenza of the Campania has done splendidly at Padula, and space has been found in the monastic buildings for the Museo Archeologico della Lucania Occidentale and also to display pictures from the area.

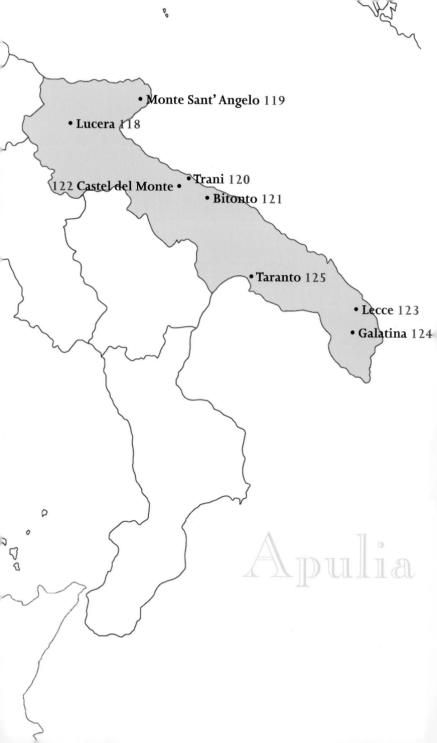

• Monte Sant' Angelo 119

• Lucera 118

122 Castel del Monte • • Trani 120

• Bitonto 121

• Taranto 125

• Lecce 123

• Galatina 124

Apulia

118

LUCERA

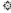

FOGGIA HAS LONG been the dominant town of Basilicata and has paid the price, not least during the last world war. Lucera to the south has been more fortunate. We think of Lucera, if we think of it at all, as the fortress town where the Emperor Frederick II settled his Saracens. But the potential of the site, on a rise above the plain, had long been recognized.

On my first visit, in 1985, I arrived in time for a late lunch, half dazed after leaving northern Umbria at dawn and pausing to survey Rieti and L'Aquila. As I walked towards the cathedral a distinguished old man in a dark grey suit handed me his card. I was still in driving mode and, besides, the gaunt gothic church founded by Charles II of Anjou was predictably shut. But I still half regret not trying the services of the *professore*, who was one of the last *ciceroni* of his type.

I made off for the castle commandingly placed to the west of the town. It was constructed between 1269 and 1283 by Charles I of Anjou on the site of the fortress built for Frederick II two generations earlier; this too was closed. But it was not difficult to squeeze below the wooden door and enter the vast empty trapezoidal space within to see the site of Frederick's palace. It is, however, from the outside that Lucera impresses, with its circuit of high curtain walls and well-preserved towers built of brick with stone dressings. The ambitious Angevin king did not wish to leave his subjects

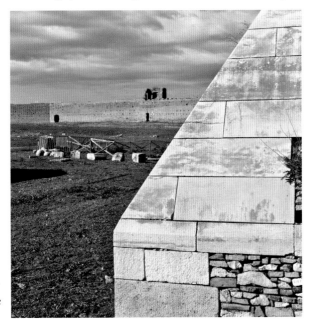

Castle, with the lower wall of Frederick II's palace and the walls of Charles of Anjou in the distance.

Museo Civico: fragment of thirteenth-century plate from the Castle.

in any doubt that he had expunged the power of the Hohenstaufen, crushing the descendants of the Saracens planted at Lucera by Frederick II after a six-month siege in 1269. But something of the taste he generated can be seen in finds from recent excavations in the castle, now in the Museo Civico, including a fine capital and ceramics of Islamic character.

When I returned to the town, the cathedral was open. The interior also is austere, a forceful reminder of the Francophile taste of the Angevins. It says something as to the calibre of many *cinquecento* pictures in the south that an altarpiece of 1535 by that modest Venetian Girolamo da Santacroce should stand out. The ruthless austerity of the cathedral itself, which is beautifully echoed in the nearby Franciscan church, seems more impressive every time I return. But it was with a sense of some relief that in 1985 I sped on to Troia on its hill to the south, once settled by Greeks who it is not altogether fanciful to assume were ancestors of the wizened veterans gathered near the stupendous Romanesque cathedral, with its richly decorated front and bronze doors of 1119 by Oderisio da Benevento.

119

MONTE SANT'ANGELO

❧

THE GARGANO IS a place apart. The promontory rises to the east of the plain between San Severo and Foggia, cutting like a spur into the Adriatic. The high point, the Monte Spigno, rises to 1,008 metres, and the land falls steeply to the coast. A local bishop experienced a vision of Saint Michael on the hill that now bears his name, 796 metres above sea level, and from the eighth century this became a major religious centre. The Norman conquerors of southern Italy first came as pilgrims, and, Assisi and Subiaco apart, there are few places where one feels closer to the pulse of medieval faith.

Lorenzo, the bishop who saw the archangel, held the see of Siponto. And unless you take the route that climbs from San Severo through the massif, the tourist-pilgrim would do well to pause at the two marvellous churches which survived when that town was destroyed by an earthquake in 1223. San Leonardo and Santa Maria Maggiore, the former cathedral, are Romanesque. Both have remarkable portals and are the more beautiful for their rural context. Siponto's successor was Manfredonia, founded in 1256 by the Emperor Frederick II's natural son, King Manfred. The grid street plan he imposed survives. Four miles beyond the town is the turn for Monte Sant'Angelo, which soon comes into sight high above. The road climbs steeply, with breathtaking views over the Gulf of Manfredonia towards Trani and the Castel del Monte.

The modern town cascades down the ridges that descend from the hill. The pilgrim would originally have walked up

through the town, but now drives, or is driven, to a point nearer the shrine. Its unremarkable entrance leads to a stairway of 1888, which must be very close in character to its thirteenth-century Angevin predecessor. The bronze doors to the basilica were ordered in Constantinople by Pantaleone of Amalfi in 1076. Their damascened decoration of silver and copper with coloured inlays is in twenty-four compartments: these include scenes from the Old Testament and a representation of the Archangel's apparition. The gothic basilica, incorporating the grotto where the vision took place, was built by the ruthlessly ambitious King Charles of Anjou in 1273. In the grotto itself is a remarkable Romanesque episcopal throne, while further medieval treasures, including the Emperor Frederick II's gift of a filigree cross, are in the museum.

Pilgrims still flock to the sanctuary. But nearby the so-called Tomb of the Rotari is generally deserted. Originally perhaps a baptistery, this is crowned by a cupola reconstructed in 1109 for the alarmingly named Rodelgrimo and his brother-in-law, Pagano of Parma. The austerity of the structure is relieved by the energy of the sculptured reliefs. The building adjoins the elegant twelfth-century façade of the church of Santa Maria Maggiore.

Monte Sant'Angelo is particularly atmospheric in the late afternoon. The many stalls and restaurants make it easy to forget how remote the place must once have seemed to those who made the pilgrimage. The best way to sense this now is to leave at dusk and head inland, descending through what still seems an isolated valley. Pause and listen for the sheep bells.

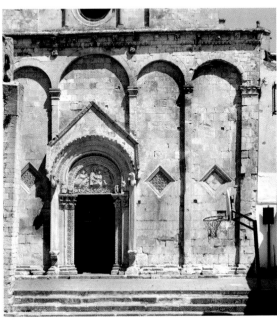

Santa Maria Maggiore di Siponto: façade.

I20

TRANI

❖

TRANI HAS CHANGED since I first knew it. I arrived at dusk on a festa and it took a good half-hour to get to the harbour. There I parked by a tiny restaurant, whose proprietor directed me to a hotel with the strictest injunction to remove everything that was visible and lock every door. Apulia is safer now. But it has often been a territory where interests clashed, and one still senses a frisson in its architecture.

Trani's early importance was due to the harbour. Much of her history can still be read from the paved waterfront, with the apse of the elegant Romanesque Templar church, the Ognissanti, hemmed in by lesser buildings. Behind is the core of the medieval town, whose successor spread to the south, its main arteries such as the Via Ognissanti notable for their later palaces. But despite their charm, with rusticated and diamond-studded façades, or the larger buildings at the southern angle

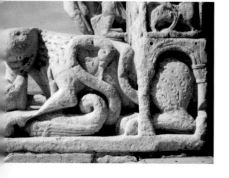

Cathedral: lion support of the west door

of the harbour – the Palazzo Quercia and the *quattrocento* complex of the Palazzo Caccetta, not to mention the massive, and much remodelled, castle of Emperor Frederick II that guards the city on the north – it is the cathedral that draws one to Trani.

Medieval towns were competitive. The basilica of San Nicola at Bari was begun in 1087. A dozen years later, another Nicola, a pilgrim who had died at Trani, was canonized and work on his cathedral began. The site, above the shore, was that of an earlier church. By the time the structure was completed in the fourteenth century, the original Romanesque scheme had been substantially changed. Time and the restorer have claimed their due, but the first impression as you approach from the west, with the sea to the left, is of an unusually unified structure. The west front expresses the form of the interior, a tall nave flanked by aisles almost equally high raised above a crypt. If you are lucky, the lower door to the latter is open. Otherwise climb the steps to the upper level, where only the back arcade of the original portico survives, and the central door has lost the astonishing bronze doors supplied, perhaps in the 1280s, by Barisano of Trani, but now responsibly moved to the nave. The thirty-two panels of the doors are set in elaborate borders, classical in inspiration; in one, the patron San Nicola Pellegrino is seen with the diminutive artist in adoration at his feet. The vigorous sculpture round the door-case is reasonably well preserved. Above the door is the central arched window, with flanking columns supported on elephants; still higher is a fine rose window. To the right of the façade, improbably raised on a tall gothic arch, is the great campanile, four-square, of five tiers, punctuated by

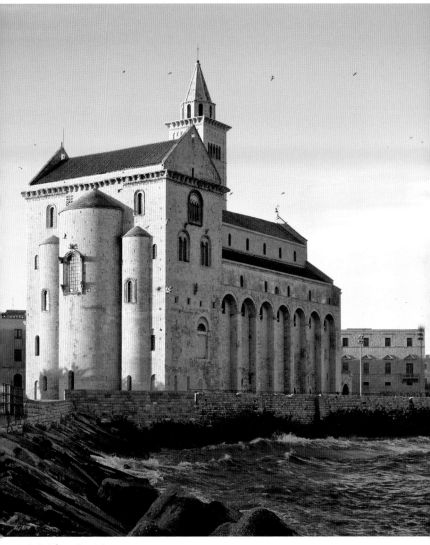

Cathedral from the Mole.

openings each progressively wider, and crowned by a short octagonal steeple.

To appreciate the development of the building one should go down to the crypt beneath the nave, and then descend to the taller crypt below the choir. Admirable in its sense of space, this was the first element of the cathedral

to be completed. The nave is an arche-typal Apulian Romanesque structure of seven bays, supported by laterally paired columns below a triforium of triple arcades set within blind arches matching those below. The main capitals, alas, were destroyed to make way for Corinthian replacements of stucco. These in turn would be swept away when the post-Renaissance decoration was removed in the pre-war restoration. And it is to this restoration that the austerity of the church is partly owed. The impression is to some extent misleading. For while the bones of the structure were laid bare, its original texture and tonality were beyond recovery, and any counterparts to the admittedly provincial murals in the crypt have long since gone. Whatever has been lost, however, the soaring space has not been compromised.

What I love about the cathedral is the exterior. This is magical in the early morning, seen from the mole to the east, as the sun defines the majestic curves of the apses. And as the light moves, so the sharp token buttresses of the lateral façades cast their lengthening or diminishing shadows. For the builders of Trani well knew the visual possibilities of shade in a land of bright sunlight.

Trani has a unique magic. But the city did not exist in isolation. To the south, beyond Bisceglie, is Molfetta where the cathedral by the shore owes much to Islamic architecture, while to the north is Barletta with a rival Romanesque cathedral. Inland at Canosa is an equally impressive cathedral; off its south transept is the mausoleum of Bohemond, conqueror and Prince of Antioch, where the bronze doors open to reveal an inscription of telling brevity: 'BOEMUNDUS'.

121

BITONTO

THE LAST POPE, Benedict XVI's first pilgrimage was to the sanctuary of Saint Nicholas at Bari. The saint's relics were stolen from Myra, and their arrival in 1087 heralded the great age of Apulian Romanesque architecture. This owed much to the prosperity assured by Norman rule. Robert Guiscard, already Duke of Apulia and Calabria, took Bari in 1071, and his successors ruled a strongly centralized kingdom that benefited both from the First Crusade and from trade with the East. The great basilica, defended by precinct walls, was not consecrated until 1197. Only a few hundred yards away, across the heart of what survives of the early city, is the cathedral. This was reconstructed in evident emulation of the basilica after Bari was sacked in 1156 by King William the Bad. Yet marvellous as the conjunction of the two buildings is, it is not Bari but its neighbour Bitonto, some seventeen kilometres inland to the west, that lingers in the imagination.

Unlike medieval Bari, the historic centre of Bitonto has not been swallowed by the modern town. Its plan survives, with twisting streets following the contours of the ground, punctuated by palaces with baroque portals or sixteenth-century loggias. Of these, the finest is in the Renaissance Palazzo Sylos Labini on the Via Planelli; it incorporates a gothic doorway in the Catalan style that reflects the long Aragonese domination of the south heralded by the succession of Alfonso of Aragon to the kingdom

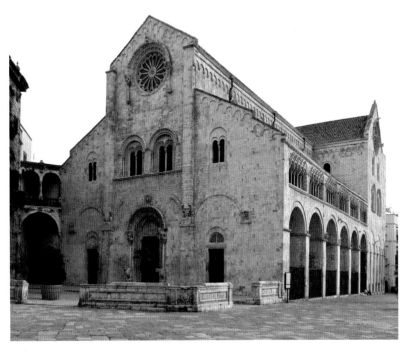

Cathedral.

of Naples in 1442. The palace is now a museum.

The cathedral of San Valentino, orientated to the south-east, flanks a narrow piazza at the very core of the town. It was built on the site of a much earlier church whose recently excavated remains, with fragmentary walls and sections of a mosaic, underlie the nave. Later alterations to the Romanesque structure were successfully reversed in the last century. Like the cathedral at Bari, that at Bitonto was inspired by the basilica there. The general disposition is the same, with a tall nave flanked by aisles only slightly lower, the soaring transepts, the three apses. But here the lateral façade facing the piazza, with the loggia of six recessed

arches below elaborate clerestory windows and the blind arcading of the transept, surpasses its predecessor. The main façade is majestic, although the portico was never finished. The central door is richly decorated: the columns are supported on beasts and the architraves carved with scenes from the Christmas story and the *Descent into Limbo*. A rose window with more animals is set high in the central gable which is capped by a blind arcade.

The interior, like its counterparts at Bari, has been ruthlessly restored – English has no precise equivalent of the Italian *ripristinato* – but its form has not been falsified, and the way the presbytery is raised above the level of the nave is both visually

Cathedral, crypt: capital.

satisfying and functionally appropriate. One significant original fitting survives, the elaborately decorated ambo of 1229, signed by 'Nicolaus sacerdos et magister'. The later tombs are of less interest.

Flights of steps lead down to the most thrilling of all Apulian crypts. Like the presbytery above, this has three apses. It is supported on thirty columns. The capitals are of exceptional quality, with bulls, pigs and other animals, humans in varying attitudes and vigorous foliage, as imaginative in design and sharp in detail as any of their date elsewhere in Italy or indeed in France. The sacristan knows not to rush the visitor.

As artists painted sequences of related pictures, so builders and craftsmen left clusters of closely related monuments. Those who respond to the magic of Bitonto may wish to see two nearby cathedrals that also reflect the basilica of Bari: Ruvo, the steep triangular outline of which is explained by the narrow width of the central nave; and Bitetto, most memorable for the façade that was rebuilt in 1335, as a prominent inscription attests, by Lillo da Barletta.

122

CASTEL DEL MONTE

No OTHER MEDIEVAL emperor was quite like Frederick II, and no medieval castle exercises so compelling a hold on the imagination as his Castel del Monte. On its hill this is visible from afar. No traveller on the way to Bari or the south could have failed to see it, a gleam of white stone or, as the fall of light dictated, a dark silhouette brooding over the bare landscape. It still does.

Frederick II was the heir through his father to the imperial house of Hohenstaufen and through his mother of the Norman kingdom. He was crowned as Holy Roman Emperor in 1220. Ruthless and demanding, this *stupor mundi* – wonder of the world, as a contemporary chronicler described him – would have stood out in any age. His intellectual curiosity was matched by the sophistication of his taste. Castel del Monte, the one extant document for the construction of which is of 1240, was unlike any of its predecessors and indeed any of the numerous fortresses the emperor had willed into construction elsewhere. It is of octagonal plan with a central courtyard; at the angles are eight towers, false octagons in that their two inner faces do not exist.

The main entrance is on the east, a gothic portal flanked by fluted pilasters with a pediment above, below a bipartite gothic window. The sharp masonry is relieved by these enrichments, by the string-course that serves in visual terms to bind the towers to the central mass, by the postern of one façade and, on the others, a single window high on

the ground floor, by the larger first-floor windows corresponding with that above the entrance, and by the numerous arrow slits.

The entrance leads to the first of eight soaring trapezoidal vaulted rooms on the ground floor. In the second of these is a door-case of deep-red *breccia*, the first evidence of what was evidently a lavish use of precious marbles in the castle. Before they were pillaged, the great rooms at Castel del Monte must have been among the richest secular apartments of the age. This second room leads into the court-yard, a noble space enriched by door-cases and window-frames, and not least by the blind arcade – in effect a *trompe l'oeil* loggia – of the upper storey. This is reached by stairways in three of the flanking towers. Here the rooms were yet more richly decorated. Acanthus abounds and ball leaf is found in two rooms; on the inner walls of three rooms were massive chimneypieces. Particularly memorable is the hexagonal vault above one of the stairways, which rests on brackets of crouching nudes.

In 1249, a year before Frederick II's death, his natural daughter, Violante, was married at Castel del Monte. Later this served as the prison of her brother Manfred's sons. The emperor clearly intended it for a very different purpose. Had he wanted to build a conventional fortress, he would have done so. The design of the entrance, and the use in some of the upper rooms of a technique akin to the Roman *opus sectile*, with small pieces of stone laid diagonally, suggests that Frederick II – who was fully aware of the antiquity of his own title and also interested in classical texts – must have aspired to create a monument that would hold its own with those of ancient Rome. And in this, if not in his epic struggle with the papacy, he unquestionably succeeded.

Castel del Monte from the south-east.

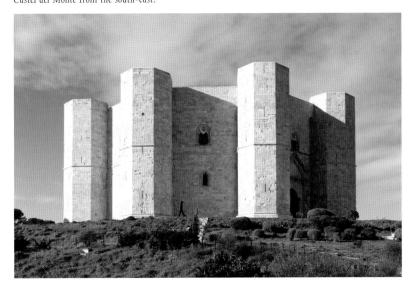

123

LECCE

✤

THE SALENTO, THE platform of the heel of Italy, has long known prosperity. After the collapse of the Roman world, it remained an outpost of the eastern empire until it was seized by the Normans in the mid-eleventh century. Thereafter it fell to the successive dynasties that ruled Naples. Otranto was the Byzantine capital, but under the Normans it was superseded by Lecce, which is more strategically placed. No work of art at Lecce is quite as memorable as the mosaic floor of the cathedral at Otranto, executed by a priest, Pantaleone, in 1163–6, but the city has much to offer.

Cathedral: Giuseppe Zimbalo, Campanile, 1661–82.

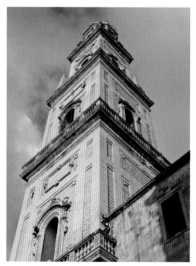

Although Lecce was an important Roman town, of which ruins of a theatre and amphitheatre survive, it is the post-Renaissance architecture that is of enduring interest. The so-called baroque of Lecce begins as an exuberant Mannerism. The local stone is easily worked when first quarried but hardens on exposure, and the builders of late sixteenth-century Lecce quickly learnt of its potential. Their taste for decorative detail made an indelible impression on such visitors as M. S. Briggs, author of the pioneering *In the Heel of Italy* (1910), and the Sitwells.

A good place to begin is the Porta Napoli with a rather theatrical triumphal arch of 1548 in honour of the Emperor Charles V, who had rebuilt the city walls and constructed the formidable fortress designed by Gian Giacomo dell'Acaja on the opposite side of the town. The straight Via Palmieri leads past several *palazzi* to the Piazza del Duomo at the heart of the city. This is dominated by the ambitious campanile of the great, if conservative, seventeenth-century architect of Lecce, Giuseppe Zimbalo. Zimbalo was also responsible for the comprehensive reconstruction between 1659 and 1670 of the cathedral, while the nearby Seminario, undeniably baroque with its striking channelled masonry and giant pilasters, was devised by Giuseppe Cino and opened in 1706.

The Piazza del Duomo is the great set piece of baroque Lecce. But almost every main artery has its quota of churches of the period, and there are literally dozens of distinguished palaces. The most spectacular among the churches is Santa Croce, just north of the Piazza Sant'Oronzo, reached from the cathedral by the Corso Vittorio Emanuele. Construction began in 1549 on relatively

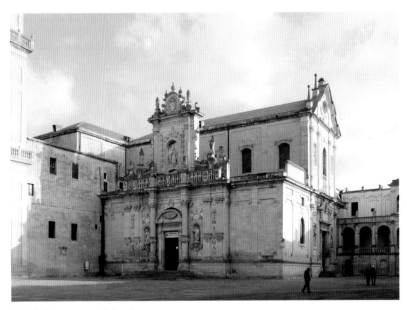

Cathedral: Giuseppe Zimbalo, 1659–70.

conventional lines. The upper part of the façade, finished almost a hundred years later, was designed by Zimbalo. Late Renaissance conventions are overwhelmed by encrusted caryatids and putti, and by a riot of ornament round a rose window that recalls so many Apulian Romanesque churches. Inexorably the craft of the stonemason establishes its own dynamic. The effect is not altogether elating.

The adjacent former convent of the Celestines, now the Palazzo del Governo, may also have been designed by Zimbalo, but was finished by Cino in a more measured baroque idiom. Some way south of the Piazza Sant'Oronzo, carefully calculated for its position at the junction of four streets, is the most

appealing of the city's baroque churches, Achille Carducci's San Matteo, in which the art of Borromini is reinterpreted in the richly ornamented way Leccese patrons had evidently come to expect.

With the arguable exception of the Renaissance Palazzo Vernazza, the palaces of Lecce are not individually of particular interest. These testify to the agricultural wealth and commercial acumen of their owners. Many have excellent door-cases, some less restrained than others; many retain their iron balconies supported on brackets of varied form. Naturally, the richer families chose to build on the more prominent streets, and their competing yet in some ways complementary mansions contribute as much to Lecce's character as do its churches.

124

GALATINA and GALLIPOLI

❖

NEAR THE HEART of the Salento south of Lecce is Galatina, once a Byzantine city, the descendants of whose Greek inhabitants preserved traces of their language long after the Norman conquest. The town belonged to the county of Soleto held in the late medieval period by the del Balzo and their Orsini heirs. The tempestuous and ambitious Raimondello del Balzo Orsini – who married Maria d'Enghien, heiress of Lecce in 1384, was granted the principality of Taranto in 1393, and died in 1406 – was responsible for the reconstruction in the prevailing gothic style of the Franciscan church of Santa Catarina di Alessandria in 1384–91. Despite the sculpture above the central door and the fine rose window the wide façade hardly prepares one for the lavishly frescoed interior with its broad nave and narrower aisles. At least three painters, all no doubt active in Naples but aware of developments in the Marche and elsewhere on the Adriatic coast, worked on the animated narrative cycles that must be contemporary with the church. The most inventive are the scenes from the Apocalypse in the first section of the nave. Later murals include the obscure Francesco d'Arecio's signed and dated *Saint Anthony Abbot* with a *kneeling Donor* of 1436. Raimondello must have planned the church as his personal memorial and his tomb, in which he is shown both as a prince and as a Franciscan is in the presbytery. This is decorated with scenes from the life of Saint Catherine and, in the vault, the *Evangelists* and *Doctors of the Church*. Behind the high altar is the octagonal apse added in 1460 as his own memorial by the builder's son, Giovanni Antonio Orsini, Prince of Taranto and Altamura, who was a key ally of Alfonso of Aragon in his struggle to oust the Angevins from the Neapolitan kingdom. He is shown as a Franciscan in his canopied tomb at the east end.

Galatina is a charming town, with

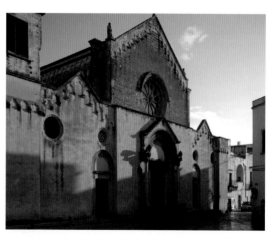

Santa Catarina di Alessandria,
1384–91.

some excellent wrought iron balconies, and a parish church, Santi Pietro e Paolo, with a fine baroque front. Galatone, nine kilometres to the west has a superb later baroque sanctuary; and its larger neighbour Nardo offers several good churches as well as a fine *guglia*. Fifteen kilometres to the south is Gallipoli. A Greek foundation and dependency of Taranto that later passed to Rome, Gallipoli was the last Byzantine possession in the Salento to fall to the Normans and for seven months in 1269 defied Charles of Anjou. Besieged four times between 1481 and 1528, Gallipoli was a significant port, and in later times owed much to the trade in olive oil to England.

The only surviving relics of classical Gallipoli are the three Hellenistic reliefs incorporated in the fountain of 1560 on the landward side of the ancient port, the Seno del Canneto, to the left of the main approach. Opposite this is the island, or Città, protected by the formidable Renaissance castle which incorporates a polygonal tower reinforced by Charles of Anjou. With its steep narrow streets, the Città is a place of tremendous charm. High in the centre is the Cattedrale with a lavish front of 1696. There are pictures by the Neapolitan Nicola Malinconico and his son Carlo, but pride of place goes to the town's artist, Giovanni Andrea Coppola (1597–1659), whose abilities almost matched his aspirations. I first saw these on a hot Sunday afternoon in September when the women were using their fans so assiduously that the priest was inaudible. There are other churches, baroque Santa Teresa and, on the Riviero Sauro facing the Ionian Sea, San Francesco and the Chiesa della Purità. A survival of a very different kind is the Farmacia Provenzano, founded in 1814 on the main street and still happily in use.

125

TARANTO

❧

TARANTO HAS BEEN a major city for two and a half millennia. Founded by colonists from Sparta about 706 BC on a peninsula that protected the enclosed harbour, the Mar Piccolo, from the Ionian Sea, the Greek Taras gradually came to control a considerable hinterland. By the late fifth century the city expanded to the east, on the ground now occupied by the Città Nuova: its population has been estimated at three-hundred thousand. The Tarentines were not judicious in their choice of allies, and the defeat of one of these, Pyrrhus of Epirus in 275 forced it to submit to Rome. Tarentum was taken by Hannibal in 212 only to be recovered by Fabius Maximus and forfeit it major sculptures. Tarentum continued to be a significant port, although it would gradually be overtaken in importance by Brindisium. After the fall of Rome, the city was under Byzantine rule until it passed in 662 to the lombard duchy of Spoleto. It was taken by the Saracens in 842, only to be recovered for Byzantium in 880. A second arab occupation lasted from 927 until 967, when the Byzantines returned, to be defeated by Robert Guiscard in 1063. Thereafter it remained an integral part of the kingdom of Naples, until it was given in 1301 to Philip I, son of Charles II of Anjou. Subsequently granted to Raimondello del Balzo Orsini, it returned to royal control on his son's death in 1463. The importance of the port meant that in the late sixteenth-century Taranto was a key base for controlling Ottoman piracy, while

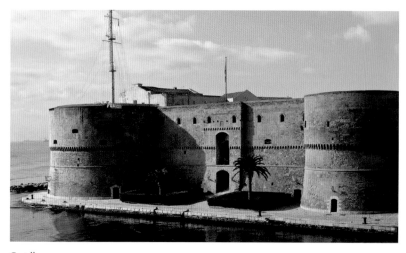

Castello.

under French occupation in 1801–15 it was equally important to Bonaparte's endeavours to dispute British domination of the Mediterranean.

The Città Vecchia is reached across the successor of a bridge built by the Angevins. Ahead, to the left, is the formidable Castello, built for Ferdinand of Aragon, but incorporating much of the structure of the earlier Byzantine fortress that had been remodelled by the del Balzo Orsini. Behind this is the single massive Doric column of what must have been a very large temple. When I first saw it, the city seemed dark and forbidding. For Gissing this was 'too close-packed to be very striking or beautiful'. But it is not without interest. The Duomo, dedicated to San Cataldo, an Irish bishop, is something of a hybrid, an eleventh-century remodelling of an earlier church that was subsequently altered. The chapel of the saint, to the right of the apse, is a compelling riot of the baroque: the frescoes of the dome are by the Neapolitan Paolo de Matteis (1713), while the altar

is a stupendous confection of marble. At the far, west end of the Via del Duomo, is San Domenico Maggiore, with a gothic portal encased in its baroque front, and, within, an altarpiece of the *Circumcision* by the idiosyncratic Sienese *cinquecento* master, Marco Pino.

The Città Nuova, with its 'great buildings of yellowish-white stone, as ugly as modern architects can make them' that confronted Gissing, is memorable above all for the Museo Nazionale, which is one of the great archaeological museums of Italy. There are finds from throughout Apulia. Among the sculptures is the unfinished ionic sixth-century *kore* from Montegranaro. There are notable holdings of Corinthian and Attic vases including many by notable artists from Tarentine tombs, as well as a substantial assemblage of jewellery found in these and elsewhere in the area. The Tarentines produced terracotta statuettes in enormous numbers: there are over forty thousand in the museum, most mercifully in store.

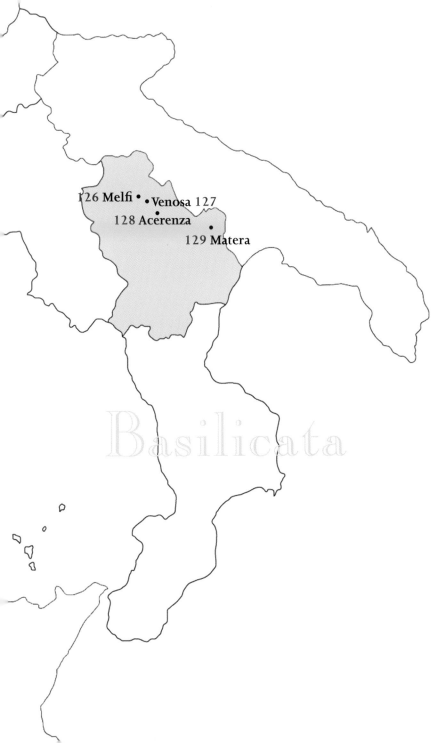

126

MELFI

✤

Although Melfi takes its name from the nearby river Melpes, recorded by Pliny, it was a place of no significance before the time of the Lombards. Elevated as an episcopal see by the Byzantines, it fell to the Normans in

Museo Archeologico: Sarcophagus from Rapolla.

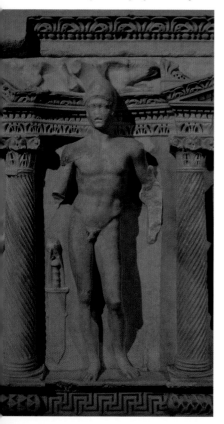

1041– to whom the city walls are due – and was briefly their capital, until this was transferred to Salerno. Pope Urban II held a Council in preparation for the First Crusade at Melfi in 1089 and later it was there that Frederick II published his *Constitutiones Augustales*. After the Angevin conquest, Melfi supported the ill-fated Conradin, but thereafter, except when occupied by King Louis of Hungary who considered himself the rightful heir to this, it formed part of the kingdom of Naples, held from 1531 as a fief by the Doria.

On its volcanic hill north east of the dark cone of the Monte Vùlture, Melfi was and is dominated by the splendid Castle on its northern flank. Begun by the Normans and strengthened under the Hohenstaufen and Charles of Anjou in 1278–81, before being brought up to date in the *cinquecento* by the Doria, this was severely damaged in successive earthquakes – for Melfi is in a seismic zone and was struck on six occasions between 1456 and 1930. The entrance is from the south across a dry moat and, in the teeth of the great pentagonal Torre dell'Orologio on the right, through a seventeenth-century gate to the irregular court. To the left, an archway leads to the stables and other survivors of the Angevin project, including the large courtyard with a central wall, behind which is the former throne room, above the hall of the knights. To the right of the entrance court is the chapel built by the Doria. Beyond this is the seventeenth-century so-called guard room and the Marcangione tower, beside which an atrium leads to a flight of stairs to the throne room. The central section of the complex, in which some early ceilings survive, is used for the Museo Nazionale del Melfese. The great treasure

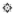

of which is the sarcophagus from nearby Rapolla, commemorating a lady, an exceptional import of the late second century AD from Asia Minor. Excavations have yielded a spectacular number of Campanian vases

The Duomo, in the heart of the town was begun in 1155 under William the Bad, but, partly because of successive earthquakes, has been largely reconstructed. Happily, a fourteenth-century wooden Crucifix survives; and, more remarkably, the campanile begun in 1153 by the obscure Nosio di Remerio still stands, perhaps because it had been strengthened just before the 1930 earthquake. Beside the Duomo is the large *settecento* Palazzo del Vescovado with fine iron balconies, so characteristic of the south, and a handsome courtyard. There are other churches in the town, which is memorable, not least, for the views it commands.

Nine kilometres south east of Melfi is Rapolla, with two notable churches. The Cattedrale, completed in 1253, has a fine portal and an impressive, if restored, campanile of 1209 by Sarolo da Mura Lucano, who carved bas-reliefs of the *Temptation* and the *Annunciation* set into the right wall of the building, which are thought to depend on Byzantine ivories. The town's original cathedral, Santa Lucia, is a remarkably well-preserved small early Norman church, restrained in detail but with two elliptical cupolas above the nave: this is usually closed, but can be viewed through a grill.

127

VENOSA

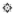

THE BIRTHPLACE OF Horace, the Roman town was the successor of the Apulian Venusia. Subsequently a Lombard stronghold, it was taken for Byzantium in 662 and then absorbed by the Lombard duchy of Benevento, before being recovered in 976 by the Byzantines. It fell to the Normans in 1041, becoming part of the county of Apulia with which Drogo of Hauteville was invested in 1046. Despite rebelling against Roger II of Sicily in 1127 and Charles of Anjou in 1268, the place under successive noble families remained subject to the kingdom of Naples to the end, participating in the unsuccessful attempt to restore the Bourbon monarchy in 1861. Still relatively small, Venosa is a city where the sightseer cannot but be aware of the patterns of the past.

The early city stands on a ridge, at the west end of which is the Piazza Umberto I, dominated by the magnificent moated castle built by Duca Pirro del Balzo Orsini from 1470 on the site of the former cathedral. Square, with a central court and circular angle towers, this conformed with the most advanced standards of military architecture: much of the interior, which now houses the Museo Archeologico, was subsequently altered for the Gesualdo in the sixteenth century: the composer Carlo Gesualdo was a younger son. The main entrance faces the central street, the Corso Vittorio Emmanuele I, some five hundred yards up which, on the left, is the new Cathedral, built from 1470 onwards in a spare late gothic mode by Duca Pirro.

The portal of 1512 is signed by one Cola da Conzo.

The road continues beyond the town, passing the modest church of San Rocco. Beside this is the entrance to the archaeological area with the footings of a Roman bath complex and numerous houses. Across the road was the amphitheatre which was used as a quarry for the great Abbazia della Trinità, immediately to the north of the archaeological area, one of the most ambitious buildings of the kind in southern Italy. The original Benedictine church, the *chiesa vecchia*, replaced an early Christian one built on the site of a Roman temple of Hymen and was consecrated by Pope Nicholas II in 1059. It owed much to Robert Guiscard who in the same year had his three half-brothers, William Bras-de-fer, Drogo and Humphrey, buried there and would himself join them after his own death in 1085. In 1135 the monks began to construct a marginally longer church with transepts, the *chiesa nuova*, behind the earlier structure, which was presumably intended to replace this.

The original church is entered through a forebuilding, which is linked to the modest monastic building on the right. The door was an addition of 1287, which demonstrates that the Benedictines were still embellishing their

Abbazia della Trinità, Chiesa nuova.

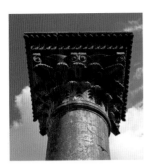

Abbazia della Trinità, Chiesa nuova: capital.

church only ten years before the monastery was transferred by Pope Boniface VIII to the Knights Hospitaller. A number of frescoes survive, including one of Pope Nicholas II and, on a pier to the left, a *Pietà* by the Neapolitan follower of Giotto, Roberto Oderisi. On the left is the only one of the Norman royal tombs to survive, that of Alberada, Robert Guiscard's first wife, the mother of his elder son, Bohemond, Prince of Antioch, who at her behest was buried in the moving mausoleum at Canosa, some fifty-five kilometres away.

The roofless *chiesa nuova*, reached from the archaeological site, is a hugely impressive space with an elegant ambulatory, much influenced by contemporary French architecture. The majestic columns of the south side of the nave with their outsize capitals are striking. The exterior also deserves close inspection. Numerous large blocks, many with fragmentary inscriptions, from the Amphitheatre and other Roman buildings were used; and the apses of the three ambulatory chapels are beautifully resolved. This aborted Valhalla of the Guiscards in which the Benedictines overreached themselves is a not unworthy memorial to a remarkable dynasty.

128

ACERENZA

❖

FEW VISIT ACERENZA by chance. Perched high – at 833 metres – on its outcrop of rock, the city hangs over the gentler country to the east and is protected by the Monte Toretta and its outliers to the west. The sightseer must take the tortuous road from Venosa, climbing successive ridges and following densely wooded valleys that echo with the bells of sheep, or wind steeply upwards from the twisting road between quake-shattered Potenza to the south-west and Altamura.

Taken by the Romans in 318 BC and later mentioned as Achervatia by Horace, Acerenza became an episcopal see in the fifth century. Subsequently held in turn by the Byzantines and the Lombards, it was taken by Robert Guiscard in 1061. Its importance under his successors can be measured by the scale of the great cathedral: Acerenza as a fief of a sequence of great families would remain part of the kingdom of Naples until unification. Yet despite being the economic and spiritual centre of its area, the city must always have seemed a place apart.

New building has inevitably encroached on the shelf below the city proper. But despite being in an earthquake zone the fabric of this, with its narrow curving streets lined with relatively modest houses of the local stone is substantially intact. If time allows, walk up from below, not least because even the smallest of cars lives dangerously at Acerenza.

The Cathedral is easily found, high in the centre. It makes sense to walk

round it before entering. The much-altered front implies the vicissitudes of buildings in seismic zones: Acerenza was badly hit in 1456. The portal itself is of the twelfth century, but much of the rest was rebuilt in 1524 and the campanile on the right was altered thirty years later and only the base of its counterpart to the left remains. Follow round to the right to see the apse of the transept chapel and then the unforgettable orchestration of the triple apses of the ambulatory, the plan of which followed that of the unfinished church at Venosa. The masonry, which inevitably includes spoil from Roman structures, is impeccable and one can ignore the cupola, an unhappy reconstruction after an earthquake of 1930.

The interior is a consistent statement of the late Romanesque. Like so many churches in the south – Altamura to the east is a rare exception – Acerenza was purged of many later accretions,

but happily the decoration of the right-hand chapel of the ambulatory was spared: so was the ambitious, if provincial, altarpiece of 1570 in the north transept. More memorable is the crypt. This was reconstructed in 1523 for the Conte di Muro Lucano, descendant of the Ferrillo who were the previous feudatories of the place. Modelled on the crypt of Saint Januarius in the Cathedral at Naples, this is supported by four square pillars, the sculpted decoration of which is answered in the pilasters of the walls and complemented by contemporary frescoes by an artist aware at whatever remove of the works of Perugino's followers in Rome. At the east end is the tomb of the Ferrillo with sculpture of equal competence. It is oddly touching to see so determined an endeavour to express metropolitan taste in so remote a setting.

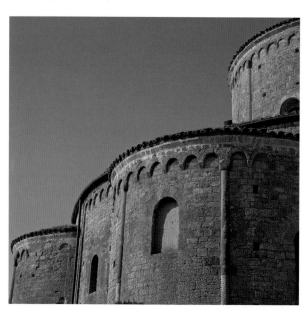

Cathedral apses.

129

MATERA

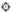

MATERA IS UNIQUE among Italian cities. The early medieval town was destroyed by the Saracens in 994, only to be reoccupied by the Byzantines. In 1064 Matera fell to the Normans and was incorporated in their kingdom. A period of sustained prosperity followed under Neapolitan rule. In 1663 the town became the capital of the province of Basilicata, a role it only lost in 1806 during the French occupation. Modern Matera is a bustling city, prosperous in a way that so many towns of the south are not. To the east is the extraordinary historic conurbation, built on and between two ridges, the Sasso Caveoso to the south and the Sasso Barisano to the north, and defended by the dramatic cliffs carved by the river Gravina.

The traveller from the north arrives in the Piazza Vittorio Veneto. To the left the Via San Biagio leads to San Giovanni Battista, an admirably austere Romanesque church of 1204, responsibly restored in 1926. The nave is unexpectedly high. Further on is the partly rock-cut San Pietro Barisano, another Norman foundation with a later façade. From the Sasso Barisano with its narrow streets there are tantalizing views over the town, its built façades masking houses largely excavated in the rock.

Return to the piazza and follow the central Via del Corso which leads to the Piazza San Francesco. In baroque San Francesco itself are panels from a polyptych by the Venetian master Bartolomeo Vivarini. Behind is the Via Duomo, which climbs past the substantial baroque Palazzo Bronzini-Padula to the fine and splendidly sited Duomo of 1268–70, raised on a terrace hanging over the heart of the town. The west front is admirably harmonious in its balance of pilasters, blind arcades and sculptural enrichments; and, unlike so many of its Apulian counterparts, the Duomo retains its subsequent decoration and additions, including the late Renaissance Cappella dell'Annunziata.

After wandering in the narrow streets behind the Duomo, return to the Piazza San Francesco and turn south on the Via Ridola. On the right is a typical rococo extravagance of the south, the Chiesa del Purgatorio of 1747, its façade decorated with macabre motifs; the circular interior is happily intact. Beyond the church of the Carmine, turn left on the Strada Panoramica dei Sassi, which curls round to emerge in the Piazza San Pietro above the river. The road continues on the line of the cliffs, and the walk northwards to the Sasso Barisano is memorable. This passes two of the rock-cut churches for which Matera is remarkable, Santa Maria de Idris and Santa Lucia alla Malva. There are fine, if fragmentary, twelfth and thirteenth-century murals in both: a *Madonna and Child* in Santa Lucia is particularly impressive.

Matera is visibly fragile. The eroded cliffs continue to erode, and rock-cut dwellings are not easily adapted to twenty-first-century domestic requirements. Much has been done to preserve a remarkable complex. And yet, more perhaps than in any other major artistic centre in Italy, you sense that Matera disintegrates before your eyes. Tourism has brought new life to the city, the continuing protection of which is imperative.

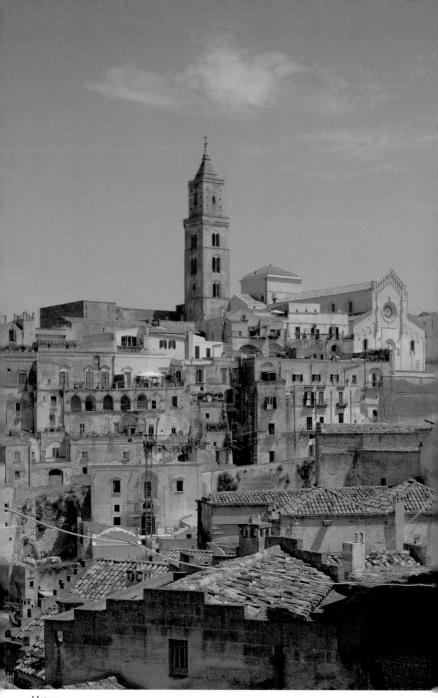
Matera

Calabria

• **Altomonte** 130

• **Rossano** 131

• **Taverna** 132

133 **Stilo** •

• **Reggio di Calabria** 134

130

ALTOMONTE

❖

ALTOMONTE WAS WELL named by Queen Giovanna I of Naples in 1352. Midway between the Tyrennian and Ionian seas, the town is on a conical hill, 455 metres high, between two rivers which are fed from the rough hills to the west: to the east the land falls away towards the coast, and, early in the morning, the gleam of sunlight can be seen on the Ionian Sea. The Roman Balbia, the wine of which was mentioned by the elder Pliny, was by 1065 known as

Brahalla: the place must have been of some importance under the Normans, as the original church was named Santa Maria dei Franchi. Its successor, Santa Maria della Consolazione, begun in 1342–5 for Filippo Sangineto at the high point of the town, was completed in 1380, three years after the extinction of his line when his county went to the Sanseverino, one of the great families of the kingdom and through them to the Ruffo. In 1443 Contessa Cobella Ruffo granted the church to the Dominican order. They constructed the monastery beside it which was enlarged in the sixteenth century.

The façade, with a restrained portal and its beautiful, asymmetrically

Santa Maria della Consolazione, after 1342–5.

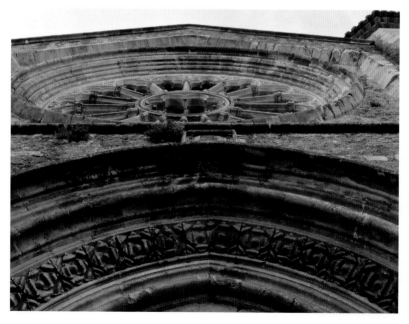

placed rose window, is very satisfying. The interior is much altered, but the choir is beautiful in its restraint. It was no doubt intended as a funerary chapel to Sangineto, whose tomb by a competent Neapolitan follower of Tino da Camaino stands behind the high altar. The tomb slab of Cobella Ruffo, who died in 1447, is set into the floor before the altar. To the south of the church is the arcaded cloister of two storeys. Part of the monastery has recently been converted into a museum. The collection is not large, but it includes a number of *trecento* panels. The finest of these, and indeed arguably the finest picture of its date south of Naples, is Simone Martini's *Saint Ladislaus of Hungary* commissioned by Sangineto in 1326. A jewel-like panel with a clear political-cum-dynastic message, this clearly aroused the indignation of the medieval vandal who cut two lines through the saint's face. It seems likely that Sangineto also ordered the polyptych by the Florentine Bernardo Daddi of which a number of panels survive. A series of early fifteenth-century Passion scenes associated with Antonio and Onofrio Penna also deserve to be better known.

The town itself has much charm. There are a number of *palazzetti* including that once occupied by the Desvernois family north of the church. A short way to the north-west is the handsome Torre della Pallotta, with an elegant double window, and beside this what remains of the substantial castle that descended from the Sangineto to the Ruffo. At Altomonte, as in too few other places in the south, we can still sense something of the cultural life of the Angevin kingdom.

131

ROSSANO

✿

THE ROAD TO Rossano writhes steeply upwards from the coast. The ancient city clings to an outcrop of the Sila Greca, protected on the west by eroding cliffs. The size of the place comes as a surprise, but shouldn't. For Rossano has a distinguished history: recorded in the Antonine Itinerary, it fell in 548 to Totila, but was recovered by the Byzantines, under whom in the eighth and ninth centuries it was a city of considerable importance, benefiting no doubt from trade on the Ionian Sea. Taken by the Normans, it would remain part of the Kingdom of Naples, from which it was held in later centuries by the Sforza, the Aldobrandini and the Borghese. A powerful earthquake in 1636 affected much of the city. By the time of Crauford Tait Ramage's visit in 1828 the area was so lawless that local proprietors 'dare[d] not move a step beyond the precincts of the village, … strongly armed…'

The existing Cathedral was built under the Angevins, but has been much remodelled. A restoration of 1913 respected the sixteenth-century roof of the nave and much of the baroque decoration. The Museo Diocesano in the adjacent Archiepiscopal Palace has a signal treasure, the Rossano Codex, a sixth-century illuminated manuscript of parts of the *New Testament* made at Caesarea on the Palestinian coast which was taken to Rossano by Melchite refugees in the seventh century: Ramage was the first British traveller to be shown it. Although Norman Douglas regarded these as more 'marvellous than beautiful', the scenes

from the life of Christ are eloquent expressions of late Roman taste in the east, using white pigments for the draperies to singular effect on the imperial purple ground of the vellum. These are the earliest illuminations of the kind. The pages are turned every three months.

Walk up from the cathedral towards the main piazza and then follow the Via Garibaldi to the south (left). At the edge of the town, perched above the road, is the beautiful small Byzantine church of San Marco: 'it has five little cupolas, but the interior, supported by eight columns, has been whitewashed.' Douglas wrote before the restoration of 1931, but this is still the case. There is another, more modest, shrine below the church.

Byzantine Rossano was a major religious centre and there were ten Basilean monasteries in its territory. Among these was Santa Maria in Partire. From Rossano drive through the tunnel at the top of the city and up on the forested flank of the Sila for some ten kilometres, before turning right to descend through a beautiful valley thick with oaks and chestnuts to the former monastery. The orthodox Basileans had been supplanted, as elsewhere, by the catholic Benedictines, when, between 1101 and 1106, the Beato Bartolomeo di Simera re-founded the monastery, securing its independence from the archdiocese of Rossano. The institution was well endowed and became powerful enough to maintain ships on the Ionian Sea. The Romanesque church is approached from the east, so that the first sight is of the three elaborately decorated apses, as beautiful for their context as satisfying in design. The interior is of the simplest, with a wide nave flanked by generous aisles, austere yet finely proportioned. Parts of the mosaic floor survives, with an inscription identifying the patron, Abbot Biagio, who is recorded in 1152. North of the church are what remains of the much later conventual buildings, which like the church were abandoned after the suppression of the monastery in 1806. Douglas walked back to Rossano, but most sightseers will head downhill, pausing to savour the views down to the Ionian Sea and across the plain below.

San Marco.

132

TAVERNA

❖

ALTHOUGH NORMAN DOUGLAS's *Old Calabria* (1915) must be the most entertaining book in English about any region in Italy, Calabria is not on most sightseers' agenda. Time and earthquakes have dealt harshly with the monuments of the area. And some of the greatest works of art to be seen in this are there, as it were, by accident. Thus the elegant gothic tomb of Isabella of Aragon,

wife of King Philip III of France, is in the Duomo of Cosenza only because she was accidentally drowned in the river Savuto on her return from the East in 1271. However remote, Calabria was at times of strategic importance, and the first English victory over a French revolutionary army on land, at Maida in 1806, was quickly celebrated in the names of a new development in north London and of Walter Scott's favourite staghound. Like other parts of the former kingdom of Naples, Calabria did not benefit from the union of Italy.

No Calabrian city has been more abused in the last half century than

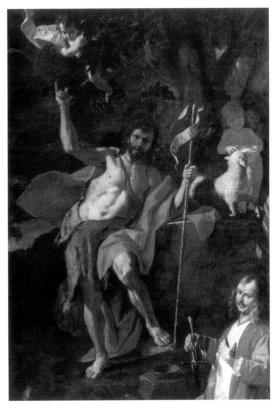

San Domenico: Mattia Preti, The Preaching of the Baptist, with the Artist as Donor, c. 1687.

Catanzaro, or so ruthlessly abandoned to the mercies of the road builder. But this is the obvious starting point from which to visit Taverna, the *patria* of the seventeenth-century painter Mattia Preti, il Cavaliere Calabrese, some twenty-six kilometres to the north. Once the seat of a bishopric, which was transferred to Catanzaro, Taverna is a sleepy rural town. The major church, San Domenico, was reconstructed in the 1670s. Preti, then based in Malta, was called on by his townsmen to supply a series of altarpieces between 1678 and 1687. Of the five canvasses on the right side of the church, only the fourth is not in its original position. The sequence begins with a key Dominican subject, the *Assassination of Saint Peter Martyr*. Preti himself presented the expressive *Martyrdom of Saint Sebastian* of 1677 on the third altar. The high altarpiece, the *Vision of Saint Dominic*, in which Christ appears like Jupiter with thunderbolts, is among the more dramatic of Preti's later works. There are four more altarpieces by him on the left wall, including the *Crucifixion* on the third altar and the appropriately eloquent *Preaching of the Baptist* on the first altar, in which the ageing Preti himself appears in his habit as a Knight of Malta.

Preti worked for other churches at Taverna, notably Santa Barbara, in the apse of which is a large canvas of 1688 showing the saint being received in Heaven. Of Preti's four other altarpieces in the church, none is in its original setting, and one, the charged and tenebrous *Baptism* on the right, was painted for the lesser church of San Giovanni Battista. The concentration of pictures by the artist at Taverna testifies both to his patrons' pride in Preti's achievement and to the calm agricultural prosperity of the country on the southern flank of the Sila.

133

STILO and GERACE

❖

Rossano has two rivals among the Calabrian towns above the Ionian Sea: Stilo and Gerace. The former was in the tenth century under the Byzantines Rossano's counterpart in southern Calabria, and well after the Norman conquest of 1071 King Roger II continued to allow the town to maintain its orthodox religious tradition. Stilo would in later centuries become a noted centre of iron-founding.

The road from the coast curves round the wide – but in high summer dry – riverbed of the Stilaro. Stilo comes into view on its terraces high on the flank of the Monte Consolino. The road climbs to reach the long Piazza Comunale with, to the left, the *settecento* front of San Francesco which houses a venerated image, the *Madonna del Borgo*, by Salvo d'Antonio, Antonello da Messina's incurably provincial kinsman.

Opposite the narrow Via Tommaso Campanella winds upwards through what was the centre of the medieval town, past a late Neoclassical fountain, towards the now derelict Duomo. This has a fine early gothic door, to the left of which the lower section of a Roman statue with two feet is capriciously set into the wall so that these stick outwards. Higher up are some a few fairly substantial houses and a path along the cliff to a modest rock-cut shrine, the Madonna del Pastorello. Beyond the piazza, a road runs down to the wide terrace before the church of San Giovanni Teresti with its paired campaniles and the adjacent former monastery. A *seicento* masterpiece, Giovanni Battista Caracciolo, Battistello's *Madonna d'Ognissanti* has been

temporarily moved from the Duomo. The charged composition may be regarded as the painter's response to Caravaggio's *Seven Acts of Mercy*.

Further on a turn to the right leads to the path up to the eroded medieval castle and to the most perfect Greek church in Calabria, La Cattolica, with its five small domes and three commensurately modest apses. This has been variously dated between the ninth and the twelfth centuries, a recent proposal being that it is a twelfth-century restoration of an earlier shrine. The earliest of the frescoes, the *Pantocrator* of the central dome would appear to be of about 1250. Whatever its date, the Cattolica built against the rockface is a precious survival, although one that Edward Lear failed to note on his visit to Stilo, as Norman Douglas was delighted to point out. No one who walks along the path to the church will forget the views down across the town to the sweeping course of the river as it carves its way to the sea beyond.

North of Stilo, but most easily reached from Bivogni behind the Monte Consolino is San Giovanni Vecchio. This was promoted as a place of pilgrimage by Roger I because of its association with San Giovanni Teresti, a monk who fled from Sicily after the Arab occupation. With its single nave and mellow triple apse, the church has a new mission at the heart of an orthodox community.

No visitor to Stilo should fail to go to Gerace, set back from the coast some fifty kilometres to the south. Still girdled by formidable city walls, Gerace was, and is, a grander place: it was much favoured by the Normans. In the heart of the city is the modest Angevin church of the Nunziatella, near the house where Lear stayed on his Calabrian journey. Higher up, above its irregular piazza, is the Cathedral,

Stilo: San Giovanni Vecchio.

the largest and most memorable in Calabria, consecrated in 1045. This is entered through the crypt beneath the central apse. The unusual height of this gives warning of the ambition of the church above. The exceptionally long nave is flanked on each side by a row of ten classical columns of varying marbles and stone, each punctuated by a central pier, which enhances the spatial impact: the columns were presumably plundered from the now-eroded but not un-atmospheric ruins of Locri down by the shore. A street to the north leads to San Francesco, which like the cathedral suffered in an earthquake of 1783. In the choir, behind the mesmerising if somewhat sinister marble high altar piece of 1664, is the fine tomb of Nicolò Ruffo who died in 1372. Across the piazza from the church is the small Byzantine San Giovanello.

134

REGGIO DI CALABRIA

❦

FEW CITIES HAVE suffered from more disasters than Reggio, which since early times has been uniquely placed to dominate the trade route through the Straits of Messina. Sacked by Dionysius of Syracuse in 386 BC, by Alaric in AD 410 and Totila in 549, it was recovered from the Saracens by the Byzantines in the mid-ninth century and taken in 1060 by Robert I Guiscard, whose base it was for the conquest of Sicily. The sixteenth century saw four devastating attacks by the Turks. In 1810, when occupied by the French, Reggio was bombarded by the British fleet; and it was bombed again in 1943. So it would hardly be surprising that little survives of the early city, even if it was not on a seismic fault line: a serious earthquake was recorded in 91 BC; another caused havoc in 1783; and on 28 December 1908, the place was largely destroyed at the same time as Messina, its counterpart across the Straits.

With the exception of the truncated survivor of the great castle of the Aragonese, who were understandably uncertain of the reliability of their Reggian subjects, the city is a reconstruction of after 1908, although partly adhering to plans prepared after the 1783 disaster. The central Corso Garibaldi runs northwards from the Piazza dominated by the neo-Romanesque Duomo, in which there are a few things salvaged from its predecessor, past the Piazza d'Italia with its orchestration of public buildings, to the Piazza de Nava, a procession of solid and sober buildings of their time. Parallel to the west is the Lungomare Mariotti,

with a sequence of buildings in varying styles, classical, baroque and Venetian Gothic. There is a certain competitive courage in the individuality of these.

But it is not for architecture that the sightseer comes to Reggio. The Museo Nazionale on the Piazza de Nava has one of the great archaeological collections of Italy. The visitor is offered a comprehensive panorama of the prehistoric cultures of Calabria: and the finds from the Greek cities on the Ionian coast, notably Metaponto and Locri, are cumulatively most impressive. Near the entrance is a fine fifth-century BC *Kouros*. After seeing this – for to do this in the reverse order would be anticlimactic – one waits in the adjacent atmospherically controlled room before being allowed to see the celebrated bronzes of Riace. Datable about 450 BC, these are the finest statues in their medium of the high point of Athenian civilization and have been plausibly identified as from the Treasury of the Athenians at Delphi, implying an association with no less a sculptor than Phidias. Both bronzes are of warriors, one older and more solidly built, the other in confident early manhood. It is ironic to think that these miracles of anatomical observation, technical virtuosity and artistic genius only survive because the vessel in which they were being taken to Italy, presumably as loot, foundered off Riace: had the bronzes reached Rome these would almost inevitably have been melted down.

Opposite: Museo Nazionale:
Phidias or associate, Warrior, c. 450 BC.

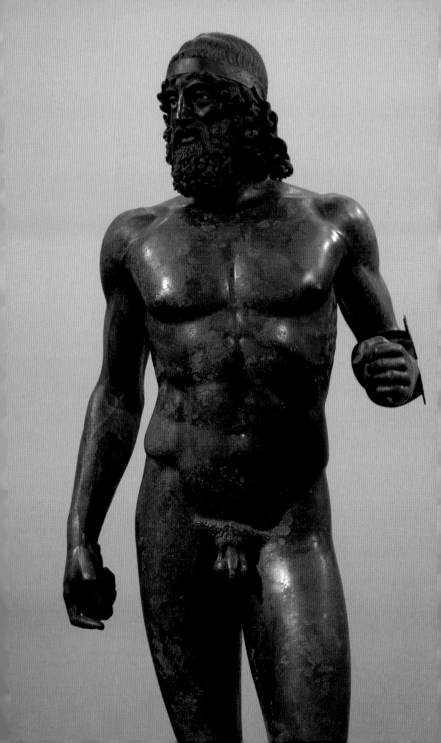

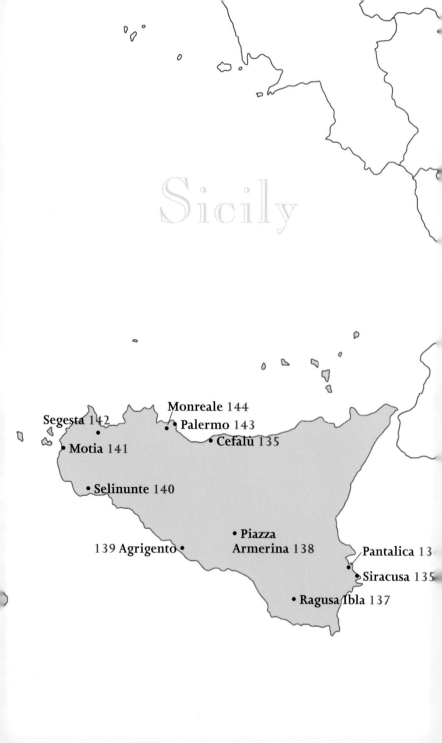

Sicily

135

SYRACUSE

✣

Syracuse was one of the great cit-
ies of the Greek world. The wealth
she owed in part to the excellence of
her harbour inspired two of the great
sieges of antiquity. In 416–413 BC the
Syracusans defeated the vast Athenian
war machine. A generation later the city
was controlled by a tyrant, Dionysius I,
the calibre of whose coinage has never
been excelled. Rome was to be a more
powerful enemy than Athens, and
despite the ingenuity of Archimedes
Syracuse fell after a protracted siege of
214–212 BC. There followed a long period

of prosperity, broken only by the disin-
tegration of the western empire in the
fifth century. Belisarius won the city
for Byzantium in 535, and it was con-
trolled by the eastern empire until the
Arab conquest of 879. With the Norman
occupation of 1086, Syracuse was for
the first time subordinated to Palermo,
upon whose subsequent fortunes she
was to depend.

The Corinthians settled on the former
island of Ortigia in the eighth century BC,
but Dionysius' city was altogether differ-
ent in scale, with walls covering a circuit
of twenty-two kilometres. The expan-
sion of modern Siracusa has affected
the context of her most famous classical
monuments, in the former suburb of
Neapolis. Near the east entrance to the
Parco Monumentale is what remains of

The Greek Theatre.

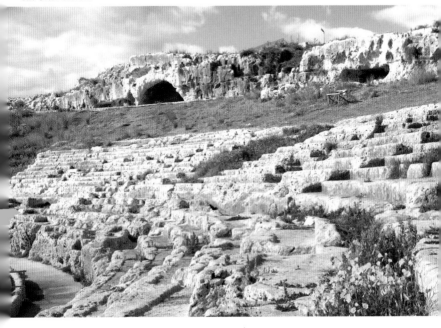

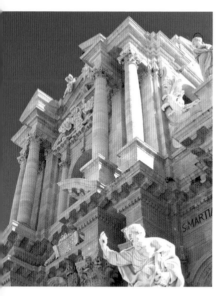

Cathedral façade by Andrea Palma, 1725–53.

the Roman amphitheatre. Three-hundred metres or so north-west is the much more appealing Greek theatre, marvellously placed with wide views over the coast. Behind are the celebrated quarries, great gashes in the hillside where, as Thucydides relates, Athenian prisoners were put to work. The largest is the Latomia del Paradiso, forty-five metres deep in places, with the Ear of Dionysius – the cavernous excavation so named by Caravaggio in 1608. It is regrettable that public access is restricted to a small area, and that the atmospheric Latomia di Santa Venera to the east is now inaccessible.

At the northern extremity of Dionysius' city, some eight kilometres by road from Ortigia, is his Castello Eurialo. Built in 408–397 BC, this was one of the most sophisticated fortifications of the time, with an elaborate system of tunnels and sallyports. The fort withstood two years of the Roman siege. It is particularly atmospheric in the late afternoon. Other tourists depart, leaving you to the sound of the wind; a curious herdsman may pepper you with questions in his dialect– 'How old are you?' 'Are you alone?' 'Are you married? 'Why not?' – as he pauses to gather his flock.

The archaeological museum east of the Parco Monumentale is uncompromisingly modern. It must be one of the most perfectly arranged institutions of the kind – a subtle orchestration of objects of every type with excellent photographs of the sites from which they came. Outstanding groups of Attic black figure vases and a handful of exceptional Greek sculptures are shown to real advantage. Further east, above a complex of catacombs of the Roman era, is the much rebuilt church of Santa Lucia, the virgin who was martyred there in AD 303.

Modern Siracusa has little to commend it. But persevere, for Ortigia – a scant kilometre long – is remarkable. The main road crosses to the Piazza Pancali, behind which are the substantial ruins of the Greek Temple of Apollo. Take the Corso Matteotti, forking right on the narrower Via Cavour, which opens into the north end of the Piazza del Duomo, at the highest point of the island. This is fringed with excellent buildings: façades of private palaces (the most spirited is the Palazzo Beneventano del Bosco); the sober archiepiscopal palace, begun in a late Renaissance classical mode by the Spanish architect Andrea Vermexio in 1618; and, not least, the Cathedral, the Christian successor of the Greek Temple of Athena, much of the structure of which still survives. Shattered by the earthquake of 1693 which devastated so much of south-east Sicily, the cathedral was rebuilt from 1725 to the design of

Andrea Palma from Trapani. At the south end of the piazza is the tall façade of Santa Lucia alla Badia, to which the *Burial of Saint Lucy*, the charged masterpiece supplied by Caravaggio in 1608 for the high altar of the eponymous church, has now been transferred. The setting is, most appropriately, an ancient quarry cast in shade: two muscular gravediggers flank the prostrate corpse; one of the mourners is dressed in red, but otherwise the palette ranges from flesh to umber. The church of Santa Lucia is orientated so the light falls from the right.

To the south of the piazza, in the former Palazzo Bellomo, is the Galleria Regionale. The building, begun in the thirteenth century, has been ruthlessly restored. Among the pictures, pride of place goes to a masterpiece of Antonello da Messina, the Palazzolo Acrèidi *Annunciation* of 1474. Although a good deal of the surface is lost, this remarkable work shows how much Antonello had learnt from his experience of contemporary Netherlandish and southern French painting. Antonello absorbs, whether in the humanity of his types or the clarity of his detail. But he does not imitate. This in part explains why his impact on the Venice of Bellini was so immediate.

At the extremity of Ortigia is the Castello Maniace – named now after the Byzantine captain who took the body of Saint Lucy to Constantinople – built between 1232 and 1260 for the Emperor Frederick II, king in his mother's right of Sicily. The recent restoration means that the visitor can now see one of the most rigorously planned of all medieval fortresses, before walking back through the narrow streets and passages of Ortigia, past silent relics of the many phases of Siracusa's long urban evolution.

136

PANTALICA

THERE IS NO more moving place in Sicily than Pantalica, a vast necropolis with a total of over five thousand tombs carved into towering cliffs above the river Anapo and its tributary, the Torrente Cava Grande. Although accessible from both Sortino and Ferla, the gorge has not been compromised by development. So we are left to our thoughts as we follow ancient tracks or flights of steps and clamber up to the least inaccessible of the gaping doorways framing dark shadows that are cut into the pale rock. The individual tombs are of little visual interest. It is their concentrations, grouped as the configuration of the cliffs dictated, that draw us on. Wind, the sounds of birds, and drifts of wild flowers play

Tombs in the Filiporto Necropolis.

North-west Necropolis

Steps in the Cava degli Pipistrelli.

their part, and we can only wonder at the laconic account of Douglas Sladen in his *Sicily: The New Winter Resort* (1905): 'A gorge full of prehistoric tombs and with remains of a megalithic building and troglodytes' caves. Explored thoroughly by Prof. Orsi. Near Sortino, which has a mail vettura from Syracuse.'

The best approach is from Ferla with its quartet of fine churches. The road strikes eastwards. Pass the visitor centre and drive on to a point where the road crests the ridge between the two valleys. Just before a bend to the left the ground falls away steeply to the Anapo on the right. Below the road, cut into successive strata of a natural amphitheatre, is the Filiberto Necropolis, with roughly a thousand tombs datable to the ninth and eighth centuries BC. Further on, to the left of the road, are the upper sections of the earlier (twelfth–eleventh centuries BC) North-west Necropolis, cut

into outcrops hanging above the gorge of the Cava Grande; the majority of the tombs seem to have served for individual families. The road ends above the Anapo. A footpath cuts down to the left towards a partly rock-cut ancient road that curls down past scattered tombs to a ford across the Cava Grande; part of the original drain survives. There are more clusters of tombs, outliers of the North Necropolis, on the opposite bank, from which a well-preserved stairway cuts down to the Grotto dei Pipistrelli (Cave of the Bats) and implies the importance this had for the ancients. The path winds upwards towards Sortino. Return to the road and drive back for roughly a kilometre. A marked track to the left leads to the foundations of the so-called Anactoron on the crest of the plateau. From this a path above the gorge continues westwards, passing the troglodyte Byzantine settlement of San Micidiario to reach the

road above the Filiberto Necropolis. A little below the Anactoron a steep path descends to the valley floor opposite the South Necropolis. Its tombs, as of the South-west Necropolis and the Filiberto Necropolis across the gorge to the west, both most easily seen from the line of the former railway, are of the ninth and eighth centuries.

Protected as it was by the cliffs below, the high ground round the Anactoron lent itself to defence. It was apparently first settled by an indigenous people in the thirteenth century BC. The Anactoron itself has been compared with Mycenaean buildings. And it is hardly surprising that the place has been associated with the early city of Hybla, whose name would survive in that of the Megaran colony of Megara Hyblaea on the coast, which was founded in about 728 BC. Whatever its name, the city that must once have controlled a considerable territory suffered a gradual decline even before the arrival of the Megarans and the colonists from Corinth who settled at Syracuse a few years earlier. As the finds from the site now in the Museo Archeologico at Syracuse demonstrate, Pantalica was the centre of a sophisticated polity in the late Bronze Age. Looking up at the irregular tiers of the tombs, we can only speculate as to the causes of the city's decay.

137

RAGUSA IBLA

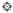

THE GREAT EARTHQUAKE of 1693 shattered most of the cities of south-eastern Sicily; it is to the spirited process of architectural renewal that their enduring interest is due. Catania is the grandest, her public buildings and palaces locked in an ambitious grid of streets. Noto is the most celebrated, ruthlessly moved towards the coast from its ancient site in the hills and laid out in a coherent plan that perfectly expressed the social patterns of the time and was realized by a succession of accomplished local architects, notably Rosario Gagliardi. Modica boasts the greatest of Gagliardi's churches and an impressive procession of palaces, while nearby Scicli is studded

San Giorgio, Rosario Gagliardi, 1738 onwards.

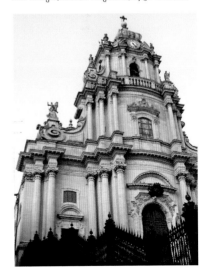

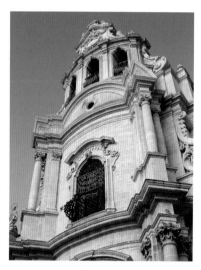

San Giuseppe, attributed to Rosario Gagliardi.

with baroque churches of immense charm. Yet none of these towns has quite the magic of Ragusa, where the old town and the new happily coexist.

The new town is to the west, an ordered plan with the substantial cathedral begun in 1706 but not finished until 1760, its façade oddly overbearing. The main road twists eastwards through the town down to the church of Santa Maria delle Scale, from where there is a splendid view over the promontory below, on which the earlier town, Ragusa Ibla, perches. Steps descend from the church steeply to the narrowest point, overlooked by the spectacularly placed church of the Purgatorio. Its pretty pilastered façade, raised above a wide flight of steps, is, as it were, the frontispiece to the old town. Nearby are a number of palaces including that of the Cosentini family, with particularly ingenious corbels supporting the obligatory balconies. The main road follows the northern

flank of the hill, but you should try to lose your way in the maze of passageways and streets behind the Purgatorio. Eventually you will reach Gagliardi's extraordinary Duomo, dedicated to Saint George and designed in 1738, as drawings in the sacristy still attest. The soaring tiered façade of golden stone dominates the long downward-sloping central piazza. It is a wonderfully resilient statement of renewed faith in the destroyed town.

At the further end of the piazza is a charming Neoclassical survival, the Circolo della Conversazione, the façade with fluted Doric pilasters. It was here that the local gentry met, the inhabitants of the many palaces, mostly of modest scale, whose great-grandparents had been addicted to the corbelled balconies on which their masons lavished such inventive attention. To the east are two other buildings of particular interest. The nearer is the church of San Giuseppe: the façade, though smaller and less spectacularly placed than that of the Duomo, is in some respects more sophisticated, rising inexorably in serpentine tiers. The canopied window above the door is flanked by columns that bear the stepped-out broken triple-arched belfry. The elliptical interior has a particular charm. Further east, the front of San Giorgio Vecchio is a quattrocento gothic survivor of the earthquake, Catalan in style, a precious reminder of Sicily's long adherence to the house of Aragon.

It is for these monuments that the visitor is drawn to Ragusa Ibla, but the whole town, renewed so lovingly on its sloping ridge, has a strange magic, not least when afternoon light lengthens the shadows and sharpens our perception of the way the site itself sits in what remains a relatively untrammelled landscape.

138

PIAZZA ARMERINA

CENTRAL SICILY ABOUNDS in handsome, unselfconscious towns. Enna and Caltanissetta are both places of greater consequence than Piazza Armerina, but no one who pauses in the latter will regret doing so. The town is well sited and the ambitious Cathedral, begun in 1604, with its earlier campanile are appropriately dominant. In the chapel to the left of the presbytery is the double-sided *Crucifix* of 1485 by an as yet unidentified Sicilian painter who like the young Antonello was aware of Provençal developments. The chapel also contains a picture by Ligozzi, who was Florentine by adoption, while a characteristic *Assumption* by an underrated Tuscan who settled in Sicily, Filippo Paladino, is the altarpiece in the left transept.

But it is not with such things that the sightseer now associates Piazza Armerina. Six kilometres to the south is the remarkable Roman villa at Casale. First recorded in 1761 and excavated in phases from 1881 onwards, most notably in 1950–4, this is one of the largest and most lavishly decorated country houses to have been found in the Roman empire.

Sited a few kilometres from the rural town of Philosophiana on the main road between Catania and Agrigento, the villa was presumably the hub of a substantial agricultural estate. It probably dates from 310–25 and was clearly built for a patron of rank. Whatever his identity, he didn't aspire to live in a villa on a logical plan that Pliny would have approved. The visitor arrived in an irregular court, and then turned through a vestibule to

reach the central, and almost rectangular, peristyle garden with a fountain, beyond which, off a corridor, were the large basilica-like hall, again irregular in plan, and the family reception rooms. Doors from the corridor and the peristyle led to an elliptical court aligned on a room with three apses, apparently used for banqueting, while the bath complex, reached through a long hall, was behind the entrance court. The owner attached little importance to symmetry or axial consistency, and it has plausibly been suggested that he wished for as much privacy as was possible in any mansion of the kind.

Some of the walls survive, as do sections of their painted decoration: but the villa is celebrated for the mosaic floors in nearly all its forty-five rooms. These were almost certainly executed by craftsmen from Rome's territories in North Africa, and more specifically Carthage, working as a team. The visitor today sees these from walkways and thus at a different angle than the mosaicists would have expected, from a greater distance and, as it must be admitted through a deposit of dust inevitable in a building open to the

Villa Casale, a duck, mosaic detail.

elements: moreover, the modern route would not have corresponded with that taken by the builder's guests.

Of particular note are the long hunting scene, with representations of Armenia and Arabia or Africa in the lateral apses, in the corridor off the peristyle and the floors of the triple-apsed banqueting-room, with the *Labours of Hercules*, and other subjects including *Endymion and Silene*. Chariot races in the Circus Maximus at Rome, where the owner no doubt had political interests, are shown in the hall leading to the bath complex. Fruit is seen in what is thought to have been the main bedroom, and a scene of erotic initiation in the smaller adjacent room. The repertoire of subjects, putti hunting or making music, animals, mythologies and so forth is familiar enough and indeed varied remarkably little throughout the empire. What impresses is, however, the technical consistency of floors rather than their quality, which falls somewhat short of that of the finest Roman mosaics of the time in Tunisia and Tripolitania. One would give much to know something about the builder of the villa and the circumstances that enabled and indeed inspired him to undertake a project of the kind.

139

AGRIGENTO

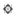

THE GREEK AKRAGAS was founded by settlers from Rhodes and Gela in about 580 BC and thus one of the last Greek colonies in Sicily. Strategically placed above the coast, the city flourished and under the tyrant Theron (488–473) controlled much of central Sicily, spreading over much of the ground north of the ridge on which the celebrated temples stand. Sacked by the Carthaginians in 406, Akragas was refounded by Timoleon. Allied subsequently with Carthage, it was first occupied by Rome in 262 and finally annexed in 210 BC. Under Rome it remained a significant city, but the decline of the empire inevitably affected Agrigentum: the inhabitants withdrawing to the site of the former acropolis on the high ridge north of the earlier centre. The place was taken in 828 by the Muslims to whom is owed its former name, Girgenti. The Normans prevailed in 1087 and Girgenti became the seat of a powerful bishopric, although it continued to have a sizeable Muslim population until 1245 when this was expelled by Frederick II. After a long period of relative decline, the city began to revive in the eighteenth century. In 1927 its name was officially changed to Agrigento. While subsequent expansion has not directly affected the major classical monuments, this does have an unfortunate impact on their context.

The great temples of Agrigento are inevitably best seen early in the morning or late in the afternoon. So the sightseer should take this into account when making plans. If he arrives early be should

begin at the Porta Aurea, near the Porta V carpark, and make for the shattered ruin of the enormous Temple of Olympian Zeus, which was only exceeded in size by the Greek temples of Ephesus and Didyma. This was begun after the city's major victory over the Carthaginians in 480 BC at Himera: captive soldiers were used as slave labourers, but even so the project was never finished. An unusual feature of the design was that telamones, giant figures set high up between the giant pilasters helped to support the frieze above. The central shrine was roofless. No single column stands. But what survives is impressive enough. Further on are the jumbled remains of further sanctuaries, including the Temple of the Dioscuri, a small section of which has

been reconstructed. The deep ravine to the west was crucial to the defence of the city and a series of wells and tunnels were excavated. Now the Giardino della Kolymbethra in which an astonishing number of different types of fruit trees flourish, this is administered by FAI, and, for a fee, one can be led through a narrow escape tunnel which originally ended outside the walls.

To the east of the Porta Aurea the Via dei Templi runs along the north side of the ridge on which the better-preserved temples stand. The sequence, best seen in the afternoon, begins with the earliest of those at Agrigento, the much reduced late-sixth-century hexastyle Temple of Hercules. This originally housed a bronze of Hercules and a picture of him

So-called Temple of Concord, mid-fifth century BC.

with Alcmena by the greatest of Greek painters, Zeuxis. Ahead, beyond a second well-tended garden, is the magnificent mid-fifth-century BC so-called Temple of Concord. After the Theseion at Athens, this is the best-preserved of all extant Greek temples, owing to its use as a church from the sixth century until 1748. Further on, at the east end of the ridge is the only almost equally well-preserved Temple of Hera Lakinia, of about 450 BC which is very similar in design to but somewhat smaller. Twenty-five of the original thirty-four columns stand. But at close quarters their impact is diminished by the eroded surface of the honey-toned tufa, which – as in all the temples at Agrigento – was originally faced in stucco and painted. While none of the temples matches the majesty of that at Segesta, the cumulative impact of these is unforgettable: and looking down towards the coast or across at the rough hills to the north, one understands why the Greek settlers chose to worship on the ridge.

North of the Porta Aurea, near the excavated sections of the Greek town, is the impressive Museo Archeologico, the finds in which come not only from Agrigento but also from other Greek settlements in the area. There is a fine, and well displayed, collection of Athenian black figure vases, including good examples by the Harrow and Lugano painters. The most complete of the telamones from the Temple of Olympian Zeus and the heads of three others are complemented by the closely contemporary marble *Ephebe*, the last alas ill-placed.

On the ridge some way to the east, beyond the cemetery, is perhaps the most atmospheric area of ancient Agrigento. A road by the cemetery wall runs down to an eroded gate of the city wall.

Follow the wall to the left and turn uphill beside the fragmentary excavated footprint of a shrine. Take a section of an ancient rock-cut road that climbs to the right and then make uphill towards the austere Norman church of San Biagio, built on the base of the early fifth-century BC Temple of Demeter and Kore on the partly rock-cut platform of this. Another fine stretch of the early road descends to the north.

Tourism hardly touches the 'modern' town on the ridge to the north, which is best approached from the Piazza Aldo Moro at its east end. The Porta di Ponte opens to the Via Atenea. Beyond the former hospital the Via Porcello on the right leads to the Salita Santo Spirito and the eponymous church with fine stuccowork by Serpotta. Much of the early structure of the town survives, as even a casual exploration of the narrow streets and flights of steps reveals. At the highpoint at the far end of the town, apparently on the site of a Greek temple, is the Cathedral begun soon after the Norman conquest but subsequently much remodelled. The eighteenth-century buildings east of this on the Via del Duomo, including the episcopal palace and the Biblioteca Lucchesiana founded in 1765, reflect the continuing domination of the city by its bishops under Bourbon rule. Steps on the opposite side of the road lead down to a simple Norman church, Santa Maria dei Greci, that stands above a Doric temple to Athena built for Theron. Here, in microcosm, we sense how conquests a millennium and a half apart have imposed their contribution. Equally eloquent is a small portable altar of the twelfth century in the Museo Diocesano: mounted in Sicily, this is of carefully polished Hertfordshire pudding stone.

140

SELINUNTE

❖

IT IS A testament to the dynamism of the Greek colonies in Sicily that the island remains so rich in buildings of the zenith of Greek civilization. The temples of Agrigento, Selinunte and Segesta have much in common, yet the sites are very different and equally remarkable in differing ways. Agrigento stands back from the coast and always did so. Selinunte is beside the shore. The westernmost Greek city on the island, this was founded by colonists from Megara Hyblaea near Syracuse in 628 BC, taking its name Selinus from the wild parsley that grew in profusion. The city expanded considerably in the fifth century, allied first with Carthage and then with Syracuse. But in 409 it was vanquished by the Carthaginians: sixteen thousand citizens were killed, five thousand were enslaved and a rump withdrew to Akragas. A year later, Hermocrates, an exile from Syracuse, tried unsuccessfully to revive the city. He failed, but the acropolis above the shore would continue to be occupied until 250 BC. Centuries later the Byzantines developed a small port near the mouth of the river. In the early medieval period hermits settled among the ruins, which were damaged by a severe earthquake. The identification of the site as Selinus was made as early as the sixteenth century, but the ruins were used as quarries even after King Ferdinand III ordered their protection in 1779.

Since I first visited Selinunte, staying in the then modest village of Marinella by the beach, a visitor centre has been built and a massive bank raised to block the view eastwards over the coast. This affects the context of the great monument of the city, the Temple that was probably dedicated to Apollo and was only marginally smaller than that of Olympian Zeus at Agrigento. Begun about 550 BC, this seems never to have been completed. The cella was originally surrounded by forty-six columns. Many of the readily serviceable rectangular blocks were recycled, and the temple is now reduced to a vast heap of huge drums and capitals, presided over by a single re-erected column. Earthquake and man have exacted their toll; and yet the place is both mesmerising and awe-inspiring. Nearby are the remains of two smaller temples, both hexastyle, the much-robbed archaic

Temple, probably of Apollo.

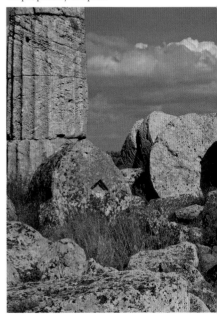

Temple F, metopes from which are in the archaeological museum at Palermo, and, to the south of this, the successfully-restored Doric Temple of Hera (E).

The road from the visitor centre winds round to the Acropolis, a substantial low but level-topped hill rising steeply from the shore. This is surrounded by a wall, the strongly defended northern section of which, with a once-covered gallery from which defenders could counter-attack, is attributed to Hermocrates. Within its walls the acropolis is crossed by two main intersecting streets from which narrower lanes run at right angles: these were laid out, possibly following the earlier plan, when the town was re-established. Of the cluster of temples in the south eastern section of the acropolis, the most impressive is the largest, Temple C, of which twelve columns have been re-erected. The fine metopes from this are at Palermo. So if time allows it is worth crossing the river to the west, the ancient Selinon, to see the intriguing Sanctuary of Malophoros.

No one who shares my near obsession with ancient quarries will wish to miss that from which so much of the stone of ancient Selinus was taken. One quarry, the Rocche di Cusa, some ten kilometres to the west, is a magical place, almost lost among olive trees, that was abandoned when the city fell in 409 BC. We can see how the quarrymen cut back into the rock and prepared to excavate blocks of specific sizes, which in some cases were never cut away. Cylindrical blocks intended for column drums, some of the same width as those of the shattered Temple of Apollo, still await transport. An even larger but perhaps less interesting quarry is at Baglio Cusa near the Selinon, some six kilometres north of Selinunte.

141

MOTZIA

❧

THE HISTORIES OF Motzia and Marsala are inextricably entwined. The Phoenicians, already masters of the sea, saw the potential of the island they knew as Motia in the eighth century BC. Set in a lagoon so shallow that the warships of the time could not reach it and defended by walls stretches of which remain impressive even though these were pillaged for stone for the nearby saltpans, Motia became an intensely populated island fortress – like its smaller counterpart of Arwad off the Syrian coast. Mariners only reached it after transhipping their loads to smaller vessels to reach the south gate – and once within this were confronted by a large ritual pool; while those from the mainland could take their carts across the road below the level of the water that ran across the lagoon to the still impressive north gate. Motia's inhabitants were increasingly drawn into the struggle between their Carthaginian kinsmen and the cities of Magna Grecia. And in 397 BC Dionysius II of Syracuse sacked the island. When the Carthaginians recovered it they transferred the inhabitants to Lilibeo, the future Marsala. Appropriately perhaps, it was due to the success in the early nineteenth century of the Whitaker family's business in the local wine that took the town's name that Joseph Whitaker owned Motzia and began the excavations there.

Boats set out from by the saltpans on the mainland. The best course is to take the Fenice service which circumnavigates the island and can just, in certain

places, cross the submerged road. This, almost certainly, was used by Dionysius II's forces. Boats land at the pier just below the former Whitaker villa. This now houses the museum Whitaker founded. One room is an increasingly rare example of a traditional arrangement, with numerous small finds placed in plain white cases. The show is inevitably stolen by a chance find of 1979, the extraordinary marble *Ephebe*. An absolute masterpiece of the fifth century BC, this represents a young athlete or charioteer in a tightly pleated tunic that, perhaps because of the exertions he has made, clings to the body to reveal what lies beneath. Nothing quite like it survives from Antiquity.

After seeing the museum, walk round the island which in high summer is noisy with cicadas. Follow the line of the walls round the shore, but head inland to see the ritual pool and, at the north end, the 'tophet' or shrine near which the *Ephebe* was found. The least robbed stretch of the wall is to the east of the north gate.

On leaving, it makes sense to head south for Marsala. Many of the warehouses built for the Whitakers and their rivals still line the shore. The westernmost now serves as the archaeological museum. The star exhibit is a section of the hull of a Carthaginian vessel, which is admirably shown.

Positioned as these were, ancient Motia and nineteenth-century Marsala depended in their differing ways upon trade. Other cross currents are exemplified by the dedication of the cathedral at Marsala to Saint Thomas à Becket, and by the provenance of its great treasure, the exceptional set of Flemish tapestries presented by King Philip II of Spain to Archbishop Antonio Lombardo, which he in turn gave to it in 1589.

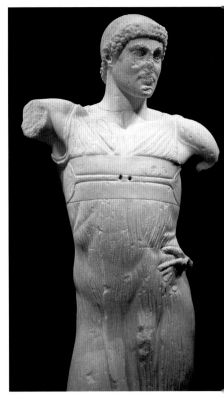

Museo Whitaker: Ephebe, fifth century BC.

142

SEGESTA

SEGESTA IS IN many ways the most thrilling of the classical sites of Magna Grecia. No visitor can but be moved by the drama of the setting, despite the intrusion of the motorway. We can still see the great temple as Edward Lear did from Calatafimi in the mid-nineteenth century, rising among the hills. On the approach from Palermo, we see the temple perched high above the valley of the Gùggera, backed by mountains: as we draw nearer it disappears behind a low hill and so happily can not be seen from the new carpark and visitor centre, from which buses run to a cleared area below the Monte Barbaro.

Most visitors will make first for the temple, but it makes more sense to take the shuttle bus up the hill, or better, to walk up the footpath that passes

The Doric Temple, begun c. 420 BC, from the north-west.

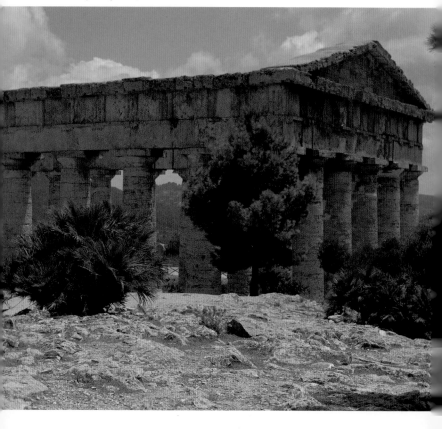

the remains of a formidable gateway in a narrow defile. The ancient city developed on the broad summit of the Monte Barbaro. Large enough to be the rival of Selinus by the early sixth century BC, it remained prosperous in Roman times and was only abandoned under the Vandals. Parts of the city wall can still be traced and a number of much-robbed buildings have been excavated. On the north-eastern bastion of the hill is the sympathetically restored theatre built in the third century BC. The view across the valley to the temple, which was well outside the city walls, is unforgettable.

Walking down from the city, before climbing up to the platform on which this stands, one takes in the temple. This dates from the latter decades of the fifth century BC. The order is Doric and the building is hexastyle, the pedimented ends thus of six columns, the sides of fourteen. The massive columns stand open to the winds – nothing of any cella survives, and it has been suggested that none was ever built. The detail is austere.

No other extant Greek temple with the exception of that at Bassae in the Peloponnese is placed so dramatically. And we cannot but be awed, as the early inhabitants of Segesta must also have been, by the contrast between so compellingly monumental an architectural statement and the wild hillside. But was the temple as originally built, and painted, so incomparably beautiful to our taste as it is now in venerable age, surrounded by the panoply of wild flowers of the Sicilian spring or drifts of black irises in December, or in high summer when the sounds of fellow tourists are drowned out by the cicadas? One can only pray that those who planned to build a hotel below the temple will never be permitted to do so.

143

PALERMO

❧

FEW CITIES ARE more favoured by nature than Palermo. Backed – and protected from its hinterland – by dramatic hills, the Conca d'Oro, and commanding a bay which has always boasted the best anchorage of the island, the site was inevitably settled in early times. The Phoenicians were followed by the Carthaginians and Rome. The Vandals were succeeded in turn by Odoacer and Theodoric, but in 535 Belisarius conquered the city for Byzantium. The Arabs prevailed in 831, to be defeated in their turn by the Normans in 1072. Palermo became their capital. The Norman kings built up one of the most efficient states of the time and their architectural contribution was immense. Their kingdom was inherited by Frederick II of Hohenstaufen, whose heirs were driven out in 1266 by Charles of Anjou. Sicily subsequently passed to the kings of Aragon, who first appointed a viceroy in 1415, and was a dependency of Spain until 1712. After a brief period of Savoyard rule, Sicily became the subsidiary kingdom of the Neapolitan Bourbons, Palermo serving as their capital while Naples itself was occupied by the French in 1798–9 and 1806–15. From 1815 the kingdom was styled 'of the two Sicilies'. As a result of Garibaldi's dramatic incursion, Palermo – and with it the whole island – passed to the kingdom of Italy in 1860. Areas of the city near the port were tragically affected by Allied bombing in 1943.

The old city is only a kilometre wide and a kilometre and a half deep, and

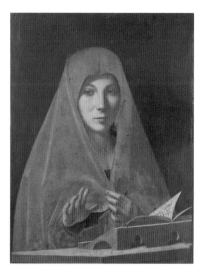

Galleria Regionale della Sicilia: Antonello da Messina, Virgin Annunciate, 1476–7.

the threads that link Palermo's past are so interwoven that at the risk of double-tracking it makes sense to explore the city stratum by stratum. Count Roger II was a determined builder. In 1130, the year of his coronation as King, he initiated work on the Cappella Palatina of the former Palazzo Reale (now the Palazzo dei Normanni), which was greatly extended during Spanish rule in the seventeenth century. The chapel shows how cosmopolitan the new king's taste was. Egyptian granite was reused and the ceiling of the nave is of Fatimid construction. But if Roger turned to the Arab world in this respect, for the mosaics of the upper walls and the nave he looked to Byzantium. A brief walk to the east is the austere church of San Giovanni degli Eremiti, also built for Roger II; this incorporated part of an earlier mosque. If time permits, this is the point at which to see two other royal buildings, both

in walking distance of the Palazzo dei Normanni. The Zisa and the Cuba were in the Norman kings' huge park, the first begun by William I and completed by his eponymous successor (1165–7), the second undertaken by William II in 1180. As with the ceiling of the Cappella Palatina, Fatimid Cairo was the inspiration for these sophisticated summer retreats, which somehow still defy the encroachment of the modern town.

Roger II's admiral, Giorgio of Antioch, was also a notable builder. He built the Martorana, Santa Maria dell'Ammiraglio, in the Piazza Bellini at the heart of the early city. Much of the structure and the distinguished campanile survive; so do the glorious mosaics, which, like those commissioned for the king, are Byzantine in taste. Next to the church is San Cataldo, built about 1160 for another admiral, Majone di Bari. The greatest church of Norman Palermo was of course the cathedral, Santa Rosalia, roughly midway between the Piazza Bellini and the Palazzo dei Normanni. This was begun in 1184, but work continued over a long period, and the interior was remodelled in 1781–1801. The main entrance from the piazza, of 1429–30, is a masterpiece of the late gothic style, while the royal tombs of porphyry, now crammed into the chapels to the left of this, are unexpectedly moving.

The later medieval and Renaissance churches and palaces of Palermo are perhaps less memorable. The early sixteenth-century Santa Maria della Catena by the port mixes late gothic Catalan forms with Renaissance motifs in a characteristically Sicilian way. More surprising is the Carrara marble fountain

Opposite: Angelo Mazzoni, Palazzo delle Poste. 1928–35.

Oratorio del Rosario di San
Domenico: Giacomo Serpotta,
putto, plaster, c. 1701.

in the central Piazza Pretoria. Executed in 1554–5 by Francesco Camilliani for a Florentine villa, this was sold a generation later and installed at Palermo.

The Piazza Pretoria abuts on the Via Maqueda, cut through the ancient city by the viceroy of that name in 1600. A few paces to the west, where it intersects the former Via Toledo, are the Quattro Canti, with four matching façades, projected in 1608 and completed in 1620. Brave the traffic, for this is an early masterpiece of baroque town planning. It serves to remind us that Spain was one of the great powers of the period, and that Palermo derived some benefit from this.

In 1624 the young Anthony van Dyck – himself a Flemish subject of the King of Spain – arrived in Palermo to receive the commission for his wonderful *Madonna of the Rosary* in the Oratorio del Rosario di San Domenico, behind the church of that saint off the Via Roma. In this sparkling canvas van Dyck came of age as a religious artist in much the same way he had recently done as a portraitist at Genoa. The oratory introduces the great genius of baroque Palermo, the stuccodore Giacomo Serpotta. His white plasterwork is of unequalled fluidity,

with allegorical figures that vie with any sculptures of their date. The nearby Oratorio di Santa Cita was decorated with equal ingenuity between 1688 and 1718 by Serpotta. But his masterpiece is arguably the decoration of the Oratorio di San Lorenzo (1698–1710), from which Caravaggio's late *Nativity* was so selfishly stolen in 1969. Both here and at the Oratorio del Rosario one senses Serpotta's deep respect for the great altarpieces for which he supplied new settings.

Palermo was notably rich in baroque and rococo palaces. Many, alas, including that of the Lampedusa family, were damaged in the Second World War. Countless façades beckon, but few of the palaces that line the main arteries can be visited, although part of one, the romantically run-down Palazzo Filingieri di Cutò on the Via Maqueda, serves as a primitive hotel. Few of the nineteenth-century buildings in Palermo are of particular note, but Angelo Mazzoni's emphatically classical Palazzo delle Poste of 1928–35 on the Via Roma is a masterpiece of the Fascist era.

To understand something of the taste of secular Palermo it is necessary to go outside the city. To the north, off the Parco della Favorita, projected in 1799, is the

earlier Villa Niscemi, while within the park is the stylish Palazzina Cinese, built by Venanzio Marvuglia in 1799 for King Ferdinand III, then in exile from Naples. Nelson and the Hamiltons were among his visitors. Many of the great Palermitan families had villas at Bagheria to the east of the city. The town has now grown, so some effort of the imagination is necessary to imagine its former charm. Walking is the best way to see something of the villas. The most accessible is the Villa Palagonia, built in 1715 for the prince of that name and long famous for the marble-encrusted saloon and the grotesque sculptures of the enclosing walls.

Finally, visit the museums. The Museo Archeologico is at the north end of the Via Roma. In contrast to the modern museum at Siracusa, this is a very traditional institution but none the worse for that. The high point is the room of sculptures from Selinunte, including metopes from two of the temples, as well as the fifth-century BC bronze *Ephebe*. In the room dedicated to bronzes are the *Ariel*, which was placed above the main entrance of Frederick II's Castello Maniace in Siracusa, and the *Hercules* from Torre del Greco, below Vesuvius, presented by King Francesco I. The Galleria Regionale is housed in the Palazzo Abatellis on the Via Alloro. The collection of Sicilian works has no rival. The star is inevitably Antonello's small *Virgin Annunciate*, his quintessential masterpiece and one of the most serene and human statements of the whole Renaissance. Very different in mood is the Malvegna triptych begun by Gerard David and completed by his younger contemporary, Jan Gossart, called Mabuse. Intimate in scale and exquisite in detail, this is eloquent of Gossart's interest in Italian art and, as a Palermitan commission, reminds us that the city remained a significant trading port.

144

MONREALE

❖

MONREALE IS ONLY eight kilometres from Palermo. The modern road rises to the spur – 310 metres above sea level – on which the town stands, skirting the processional route laid out in 1762. It was at Monreale that in 1174 King William II founded the great monastery of Santa Maria Nuova, which became in turn a royal palace and the archiepiscopal seat. The king's motive was to challenge the pretensions of the then Archbishop of Palermo – a neat solution by comparison with the murder of Saint Thomas à Becket by minions of the contemporary English monarch. And the riches of William II's realm were liberally lavished. By 1189 the building

Cathedral: apse mosaic, Pantocrator, late twelfth century

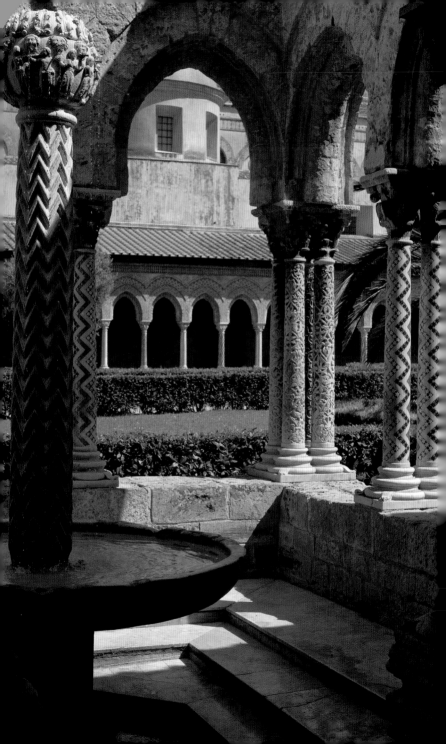

was effectively finished; it is the consummate achievement of the Normans in Sicily.

The façade is flanked by towers and partly masked by a late portico, which protects the wonderful portal with its bronze doors by Bonanno Pisano – the deviser of the Leaning Tower. The lateral (north-west) façade boasts equally fine bronze doors of 1179 by Barisano da Trani, and it is here that the tourist enters. The interior glows. Even on an overcast day, light is reflected from the glittering mosaics. A devastating fire of 1811 necessitated a long programme of restoration, but happily the apse mosaics were not significantly affected. The great *Pantocrator* dominates the long cycles of scenes from the Old and New Testaments. The scale of the project meant that, as for the doors, craftsmen had to be attracted from outside Sicily – from Venice and Byzantium. For uncouth adventurers as the Normans had so recently been, they had an instinctive respect for the artistic tastes of more established rulers.

The cathedral museum is entered from the right transept. Exhibits include a fine Roman sarcophagus and a beautiful terracotta group of the Madonna and Child with saints in the style of Gagini: from one of the upper rooms there is an excellent lateral view of the richly decorated masonry of the apse. The cloister, south of the cathedral, is one of the most beautiful complexes of its date in Europe. The ogival arches of the loggia rest on 228 double columns, variously decorated with mosaics and arabesques. The carved capitals of these are wonderfully inventive. On one, King William II himself is shown, offering his cathedral to the Virgin; there are biblical narratives and scenes of rural life, Norman knights and peasants, as well as a few animals and stylized plants. At the south-west corner is a fountain. This takes the form of the stylized trunk of a palm and is enclosed within a square loggia, a wonderfully exotic touch that speaks perhaps of Cairo or Andalusia.

Opposite: Cathedral: fountain in the cloister, late twelfth century.

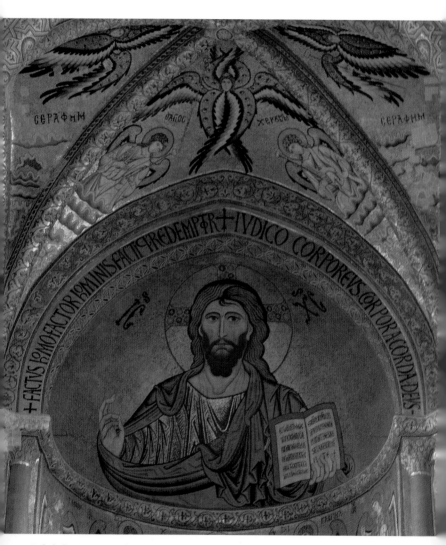

Cathedral, apse mosaic, Christ.

145

CEFALÙ

❁

'DON'T NEGLECT CEFALÙ', was Ester Bonacossa's injunction to me when I first planned to go to Sicily. No one who follows the north coast of Sicily eastwards from Palermo will wish to do so. Dominated by the great outcrop, the Rocca, which was already occupied in the megalithic period, Kephaloídion as the Greeks knew it was a place of some significance to judge from the fine polygonal masonry of the surviving archaic fortification by the shore. Taken by Rome in 254 BC, it was, despite the strength of the position, of relatively minor account until after nearly two centuries in Arab hands it fell to Roger I in 1063. His son King Roger II founded the great Cathedral, built on lower flank of the Rocca, in 1131, evidently intending this as a monument to his family. Although never completed, it is one of the signal achievements of Sicilian medieval architecture.

The front, visible for miles on the approach from the west and dominating the centre of the town, is flanked by a pair of campaniles. The splendid marble door is protected by the tripartite portico added by Ambrogio da Como in 1471: above, the central window is flanked a band of interlacing arches below a blind arcade. The interior was drastically restored from 1925. But even from the entrance the visitor is perforce aware of the prodigious mosaic of the apse, which is dated 1148. This is in tiers: with a majestic figure of *Christ Pantocrator* above; the Virgin with the four archangels; the twelve apostles; and a row saints and prophets below. The visual impact of the mosaic is of course enhanced when afternoon light filters through the cathedral. We appreciate it as a work of art, but for the Normans and their subjects it had a deeper message, as a statement of the authority of the church in a territory where Islam had taken hold and had to be suppressed. The mosaic was thus both a religious and a political statement. The second great treasure of Cefalù, in the Museo Comunale Mandralisca, is a wholly personal artistic statement. We do not know the identity of the middle-aged man, his face creased in a near smile, who gazes at us sideways in the celebrated portrait of the 1460s by Antonello da Messina. And we have no means of knowing who was so discomfited by the calm insistence of the gaze that he scored through both eyes. But we do recognise that the panel is one of the seminal works in which the artistic movement perfected by Jan van Eyck and his Netherlandish contemporaries came, as it were, to be naturalised in Italy. The presence of the portrait and of four fine Attic black-figure vases makes Barone Mandralisca's house of curiosities one of the more memorable small museums in Italy.

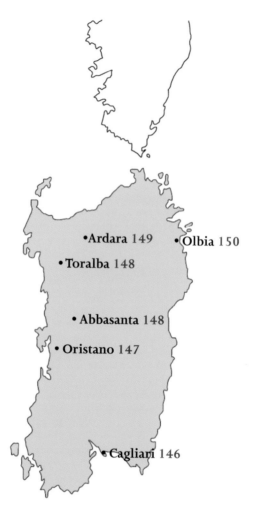

Sardinia

146

CAGLIARI

CAGLIARI CLAIMS PRECEDENCE among the cities of Sardinia. The port of the Phoenicians and their Carthaginian heirs passed before 100 BC to Rome, and by AD 312 Cagliari was an episcopal see. With the Byzantine collapse in the West, the city – and indeed the rest of Sardinia – was subject to rival maritime powers. But in 1217 the Pisans established control, fortifying the ridge that remains the heart of the town. Cagliari fell to the Aragonese in 1326, and remained under Spanish control until 1720, when Sardinia was awarded to Vittorio Amadeo II of Savoy.

Although the tower of San Pancrazio of 1305 at the north-east angle survives, the Pisan walls have for the most part

been replaced by successive Spanish and Piedmontese interventions, necessitated by the evolution of defensive warfare. At the higher, north, end of the ridge was the Citadel, and below this parallel streets were laid out. The Palazzo Reale, built for Carlo Emanuele III, and the Cathedral dominate the central piazza that slopes steeply to the west. The Romanesque façade of the cathedral is a re-creation of 1933, but the side door to the right of this is an enchanting gothic fantasy, as delicate as lace. The interior is memorable not least for its wealth of sculpture. At either side of the central door are two pulpits made up in the seventeenth century from that supplied by Guglielmo da Pisa in 1159–62 for the cathedral at Pisa, which was displaced by Giovanni Pisano's masterpiece and despatched in 1312 to Cagliari. Of the sixteen narrative reliefs, the most memorable is perhaps that of the soldiers – medieval knights in full armour – by the tomb. The church is rich in baroque altars

Cathedral: Guglielmo da Pisa, pulpit, 1159–62.

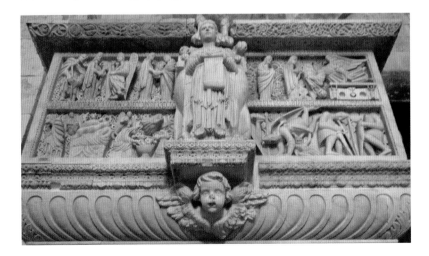

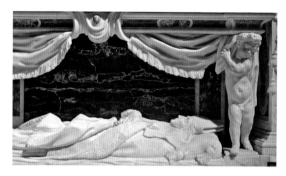

Cathedral, tomb of Bishop
Bernardò dei Cariñeni.

and funerary monuments. Of these the most striking, in the last chapel on the left, is that to Archbishop Bernardò di Cariñeni (d. 1722), whose effigy, framed by curtains that have been drawn apart, is beneath the altar.

Below the presbytery is the Santuario dei Martiri, three marble-faced chapels cut into the rock. The vault of the central Cappella della Madonna dei Martiri is enriched with 584 circular compartments, and the decoration of the sanctuary evidently reflects the taste of Archbishop Francesco d'Esquivel (d. 1624), whose monument dominates the vestibule. The smaller lateral chapels are dedicated to the martyrs of Cagliari, Saturninus and Luciferus. The marble facings incorporate fine Roman sarcophagi that had come to be associated with the saints. It is not difficult to understand why Prince Carlo Emanuele of Savoy, who died at Cagliari in 1799, was buried in one chapel and Queen Giuseppa Maria Luigia, who died in 1810, chose to be buried in the other. Their restrained Neoclassical monuments are respectively by Antonio Cano and the Sardinian Andrea Galassi, who had studied under Canova to some effect.

On the site of the Citadel a museum complex was built in the 1980s. This already seems outmoded. The Museo Archeologico houses the main collection of prehistoric material from the *nuraghi* and other sites for which Sardinia is justly celebrated. Apart from some small figurines and metal statuettes that anticipate Giacometti, most of the material is of specialized interest. The most ambitious of the Roman sculptures is a statue of the younger Drusus, efficient but uninspired. The Pinacoteca Nazionale is higher up. Sardinia was a backwater where painting was concerned, but the sequence of polyptychs from the church of San Francesco di Stampace is unexpectedly impressive, not least for that of San Bernardino of 1455 by two Catalan masters, Rafael Tomas and Juan Figuera. The selection of the saint's miracles includes one, of Bernardino floating across a river on his cloak, that Italian patrons seem to have considered too improbable to merit depiction.

There are other things to see at Cagliari, including the eroded and much restored Roman amphitheatre west of the ridge. But the tourist's time may best be used by making for some of the neighbouring sites: Dolianova to the north-east, with the marvellous and well-preserved church of San Pantaleo, begun in the twelfth century and completed by 1299; or, to the north-west, the smaller Romanesque Santa Maria

at Uta, beautifully set among trees; and its more modest neighbour, San Platano of about 1144 at Villaspeciosa, whose front is enriched with spoil from earlier monuments. These, and their numerous counterparts throughout the island, suggest the strength of the religious revival of their period.

The Nuraghe Su Nuraxi near Barumini, one of the three most celebrated monuments of the kind, is roughly an hour north of Cagliari. The Sardinian term, *nuraghe*, which may preserve its prehistoric form, meaning a pile of stones with an internal cavity, does less than justice to the sophistication of the prehistoric fortresses for which the island is renowned. The tower at the centre, originally eighteen and a half metres high, is datable to 1500–1300 BC, while the four adjoining ones were added in about 1300–1100 BC; the fortifications were extended after 1100 BC, when many of the circular structures in the village outside the walls were built. Further structures were added in the Iron Age (800–500 BC). Visitor numbers mean that guided tours are the rule; and the circuit of the *tholos*-crowned internal chambers and the narrow internal passages is not, perhaps, for those who suffer from claustrophobia, but tells us something of the cramped conditions in which the builders of *nuraghi* expected to protect themselves.

Two miles to the west is the parish church of San Pietro in the small town of Tuili. The retable of 1500 by the Master of Castelsardo is perhaps the masterpiece of Sardinian Renaissance painting, fascinating for what it tells of complementary strands of Italian, Spanish and northern influence. The anonymous painter's radiant colour is a wonderful contrast to the dark passages of the Nuraghe Su Nuraxi.

147
ORISTANO and SANTA GIUSTA

❖

ORISTANO WAS THE medieval successor of the Roman Tharros, whose excavated ruins lie in the shadow of one of King Philip II of Spain's watchtowers on the peninsula across the gulf to the west. The heart of the town is rather well preserved. The apse of the much remodelled Cathedral backs onto the main piazza. A little to the north is the tetrastyle portico of the circular church of San Francesco. This does little to prepare us for the masterpiece on the altar on the left, an intensely felt polychrome statue of *Christ on the Cross* by a Spanish sculptor of the late fifteenth century, which was clearly intended to be looked at from below. Beyond in the sacristy is the *Stigmatization of Saint Francis* by the only competent Sardinian painter of the High Renaissance, Pietro Cavaro. Much of the rest of the retable is in the Antiquarium Alborense in the Piazza La Corrias, which holds a small collection of antiquities from local sites.

Some three kilometres south of Oristano is the smaller town of Santa Giusta. This was of some importance in early times, as the little Roman bridge beside the main road south hints. The great church on a rise to the north of the town was built in 1135–45 as the cathedral of the diocese of Santa Giusta, first mentioned in 1119, which was suppressed in 1503. The tall central section of the west front implies the structure of the interior, with a nave divided from narrower lower aisles by screens of columns. Taken from the town's

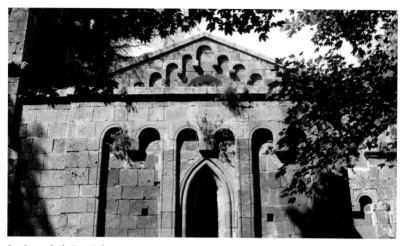

San Leonardo de Siete Fuèntes.

predecessor, Othoca, and from Tharros, these are of differing colours and widths, one fluted, another spiral cut. The presbytery is raised above a wide crypt that rests on narrower columns. The arcaded apse is particularly successful, but the campanile beside it is largely reconstructed. The architect was no doubt Pisan, and elements of the building were echoed in other Romanesque churches on the island.

A number of such churches survive in or near villages to the north of Oristano. The small but elegant San Paolo by the cemetery at Milis, finished in the early thirteenth century, follows the model of Santa Giusta, the simple arcaded façade with bands of dark trachite stone alternating with the creamy *pietra arenaria*. Five kilometres to the north is Bonarcado. Built out from the hillside Santa Maria, consecrated in 1146–7, was a dependency of the Camaldolese abbey of San Zenone at Pisa. Below the church is the small cruciform sanctuary of the Madonna di Bonacattu, an early foundation remodelled after 1242. Further on, across the Monte Ferra, built of dark volcanic stone and shadowed by trees, is San Leonardo de Siete Fuèntes, which also reflects elements of the design of Santa Giusta.

148

THE NURAGHI LOSA and SANTU ANTINE

THE NURAGHI OF Sardinia are so numerous that the non-archaeologist will only have the appetite for a selection. Of the three most impressive, two, the Losa and Santu Antine *nuraghi*, are some forty kilometres apart and both in earshot of

the Strada Carlo Felice, the main road from Cagliari to Sassari.

Despite the proximity of the road both sites are more atmospheric than their counterpart, the Nuraghe Su Nuraxi (see no. 146). The great triangular basalt tower of the Nuraghe Losa, near Abbasanta, datable to the first half of the second millennium BC, now gilded with lichen, rises above the splendid defensive wall of the former town, which was reconstructed in the seventh century BC. The carefully battered tower

Nuraghe Oes.

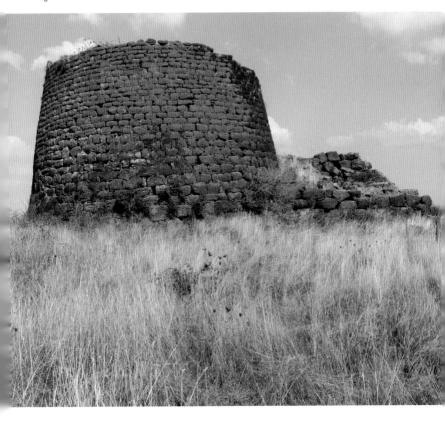

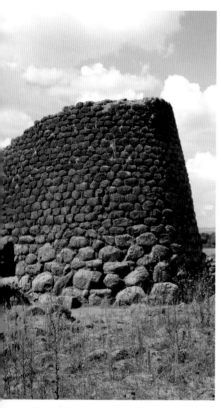

Nuraghe Losa.

the builders. The *nuraghe* was a formidable place of strength and refuge, and it is hardly surprising to learn that it continued to be used until the early medieval period.

The Nuraghe Santu Antine near Torralba is similar in many ways. The central tower, variously dated to the late ninth or eighth century BC and still over seventeen metres high, is set within a lower triangular outwork, with a projection at the centre of one side, strengthening the entrance passage to the courtyard within, which has been variously thought to be part of the original complex or an early addition. At either end of the court are openings to the *tholoi* in the angle towers, from which corridors lit by narrow openings in the outer wall lead to the *tholos* in the third angle, and subsidiary passages behind the angle towers. In the centre, the lower part of the wall of the central tower is exposed. The entrance leads to the impressive central *tholos*, which is surrounded by a circular passage except where stairs rise to a second, lower, *tholos*, and then to a third, of which only the lower courses survive. The masonry is of conspicuously fine calibre, with for the most part regular courses of carefully graded blocks, of which some thirty survive. And the detail, for instance the narrow outer faces of the window openings, is remarkably consistent. No wonder the place has come to be known as the 'Reggia nuragica'. Echoed to the south by the fine unrestored Nuraghe Oes hard by the railway line (take a torch!), the fortress dominates the so-called Valle dei Nuraghi, a natural amphitheatre that must long have known a gentle prosperity.

One wonders what was made of the *nuraghi* by the medieval bishops of Torres, whose beautiful church of San Pietro di

was protected by three Late Bronze Age lower towers; that to the south masked the main entrance. Passages led to *tholoi*, in the flanking angles, and to the central chamber, off which there are three circular projections; just before this is entered, a flight of steps, with sides like those of the other passages tapering to the top, climbs to a second *tholos* above the first, and then to a third (of which only the lower part survives). The external masonry is beautifully graded and eloquent of the engineering ability of

Sorres on the ridge above Torralba was built between 1170 and 1190 under Pistoiese rather than Pisan influence. This boasts perhaps the most satisfying of all Sardinian Romanesque façades.

Few modern roads – even in a country with so consistent an interest in road construction as Italy – are so memorable as that from the Abbasanta turn near the Nuraghe Losa through the hills to Olbia. A series of monuments that enrich our understanding of both prehistoric and medieval Sardinia are within easy reach: the solemn basalt church at Ottana, which retains a mid-fourteenth-century Pisan polyptych; a cluster of rock-cut tombs, Sas Còncas, half a kilometre from the turn for Oniferi; and, to the south of the turn for Lula and Dorgali, two exemplary monuments of the world of the *nuraghi*. Some four kilometres from the turn, to the left of the road as this rises, is the path to the Tomb of the Giant Sa Ena 'e Thòmes. The central monolith of this long barrow was carved to leave a raised border and central band; below is the small arched entrance to the tomb chamber. The tomb is better preserved than its counterparts at Arzachena and much more appealing as, lizards apart, it is likely to be deserted. Continue onwards towards Dorgali for a further four kilometres for the entrance to Serra Orrios, the best-preserved nuragic village, with groups of round structures and two shrines of the Late Bronze Age. Alas, we know nothing of the religion practised here, but the charm of the site, shaded by olive trees, is not in doubt.

149

ARDARA and SANT' ANTIOCO DI BISARCIO

❧

EVERY VISITOR WILL have his own favourites among the Romanesque churches of northern Sardinia. The largest is San Gavino of Porto Torres, with apses at either end; more charming are the black and cream striped San Pietro di Simbános on an isolated ridge inland from Castelsardo and its pink neighbour at Terqu. But to sense the resilience of the twelfth-century church we can do no better than visit the sequence of five churches of the period on a forty-kilometre stretch of the main road from Sassari to Olbia.

The best known is the controversially restored abbey of La Trinità di Saccargia, founded in 1116, with an assertive striped church and a soaring campanile. The apse was frescoed in the thirteenth century, with Christ in Majesty above the Virgin and the apostles and, below, Passion scenes above fictive hangings, the only such scheme to survive on the island. A couple of kilometres east, abandoned on a rise between the modern road and a power station, is San Michele di Salvènero, also radically restored. This was built in 1110–30 for the Vallombrosan Order – which of course had strong Tuscan connections – and altered a century later. The apse is particularly successful, and there are numerous parallels in design with the church's larger neighbour.

Some ten kilometres further on is Ardara. The black church of Santa Maria del Regno lies on a terrace east of the town. External detail is pared down to

the point of severity. But the interior is remarkable. The entire altar wall of the wide nave is filled by a glowing retable with scenes from the life of the Virgin by a later *quattrocento* master, possibly Martin Torner from Majorca. The predella, however, is from a different world. The central panel, Christ set against a landscape, bears a *cartellino* with the date 1515 and signature of Giovanni Moru, who must have known northern Italian pictures of the previous generation. On the left wall

is a damaged dossal of the Passion by a Pisan of the late *Trecento*.

Sant'Antioco di Bisarcio is some six kilometres east, easily visible from the road: a great church with a campanile and the remains of associated buildings on a platform above the valley floor. Bisarcio was the seat of a bishopric until 1503. The original church, of before 1090, was destroyed by fire and reconstructed after 1150 by builders aware of developments at Santa Giusta (see no.

La Trinità di Saccargia.

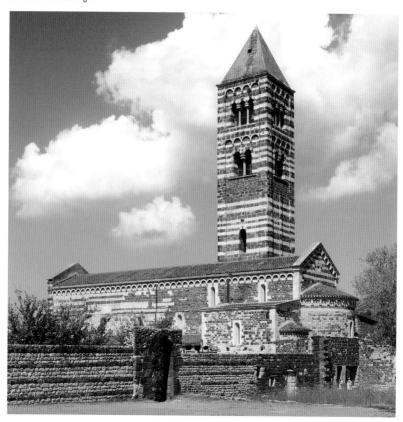

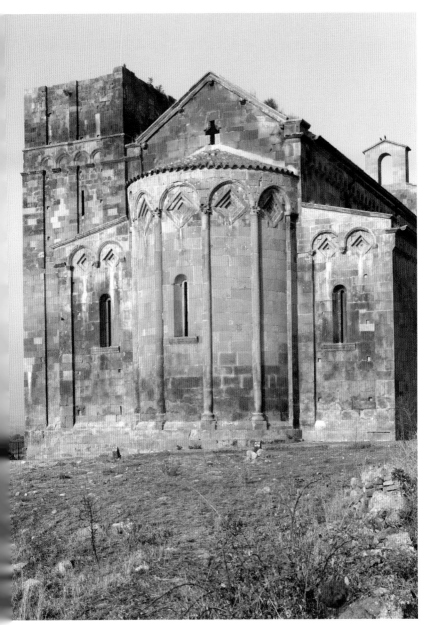

Sant'Antioco di Bisarcio.

98). A generation later, after 1170, an extension on two floors was set against the entrance front; part of this was lost when the north-west corner collapsed in the fifteenth century, but the elaborate decoration of what survives implies an understanding of French work. There are worn carvings of animals and, above the left door, of prophets; much of the detail is classical and acanthus plentiful. The entrance opens to a narthex, above which were three rooms reached by a narrow stair and, originally, by a passage from the episcopal palace. The first, with a bench and a chimney, was the chapter house, and beside this was the bishop's chapel, its altar below the central window of the original façade. The church itself is admirably coherent, the uniform columns with capitals of Corinthian derivation, with heads or stylized flowers between the volutes. The exterior of the apse, splendidly placed above a low cliff, is beautifully handled. So is the campanile, with generous angle shafts and narrower central ones that are linked by pairs of twin arcades.

Sant'Antioco is so perfect in its way that it may seem pointless to go on to the less ambitious Nostra Signora di Castro on an isolated rise east of Oschiri. But this too has a rare charm, not least on a morning when the buildings emerge from swirling mist and you rouse the resident cats. The controlled façade, with plain pilasters and blind arcades defining the roof line, might stand as a microcosm of the Sardinian Romanesque.

150

OLBIA

❖

OLBIA, ON THE north-east coast of Sardinia, was a major Greek and Roman port, and survived as a more modest provincial town, Terranova, under Spanish rule. The place is not particularly eloquent of its past. Eroded arches of the Roman aqueduct stretch to the north-west, and on the site of an early necropolis there is the fine early twelfth-century church of San Simpliciano. Now entered from the east, this may have been planned with apses at either end, as at Porto Torres; classical spoil was put to use and the initial stone structure was heightened, so that a second blind arcade, largely of brick, rises above the original. Fine as it is, the church is outshone by perhaps two dozen others on the island. Olbia's

Pozzo Sa Testa.

claims on the tourist are owed to the discovery, when a road was tunnelled through the site of the former harbour, of a remarkable number of ancient boats.

Some of these are housed in the impressive new museum on the waterfront, which was built to display a sequence of local finds ranging from the Bronze Age of the early *nuraghi* to the time of the Phoenicians and their successors. Fortunately, the building was ambitious enough in size to accommodate such of the vessels as have thus far been prepared for public view. There are no fewer than four great oaken masts of boats of the time of Nero, rare survivals. Shown with these in the first room are two Vandal ships of the sixth century, compelling evidence of the new power that had seized the North African underbelly of imperial Rome and wrought havoc throughout the western Mediterranean.

The outer timbers are of oak, the joists, attached to them by both copper and wooden nails, of pine. The larger of the vessels was found in two sections, broken to the right of the keel, which itself had already had to be repaired. The Roman ships await attention, but a small medieval boat is already shown, its dimensions implying the level of silt that had choked the harbour and thus preserved the hulks of the earlier vessels.

The modern ferry port of Olbia is matched by the industrial zone that has crept round the bay, almost engulfing the beautiful nuragic well, Sa Testa, the path to which is behind a supermarket, Centrocash. The small enclosure leading to the steps down to the water seems a miraculous survival. So in a different way is the Nuraghe Cabu Abbas on an outlier of the range of hills to the north, whose early inhabitants must have been able to monitor movements on the roadstead.

GLOSSARY

✿

Ambo, ambone Pulpit
Ambulatory Area round a choir or presbytery
Arca Tomb

Baldachin Columned structure above an altar
Balze Eroded slopes
Barrel vault Arched roof
Broletto Communal palace

Ca' Venetian for palace
Campanile Bell-tower of church
Campo Venetian equivalent of a piazza
Camposanto Cemetery
Cantoria/e Balcony for a choir
Cartellino Label, often inscribed
Cella Central chamber of a classical temple
Certosa Charterhouse (Carthusian monastery)
Ciborium/ia Canopy above a high altar
Cimasa Cresting or upper section
Cinquecento Sixteenth century
Collegiata Collegiate church
Condottiero Mercenary commander
Cosmati Type of mosaic associated with the Cosmati family

Decumanus maximus Principal cross-street of a Roman town
Dugento Thirteenth century
Duomo Cathedral
Enceinte Line of walls of a castle

Exarchate Byzantine province, governed by an exarch

Foresteria Guesthouse
Forum Roman marketplace

Ghibelline Adherent of the Holy Roman Empire
Grisaille Decoration in shades of grey
Grotteschi Type of classical decoration with exotic detail
Guelf Adherent of the papacy
Guglia Free-standing connical monument

Intarsia/e Inlayed woodwork

Lungarno/i Road beside the river Arno (e.g. in Florence and Pisa)

Metope Section of Doric frieze
Mole Pier of harbour

Narthex Vestibule at west end of a church
Necropolis Cemetery
Nuraghe/i Sardinian fortified structure(s)

Oculus Circular opening in roof
Opus anglicanum medieval English embroidery
Opus sectile Type of Roman construction with small pieces of stone arranged diagonally

Pala Altarpiece
Palaestra Roman gymnasium
Paliotto Small altarpiece
Patria Hometown
Pendentives Compartments below a dome
Pentatych Altarpiece with five main lateral panels
Piano nobile Principal floor
Pietra arenaria Sandstone
Pietra serena Grey stone, easily carved
Pilaster Engaged column
Polyptych Altarpiece of many panels
Podestà Mayor
Portico in antis Portico recessed from a façade
Predella Row of small panels at the foot of an altarpiece
Presbytery Area of chancel reserved for priests, usually raised
Pyx Container for the consecrated Host

Quattrocento Fifteenth century

Reliquary Container for a religious relic

Salita/e Street on a slope (especially in Genoa)
Scuola Venetian confraternity
Seicento Seventeenth century
Settecento Eighteenth century
Sgraffito Incised decoration
Signoria Lordship
Sinopia Underdrawing of a fresco
Stela Upright stone memorial
Stucco Plaster
Studiolo Study

Tempietto Small temple
Tholos/oi Round room rising to an internal dome
Tondo/i Circular picture or sculpture
Trecento Fourteenth century
Tufa Volcanic stone
Tumulus/i Mound(s)
Tympanum Recessed face of a pediment, often carved

INDEX

Page references in italic refer to illustrations

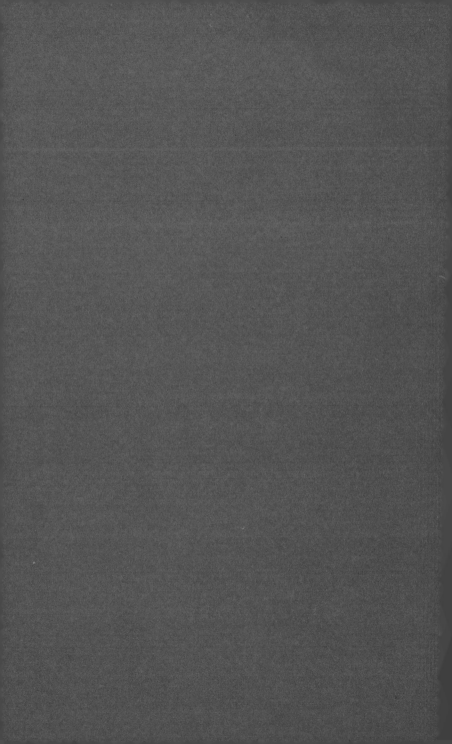